KEY WRITE
TWENTIE

D0863342

> The twentieth century was a great era for aesthetic theory. In making that important but often obscure theorizing accessible, this marvelously lucid book will prove invaluable for students and teachers alike.
>
> David Carrier, Champeney Family Professor, Case Western Reserve University/Cleveland Institute of Art

Key Writers on Art: The Twentieth Century is a unique and authoritative guide to modern responses to the visual arts. Written by international experts, the entries cover key figures who represent a wide range of disciplines and approaches, reflecting the breadth of modern art study. These include:

- Adorno
- Bourdieu
- Bryson
- Danto
- Derrida
- Freud
- Gombrich
- Kristeva
- Panofsky
- Sontag
- Wittgenstein
- Wölfflin

Written in an accessible style, and alphabetically arranged, the essays provide an analysis of each writer's ideas and influence, as well as a brief biography, a list of their key texts, and a helpful guide to further reading.

Together with its companion volume, *Key Writers on Art: From Antiquity to the Nineteenth Century*, this book provides an invaluable resource for all those interested in aesthetics, art history or visual culture.

Chris Murray is a freelance editor and writer. He is the editor of *Key Writers on Art: From Antiquity to the Nineteenth Century*, also available from Routledge. He is currently compiling an encyclopedia of the history, concepts and methodologies of art history.

ROUTLEDGE KEY GUIDES

Routledge Key Guides are accessible, informative and lucid handbooks, which define and discuss the central concepts, thinkers and debates in a broad range of academic disciplines. All are written by noted experts in their respective subjects. Clear, concise exposition of complex and stimulating issues and ideas makes *Routledge Key Guides* the ultimate reference resources for students, teachers, researchers and the interested lay person.

Ancient History: Key Themes and Approaches
Neville Morley

Business: The Key Concepts
Mark Vernon

Cinema Studies: The Key Concepts (Second edition)
Susan Hayward

Cultural Theory: The Key Concepts
Edited by Andrew Edgar and Peter Sedgwick

Cultural Theory: The Key Thinkers
Andrew Edgar and Peter Sedgwick

Eastern Philosophy: Key Readings
Oliver Leaman

International Relations: The Key Concepts
Martin Griffiths and Terry O'Callaghan

Key Writers on Art: From Antiquity to the Nineteenth Century
Edited by Chris Murray

Key Writers on Art: The Twentieth Century
Edited by Chris Murray

Popular Music: The Key Concepts
Roy Shuker

Post-Colonial Studies: The Key Concepts
Bill Ashcroft, Gareth Griffiths and Helen Tiffin

Social and Cultural Anthropology: The Key Concepts
Nigel Rapport and Joanna Overing

Sport and Physical Education: The Key Concepts
Timothy Chandler, Mike Cronin and Wray Vamplew

Sport Psychology: The Key Concepts
Ellis Cashmore

Television Studies: The Key Concepts
Neil Casey, Bernadette Casey, Justin Lewis, Ben Calvert & Liam French

Fifty Eastern Thinkers
Diané Collinson, Kathryn Plant and Robert Wilkinson

Fifty Contemporary Choreographers
Edited by Martha Bremser

Fifty Contemporary Filmmakers
Edited by Yvonne Tasker

Fifty Key Classical Authors
Alison Sharrock and Rhiannon Ash

Fifty Key Contemporary Thinkers
John Lechte

Fifty Key Figures in Twentieth Century British Politics
Keith Laybourn

Fifty Key Jewish Thinkers
Dan Cohn-Sherbok

Fifty Key Thinkers on the Environment
Edited by Joy Palmer with Peter Blaze Corcoran and David A Cooper

Fifty Key Thinkers on History
Marnie Hughes-Warrington

Fifty Key Thinkers in International Relations
Martin Griffiths

Fifty Major Economists
Steven Pressman

Fifty Major Philosophers
Diané Collinson

Fifty Major Thinkers on Education
Joy Palmer

Fifty Modern Thinkers on Education
Joy Palmer

Key Concepts in Eastern Philosophy
Oliver Leaman

Key Concepts in Language and Linguistics
R. L. Trask

Key Concepts in the Philosophy of Education
John Gingell and Christopher Winch

Communication, Cultural and Media Studies (Third edition)
John Hartley

KEY WRITERS ON ART: THE TWENTIETH CENTURY

Edited by Chris Murray

Routledge
Taylor & Francis Group

LONDON AND NEW YORK

First published 2003
by Routledge
11 New Fetter Lane, London EC4P 4EE

Simultaneously published in the USA and Canada
by Routledge
29 West 35th Street, New York, NY 10001

Routledge is an imprint of the Taylor & Francis Group

Reprinted 2004

Typeset in Bembo by Taylor & Francis Books Ltd
Printed and bound in Great Britain by Biddles Ltd, King's Lynn, Norfolk

British Library Cataloguing in Publication Data
A catalogue record for this book is available from the British Library

Library of Congress Cataloguing in Publication Data
A catalog record for this book has been requested

ISBN 0–415–22201–X (hbk)
ISBN 0–415–22202–8 (pbk)

ALPHABETICAL LIST OF CONTENTS

CHRONOLOGICAL LIST OF
CONTENTS

CONTRIBUTORS

Mieke Bal is Professor of the Theory of Literature at the University of Amsterdam, Doctor Honoris Causa of the Universitetet i Bergen, Norway, and A.D. White Professor-at-large at Cornell. She co-founded (1993) the Amsterdam School for Cultural Analysis (ASCA), an interdisciplinary research institute. Her work ranges from literature to visual art, and her approach from semiotics to anthropology, feminism and social critique. Her books include *Reading 'Rembrandt': Beyond the Word-Image Opposition* (1991) and *Looking In: The Art of Viewing* (2001).

Paul Barlow teaches at the University of Northumbria at Newcastle. His research interests centre on Victorian culture, in particular on the Pre-Raphaelites and on the historian Thomas Carlyle. He is co-editor of *Victorian Culture and the Idea of the Grotesque* (1999) and of *Governing Cultures: Art Institutions in Victorian London* (2000). He has just completed *Time Present and Time Past: The Art of John Everett Millais*.

Hugh Bredin teaches philosophy at Queen's University, Belfast. He has written articles on figurative language, translated books by Umberto Eco, and co-authored (with Liberato Santoro-Brienza) a recent introduction to aesthetics, *Philosophies of Art and Beauty* (2000). He is currently working on topics in medieval aesthetics.

Norman Bryson is Chair of the History and Theory of Art at University College London. Basing his work on semiotics, he has examined the relation between visual and non-visual signs (*Word and Image: French Painting of the Ancien Regime*, 1981), the role of perception in visual discourse (*Vision and Painting: The Logic of the Gaze*, 1983), the structuring principle of absence in visual representation (*Tradition and Desire: from David to Delacroix*, 1984), and the semantics of still life (*Looking at the Overlooked: Four Essays on Still Life Painting*, 1990).

Marcus Bullock is coordinator of the interdisciplinary Modern Studies Program at the University of Wisconsin–Milwaukee. His books include *Romanticism and Marxism: The Philosophical Development of Literary Theory and Literary History in Walter Benjamin and Friedrich Schlegel* (1987), *The Violent Eye: Ernst Jünger's Visions and Revisions on the European Right* (1992), and he is co-editor of *Walter Benjamin: Selected Writings 1913–1926* (1997). He is currently working on representations of perilous desire since Edgar Allan Poe's 'Imp of the Perverse'.

Daniel F. Chamberlain teaches phenomenological hermeneutics, as well as Hispanic language, literature and culture, at Queen's University in Kingston, Ontario. His *Narrative Perspective in Fiction: A Phenomenological Mediation of Reader, Text, and World* (1990) examines the impact of Merleau-Ponty's philosophy on literary interpretation. At present his research focuses on the temporal dimension of perception as revealed through oral and written narrative traditions.

David Craven is professor of art history at the University of New Mexico and is affiliated with the Latin American Institute there. He has written five books and published numerous articles in major art journals in North America, Latin America and Europe. His most recent book is *Art and Revolution in Latin America, 1910–1990* (2002).

Nicholas Davey has lectured at the City University London (1976–79), at the University of Manchester (1979–80), the University of Wales Cardiff Institute (1981–96), and is currently a Reader in Philosophy at the University of Dundee. His principal teaching and research interests are in aesthetics and hermeneutics. He has published widely in the field of Continental philosophy, aesthetics and hermeneutic theory.

Donald Dryden has published several articles on Susanne Langer's life and work and is currently finishing his doctoral dissertation on the philosophy of psychology at Duke University. His research interests centre on the intersection of evolutionary biology, psychology, phenomenology and the neurosciences as these relate to developing a non-reductive theory of mind and consciousness that recognizes the central importance of metaphorical and other imaginative processes for human language, culture and cognition.

Bridget Fowler is a senior lecturer at the University of Glasgow, where she teaches the Sociology of Literature and Art. Influenced for many years by Bourdieu, she has undertaken reception studies of a specific cultural

form, *The Alienated Reader: Women and Popular Romantic Literature in the Twentieth Century* (1991), and a full-length monograph on Bourdieu, *Pierre Bourdieu and Cultural Theory: Critical Investigations* (1997). She is currently working on a critical application of his work on photography.

Alexandra Gajewski-Kennedy teaches History of Art at Birkbeck College, School of History of Art, Film and Visual Media. Her main interest is medieval architecture. She has published on the Cistercian abbey of Le Lys, France (1999) and on Cistercian architecture in Anjou, France (2002). She is currently working on a study of the art and architecture of the duchy of Burgundy in the twelfth and thirteenth centuries.

Mike Gane teaches sociology at Loughborough University. His main interests are in social theory, cultural analysis and gender. His works include the edited collection *Baudrillard: Masters of Social Theory* (4 vols) and *Jean Baudrillard: In Radical Uncertainty* (2000). He is currently writing a book on French social theory.

Willi Goetschel is Associate Professor at the University of Toronto, where he teaches Modern German Literature and Thought. He is the author of *Spinoza's Modernity: Mendelssohn, Lessing, Heine* (forthcoming) and *Constituting Critique: Kant's Writing as Critical Praxis* (1994). He is also the editor of the collected works of Hermann Levin Goldschmidt (1993–). Currently he is working on a study of Heine and Critical Theory.

Paul Gorner is Senior Lecturer at the University of Aberdeen and editor of *Reid Studies*. His main interests are Heidegger, Kant, and German Idealism. His *Twentieth Century German Philosophy* appeared in 2000, and he is currently writing a book on German Idealism.

Carol S. Gould is Professor of Philosophy at Florida Atlantic University. She publishes widely in the areas of aesthetics, the philosophy of literature and Greek philosophy. She is currently working on a book about the aesthetic qualities of persons and their representation in the arts.

Geoffrey T. Harris is a research fellow in the European Studies Research Institute at the University of Salford. His main interest is twentieth-century French politics and literature. His works include *De l'Indochine au R.P.F., une continuité politique: les romans d'André Malraux*

(1990) and *André Malraux: A Reassessment* (1996); and he edited *André Malraux: Across Boundaries* (2000).

Jonathan Harris is Reader in Art History in the School of Architecture at the University of Liverpool. His research interests include modernism and modernity in the twentieth century, art in the USA during the 1930s, and the historiography of art. He is author of *Federal Art and National Culture* (1995) and *The New Art History: A Critical Introduction* (2001). With Francis Frascina he co-edited *Art in Modern Culture* (1992) and co-wrote *Modernism in Dispute: Art since the 1940s* (1993).

Casey Haskins is Associate Professor of Philosophy at Purchase College, State University of New York, USA. He is co-editor of *Dewey Reconfigured: Essays on Deweyan Pragmatism* and is currently writing a book on the concept of autonomy in modern philosophy of art and art criticism.

Richard Hooker taught in the History of Art Department at the University of Glasgow for eight years and now works in environmental consulting in New York.

Juliet Graver Istrabadi has a background in teaching and curatorial work and is currently pursuing independent research. Recent projects include studies on ancient Greek jewellery, the 'classical ideal' and nineteenth-century American art, and the relationship between historiography, archaeology, and museology.

Stephen Kite is an architect and lecturer in architecture at the University of Newcastle upon Tyne. His research interests are in the history and theory of architecture and its wider connections to aesthetics and visual culture. Recent publications include 'The Glory of New-Found Space: tectonics and spatiality in Adrian Stokes's Pisanello', *The Journal of Architecture* (1999) and 'The Urban Landscape of Hyde Park: Adrian Stokes, Conrad and the Topos of Negation', *Art History* (2000). He is currently researching the traditional architectures of SE Arabia.

Peter B. Lewis teaches philosophy at the University of Edinburgh. His main interests are aesthetics, and the philosophies of Wittgenstein, Schopenhauer and Collingwood. He has contributed articles to periodicals such as *British Journal of Aesthetics*, *Philosophical Investigations* and *Collingwood Studies*. At present he is editing a volume of essays on Wittgenstein and aesthetics.

Tommy L. Lott is Professor of Philosophy at San Jose State University. He is author of *The Invention of Race: Black Culture and the Politics of Representation* (1999) and *Like Rum in the Punch: Alain Locke and the Theory of African-American Culture* (forthcoming). He is editor of *Subjugation and Bondage: Critical Essays on Slavery and Social Philosophy* (1998) and *African-American Philosophy: Selected Readings* (2002), and co-editor of *The Idea of Race* (2000) and *Philosophers On Race: Critical Essays* (2002).

Julian M. Luxford is a fellow at Clare College Cambridge. His main interests are later medieval monastic visual culture and monastic history. Other research interests include medieval manuscript studies, Netherlandish art of the fifteenth to the seventeenth centuries, and the historiography of art history. He has contributed articles to many books and journals, including *Antiquaries Journal*, *Konsthistorisk Tidskrift*, *Medium Ævum* and *Scriptorium*.

David Macey is a freelance writer and translator. His works include *Lacan in Context* (1988), the *Lives of Michel Foucault* (1993), *Frantz Fanon: A Biography* (2000) and *The Penguin Dictionary of Critical Theory* (2000). He has translated Alain Touraine's *What is Democracy?* (1997) and his *Can We Live Together?: Equality and Difference* (2000).

Sue Malvern lectures in history of art at the University of Reading. Recent publications include 'Hidden spaces and public places: women, memory and contemporary monuments – Jenny Holzer and Rachel Whiteread, Secret Spaces and Forbidden Places: Rethinking Culture' (2000), and 'Memorizing the Great War: Stanley Spencer at Burghclere', *Art History* (2000). She has curated exhibitions and is currently working on a book, *Witnessing, Testimony and Remembrance. Modern Art, Britain and the Great War.*

Charles Nussbaum is associate professor of philosophy at the University of Texas at Arlington. He has published papers in the philosophy of mind, aesthetics and the history of modern philosophy. He is currently writing a book on musical representation.

Travis Nygard is an undergraduate art history student at Gustavus Adolphus College in St Peter, Minnesota. His work includes 'Wearing Human Bone: A Form of Ancient Mayan Ancestor Veneration', in the proceedings of the National Conference on Undergraduate Research, Lexington (2001). Papers in preparation focus on the sculptural

monuments and inscriptions of the Classic Maya site of Yo'okop in Quintana Roo, Mexico; and on the history and context of a marble crucifix by Cellini.

Kelly Oliver is Professor of Philosophy and Women's Studies at Stony Brook University. She is the author of *Noir Anxiety* (2002), *Subjectivity Without Subjects: From Abject Fathers to Desiring Mothers* (1998), *Family Values: Subjects Between Nature and Culture* (1997), *Womanizing Nietzsche: Philosophy's Relation to 'the Feminine'* (1995) and *Reading Kristeva: Unraveling the Double-bind* (1993). She has also edited several anthologies, including *Enigmas: Essays on Sarah Kofman* (1999), *The Portable Kristeva* (1997) and *French Feminism Reader* (2000).

Michael Paraskos is a lecturer in Fine Art at the University of Hull. He has published several articles relating to Herbert Read and was the researcher on the 1993 exhibition *Herbert Read: A British Vision of World Art* at Leeds City Art Gallery. He is currently working on a book entitled *English Expressionism*.

David Pariser is an art educator who teaches at Concordia University, Montreal. He has a background in perceptual and educational psychology. He is a Fellow of the American Psychological Association and has published reviews, essays and research articles in *Leonardo, Studies in Art Education, Poetics, The American Journal of Education* and other journals. His interests include the juvenile drawings of great artists, emerging models of graphic development, and cross-cultural studies of aesthetic and graphic skills.

Lloyd Reinhardt is retired and lives in Australia. He taught philosophy at the University of Sydney from 1978 to 2001. As a visitor or staff member, he has also taught at Keele University, the University of London, Warwick University, University of Kent, University of California at Santa Barbara, and Queensland University. He has published papers in various journals and collections on Wittgenstein, metaphysics, ethics and aesthetics. He has been the co-editor (with William Christie) of *Literature and Aesthetics*.

Aaron Ridley is Senior Lecturer in Philosophy at the University of Southampton. His books include *Music, Value and the Passions* (1995), *R.G. Collingwood: a Philosophy of Art* (1998) and *Nietzsche's Conscience: Six Character Studies from the 'Genealogy'* (1998). He is currently completing another book on the philosophy of music.

Mark Rollins teaches courses on perception, cognition and the arts at Washington University, where he is chair of the Department of Philosophy. His main interests are picture perception and the philosophy of art history. His works include *Mental Imagery: On The Limits of Cognitive Science* (1989) and *Danto and His Critics* (1993). He is currently completing a new book, *Minding the Brain: The Perceptual Encoding of Mental Content.*

Carl Rollyson is professor of English at Baruch College, City University of New York. He is the author of *Marilyn Monroe: A Life of the Actress* (1986), *Beautiful Exile: The Life of Martha Gellhorn* (2001), *The Lives of Norman Mailer: A Biography* (1991) and (with Lisa Paddock) *Susan Sontag: The Making of an Icon* (2000).

Stuart Sim is Professor of English Studies at the University of Sunderland. He has published widely on critical theory and contemporary continental philosophy, as well as seventeenth- and eighteenth-century English prose fiction. His works include *Beyond Aesthetics: Confrontations with Poststructuralism and Postmodernism* (1992), *Post-Marxism: An Intellectual History* (2000) and *Lyotard and the Inhuman* (2001).

Ernst van Alphen is Professor of Literary Studies at Leiden University. His works include *Francis Bacon and the Loss of Self* (1992), *Caught By History: Holocaust Effects in Contemporary Art, Literature and Theory* (1997) and *Armando: Shaping Memory* (2001).

Alan Wallach teaches art history and American Studies at the College of William and Mary. He was co-curator of the exhibition 'Thomas Cole: Landscape into History' and co-author of its catalogue (1994). His most recent book is *Exhibiting Contradiction: Essays on the Art Museum in the United States* (1998). His current concerns include the influence of corporate sponsorship on museums, and the history of landscape vision in the United States before the Civil War.

Boris Wiseman is a lecturer in the French Department at the University of Durham. His areas of specialization are twentieth-century French literature and thought, structuralism, post-structuralism, French ethnography and aesthetic theory. His research is centrally concerned with various forms of interdisciplinary connections, such as those between anthropology and aesthetics, anthropology and literature. He is currently writing a book on Lévi-Strauss's aesthetic thought.

Mary Bittner Wiseman is professor emerita of philosophy at Brooklyn College and The Graduate Center of The City University of New York. She is the author of *The Ecstasies of Roland Barthes* (1989) and has just completed *Accommodating Women in Western Art: An Essay in Interpretation*.

Richard Woodfield is School Research Professor in Art and Design at Nottingham Trent University. He has a special interest in art historiography. He recently published *The Essential Gombrich* (1996), *Framing Formalism: Riegl's Work* (2000) and *Art History as Cultural History: Warburg's Projects*. He is currently working on an analysis of Gombrich's work, and is constructing the Gombrich Archive.

Linnea Wren teaches art history at Gustavus Adolphus College in St Peter, Minnesota. Her interests are pre-Columbian art of Mesoamerica and contemporary artists' exploration of spirituality through the human body. Her publications include *Perspectives on Western Art* (vol. 1, 1989; vol. 2, 1995), as well as numerous articles and essays. Currently she is studying the sculptural monuments and inscriptions of the Classic Maya site of Yo'okop in Quintana Roo, Mexico.

D.R. Edward Wright teaches Italian Renaissance art, as well as contemporary thought, at the University of South Florida in Tampa. His interests include Medicean iconography, word-image relations and continental philosophy. He has recently completed a major study of Renaissance artistic pedagogy entitled *Education(s) in Art: Reading Alberti on Painting, 1435–1600*.

PREFACE

The aim of the two volumes of *Key Writers on Art* is to provide, both
for students and the general reader, a stimulating and wide-ranging
introduction to the many writers and thinkers – across disciplines –
whose ideas play an important role in our understanding of the visual
arts. Over the past few decades, the study of art has become
increasingly complex and many-sided, with the concepts and
methodologies of a range of disciplines being used to explore the
relationships between the artist, the work, the viewer, and society. To
the more traditional concerns with technique, style, artists' lives,
cultural and historical contexts, iconography and so on, has been
added a keen interest in the tools of analysis provided by, for example,
the psychology of perception, psychoanalytical theory (orthodox and
reformed), sociology, political thought (above all Marxism in its many
forms), structuralism, semiotics, feminism, cultural theory and
deconstruction.

It is this very diversity of approaches, traditional and modern,
that the two volumes of *Key Writers on Art* aim to illustrate. So
there are entries not only on aestheticians and art theorists (though
they are well represented), but also on art critics and art historians,
religious thinkers, poets, artists, social and political scientists, cultural
theorists, connoisseurs, anthropologists, psychologists, and semioti-
cians.

The entries in the first volume, which covers the period from
classical antiquity to the end of the nineteenth century, are arranged
chronologically to reflect broad historical changes. The entries in the
second volume, which covers the twentieth century, are arranged
alphabetically. For ease of reference, there are chronological and
alphabetical listings in both volumes, and both have a general index.
Cross-references have been indicated in bold throughout. Each entry
ends with a paragraph of biographical data and, for those interested in
finding out more, a further reading section that lists both primary and
secondary texts.

Key Writers on Art: From Antiquity to the Nineteenth Century brings together the writers of the classic texts of art history and aesthetics, as well as a number of less familiar, but historically significant figures. Covering the period that stretches from classical antiquity to the Middles Ages, and from the Renaissance to the end of the nineteenth century, it includes entries on (among others) Aristotle, Alberti, Vasari, Diderot, Winckelmann, Hegel, Ruskin, Tolstoy and Nietzsche. There is no suggestion that taken together the entries in this volume represent a single, continuous development in our understanding of art. It is the profound differences between these thinkers and writers over what they take to be the nature, purpose and values of art that are often more significant than their similarities.

Key Writers on Art: The Twentieth Century contains entries on twentieth-century thinkers from many disciplines; some have written specifically about the visual arts, either as historians or aestheticians; others have developed ideas (in sociology, political philosophy, psychoanalytical theory and so on) that can be applied to the study of art. They include: Adorno, Baudrillard, Benjamin, Danto, Derrida, Arnold Hauser, Julia Kristeva, Panofsky, Wittgenstein and Richard Wollheim.

Given this broad scope, the task of creating a balanced, representative selection of entries was often a difficult one; beyond a certain point, every important addition meant the loss of someone whose claims for inclusion were just as strong. As a main concern was to illustrate a broad range of approaches and styles, four overlapping – and sometimes conflicting – principles were used in making the selection. Candidates had to fall into at least one of the following groups:

- those who are widely studied in art history, art theory or visual culture (Plato, Vasari, Kant, Hegel, Winckelmann, Wölfflin, Benjamin, Gombrich)
- those who represent an important period, concept, focus or methodology (Plotinus, Bellori, De Piles, Locke, Lévi-Strauss, Pollock)
- those whose relevance to the analysis of art has yet to be fully explored (Kierkegaard, Lyotard)
- those who are generally neglected by current interests and courses of study (Read, Stokes, Simmel).

While it cannot claim exhaustive coverage of all figures who have influenced this field, the result, I hope, will provide those interested in the visual arts with an invaluable guide not only to its essential (and often daunting) texts, but also to a number of important but far less familiar works. Readers may notice that writers on photography and

on architecture and design are not included, and that only a few artists, those whose ideas are historically significant, have been selected. These groups will I hope be covered in future projects.

I'd like to thank all the contributors for their commitment and hard work; having only 2,000 words to introduce a subject about whom there is so much to say is an exacting and sometimes thankless task. I'd also like to thank Roger Thorp for commissioning the project, and Elisa Tack, Milon Nagi and Barbara Duke at Routledge for their efficiency, patience and good humour in seeing the two books through to completion.

KEY WRITERS ON ART:
THE TWENTIETH
CENTURY

THEODOR ADORNO (1903–69)

GERMAN PHILOSOPHER AND MUSICOLOGIST

Adorno's writing about visual art and the aesthetic is philosophically
motivated. Unlike the American critic Clement **Greenberg**, with
whom he is sometimes compared, Adorno's writing about art does not
carry the baggage of an intimate involvement with the production and
consumption of visual art at a particular place and time. So, although
Greenberg took philosophical argument seriously, and his invocation
of Kant is well known, Greenberg's use of Kantian philosophy was
thoroughly intertwined with his stake in the cultural politics of the
New York art world of the 1940s through to the 1960s. Adorno never
had that kind of interest or experience in the world of visual art and
thus had correspondingly little commitment to the specific dynamics
of the art world. A significant consequence is that Adorno's writing
about art is calibrated against a philosophical standard rather than the
traditions of the world of art criticism or art history. This lack of
proximity to the objects and cultures of the art world can certainly be
used as a criticism, but it needs to be counterbalanced with a sense of
the strength of Adorno's corresponding commitment to the
philosophical definition and unpacking of issues that become forgotten
or obscured in an environment where art is, above all, loved. Thus,
one of the questions preoccupying Adorno was whether art is different
from any other kind of material artefact. Now, at one level this can be
identified as an abstract philosophical problem, but it is more than that
because it sets a tone of scepticism about art *per se* which is not at all at
home in the world of art lovers.

It is important to understand that, by questioning if art *per se* has any
value, Adorno's negativity is of a different order from the more
familiar 'negativity' that is arguably central to the way the history of
the art of the last 150 years has been written. As the cliché goes, the
history of the art world over the past 150 years has been about a series
of rejections of the terms within which previous art worlds had
operated. Within this matrix, the negative definition of one art against
another is the struggle that dominates the processes by which critical
benchmarks are established and judgements made. Although Adorno
was very much involved in this kind of struggle through his
notoriously negative evaluations of popular culture, he was just as
committed to asking questions about the ultimate value of *any* art. Put
another way, if Vasari, for example, had explained one of the purposes
of *The Lives of the Artists* (1550, 1568) as to discriminate 'the good'

from 'the better' and 'the best', Adorno is as concerned with asking whether the best is worth bothering with. It is within this problematic that several aspects of Adorno's philosophical constitution congeal.

First and foremost, Adorno's scepticism about the ultimate value of art was a function of his philosophical disposition and his distance from the world of art, but he also located the question historically. That is to say, he did not deny that art may once have been immensely significant, but he wonders whether it still is. In other words, for Adorno art is not an absolute given that never changes, but a historically changing conglomeration of ideas and objects. This principle is taken directly from Hegel and is the most fundamental difference between Adorno and any thinker who holds that art, however variable in its specific characteristics, is a given. In the Draft Introduction to *Aesthetic Theory* (1970), which is his most significant discussion of art, Adorno extends this principle to a critique of traditional aesthetics, which, he complains, makes normative claims for art and aesthetic experience, while extrapolating them from the experience of a relatively narrow range of art. In *The State of the Art* (1987), Arthur **Danto** has expressed a virtually identical opinion of philosophical aesthetics, saying

> the irrelevance of esthetic theory is due to the fact that it has often been a response to a particular body of art and of limited application to another order. Plato, Aristotle, Hume and Kant, powerful and sympathetic thinkers all, were giving universal validity to thoughts suited to a very local art, so that in large measure, esthetic theory is a body of criticism concealed as such by the unacknowledged provincialisms of its authors.

For Danto, the unacknowledged provincialism of aesthetics signals its demise and clears the way for his institutional theory of art. For Adorno, the same shortcoming demands the need for the reorientation of philosophical aesthetics in a way that understands the historical specificity of its relationship to art.

Accordingly, when Adorno writes about art, the reader is made acutely aware that she is reading the work of an author who is aware of himself writing at a particular time and place. Among other things, this means Adorno is writing at a particular moment in history, and he makes a quite explicit claim about the art of this moment: 'Everything about art has become problematic: its inner life, its relation to society, even its right to exist.' We can legitimately understand this overt and specific invocation of the historical moment in the late 1960s, when it

was written. Equally, this claim is a diagnosis of the failure of revolutionary modern art of the early years of the twentieth century. It is in the light of his prognosis of the failure of the avant-garde that Adorno's argument describes what art *ought* to be aiming for, not the existing condition of art; but his prescriptions are often expressed in the present, rather than in the future tense. An effect is to give the impression that he is describing the existing condition of art. (Zuidervaart (1991) uses the terms 'retrospective' and 'prospective' to distinguish Adorno's different treatment of pre-modern and modern art, but he also notes that within the discussion of modern art Adorno engages both in defining an aesthetic for existing works, and also for a future art. It is this second contrast within his discussion of modern art with which I am concerned here.) More contentiously, descriptive and prescriptive statements by Adorno frequently have a polemical edge, giving his argument a combative tone. Sometimes Adorno's language and argument echo early avant-garde manifestos, sometimes modernist criticism, sometimes history, sometimes philosophical aesthetics, sometimes Marxism. This deliberate confusion of presentational strategies serves to undermine any distinction between philosophy, history and criticism.

A blurring between the descriptive and prescriptive is nothing new, especially within the tradition of critical accounts of twentieth-century art. Controversy over how and why this art is significant is inseparable from its development. But the way different arguments have been presented has varied enormously, as have their aspirations. From the first arguments over the significance of Cubism, through Greenberg, to the analysis of the current condition of art, one of the more familiar critical strategies has been to frame established achievements of the past in a way that justifies a particular approach to present practice. This is rightly condemned when writing history, but less commented on in manifestos and criticism, which tend, by definition, to be more overtly partisan, and are accepted as such.

Confusion has been especially typical of the reception of the work of both Greenberg and Adorno. One of the more naive objections to aspects of Greenberg's criticism questions the dogmatic and pre-scriptive presentation of some of his descriptions of the history of modern painting. This misreads him by dissociating his theory from the context in which it was first articulated; whether his history of modern painting was right or wrong is of secondary interest to its function in defining a context to underwrite the practice of early Abstract Expressionist painters. Likewise, to be mortified by Adorno's negative opinions about Jazz and Surrealism may be a reflexive

reaction by the culturally sophisticated, but dismissing him as a miserable European elitist might just be a way to avoid acknowledging the extraordinarily high stakes of his argument.

Adorno does not conceive of his discussion as relating directly and unproblematically to its object; its combative tone signals an engagement with the on-going dispute about the meaning and significance of modern art. Obviously the same goes for Greenberg, but a part of the problem with Greenberg's theory was its success in surviving the historical and critical moment of its origin to become, for a while, the dominant account of the history of twentieth-century art. The transition from criticism to history, from prescription to description, derives from the way Adorno's writing moves seamlessly between polemic and argument, concealing their differences. As an author, he is committed to attempting to pre-empt the kind of unthinking reception which was the fate of Greenberg's theory.

Unlike Greenberg's theory, Adorno's did not develop out of a rapport with an emerging category of art. By the mid-1960s, the kind of high modernism that his work is sometimes described as defending was far from new. This distance from the art he defends is not to claim Adorno's theory of modernism is any less partisan than Greenberg's, but Adorno's relation to the art he is defending is neither as materially nor as historically proximate – an irrelevant observation if its purpose is to argue the validity or otherwise of either theory. What it does is signal the potential for their having radically different motivations. Greenberg's theory of modernism is essentially an attempt to assimilate an emerging form into the tradition of the avant-garde. Adorno is clear that this function of the critic is actually counter-productive:

> This integration is not, as the progressivist cliché would have it, some posthumous benediction that says this or that artistic phenomenon was meet and proper after all. Reception tends to dull the critical edge of art ... Once art works are buried in the pantheon of cultural exhibits, their truth content deteriorates (*Aesthetic Theory*).

Generations of radical artists have been tormented by the effortless assimilation of their works, ideas, gestures and personalities. Adorno is unflinching in his pursuit of the implications of this eternally recurring failure, and shows how difficult it is to sustain serious doubts about whether art really is worth bothering with any more. Maybe this is because he was just a boring theorist who was too far from the real action: the objects, events and publications of the art world. But then

maybe his immersion in theory allowed him to think thoughts that art world professionals literally cannot afford to think.

Biography

Theodor Wiesengrund Adorno Born Frankfurt 11 September 1903. His mother was a singer, his father a successful wine merchant. He studied privately with Siegfried Kracauer and then at the University of Frankfurt, and with Alban Berg in Vienna, where he met Arnold Schönberg. He was associated with the Institut für Sozialforschung (Institute for Social Research) throughout his career, working closely with Max Horkheimer. He taught at Frankfurt 1931–33, then, when Nazis came to power, moved to Oxford (Merton College 1934–37); Princeton 1938–41 (where he worked on the Princeton Radio Research Project), and Los Angeles 1941–49. In 1950, when the Institut reopened, he returned to Frankfurt, finally to become its director. Died Visp, Switzerland, 6 August 1969.

Bibliography

Main texts

Kierkegaard: Construction of Aesthetic (*Kierkegaard: Konstruktion des ästhetischen*; 1933), trans. Robert Hullot-Kentor, Minneapolis: University of Minneapolis Press, 1989.

Minima Moralia: Reflections from Damaged Life (*Minima Moralia: Reflexionen aus dem beschädigten Leben*; 1951), trans. E.R.N. Japhcott, London: Verso, 1974.

Prisms (*Prismen*; 1955), trans. Samuel and Shierry Weber, Cambridge, Mass.: The MIT Press, 1981.

Negative Dialectics (*Negative Dialektik*; 1966), trans. E.B. Ashton, London: Routledge and Kegan Paul, 1973.

Aesthetic Theory (*Ästhetische Theorie*; 1970), trans. Robert Hullot-Kentor, London: Athlone Press, 1997.

Secondary literature

Arato, A. and Gebhardt, E., *The Essential Frankfurt Reader*, New York: Continuum, 1994.

Buck-Morss, S., *The Origin of Negative Dialectics: Theodor W. Adorno, Walter Benjamin and the Frankfurt Institute*, Brighton: Harvester Press, 1977.

Crook, S. (ed.), *Adorno: The Stars Down to Earth and Other Essays on the Irrational in Culture*, London: Routledge, 1995.

Danto, A.C., *The State of the Art*, New York: Prentice Hall Press, 1987.

Rose, G., *The Melancholy Science: An Introduction to the Thought of Theodor W. Adorno*, London and New York: Macmillan, 1978.

Zuidervaart, L., *Adorno's Aesthetic Theory: The Redemption of Illusion*, Cambridge, Mass.: The MIT Press, 1991.

RICHARD HOOKER

RUDOLF ARNHEIM (1904–)

GERMAN-BORN AMERICAN PSYCHOLOGIST

Rudolf Arnheim once identified himself with Athena's emblem – the little owl perched on the goddess's shoulder. Such an image tells us of a keenly observant psychologist with a special love of humanism, reason and the visual arts. As he says, 'I had realized at an early age that the study of the mind in its relation to the arts would be the subject of my life's work' (*Thoughts on Art Education*, 1989).

His work has three aims:

1 To rehabilitate visual perception and the visual arts as media for thought. Arnheim articulated his key thesis with *Visual Thinking* (1969). Here he began his enduring attack on the entrenched notion that 'true thinking' could only take place through the medium of words. He insisted that language and imagery were equal partners in the activity that we call 'thought'. This bold assertion was good news to beleaguered art teachers, whose chosen discipline was discounted as a 'frill'. It was equally good news for developmental psychologists, who were now encouraged to consider the child's visual artwork as more than an undisciplined, blurting of emotion onto paper. Perhaps the most dramatic vindication of Arnheim's faith in the primacy of visual thinking is found in the recent research of psychologist John Kennedy (1993) with the blind. Kennedy argues that some universal features of drawing and visual representation are 'wired in' – and thus available to blind people. Kennedy found that, using raised line images, blind people can understand perspective through touch, and, even more remarkably, can use it in drawing. These surprising findings suggest that people 'think visually' – *even in the absence of vision itself*. As Arnheim surmised, thought does require a visual medium. Perhaps it is the case that the mind creates visual/spatial models for understanding the world, even in the absence of physical stimuli from the eyes.

2 To help his contemporaries to see intelligently and critically. This is perhaps Arnheim's most elite project, for he has never shied away from rendering aesthetic judgements on artworks, old and new. He is not cowed by social activism, epistemic relativism or various forms of postmodern obscurantism. Unlike many who deal with the art world, he believes that one has to make qualitative distinctions among artworks. Like the noted critic Robert Hughes, Arnheim believes that one can speak meaningfully about artistic quality and masterpieces. The art historian David Carrier (1997) quotes Arnheim on 'beauty': ' . . . if beauty is properly defined (i.e. not as classical prettiness), it is just about the only subject of aesthetics that is worth discussing, especially as the standard needed to measure all the depressing stupidities and trivialities offered nowadays as art.' Arnheim offers reasoned judgements about artworks, showing why some are of higher quality than others. This sort of presentation is unusual in a world where art critics most often avoid making aesthetic and moral judgements.

3 To give other researcher practitioners and teachers of art a storehouse of generative ideas. Arnheim's prolific output has given impetus to many research programmes in the arts. One researcher, Claire Golomb (1992), has done extensive research based on Arnheim's analysis of children's use of visual media. At Harvard University's Project Zero, Arnheim's ideas (and those of Nelson **Goodman**) have provided much of the basis for research into the arts. There are hosts of architects, art educators, perceptual and developmental psychologists, art therapists and art historians who have benefited from his speculative and descriptive essays.

Rudolf Arnheim grew up in the rich intellectual ferment of Berlin in the 1920s. He studied with the pioneers of Gestalt psychology, Max Wertheimer and Wolfgang Kohler. Influenced by the philosopher Helmholtz's theories of visual perception and by Kant's epistemology, Arnheim began to make the case that visualization plays a key role in thought processes.

Informed by a wide knowledge of art history, cognitive, developmental and perceptual psychology (especially the Gestalt school), Arnheim made universal claims about human perception and cognition. In *Picasso's Guernica* (1962) he described how artists such as Picasso solve the visual problems that constitute their work. He found it axiomatic that all humans are equipped with a capacity for identifying and creating visual order in the world. For example: the

eye groups visual objects together on the basis of shared properties – size, colour, location, texture; the eye will 'parse' complex patterns into combinations of simpler patterns; and so on. Arnheim finds that these universal features are shared by all artwork. Thus, artworks are accessible to everyone, regardless of culture or historical period.

Arnheim's rejection of naturalism in *Toward a Psychology of Art* (1966) is a thread that unifies his writing. A noteworthy debate developed on this point between him and the art historian Ernst **Gombrich**. Gombrich's thesis was that, driven by the quest for visual illusion, the trajectory of Western art history was progressive; artists 'improved' on each other as they developed illusionistic and realistic rendering. The debate between Arnheim and Gombrich hinged on two questions: Is there such a thing as progress in art? Was the goal of Western art the achievement of illusionistic/realistic images?

Arnheim's position was that only rarely does the artist seek the creation of mimetic form. It is more often the case that artists seek form and organization in a medium that elicits the same constellation of forces as the referent. In other words, the quest is not for likeness, but *equivalence in a medium*. For example, in one of his analyses in *Art and Visual Perception* (1954, 1974), Arnheim describes the felicity with which Michelangelo has rendered the scene when God infuses the spark of life into Adam. The artist has taken liberties with his text. In Genesis it states that God 'blew the breath of life' into Adam. But Michelangelo shows no such thing. Arnheim speculates that Michelangelo may have rejected a literal illustration of this moment for the same reason that Hollywood films have such an awkward time with Big Screen Kisses: one person's head always obscures the face of the other; noses get in the way. In a film, this problem is easily solved by using several shots of the same scene. The painter elected to use touch and gesture as a way of showing the same moment. And, most satisfactory of all, the artist hit upon the genial solution of interposing space, a gap between the finger of God and that of his creature. It is this charged space that is the 'functional equivalent' of the breath of life in the story. This indeed is 'thinking in a medium'.

Arnheim offers this definition of art: 'The ability of perceptual objects or actions, either natural or man-made, to represent, through their appearance, constellations of forces that reflect relevant aspects of the dynamics of human experience. More specifically, a "work of art" is a human artefact intended to represent such dynamic aspects by means of ordered, balanced, concentrated form' (*The Power of the Center*, 1988). The example from the Sistine Chapel is a clear instance

of a successful work of art, for it presumably arouses in the viewer a constellation of forces that evokes the moment of creation.

Arnheim makes judgements about art using a mix of formalistic, thematic and historical elements. In other words he looks at the way in which the organization and colour of the work are consonant with the message the artist wishes to convey. His judgement is also rooted in the notion that a true artwork speaks to the viewer simultaneously at two different levels: the specific and the general. One could argue that Arnheim is a universalizing Modernist – and an art historical reformer. He believes that with some historical background, and the tools of visual analysis, any viewer can get in touch with the significance of a work. According to him, each viewer has direct access to the work – without interference from the One True Church of Art History.

To the extent that Arnheim does not believe in artistic progress, he is not a 'true Modernist'. But this does not make him a Postmodernist either. Arnheim rejects art historical progress because he recognizes the integrity of all artistic approaches to representation, be it the ambiguous space of a medieval painting, or the expressive forms of a Brancusi sculpture. Arnheim does not believe that technical innovations such as Renaissance perspective, photography, motion pictures or computer animation are unilateral 'advances' in the practice of the visual arts. All of these developments are of secondary importance to the artist's real work, which is to take skilful advantage of his or her chosen medium and to use its special qualities to convey a worthwhile insight or observation. Thus, Lautrec's paintings of circus performers and Calder's wire sculptures on the same theme are parallel examples of superlative artistic explorations of different media. Calder's work is far less 'realistic' than Lautrec's, but both sculpture and painting are equally vital, credible images. And in neither case is one artist's creation an 'advance' over the other.

Arnheim points out that each technical advance brings its own drawbacks: the invention of perspective is often hailed as a decisive moment in the history of Western art, but for Arnheim it also heralds the advent of arbitrary distortions in size and shape. Depending on the artist's position, objects and figures are mechanically assigned their relative size on the picture plane. In a medieval illustration, the relative sizes of people and objects are governed by the requirements of the narrative, not the dictates of a geometrical rule. In Chinese classical landscapes, human figures are sometimes diminutive, not because of geometrical considerations, but because the natural world is supposed to dwarf humanity. So, when an artist adopts systematic perspective, certain other organizational prerogatives are ruled out. Thus, no

representational system, from Byzantine icons to Impressionist land-scapes, is necessarily 'an advance' on what preceded it. Each artist works within self-imposed and culturally-imposed limits.

Arnheim makes parallel claims about art historical development and individual graphic development: in both cases the notion of 'progress' is moot. In a classic chapter on the development of children's drawing in *Art and Visual Perception*, Arnheim describes the child's approach to representation. Arnheim shows how reasonable and easily understood are the so-called 'distortions' of children's art. He is an advocate for the various systems of spatial rendering that children normally use. He points out that each system has clear advantages and limitations – the young child's schematic drawings give an unambiguous impression of the canonical aspects of an object, while the later and more detailed drawings of a pre-adolescent enumerate as many vital elements as possible. Although there is evidence of a regular sequence in the development of children's graphics, each phase of representation is uniquely equipped to convey certain kinds of information. The child, like the artist, is not necessarily seeking a 'realistic' portrayal of his subject, but instead looking for the best equivalent statement in the medium.

One gains a sense of Arnheim's methods, his high standards and the consistency with which he has approached the arts, if one considers his earliest published book of essays, *Film as Art*. Here, Arnheim demonstrates his knack for swimming against the current. Far from hailing the coming of the 'talkies', he claims that the advent of the soundtrack was a severe blow to the possibility of film as a real art form. According to Arnheim, it was precisely because silent film was so limited that it had potential as an art form. He refers to the film work that superseded silent films as 'destroyed cathedrals' – art forms that once held great promise but were distorted by the impact of technical gimmicks. Film slipped into the category of 'mere entertainment'. So, as far back as the 1930s, Arnheim gave short shrift to technology and was steadfast in his search for a 'pure art form'. We also sense his distrust of popular culture. As he says, 'I no longer write about films, perhaps because we rarely get to see good new films, but mainly because it seems to be my fate that the new media disappear when I deal with them. This happened with the silent film replaced by sound film, and with radio overshadowed by television, and now it almost looks as though painting is threatened by so-called computer art. Perhaps I am an archaeologist.'

Biography

Rudolf Arnheim Born Berlin 15 July 1904. Arnheim studied in Berlin, where his doctorate (1928) was on the psychology of visual expression. During 1928–33 he covered cultural affairs for the journal *Film als Kunst*. In Italy between 1933 and 1940 he worked for the League of Nations, and in 1939 for the BBC Overseas Service. He emigrated to the USA in 1940, taking citizenship in 1946. In 1942 he held a Guggenheim fellowship; between 1943 and 1968 he was a member of the psychology faculty at Sarah Lawrence college. He was also on the faculty of the New School for Social Research, New York, and wrote *Art and Visual Perception* in 1954. A Fulbright scholarship in 1959 took him to Ochanomizu University in Tokyo. In 1967 he was Visiting Professor at Columbia University; between 1968 and 1974 Professor of the Psychology of Art in the Department of Visual and Environmental Studies, Harvard; and between 1974 and 1984 Visiting Professor at the University of Michigan.

Bibliography

Main texts

Radio, an Art of Sound, London: Faber and Faber, 1936.

Art and Visual Perception: A Psychology of the Creative Eye: The new version, Berkeley: University of California Press, 1954 (revised edition 1974).

Film as Art, Berkeley: University of California Press, 1957.

Picasso's Guernica, The Genesis of a Painting, Berkeley: University of California Press, 1962.

Toward a Psychology of Art, Berkeley: University of California Press, 1966.

Visual Thinking, Berkeley: University of California Press, 1969.

Entropy and Art: An Essay on Disorder and Order, Berkeley: University of California Press, 1971.

Toward a Psychology of Art: Collected Essays, Berkeley: University of California Press, 1972.

The Dynamics of Architectural Form, Berkeley: University of California Press, 1977.

New Essays on the Psychology of Art, Berkeley, University of California Press, 1986.

The Power of the Center: A Study of Composition in the Visual Arts, Berkeley: University of California Press, 1988.

Parables of Sun Light: Observations on Psychology, the Arts, and the Rest, Berkeley: University of California Press, 1989.

Thoughts on Art Education, Los Angeles: The Getty Center for Education in the Arts, 1989.

To the Rescue of Art: 26 Essays, Berkeley: University of California Press, 1992.

The Split and the Structure: 26 Essays, Berkeley: University of California Press, 1996.

Secondary literature

Aristarco, G., 'Destroyed Cathedrals', in *Rudolf Arnheim Revealing Vision*, Kent Kleinman and Leslie Van Duzer (eds), Ann Arbor, Michigan: The University of Michigan Press, 1997.

Bang, M., *Picture This: Perception and Composition*, Boston: Little Brown and Co., 1991.

Carrier, D., 'Rudolf Arnheim as Art Historian', in *Rudolf Arnheim Revealing Vision*, Kent Kleinman and Leslie Van Duzer (eds), Ann Arbor, Michigan: The University of Michigan Press, 1997.

Collins, B., 'Rescuing Art and Culture', *Art Journal*, 52, 2 (1993), 93–7.

Corwin, S. (ed.), *Exploring the Legends: Guideposts to the Future,* Reston, Virginia: National Art Education Association, 2001.

Golomb, C., *The Child's Creation of a Pictorial World*, Berkeley: University of California Press, 1992.

Kennedy, J., *Drawing and the Blind. Pictures to Touch*, New Haven: Yale University Press, 1993.

DAVID PARISER

MIEKE BAL (1946–)

DUTCH CULTURAL THEORIST

Mieke Bal's writing on visual culture makes a unique contribution to modern art history in several crucial respects. In the first place, there is a reformulation of where the work of art stands in time. In classic art history, the labour of the historian consists in restoring the work to its original temporal horizon, the social and cultural context of its first appearance. The essential problem is to establish how the work came into existence, and what forces made it assume the form that it did. In principle there is no limit to the number of determining factors the account may adduce – provided that they are all found to 'converge' in the work of art. From this perspective, which is dominated by a concept of *causality*, the work appears at the end of the line; here all the chains of determination join and terminate. In more recent art historical discussion this causal mode of analysis has, to be sure, undergone some important revisions: the work of art is recognized as not only reflecting its context but mediating it, reflecting upon it; and the work is understood as not simply passive with regard to the cultural forces that have shaped it, but active – it produces its own range of social effects, it acts upon its surrounding world. Nevertheless these concessions still unfold within the tense that the French linguist Émile Benveniste, in *Problems in General Linguistics*, called 'historical':

14

Events that took place at a certain moment of time are presented without any intervention of the speaker in the narration. . . . We shall define historical narration as the mode of utterance that excludes every 'autobiographical' linguistic form. The historian will never say *je* or *tu* or *maintenant*, because he will never make use of the formal apparatus of discourse, which resides primarily in the relationship of the persons *je* : *tu*. Hence we shall find only the forms of the 'third person' in a historical narrative strictly followed.

Whatever is said about works of the past must be viewpointed to the third person, the period observer; it must never appear to emanate from the discourse of art history, here and now. But for Mieke Bal, the art of the past exists undeniably in the *present*, where it continues to generate powerful social effects. The 'historical' tense, lacking as it does the means to place the speaker within the narration, is structurally dis-equipped to describe such effects. Yet the present life of the images is part of their ongoing history; if we cannot describe *that*, our sense of the span of images in history will be drastically truncated. The problem with the historical tense is that it is not historical *enough*. A truly historical art history must have the means to be able to say *je, tu, maintenant*. Which is where Bal makes her intervention in art history. Her writing articulates the meanings of work in the present, when seen in particular circumstances by particular viewers. There is no attempt to conceal that location, or to project meaning backward into the historical past. On the contrary, Bal's work consistently fore-grounds works of art as *events of the present*.

Bal's writing on art parts company with the received discipline of art history in a further crucial respect: there is a different under-standing of the scope – and limits – of the work of art's meaning. Classic art history based its account of meaning on what was, in the period when art history emerged as a modern discipline in the early twentieth century, the leading model of communication – *expression*: by means of certain signs a speaker (or artist) conveyed his or her thoughts to a listener (or viewer). It was the task of the art historian to retrieve that original intention, standing behind the work; an intention which, at the moment of its expression, would have had a clear outline and form.

Bal's work begins from a later, semiotic understanding of symbolization that profoundly problematizes each step in the seemingly simple series *speaker : message : hearer*. The fact that works of art occupy a different kind of space from the space of other objects

in the world – a space which in the case of painting is marked by the four sides of the frame – means that the work is built to travel away both from its maker and from its original context, carried by the frame into different times and places. The frame establishes a convention whereby art is marked as semantically mobile, changing according to its later circumstances and conditions of viewing. Each later viewer brings to the work his or her specific cultural baggage, and it is through viewing codes now brought to bear on the work in its new situation that it is seen and interpreted. Yet this state of being 'completed' by the viewer is not only a result of the work's journey through time: even in its original context, different viewers would have responded to the work in various ways. Since paintings involve highly saturated, dense and complex patterns of signification, there is no way that even in the year of a work's first appearance any specific viewer would have been able to exhaust the sum of possibilities it contains. (Bal first argued for an inescapably 'retro' or 'preposterous' view of history in *Reading 'Rembrandt'*, an argument further developed and refined in *Quoting Caravaggio*.)

Rather than being a 'relay' conveying an intention from artist to viewer, the work is thus an occasion for a performance in the 'field' of its meaning – where no single performance is capable of actualizing or totalizing all of the work's semantic potential. However coherent or persuasive a particular interpretation may be, there will inevitably be a remainder not acted upon, a 'reserve' of details that escape the interpretative net. To the viewer of art, such details can be highly significant, despite or even because of their marginal status; they can become the basis for a quite different understanding of the painting.

Pressing on details, especially when these have been marginalized, is an essential feature of Bal's interpretive style. (In her strategy of attending to the detail that exceeds, or falls outside of, dominant patterns within a work, Bal's approach comes close to that of Naomi Schor.)

In this, her writing goes against the goal most art historians believe they are pursuing: the central, most plausible interpretation, the one that covers and gives order to the greatest possible number of visual elements. That dominant style of art-historical writing recognizes, of course, that there may be a remainder in the picture that the interpretation does not presently deal with. It may even acknowledge that a great many alternative accounts are possible, laying no claim to the final word. But in its own construction and trajectory it is obliged to pursue the 'central form' (in Reynolds's phrase) of explanation, the account that absorbs the maximum number of details into a coherent

and unitary interpretation. Bal begins and stays with the detail, where the devil is: What has had to be relegated to the margins of the image, for its coherence to be maintained? What details do *not* fit the prevailing explanatory patterns? This makes for some sharp observation of paintings.

Few viewers, perhaps, have paid much attention to the strange depressions in the plaster above the picture of the *Last Judgement* that hangs on the wall in Vermeer's *Woman Holding a Balance* (National Gallery, Washington). Yet in a painting whose subject is balance – twice over: in the scales the woman holds in her hand, and in the heavenly judgement above – the way a picture is balanced may indeed be critical. Hanging a picture on a wall is no easy task. It is hard to get things right the first time; you have to move the nail, and the mark of its previous position is a permanent reminder of the picture's having once been *out* of balance.

Bal notes that Vermeer's careful recording of how the *Last Judgement* was once, in this room, out of balance, introduces an antithetical note into the scene. For unlike many contemporary pictures on the subject of the woman with the scales, this one does not incline towards any obvious allegory. The woman in the Vermeer is not greedily inventorizing worldly goods – which would make a pointed contrast between her (female) vanity and the (male) spirituality of the picture behind her, where souls are weighed. Nor does the picture detain us anecdotally with *what* she is balancing, as it would if it wanted to present a genre scene of daily life. The emptiness of the scales is an invitation to reflect on what 'balance' is, on how priorities are made. Is this a representation of the sacred as having a greater value than the profane? Or is it the opposite: is the sacred a dim and secondary realm, is it the actuality of this everyday room and of this evidently pregnant woman standing within it that counts as the immediate, even the higher, value? The detail that discloses 'imbalance' in the picture opens up interpretative possibilities that this particular Vermeer seems unwilling to foreclose. The marginal detail can become the centre of the picture; it can infiltrate its whole surface with provisionality. And in turn, reading for detail, as Bal does in 'Dispersing the Image: Vermeer Story' (in *Looking In: The Art of Viewing*) can become a model of the non-curtailability of interpretation.

This might seem a recipe for finding infinitely 'open' texts – yet Bal's approach differs from that of Derridan deconstruction. Works of art cannot, Bal argues, signify indefinitely in all directions, for the reason that it is *particular* viewers who activate their potential, in their specific circumstances. Meaning-making is an activity that always

occurs within a pre-existing social field, and actual power relations: the social frame does not 'surround' but is *part* of the work, working inside it. Which lead to a third point of difference between Bal's writing and orthodox art history, besides its understanding of the work of art's unbreakable temporal relation to the present, and the fundamental polysemy of its signs. The meaning of a work of art does not, for Bal, reside in the work itself but rather in the specific performances that take place in the work's 'field': rather than a property the work has, meaning is an event or an enactment. Despite art history's rhetoric of impersonality, even the most 'historicist' account of a work of art is rooted in an actual encounter with a work in the present. Bal's objective is to acknowledge this encounter, to explore it, and, above all, to personify the encounter through her style of writing. Hence Bal's compelling descriptions of the actuality of viewing, whether in the ethnographic museum, the Universal Survey museum, or the contemporary art gallery. (See, for example, her account of the display of visual materials at the American Museum of Natural History, in 'On Show: Inside the Ethnographic Museum', in *Looking In: The Art of Viewing*.)

Mieke Bal's work has brought to the fore something that the twentieth-century discipline of art history generally lacked – a coherent and well developed theory of spectatorship. Modern art history had no trouble investigating the *makers* of art. Ever since the development of connoisseurial studies after Morelli and Berenson, the focus on the artist became a central and seemingly inevitable feature of art-historical inquiry. But there was little corresponding focus on art's viewers. There have been notable exceptions. Michael Fried's fascinating book *Absorption and Theatricality: Painting and Beholder in the Age of Diderot* (1981) places a picture's relation to its audience at the centre of his study of French painting of the eighteenth century. In another reach of the discipline, social historians of art of the past generation made brilliant use of Salon reviews in order to establish how a painting's initial audience may have understood (or misunderstood) the work before them. (See, in particular, T.J. **Clark**, *The Painting of Modern Life: Paris in the Art of Manet and his Followers* (1985), and Thomas Crow, *Painters and Public Life in Eighteenth-Century Paris* (1985).) Yet it is Bal who has placed the spectator at the absolute centre of her discussion, and it is in the name of the spectator that she mobilizes her compelling arguments around the temporality of art, the polysemy of its systems of visual signs, and its affective power. This focus gives to her work a unique position within debates on the nature and social impact of visual art.

Biography

Mieke Bal Born 1946. She has been Professor of Theory of Literature at the University of Amsterdam, Doctor Honoris Causa of the Universitetet i Bergen, Norway, and A.D. White Professor-at-large at Cornell University. In 1993 she co-founded the Amsterdam School for Cultural Analysis, internationally known as ASCA, an inter-disciplinary Research Institute. She was also a co-founder of the doctoral Program in Visual and Cultural Studies at the University of Rochester, N.Y., that became a model for numerous comparable programmes in the USA. Her work ranges from literature to visual art, from ancient to contemporary, and her approach from semiotics to anthropology, feminism and social critique.

Bibliography

Main texts

Reading 'Rembrandt': Beyond the Word-Image Opposition, New York and Cambridge: Cambridge University Press 1991. (A reworking, abridged and differently organized, of Verf en verderf. Lezen in 'Rembrandt', Amsterdam: Prometheus, 1990.)

On Meaning-Making: Essays in Semiotics, Sonoma, Cal.: Polebridge Press, 1994.

Double Exposures: The Subject of Cultural Analysis, with Edwin Janssen, New York: Routledge, 1996.

The Mottled Screen: Reading Proust Visually, trans. Anna-Louise Milne, Stanford: Stanford University Press, 1997. (Images littéraires, ou comment lire visuellement Proust, Montréal: XYZ Editeur/Toulouse: Presses Universitaires de Toulouse, 1997.)

Hovering Between Thing and Event: Encounters with Lili Dujourie, Munich: Kunstverein München; Brussels: Xavier Hufkens; London: Lisson Gallery, 1998.

Jeannette Christensen's Time: Bergen, Center for the Study of European Civilization, 1998

Quoting Caravaggio: Contemporary Art, Preposterous History, Chicago: University of Chicago Press, 1999.

Louise Bourgeois's Spider: The Architecture of Art-writing, Chicago: University of Chicago Press, 2001.

Looking In: The Art of Viewing, ed., and with an introduction by, Norman Bryson, Amsterdam: G & B Arts International, 2001.

Travelling Concepts in the Humanities: A Rough Guide, Toronto: University of Toronto Press (in press).

Secondary literature

Bahri, D., 'Roses in December: Cultural Memory in the Present', College English 63, 1 (Sept. 2000), 95–101 (on The Practice of Cultural Analysis: Exposing Interdisciplinary Interpretation).

Benveniste, É., 'Tense in the French Verb', in *Problems in General Linguistics*, trans. Mary Elizabeth Meek, Coral Gables, Florida: University of Miami Press, 1971.

Bryson, N., 'Introduction' to *Looking In: The Art of Viewing*, Amsterdam: G & B Arts International, 2001.

Culler, J., 'New Literary History and European Theory', 1–14 in *New Literary History* 25, 4 (1994), 1–14 (on 'First Person, Second Person, Same Person: Narrative as Epistemology').

Holly, M.A., 'Quoting Rembrandt', *Semiotica* 104, 3/4 (1995), 355–64 (on *Reading 'Rembrandt'*).

Jobling, D., 'Mieke Bal on Biblical Narrative', *Religious Studies Review* 17, 1 (1991), 1–11 (on *Lethal Love, Murder and Difference* and *Death and Dissymmetry*).

Kemp, S., 'On Reading "Rembrandt" ', *Journal of Literature & Theology* 7 (1993), 302–5.

Malbert, R., 'If it ain't baroque . . .', *Times Literary Supplement* 15 September 2000 (on *Quoting Caravaggio: Contemporary Art, Preposterous History*).

Moebius, W., 'The Reach of Cultural Analysis: Some Cuttings', *The Comparatist* 2001, 154–7 (on *The Practice of Cultural Analysis: Exposing Interdisciplinary Interpretation*).

Pollock, G., 'On Reading "Rembrandt" ', *The Art Bulletin* LXXV, 3 (1993), 529–35.

Schor, N., *Reading in Detail: Esthetics and The Feminine*, New York and London: Methuen, 1987.

Scott, D., 'Reading Proust's mottled screen', *Semiotica* 131, 3/4 (2000), 377–81 (on 'The Mottled Screen: Reading Proust Visually').

NORMAN BRYSON

ROLAND BARTHES (1915–80)

FRENCH LITERARY AND CULTURAL CRITIC

In the summer of 1986 at the Pavillon des Arts in Paris, there was an exhibition of excerpts from Roland Barthes's essays on visual images. His words were printed on plaques large enough to be read from several feet away and were accompanied by the images about which he wrote. The exhibition, 'Le Texte et l'image', not only made the point that images are inextricably bound up with words, it also comprised an anthology of this and other of Barthes's ideas about visual art. Curated by a professor of philosophy, 'Le Text et l'image' was itself a work of philosophy whose message was twofold: written words are material objects, and visual images are themselves a kind of writing, inscriptions of intelligibility engraved on the space of the world.

The images Barthes wrote about were those through which this double message, and his ideas of art in general, were able most clearly to be articulated. These ideas, however, must be understood within the framework of his accounts of three things: interpretation; what he

called 'the third meaning'; and the 'gesture'. Both visual and verbal arts are interpretable; but only visual arts assume a third meaning; and only visual arts whose final state involves the hand of the artist are gestural.

Interpretation

Interpreting is an activity performed on whatever an agent is trying to grasp, to understand, engage with or 'read', whether it is something in her experience, a newspaper article, novel, cartoon, painting, drawing or sculpture. The activity is productive and creative. Differences between art and non-art, fine and mass art, verbal and visual art are irrelevant here. Barthes distinguished two ways of reading, one more passive, or 'readerly', the other more active, or 'writerly'. The former consumes what is already written, affording the reader only the freedom to accept or reject it, while the latter results from an interaction between the reader and the already written, between what the reader teases out of the text and what it, in its turn, teases out of her. Neither reader nor text is assumed to be completed, finished off; instead each is construed as a set of possibilities and powers from which various readings can come. Barthes refers to writerly reading as '(implicitly) writing', which can be called 'interpreting'. It is a performance, and what it produces can be recorded. This is precisely what criticism is: the record, itself interpretable, of a unique interaction between critic and object. The difference between this, post-structuralist, criticism and its modernist ancestor, practical criticism, is that now work and critic are conceived not as ready-mades but as works-in-progress, subject to the underground operations of both the unconscious and those primitive needs whose satisfaction is to be wrested from the earth in the form of labour.

The third meaning

In his essay 'The Third Meaning' (1970), Barthes identifies three levels of meaning in his analysis of the image of an old woman weeping in a still from Eisenstein's film *Ivan the Terrible*. The first is the level of communication, the second of signification, and the third of signifying. The first imparts information; it says what the meaningful objects are. In Titian's San Rocco *Annunciation*, for example, a descending winged creature addresses a kneeling woman who, oblivious to him, is reading a book. The second level says what the objects mean, where the meaning draws upon a common lexicon and is intentional. In the Titian, the lexicon is the Gospel of Luke. On this

level signs are deciphered, while on the third level *signifying* occurs. It, like interpretation, is an event, but one in which people are more passive than they are in interpreting. In Barthes's example, the third meaning is revealed to or received by the observer of the old woman in Eisenstein's frame, which differs from a photograph in being part of a story. The closed eyelids, drawn mouth, and fist over breast belong to the obvious signification of grief. However, the kerchief set low on her forehead as 'in those disguises which seek to create a foolish and stupid expression', the circumflex accent of the eyebrows, and the half-open mouth corresponding to the curves of kerchief and brows 'metaphorically speaking, like a fish out of water' do not. Based on such unique elements in the *signifier* (the material aspect of a sign linked to the sign's conceptual aspect, the *signified*), signifying takes the signifier out of the narrative flow and itself has no place in the codes governing the circulation of signs, the site of the stable, the general, the obvious.

Signs inhabit a grid, made of vertical lists of signs that can be substituted for each other and horizontal strings of signs that comprise phrases, clauses, sentences, stories. The axes are 'pure perpendiculars, the legal upright of the narrative'. The third meaning, in contrast to signs, is unstable, fugitive and erratic, and as such calls for a vertical reading of the signifier which disjoins it from the horizontal string of signs, the context, in which it appears. This disjunction disturbs, subverts, is indifferent to and discontinuous with the law of narration. Barthes calls this meaning 'obtuse'; in exceeding the perpendicular, an obtuse angle can seem to open up the field of meaning indefinitely, in excess of the obvious meanings of knowledge and culture. Excessive, the third meaning appears as a supplement that intellection cannot absorb and has, Barthes says, something to do with disguise and emotion. 'It simply designates what is to be loved, to be defended.' Nothing from the vertical list is privileged by being tied down to a signified or a referent: signifying is the appearing and disappearing of each item on the list, where each disappears only to appear disguised as another, and so on. Those that most touch the observer are what are to be loved.

When in 1970 Barthes said that neither photographs nor figurative paintings can have obtuse meanings because 'they lack the diegetic [narrative] horizon' that obtuse meanings subvert, he unduly limited the application of the concept. In *Camera Lucida* (1980), he identified two elements in the photograph, *studium* (the culturally coded) and *punctum* (what, unpredictably and idiosyncratically, rises up to pierce the viewer), the one obvious, the other obtuse. Moreover, in 1970 Barthes spoke of an 'autonomous art' in which 'anecdotalized images

and obtuse meanings are placed in a diegetic space'. Barthes seems to have ignored the fact that a number of figurative paintings do inhabit such a space, namely, those that tell a story.

The gesture

In a 1979 article about American artist Cy Twombly's works on paper, Barthes distinguished messages, intended to produce information, and also signs, intended to produce intellection, from gestures, productive of all the rest (the 'surplus') without necessarily intending to produce anything. The gesture proceeds from the painter's body and the contact of his pencil, crayon, paint brush or finger with the paper, canvas, panel or wall he marks. Memories and anticipations of the movement of his hand and the touch of his pencil, say, inhere in the paper. The paper is what the art object is, and it is, in turn, the object of the artist's desire. For it cooperates in giving birth to the line deposited upon the drawing instrument's descent to the paper's surface. With this line, art displaces its centre from the object of desire (the paper) to the subject of desire, the performer of the graphic event of which the line is the trace. The line, whether drawn, painted, etched or incised, Barthes calls a visible action, and its production, a kind of writing. The product can, but need not, be words so long as the lines and strokes have elements that are opaque and non-signifying, elements that do more than merely compose the wings of Titian's announcing angel, for example. To be gestural the surface marks must be made by hand and must participate in culture's codes. The gesture, which seems always about to be or just to have been performed by an individual in an instant is not stable and general as are the signs that follow language's rules of formation and transformation. It moves over these signs, lightly, focusing on the material element, the signifier, indifferent to what the signs signify, as the third meaning of the movie still is indifferent to the narrative the still advances.

Both gesture and obtuse meaning arrest the forward movement of the horizontal string of signs that is the context within which signs signify something, as they stop the narration without which the mind can hardly imagine history's contradictions being resolved. Barthes finds what he calls 'the tremor of time' in the trace left by the artist's hand as it simultaneously writes and erases, and in the appearance of the sign as it simultaneously signifies something and nothing but its own materiality. And he will find a pathetic tremor in the photograph. The invention of photography instituted the unprecedented consciousness of the photographed object's having-been-there.

Photography can prove the past existence of what stood before the camera, and often the viewer's acknowledgement that the object was and is no longer (or is no longer precisely what it was when photographed) is the *punctum* that breaks through the photograph's *studium*. The obtuse meanings of images – whether anecdotalized images like film stills, images made by the artist's hand, or photographs – need the culturally coded systems of signs to decontextualize, to operate, to work on, as Barthes put it, 'for nothing'. In *Fifty Days at Illiam*, a painting cycle that illustrates Homer's *Iliad*, Cy Twombly gives narrative-arresting vertical readings of the Trojan War in the ten canvases that comprise the series, which he, underscoring the unity of the narrative, calls 'a painting in ten parts'. Moreover, on each canvas is his act of painting made visible, even as each makes palpable the actions of the war, its causes and consequences. Housed in their own room in the Philadelphia Museum of Art, the paintings are spare markings on a white ground, black, lightly-scribbled lines, cloud-like shapes of colour – red for the turbulent characters of the Greeks, blue for the more cerebral spirit of the Trojans – and proper names, sometimes in lists, sometimes randomly strewn over the canvas. The hanging is as formal and structured as the paintings are not, with three canvases on each of the longer walls, Greeks on one side, Trojans on the other. This grouping of six begins with the Vengeance of Achilles and ends with the Shades of Eternal Night, the third of the Trojan trio. On the shorter wall flanking the entrance hang paintings of the names of the heroes of each side, and opposite the entrance hangs the largest canvas, sixteen feet by ten, Shades of Achilles, Patroclus and Hector, clouds of red, blue and white.

Everything speaks, and it is its speaking that Barthes hears. In writing the names of gods and warriors, Twombly implies that name and man alike are written and alike must be read, as, Barthes would add, must all works of visual art. They are read through language – that is, systems of signs – but they can be read through language to the actual writing (the gesture) of the signs' signifiers and to the arrest of the seemingly relentless movement from signifying to signifying something. The eye gives art this edge, an edge that is 'erotic' because, like the one formed by a garment's gaping, it reveals what can be glimpsed but not said. 'Is not the most erotic portion of the body where the garment gapes?' The body of any text, visual or verbal, gives pleasure when its language has two edges: one obedient and conformist, and 'another edge, mobile, blank (ready to assume any contours), which is never anything but the site of its effect: the place where the death of language is glimpsed'.

Biography

Roland Gérard Barthes Born Cherbourg on 12 November 1915, the son of a naval officer who died before his son's first birthday. He moved to Paris with his mother when he was nine. Hospitalized for tuberculosis in 1934–35 and 1941–46, he was thus excused from military service. He earned a Sorbonne licence in classics in 1939 and the *diplome d'études supérieures* on Greek tragedy in 1941. He published an article that grew into his first book, *Le Degré zéro de l'écriture*, while convalescing in Paris in 1947, and was a reader in universities in Romania and Egypt in 1948–50. He held academic posts in Paris from 1950, publishing his first book in 1953 and *Mythologies* in 1957. Barthes was awarded the Chair of Literary Semiology in the Collège de France in 1977, the year his mother died. He died in Paris on 26 March 1980.

Bibliography

Main texts

Mythologies, trans. Annette Lavers, New York: Hill and Wang, 1972 (a selection).
The Eiffel Tower and Other Mythologies, trans. Richard Howard, New York: Hill and Wang, 1979 (a selection).
Critical Essays (*Essais critiques*, 1964), trans. Richard Howard, Evanston, IL: Northwestern University Press, 1972.
S/Z, trans. Richard Miller, New York: Hill and Wang, 1974.
New Critical Essays (*Nouveaux essais critiques*, collected and published with *Le Degré zéro de l'écriture*, 1972), trans. Richard Howard, New York: Hill and Wang, 1980.
Image Music Text, trans. Stephen Heath, New York: Hill and Wang, 1977.
Camera Lucida, Reflections on Photography (*La Chambre claire*, 1980), trans. Richard Howard: New York, Hill and Wang, 1980.
The Grain of the Voice, Interviews 1962–1980 (*La Grain de la voix. Entretiens 1962–1980*, 1981), trans. Linda Coverdale, New York: Hill and Wang, 1985.
The Responsibility of Forms: Critical Essays on Music, Art, and Representation (*L'Obvie et l'obtus: essais critiques III*, 1982), trans. Richard Howard: New York, Hill and Wang, 1985.
'Roland Barthes, Le Texte et l'image', Pavillon des Arts, 7 May–3 August 1986 (an exhibition curated by Jerome Serri).
A Barthes Reader, Susan Sontag (ed.), New York: Hill and Wang, 1982.

Secondary literature

Bensmaia, R., *The Barthes Effect: The Essay as Reflective Text* (*Barthes a essais: Introduction au texte reflechissant*, 1986), trans. Pat Fedkiew, Minneapolis: University of Minnesota Press, 1987.
Brown, A., *Roland Barthes: The Figures of Writing*, New York: Oxford University Press, 1992.

Culler, J., *Roland Barthes*, New York: Oxford University Press, 1983.

Lavers, A., *Roland Barthes: Structuralism and After*, Cambridge: Harvard University Press, 1982.

Moriarty, M., *Roland Barthes*, Stanford, CA: Stanford University Press, 1991.

Payne, M., *Reading Knowledge: An Introduction to Barthes, Foucault, and Althusser*, Oxford: Blackwell, 1999.

Rabaté, J.-M. (ed.), *Writing the Image after Roland Barthes*, Philadelphia: University of Pennsylvania Press, 1997.

Wiseman, M.B., *The Ecstasies of Roland Barthes*, London and New York: Routledge, 1989.

MARY BITTNER WISEMAN

JEAN BAUDRILLARD (1929–)

FRENCH SOCIOLOGIST

Baudrillard has privileged art – and literature – as a key domain of analysis, and from his earliest writings in the 1960s he has taken examples to illustrate his theoretical sociology and philosophy from it. More recently he has developed a keen interest in photography, and has had his own photographs published and exhibited. The only academic conference on Baudrillard's work in France to date was held at the University of Grenoble and focused on his contributions to the sociology of art. In general, however, his writings on art have been found difficult to interpret and have been the subject of a number of profound misunderstandings by sociologists and by some artists themselves.

The major influences on Baudrillard have been Walter **Benjamin** and Marshall McLuhan, but Baudrillard's own radical line of analysis followed his formation in literary analysis specializing in the German tradition (Hölderlin to Peter Weiss) and sociology and semiology under the influence of Bataille, **Foucault** and **Barthes**, and specializing in the analysis of modern consumerism. The character of Baudrillard's analysis is structural and formal, concerned mainly with the sign, code, and so on, but decisively influenced by Situationism and a range of writers from Baudelaire to Rimbaud and Jarry, and more fundamentally by Marx and Nietzsche.

The key to understanding Baudrillard's writing on art is the link he establishes between the sign and consumption, and the background framework he establishes for establishing this link. This framework he describes as a 'genealogy' of cultural formations, and it functions as a sequence of historical periods of Western culture. It can thus be read as

a variant of well-known analyses of cultural epochs from the Renaissance to the postmodern. For example, Baudrillard seems to begin his writings with a direct appeal to Foucault's famous analysis of Velázquez's painting *Las Meninas* in suggesting that, with the appearance within the picture of the named artist (and the signature), the relation of the painting to the world is significantly altered. From the Renaissance, Baudrillard suggests, there have been four different and successive orders of 'simulacra'. Each of these can be analysed by means of the theory of the sign in opposition to the symbol (no element of the real outside the symbol). This is radical in the sense that the 'real' is given a meaning of very specific significance: for Baudrillard the real does not exist as such within symbolic cultures. It, the very category of the real, makes its appearance with the birth of modernity itself, and art has a privileged role in this process. Baudrillard's ideas here seem in fact to be much closer to an anthropology of art than to a sociology of art in the conventional sense.

Baudrillard, however, has not written very much which explicitly examines so-called primitive art. It is clear, nevertheless, that such art is not only given its due importance as ritual; he also notes that as part of the symbolic world it does not function as representation and possession of an outside reality. In his early writings, Baudrillard characterized this culture as one based on 'symbolic exchange'. The world of the anonymous artist or group of artists partakes of a more or less faithful copy of a world which already exists, as a world which is created by God. Since there is no authentic art as such, there can be no fakes. Everything changes, of course, with the emergence of the individual artist with a style recognized in relation to a signature. At first such an artist remains a craftsman or master craftsman. In terms of the structure of his work, the culture becomes one in which the work of art comes to 'represent' an outside reality, and this process is rationalized more and more with techniques of capturing real perspective and its double (the curious and, for Baudrillard, enchanted order of the *trompe l'oeil*). Paintings represent mythic or religious themes as established by ancient or sacred texts, so there remains at this stage of semiotic relations a 'symbolic' referent. This order of representation Baudrillard conceives as the first order of simulacra, since the representation is founded on, or produces, a separation of the real world and its representation. The masterwork can be copied, and works in the original craft style of the artist can be faked.

The next stage in the process of capitalist development, mechanization and industrialization, eventually creates the possibility of the

mass production of art objects, and the mechanical reproducibility of representations. Here the authentic original is the starting point of the process of the reproduction of art commodities. This is the classic terrain of Marxist theories, and the theory remains secure as long as there is clear separation between (bourgeois) art and life, art and function. They falter, according to Baudrillard, when capitalism shifts gear, art no longer remains attached to a transcendent aesthetic objective, but becomes integrated more and more with the design of commodities (Bauhaus). Once the commodity is aestheticized its value is no longer dependent on function. It becomes an object in an object system, such as a designer kitchen. The dominance of the logo, the brand label, means not only the appearance of monopoly capitalism but the integration of aesthetic and commodity, the fusion of image and status.

Baudrillard analyses this as a shift to sign-exchange, the shift from commodity to object. Consumer society is a society which consumes signs, and becomes a society saturated with the aestheticized images of advertising. Baudrillard gives this the most radical reading: this society is no longer based on production, but on representation and seduction. Identity is determined not by function in production, but by style and mode of consumption. This third-order mode of simulacra is no longer based on a clear distinction between representation and the real world. It is as if the real has swallowed its own image. The prevalence and pervasiveness of the image, of mass media, is such that the world can no longer be experienced independently from its representation (now become evidently a problematic term). The world is paradoxically both more aestheticized and more real. (Baudrillard borrows the term 'hyperreal' from the world of art to conceptualize this transition.) At the same time the boundary between the aesthetic realm and other value realms breaks down in a process Baudrillard calls 'transaestheticization'.

Radical conclusions are drawn from this analysis. One is that it becomes impossible for art to function as a critical medium, just as within society itself critical movements and theory become obsolete or absorbable as fashion. The dominant problems of society are no longer those of exploitation and scarcity, but ones of exclusion, saturation and obesity, where thresholds are abandoned and pathologies of the code such as viruses and cloning develop. These latter phenomena are driven, according to Baudrillard, by new exponential logics, fatal strategies, extreme events and spirals and logics of indifference such as massification and replication, both of which come to replace dialectical and transcendental logics. In art these 'logics to extreme' are of two

types. One towards more and more extreme objects, the other towards replication. But they imply the end of the classical art aesthetic as an independent tradition. Art both merges with fashion and also disintegrates into endlessly subdividing styles, and as such renounces the traditional rules of art as an independent aesthetic domain by progressively producing, reproducing and possessing more and more technically sophisticated reality. In so doing, art renounces the symbolic function altogether and destroys the possibility of illusion (always based on an absence rather than a superabundance of dimensions).

Modern art no longer stands back, no longer possesses a critical function; it merges with the logic of modern culture in such a way that it colludes with its fundamental processes (promotional advertising). Is this the end of the story? Not quite. In his writing over the last decade Baudrillard has outlined a theory of a fourth order of simulacra. This is the order of radical uncertainty and chaos, beyond the dominance of the code, and where only singularities exist. The changes to theory in Baudrillard's recent writings are remarkable, and are dominated by the concept of 'impossible exchange'. In order to analyse contemporary culture, he has argued, it is necessary to reverse thinking on time and space as virtual reality becomes predominant: events do not any longer take place in a continuous and linear time and space; rather the reverse. Modern painting, for example, he suggests, 'could be characterised as the simplified form of the impossible exchange ... the best discourse about a painting would be a discourse where there is nothing to say, which would be equivalent of a painting where there is nothing to see' ('Objects, Images ...').

But Baudrillard does not just chart the sequence of orders of simulacra (and the fate of the category of the real in Western culture), he has struggled to identify the right order of response to these orders; in this sense his writing establishes a meta-aesthetic. Thus it is a mistake to think that Baudrillard's response is one of outright rejection of the course of modernity, but it seems that, after a brief period of support for a kind of messianic Marxism in the 1960s, he moved to adopt a position on modern culture more in line with Nietzsche and Baudelaire, which was critical of the politics and aesthetics of *ressentiment* and nostalgia.

In his writings in the 1990s, his terminology for thinking some of these issues changed, from that of simulacra and simulation to that of forms of illusion and disillusion. Primitive cultures are always a form of 'seduction' and 'fundamental illusion', a 'vital illusion of appearances' before all representation, interpretation and aesthetics can come into existence. Aesthetics is an attempt to master this 'symbolic operation'

as an extreme phenomenon. The realm of modern aesthetics, in Baudrillard's view, is an attempt to banish this world of radical illusion by mastery of radical disillusion. Thus the emphasis shifts in modern culture away from absence towards presence and above all to reality and its subtypes – surreality, hyperreality, virtual reality and so on. Ironically, the long-term logic of the modern aesthetic abolishes the hypothetical distinction between sign and reality in simulation and virtual reality, so that the real in a sense disappears and with it the type of image and imagination which accompanied it. Baudrillard reads the early work of Andy Warhol as marking the moment when the simulacrum eliminated the old unity of representation (the real and its image) and became pure, unconditional simulacrum, the 'trans-aesthetic illusion'. When, later, Warhol repeated this theme in 1986, he fell back, according to Baudrillard, into an 'inauthentic form' of simulation. Thus, despite himself, Baudrillard seems to have a meta-aesthetic which condemns on aesthetic grounds certain kinds of aesthetic enterprises. Another example is his clear rejection of New York 'simulationists', and art exhibitions of 'plasticised, vitrified, frozen excrement, or garbage' which do not form an irruptive moment of clarification but simply a form of aesthetic disillusion. The current situation of art in Baudrillard's view is to have reached a state of radical indifference, a 'metalanguage of banality'.

Curiously, Baudrillard's interest in the contemporary art object now takes a new form. It is, he suggests, 'the simplified form of the impossible exchange', a situation in which it is the void, the nothingness, which becomes obsessive. In this sense the central issue of modern art is how it materializes this nothingness 'and within the limits of indifference to play the game according to the mysterious rules of indifference'. In this sense, art continues to occupy a leading illustrative role in Baudrillard's thinking for a culture characterized by disenchantment through the perfection of the unconditional simula-crum. In this situation there is a new vital place for the photograph as a fatal singularity beyond the aesthetic.

Biography

Jean Baudrillard Born Reims, July 1929. An outstanding pupil, he left school early and did not have a conventional academic career. He qualified as a teacher of German and taught in provincial schools for ten years before taking a qualification in sociology and beginning to teach sociology at Nanterre in Paris in 1966. His first works included reviews of German and Italian literature for the journal *Les Temps*

modernes, translations of Bertolt Brecht and Peter Weiss, and contributions to the journals *Utopie* and *Traverses*. In 1976, he published *Symbolic Exchange and Death*. He retired early in 1987 and devoted his time to writing and travel, lecturing in the United States, Spain, Italy and Australia.

Bibliography

Main texts

For A Critique of the Political Economy of the Sign (*Pour Une Critique de L'Economie du Signe*, 1972), trans. Charles Levin, St Louis: Telos Press, 1981.
Symbolic Exchange and Death (*L'Echange Symbolique et la Mort*, 1976), trans. Iain Hamilton Grant, London: Sage, 1993.
The Transparency of Evil (*La Transparence du Mal*, 1990), trans. James Benedict, London: Verso, 1993.
'Objects, Images, and the Possibilities of Aesthetic Illusion', in *Jean Baudrillard, Art and Artefact*, N. Zurbrugg (ed.), London: Sage, 1997.
Selected writings:
Jean Baudrillard: Selected Writings, M. Poster (ed.), Oxford: Polity, 1988.
Revenge of the Crystal: Selected Writings, trans. P. Foss and J. Pefanis (eds), London: Pluto, 1990.
The Uncollected Baudrillard, G. Genosko (ed.), London: Sage, 2001.

Secondary literature

Gane, M., *Jean Baudrillard: In Radical Uncertainty*, London: Pluto, 2000.
—— (ed.), *Jean Baudrillard: Masters of Social Theory* (4 vols), London: Sage, 2000.
Genosko, G., *Baudrillard and Signs: Signification Ablaze*, London: Routledge, 1994.
——, *McLuhan and Baudrillard: The Masters of Implosion*, London: Routledge, 1999.
Kellner, D., *Jean Baudrillard: From Marxism to Postmodernity and Beyond*, Cambridge, Polity: 1989.
—— (ed.), *Baudrillard: A Critical Reader*, Oxford: Blackwell, 1994.
Kroker, A. and Cook, D. (eds), *The Postmodern Scene*, London: Macmillan, 1988.
Majastre, J.-O. (ed.), *Sans Oublier Baudrillard*, Brussels: La Lettre Volée, 1996.
Stearns, W. and Chaloupka, W. (eds), *Jean Baudrillard: The Disappearance of Art and Politics*, London: Macmillan, 1992.

MIKE GANE

MICHAEL BAXANDALL (1933–)

BRITISH ART HISTORIAN

Michael Baxandall, in a remark to a colleague at a social gathering, once said, 'I want to do Roger **Fry** over again after nature'. Not just a witty riff on Cézanne's express desire to redo the painting of Poussin

after nature – that is, to combine the crystal-clear formal organization of seventeenth-century French classical painting with the direct observation of natural luminosity typical of the outdoor painting of the Impressionists – this seemingly casual remark is in fact the key to Baxandall's approach to art. Roger Fry, who had published an influential book on Cézanne in 1927, was himself a painter, a museum curator and an acutely perceptive art critic. His guiding interest was the formal aspects of art, line, shape, texture, and this is what distinguishes the writing of Baxandall, also an exceptionally sensitive observer. In his work the visual qualities of the art and our experience of them are primary, rather than taking second place to some larger explanatory imperative of a cultural, socio-economic or psychological nature. In other words, the historical background material contributes to the formal analyses, rather than the reverse, where the art is treated as a symptom of some general historical pattern. Like Fry, Baxandall seems to be attracted to art of the finest quality where the visual interest is high; but he parts company with him on one important matter. Fry practised what is known as evaluative criticism, passing judgement on aesthetic worth, something that became the target of hostile comment during the 1920s and 1930s. Art critics were accused of trying to force entirely subjective tastes onto an unsuspecting public in an elitist and dictatorial manner. (It was the fashion among that generation to look down on the bourgeoisie as uncultured and dull.) Shortly before he died, Roger Fry, in his inaugural lecture as Slade Professor of Fine Arts, conceded that if art history hoped to become a serious academic discipline, rather than just a 'fancy' subject, it had to develop into a systematic study following scientific methods wherever possible. In the interest of such objectivity, Baxandall furnishes extensive verbal and visual documentation that more than justifies the formal analysis as informed by contemporary cultural contexts. Typically his publications are quite well illustrated, this being essential to his presentation (unlike Clive **Bell**'s *Art* (1914), which in 290 pages had a total of six illustrations). His readers are to be exposed to the full range of visual material so that they can *see* for themselves.

The idea of 'redoing' Roger Fry implies a shift from a model of art criticism that was idiosyncratically personal, and based on one vague, all-purpose concept, to something more historically specific, and appropriate to artistic styles unrelated to early modernism. The phrase 'from nature' identifies an important distinction between the philosophical positions that ground Fry's and his own projects. It is a difference between the work of G.E. Moore in ethics, and that of the positivists in scientific philosophy, between a focus on 'mind' and on

'physical nature'. For Moore and followers like Fry, philosophical conclusions in aesthetics could be validated by rational examination of one's own states of consciousness. The positivists avoided words like 'mind' or 'consciousness', as well as Moore's method of introspection. For them, knowledge could be guaranteed only by evidence gathered by the senses in the external world. The philosophical work which interests Baxandall is concerned with such issues as how to apply the investigative methods of the physical sciences to philosophy and to the study of humans in society; the role of language in knowledge; linguistic meaning and how language relates to reality; and the logical structure of explanation. These theoretical foundations are basic to Baxandall's criticism, as demonstrated by a mention in one of his letters of T.S. Eliot's concept of the 'dissociation of sensibility'. By this, Eliot meant an absence of intimate connection between a writer's own life experiences and their broader philosophical significance. He disliked poets who were either so intellectual as to be out of touch with sense and feeling, or else so exclusively sentimental that ideas seemed like an afterthought. Similarly, Baxandall is unsympathetic to dissociation of sensibility in writing about art, where some simplistic formal observation that takes no account of how the work was experienced must bear the burden of an extensive theoretical apparatus. Modern British philosophy has allowed Baxandall to establish his critical project on a clearly defined philosophical foundation, in regard to such matters as the factual object of art criticism, the nature of historical explanation and how reconstructions of historical context relate to art.

On the matter of the actual object of art criticism, it is helpful to bring up the so-called 'linguistic turn' in philosophy. It is argued that, from our limited perspective, we cannot know the world as it really is, independently of our sensory experience of it. Experiences must be formulated verbally, in clear and well-constructed statements. Baxandall has indicated that his explanations are concerned with human experiences of the art object formulated in words, as distinct from the thing in itself. Thus, rather than working from photographs, he tries to experience the artworks, when possible, in their original settings under local conditions of lighting, in relation to other objects, and so on. His rich and subtle descriptions are normally illustrated with photographs of the artefacts from several points of view, in different lighting situations and different degrees of detail.

With regard to the nature of objective explanation, philosophers and sociologists have made an important distinction between the

model used for the physical world (cause and effect) and one suitable to humans, who have greater freedom of choice (teleological description). It is a distinction between explanation of which antecedent causes produced one particular effect, and only that particular effect, and an understanding of why people do or do not behave in accordance with some generally agreed-upon set of goals or objectives. For the purposes of understanding formal choices in visual art, Baxandall has adopted the 'teleological description' model, because, as it seems from his criticism, individual freedom of choice plays a major role in his humanistic sense of the delicate balance between external facts and creative decision-making. Humans are determined in the sense that we operate within definite parameters of possibility and limitation. But, given those parameters, the best artists are free to use them as creatively as possible. Baxandall refers to his teleological reconstructions as 'patterns of intention', the emphasis being on 'patterns'. As a critical strategy it is an effort to avoid dubious recreations of what went on in private, inside the mind of the artist, in the genesis of the work. In terms of the literary criticism of the 1940s and 1950s, it avoids the 'intentional fallacy', the idea that the actual achievement of an artist is to be measured against what he or she originally intended to achieve. The literary critics Monroe Beardsley and W.K. Wimsatt argued that a poem does not belong to its author, or to the critic, but to its public, because they are its consumers and have certain expectations owing to the fact that they share a common coinage with the poet: language. This is, roughly, what Baxandall's 'period eye' signifies, a visual language current in the historical culture, which shows what formal qualities patrons and the public might have looked for and appreciated when used in interesting ways. An economic metaphor, invoking the market, consumers, supply and demand, is particularly appropriate here. Paintings and sculpture are produced in a sort of cultural marketplace where clients and consumers have specifiable needs, interests and values, and artists draw upon locally available resources (material, technological, financial and so on) to meet those particular demands. Baxandall has been attentive to historical writing about visual art in the belief that certain key words embody aesthetic values which the earliest viewers might have looked for, or lamented in their absence. This practice of isolating key terms and defining them has antecedents in physical science, where clear definitions of basic vocabulary are deemed essential to comprehension of the discipline. Positivist writers saw the principal task of the aesthetic philosopher as the definition of aesthetic terminology, 'art', 'beauty', and so on. Baxandall's concern is

somewhat different in that he works with terms in their original language (Italian, German, Latin) from texts contemporary with the art. In assembling the diverse assortment of cultural and other variables he calls 'intention', Baxandall is guided always by their relevance to the experience of aesthetic objects in their own unique context.

The matter of how Baxandall's extensively researched 'patterns of intention' relate to the visual properties of the art has to be explained in terms of theory of meaning and reference in modern British philosophy. A common way of thinking about this relation would be to treat his scholarly text as a reference to some cultural reality that influenced the artist to make the specific forms we see in the illustrations. Strictly speaking, however, because we cannot experience that 'cultural reality', Baxandall's verbal descriptions are best treated as meaningful primarily in relation to something we *can* observe: the art. Obviously, his sentences make linguistic sense because they follow the rules of English usage and the individual terms relate to things we might possibly experience. But taken collectively as a reference to a non-existent world, and only in that respect, they could be compared to *Alice in Wonderland*. For Lewis Carroll the truth or falsity of the Alice story was not an interesting issue because his writing had another function than resembling reality. He was using a verbal construct with recognizable elements – of which the actual referent was a real thing, Victorian fairy tales – to show a young girl bored by classroom drill the delights of experiencing a rich fantasy life. The words point away from themselves and their immediate referents to something the real Alice could actually experience, children's literature, which was forbidden as harmful in many Victorian households. *Alice* has what philosophers (and Baxandall) would call an 'ostensive' relation to its object. Another way of thinking about this would be J.L. Austin's speech act theory, his idea of 'doing things with words'. The simplest act would be to utter a string of English words ('the cat is on the mat') which have a meaning and a potentially observable referent, and will, thus, be either true or false. Doing things with words involves such linguistic acts as promising, lying, hoping ('I hope the cat is on the mat and not drinking from the toilet'), where the true location of the cat is a non-issue. In a further scenario the words can act upon the listener, as when I exclaim 'the cat is on the mat!' and John goes to shoo her off. Baxandall places his own work in this third category. Rather than making any claim as to whether cultural variable X did or did not influence artist Y, his writing acts on readers, *enabling* them to experience works of art as an organic part

of their history and environment. His work differs, then, from a kind of criticism where detached, uninvolved, matter-of-fact descriptions purport to represent the art as it really is, without regard to the cultural and social conditions in which it could have been experienced.

Because his approach is all of a piece and hard to duplicate (requiring vast bibliographic resources, travel, hours of looking, and an extraordinary ability to synthesize it all in detail) it has been influential in discrete doses. Historians of art and of literature with an interest in writing on images, and related problems of literary interpretation, have taken to *Giotto and the Orators* (1971). The 'period eye' concept has attracted sociologists, and also art historians with an art-in-social-context orientation. The methods demonstrated in *The Limewood Sculptors of Renaissance Germany* (1980) have been accepted as an alternative methodology for the study of northern, that is non-Italian, European art. *Shadows and Enlightenment* (1995) has appealed to those interested in matters of visual perception as a factor in viewer response. If there has been dissent or disagreement, it is possibly because both enthusiasts and critics may view him as an historian pure and simple for whom a representational model of the connection between society and art ought to be dominant. The work reads just as impressively when he is seen for his delight, the rich experience of looking at great art in a knowledgeable manner.

Biography

Michael David Kighley Baxandall Born Cardiff, Wales, 18 August 1933. Baxandall studied English Literature and Art History at Cambridge University, and undertook postgraduate studies at the University of Pavia in 1955–56, and the University of Munich 1957–58. He was Junior Resident Fellow, Warburg Institute, London 1959–61; Assistant Keeper, Victoria and Albert Museum, London, 1961–65. Again at the Warburg Institute he was Lecturer in Renaissance Studies, 1965–72; Reader in the History of the Classical Tradition, 1973–80; Professor, 1981–88; and Honorary Fellow, 1988. He became Slade Professor of Fine Art, Oxford, 1974–75; A.D. White Professor-at-large, Cornell University, 1982–88. At the University of California, Berkeley, he was Professor of the History of Art, 1986–96; and is Professor Emeritus there at the time of writing.

Bibliography

Main texts

Giotto and the Orators, Oxford: Clarendon Press, 1971.
Painting and Experience in Fifteenth Century Italy, London, Oxford, New York: Oxford University Press, 1972.
The Limewood Sculptors of Renaissance Germany, New Haven and London: Yale University Press, 1980.
Patterns of Intention, New Haven and London: Yale University Press, 1985.
Tiepolo and the Pictorial Intelligence (with Svetlana Alpers), New Haven and London: Yale University Press, 1994.
Shadows and Enlightenment, New Haven and London: Yale University Press, 1995.
Exhibitions:
'Tilman Riemenschneider: Master Sculptor of the Late Middle Ages', Washington, D.C.: National Gallery of Art; New York: Metropolitan Museum of Art; New Haven (distributed by Yale University Press, 1999).

Secondary literature

Art History, 21, 4 (December 1998), 463–545 (articles by Michael Ann Holly, Allan Langdale, Malcolm Baker and Alex Potts, with additional bibliography).

D.R. EDWARD WRIGHT

CLIVE BELL (1881–1964)

BRITISH CRITIC AND ART HISTORIAN

Clive Bell broke new ground in aesthetics by defining art independently of representational subject matter, political content, emotional expression or social context. He developed a formalist theory of art that has become one of the classics of twentieth-century philosophical aesthetics. The initial, and now canonical, statement of it is found in the widely-read first chapter of his *Art* (1914), though some of his art criticism, both contemporaneous with and later than that book, give us a more nuanced picture of his views. He defines art in terms of a property he calls 'significant form'. The grasp of significant form in art is, according to Bell, the source of aesthetic appreciation and one of the most exquisite human pleasures. Both his theory and his arguments have been attacked from many quarters but, as will be shown, he articulates something important about our experience of artworks that gives his work a heightened contemporary interest.

That said, it will be useful to keep in mind three facts about Bell's artistic culture. First, photography, very much on the ascent, was

thought to reproduce mechanically visual appearances. As he indicates in, for example, his first chapter to *Landmarks in Nineteenth Century Painting* (1927), Bell was eager to differentiate the painter's task from the photographer's. He speaks of painters who turned into 'mere pictorial chatterboxes'.

Second, the public was gaining access to artefacts from other cultures that were visually beautiful, but intellectually unintelligible or unfamiliar: for example, African masks, Japanese prints and Asian manuscripts. Third, artists of great talent were beginning to work towards abstraction.

Bell's formalism, like any momentous aesthetic theory, is a response to the art world. He explains why people might appreciate an African mask as an aesthetic object, though they do not understand it in the way they might an English portrait. Moreover, at a time when the typical spectator gravitated to representational artworks that were impressive in their verisimilitude or effective for eliciting moral sentiment, Bell argues that representational content is irrelevant to true aesthetic appreciation of artworks. His notion of appreciation includes both enjoyment and a distinctive, intuitive discernment, which leads to the rapture that Bell deems unique to aesthetic experience. Representational content, for Bell, except in an enlightened spectator, will either conceal or cloud the artistic essence of a work, which one cannot appreciate while focusing on the subject matter or technical virtuosity of the artist. This aesthetic meaning resides, for Bell, only in the formal elements of an artwork.

Thus he championed successfully artists such as Gauguin, Matisse, Duncan Grant, and his two heroes, Cézanne and Picasso, all of whom were painting in ways that baffled many spectators, at least those who bothered to heed the works of these painters at all. He achieved this both through his critical writings and through his collaboration with Roger **Fry** on the groundbreaking First (1910) and Second (1912) Post-Impressionist Exhibitions in London.

Fry, too, developed an influential version of formalism in response to art. Unlike Fry, however, Bell has a central place in philosophical aesthetics because his formalism has deep roots in the ethics and epistemology of G.E. Moore, one of the seminal figures in contemporary Anglo-American philosophy.

Moore, an ethical intuitionist whom Bell encountered at Cambridge in 1899, influenced all of the members of the Bloomsbury group, but Bell made special use of Moore's views. While some scholars have questioned the acuity of Bell's understanding of Moore,

Bell's work does reflect Moore's analytic method and ethical ideals. He modelled his own idea of aesthetic goodness as immediately known and unanalysable on Moore's notion of ethical goodness. Less centrally, he seems to appeal to Moore's ethical notions to justify the moral value of aesthetic experience, which he takes as one of the most exalted and worthwhile human activities. As for the moral value of art, Bell insists that an artwork, *qua* artwork, should have no moral content, but that the purely aesthetic experience of artworks is one of the greatest human ethical attainments. This aestheticism has led some to charge that Bell draws an elitist separation of art from morality and culture.

Let us look more closely at the theory itself. Not only is art independent of morality, Bell argues, but art, by its essence, has nothing to do with the emotions of everyday life or history or ordinary perception of the material world, for art must be defined by reference to its purely formal elements, more specifically a quality he calls 'significant form'.

What is 'significant form'? In developing this idea, he begins from two premises, both based on the data of introspection: first, that there is a distinctive aesthetic experience; and second, that this experience is the same whether one is appreciating an early classical Greek pot, a Picasso drawing, a Rembrandt self-portrait, or the mosaics at Ravenna. Just as the same base conditions obtain whenever we have a perceptual experience of yellow, so the same conditions must give rise to every occurrence of the aesthetic experience. Though he refers to the aesthetic experience as the 'aesthetic emotion', he construes it much more as a perception than an emotion.

Thus he reasons that all works that elicit this experience share a common property, which is the source of aesthetic value and the defining feature of art. This property, 'significant form', is both necessary and sufficient for art. In order for a created object to be an artwork, then, it must possess significant form; even if a canvas is painted by Leonardo da Vinci, without significant form it cannot attain the status of art. In *Since Cézanne* (1922), he avers that the only important distinction to be drawn between artists is that between good and bad artists, not between artists of one movement and those of another – a radical claim for a critic so conversant with art history.

He describes significant form as emerging from colours, lines, forms and their relations that 'stir our aesthetic emotions'. Many commentators have found his account at best inexact; others have charged him with circularity: significant form is what elicits the aesthetic experience, and the aesthetic experience is that which we

feel in the presence of significant form. Bell does not really address this matter, but his problem is that facing any philosophical theory moving from the subjectivity of experience to a world existing outside of that experience.

As for his imprecision in characterizing significant form, it is reasonable to say that it is a higher-order quality that emerges from the combination of purely formal qualities, such as line, colour, picture space and texture; significant form emerges from these formal qualities in the way that, for example, harmony arises from the combination of two musical notes. Significant form, according to Bell, cannot be the same as beauty, for our responses to beauty are conditioned by our desires and emotions of everyday life. A portrait of a beautiful person elicits in us emotions that may be tinged with eroticism, personal psychological associations, or political feelings. For Bell, such responses have nothing to do with art. Our responses to significant form are separate from so-called ordinary life.

Thus, representation in art is not inherently bad, nor is beauty; they simply must not be confused with the aesthetic dimension of the work. What he does judge bad, however, is purely descriptive or political art, such as that of the Italian Futurists, which he declines to call art. In contrast, in an essay on Pierre Bonnard in *Since Cézanne*, Bell remarks that Bonnard, while he 'loves what he paints' conveys 'something more significant than his feelings for cups or cats or human beings'. Rather, Bonnard 'created form with a significance of its own, to the making of which went his passion and its object, but which is something quite distinct from both ... a work of art.'

Just as, for Bell, significant form is separate from life, we grasp significant form by means of a separate aesthetic sense, which remains uncultivated in many people. Significant form is discerned immediately, intuitively, and non-inferentially. The immediacy of this aesthetic perception may require great concentration. We see the lines, colours and shapes visually, but we must focus on them and their relations in order to have that grasp of significant form. Indeed, Bell writes often of the responsibility of the critic to emphasize those formal qualities that will lead the viewer to an experience of significant form. Again, his essay on Bonnard, whose works admit of a plurality of interpretations, provides a good example: 'tones of miraculous subtlety seem to be flowing into an enchanted pool ... From this pool emerge gradually forms which appear sometimes vaporous and sometimes tentative ... When we have realized that the pool of colour is, in fact, a design of extraordinary originality and perfect coherence our aesthetic appreciation is at its height.'

One might ask why Bell refers to aesthetic form as 'significant'. Bell sometimes suggests that significant form does in a way signify. In *Art*, he proposes a 'metaphysical hypothesis' whereby significant form reveals something about ultimate reality. He rarely returns to this theme, but he persists in affirming, as he does in *Art*, that 'Great art remains stable and unobscure because the feelings that it awakens are independent of time and place ...'

Some aestheticians and critics object to the distance Bell appears to place between art and life, between art and culture. Some, among them would be defenders of Arthur **Danto**'s aesthetics, object to his implication that a work can be understood independently of an artist's intentions or psyche; others to his clear opposition to the recently voguish historicist or political interpretations of artworks. Indeed, Bell himself does not always seem to follow his own admonition to the critics to focus on form alone.

These are complex issues, for Bell does seem sensitive to the role of personality and history in the artist's vision. Clearly, he is inimical to a historicist criticism that would analyse a work of art as a document revealing the historical and social conditions of a specific culture. He is equally hostile to a critical approach that treats the artwork as the key to an artist's individual psyche. But, as his critical essays make evident, he values the history of art; he looks for the influence of Pissarro on Cézanne, and understands the politics of the art world and the idiomatic nature of artistic expression. Similarly, he remarks on the individual sensibility of various artists. The key to this is his notion of the 'artistic problem': the projects that artists set for themselves, projects partly determined by the art that has preceded them, partly by an artist's own aesthetic and intellectual imagination. Bell advises us to understand the artistic problem in analysing a painting, which an analysis of its form will enable us to do. In truth, though, Bell's own critical essay shows that we do need more outside information than Bell explicitly admits.

We can see the value of Bell's contribution by looking at his own underlying project. His endeavour is to make the analysis of art both aesthetic and non-subjective. He clearly acknowledges the role of aesthetic pleasure in our response to artworks, but he also believes that we should give reasons for our judgements about art. Art, he is telling us, is too rigorous to be treated as a matter of mere preference.

Even those many contemporary aestheticians who defend relativism about art, or who reject the notion of there being a single essence exemplified by all of the wildly different things we call art, acknowledge the importance of Bell's contribution. Bell's theory is beset with conceptual problems and is now surpassed by later formalist

thinkers such as Monroe Beardsley, Clement **Greenberg** and, more recently, Nick Zangwill. None the less Bell, with his insouciant erudition and passion for art, remains a key figure in contemporary art theory.

Biography

Arthur Clive Heward Bell Born East Shefford, Berkshire, 16 September 1881, son of a wealthy coal merchant. Bell went up to Cambridge University in 1899, where he met G.E. Moore, Leonard Woolf, Lytton Strachey and Thoby Stephens, friends who would lead him to the centre of Bloomsbury. After Cambridge, Bell went to France, becoming immersed in avant-garde art. In 1908 he married the artist Vanessa Stephen, the sister of Virginia Woolf.

Dividing his time between France and England, Bell was an active art reviewer and cultural critic. With Roger Fry, he organized the First (1910) and Second (1912) Post-Impressionist Exhibitions in London. Important publications were *Art*, 1914, and *Since Cézanne*, 1922. Bell died in London on 17 September 1964.

Bibliography

Main texts

Art, London, Chatto & Windus, 1914; J.B. Bullen (ed.), Oxford: Oxford University Press, 1987.
Since Cézanne, London: Chatto and Windus, 1922.
Landmarks in Nineteenth Century Painting, London: Chatto and Windus, 1927.
Civilization: An Essay, London: Chatto and Windus, 1928.
An Account of French Painting, London: Chatto and Windus, 1931.
The French Impressionists: With Fifty Plates in Full Colour, London: Phaidon, 1952.
Old Friends: Personal Recollections, London: Chatto and Windus, 1956.

Secondary literature

Beechey, James, *Clive Bell*, London: J. Murray, 2001.
Bell, Q., *Elders and Betters*, London: J. Murray, 1995 (published in the USA as *Bloomsbury Recalled*, New York: Columbia University Press, 1995).
Bywater, W.G., *Clive Bell's Eye*, Detroit: Wayne State University Press, 1975.
Dean, J.T., 'Clive Bell and G.E. Moore: The Good of Art', *British Journal of Aesthetics* 36 (1996), 135–45.
Dickie, G.T., 'Clive Bell and the Method of *Principia Ethica*', *British Journal of Aesthetics* 5 (1965), 139–43.
Elliott, R.K., 'Bell's Aesthetic Theory and Critical Practice', *British Journal of Aesthetics* 5 (1965), 111–22.
Gould, C.S., 'Clive Bell on Aesthetic Experience and Aesthetic Truth', *British Journal of Aesthetics* 34 (1994), 124–33.

Lang, B., 'Intuition in Bloomsbury', *Journal of the History of Ideas* 25 (1964), 295–302.

McLaughlin, T.M., 'Clive Bell's Tradition and Significant Form', *Journal of Aesthetics and Art Criticism* 35 (1977), 433–43.

Meagher, R., 'Clive Bell and Aesthetic Emotion', *British Journal of Aesthetics* 5 (1965), 123–31.

Zangwill, N., 'Feasible Aesthetic Formalism', *Nous* 33 (1999), 610–29.

CAROL S. GOULD

WALTER BENJAMIN (1892–1940)

GERMAN LITERARY AND CULTURAL CRITIC

There is much in Walter Benjamin's most vivid writings that might qualify him as the quintessential eye of twentieth-century modernity. Though no one could quite fill such a central role in a visual world that rises to such centreless complexity, weighing this claim does throw light on both the man and the spectacle of his times. The section 'This Space to Rent', in the collection of brief observations he published as *One Way Street* (1928), comments on the decay of criticism as compared to other, more contemporary forms of expression. The unprecedented spread of advertising into every aspect of public display exhibited irresistible energies that consigned older modalities of discourse to the narrowing bourgeois interior space, and to a faltering stage in history. Criticism, he says, depends on 'distance', something ever more difficult to sustain against the noise, shocks and speed of urban experience, while the forms of advertising press into momentary experience with a direct sensory force. In closing, he asks again what makes advertisements superior, and concludes: 'Not what the moving red neon sign says – but the fiery pool reflecting it in the asphalt' (*Reflections*, 1978). His concern with phenomena that spill out in this way across the divisions and definitions of established meaning carries us straight into the realm of modern artefacts massed in bewildering profusion, moved by the uncontrollable forces of market exchange.

The strange and estranging effects of technology under the command of commercial impulses, such as that electric illumination which now invades nocturnal space with an intensity akin to violence, close down the last hope that we can arrive at a framework of adequately distinguished meanings in our life assembled with the snug joints of contemplation and reasoned reflection. Benjamin's eye

records a new state in the history of our senses. Few critics have as ruthlessly tested the formulae of discrimination and explication against the immediate impact of sensory presence as Benjamin, though his method of exploring the phenomena of urban experience by intense description of passages through the chaos of city streets is not itself new. It recalls many antecedents in the nineteenth century, most significantly Charles Baudelaire. Benjamin's extensive writings on Baudelaire in the role of *flâneur* also indicate how deliberately he understood his own pursuit of visual experience through this model. The effect of encountering human figures like the whore or the sandwichboard-man on show in the street, or reviewing the parade of commodities put on display in shop windows, alerts Benjamin to the first law of modern seeing: that the forms that emerge in all such human and non-human images take their shape under the iron rule of commercial forces.

Yet the parallel between these two men in their two centuries also indicates how different this grasp of the visual sense has become in its later history. Baudelaire's view still owes much to classical aesthetics; he preserves the traditional place of painting as the ultimate site where visual powers concentrate to produce an art of seeing. The spectacles of capitalist Paris in the nineteenth century galvanize him with aesthetic terror. He retreats into the responses of horror, disgust and cold mockery of his surroundings while he embraces them as the objects of his artistic modernity. Benjamin, by contrast, moves resolutely forward into the realm of politics and economics in order to realize Baudelaire's vision as a penetration of the forces that produce these glitteringly cadaverous and yet fascinating effects. 'Paris, Capital of the Nineteenth Century' (1935) describes the power of fashion to control our visual responses in order to sell a commodity, as 'the sex-appeal of the anorganic'. The much-discussed essay, 'The Work of Art in the Age of Mechanical Reproduction' (1936), which denounces the characteristic fascist aestheticization of politics, moves this concern with the power of fascination vested in objects of mass appeal from the circumstances of the nineteenth into the crises of the twentieth century.

One distinct effect of an aesthetic theory that regards the separate status of artistic expression as its most dangerous vulnerability to reactionary mystification can be identified in the way that Benjamin continually moves the focal concern of the modernist eye further and further away from the tradition of painting. This position attains an explicit statement in 'The Work of Art in the Age of Mechanical Reproduction', where he develops the argument that mass-produced

images bring about the destruction of that 'aura' which hovers about great, unique art objects like the paintings of the Italian Renaissance masters and confers on them their overwhelming authority. In place of a philosophical or critical definition of this 'aura', he suggests the visual experiment of contemplating a twig against the horizon marked by the outline of a mountain range. The spilling-over of one impression into the other causes a kind of impenetrability, which he calls the 'unique phenomenon of a distance however close it may be' (*Illuminations*, 1968). The essay 'On Some Motifs in Baudelaire' (1939) further discusses the aura as that quality by which images acquire an apparent capacity to return our gaze. Although it does seem paradoxical, the theory in the 'Work of Art' essay affirms the power of mass-reproduced images to dispel aura and free our hitherto mystified perceptions for a revolutionary political consciousness. Though film in the 1930s had shown itself adaptable to Nazi propaganda under Goebbels, had accommodated the transition of the Soviet Union from a revolutionary state to Stalinist autocracy, and had become the perfect vehicle for phantasmagorical dreams in Hollywood, Benjamin argues that this new medium maintains an inalienable connection with social revolution.

The distracted form of vision we learn in the cinema, he argues, breaks the spell of artforms inherited from traditional reception of the unique, original object. The film audience frees itself from those rituals of rapt aesthetic attention in which we lose ourselves to the power of aura. What we learn without such deep absorption, acquired unconsciously and by collective experience in processes of habit, purges mystery and awe from our senses. This effect of the medium surpasses the significance of a communicative intention. Even the work of the surrealists, who had set their purpose on a revolutionary statement of freedom from the trammels of tradition, still remained bound by the limitations of the painted medium. 'The Work of Art in the Age of Mechanical Reproduction' insists that 'the same public which responds in a progressive manner toward a grotesque film is bound to respond in a reactionary manner to surrealism' (*Illuminations*).

To make sense of Benjamin's position here, we should not spend time mulling over whether or not the positive assertions about film do or do not correspond with the phenomenon of cinematography in history, any more than we should linger with surprise over the quite contrary view of tradition that he develops on narrative forms in the essay 'The Storyteller' at almost the same time. The core of his argument always proceeds in its negative phase. In particular, he is

clearly far more consistent in the implicit and explicit attack on the privileged status of paintings within the hierarchy from which we learn to see permanence and value, than he is in his apparent optimism about the technology of the entertainment industry. When he writes that 'The reactionary attitude toward a Picasso painting changes into the progressive reaction toward a Chaplin movie' (*Illuminations*), we should catch the note of mistrust and look for the reasoning on which it stands rather than hold on to the sanguine impression that technology and the mass market might offer a natural course to salvation. He aims to challenge the natural, unconscious prejudices of cultivated and discriminating persons who look without critical hesitation to the higher expressions of civilization for an intellectual resource to use against barbarism.

His very last writings before his death in 1940, the 'Theses on the Philosophy of History', repeat this reserve toward 'cultural treasures', finding that 'there is no document of civilization that is not at the same time a document of barbarism' (*Illuminations*). And for this reason too, he concludes his essay 'Surrealism' (1929) with an endorsement of the effect that this artistic movement will have in modern culture precisely because it does not fall neatly within the realm of artistic expression. Despite an unsparing account of its shortcomings, he finds that, by extending directly into modern experience as such, surrealist activity contributes to the fund of mistrust on which alone we can depend for insight into the forces that rule and corrupt social relations. That mistrust communicates itself in a specific technique by which the surrealist artwork reappraises traditional painting. Collages and *Merzbilder* occupy the space normally reserved for a privileged expression of an exalted painterly sensibility, and fill it with objects from the detritus of commercial activity like tickets, spools of cotton and cigarette butts. 'The whole thing was put in a frame. And thereby the public was shown: look, your picture frame ruptures time; the tiniest authentic fragment of daily life says more than painting' (*Reflections*).

The deep personal mistrust of paintings emerges strongly in Benjamin's letters before it makes its way into critical or philosophical writing. On 26 March 1921 he wrote to his friend Gershom Scholem that he had been to see an exhibition of paintings by the Blau Reiter group, where he had come to the realization that he could 'depend' only on their style, which used the frame to exclude the beautiful semblance of worldly images: 'Everything else has pitfalls that require you to be on guard.' A year earlier he reports having read Wassily Kandinsky's *Concerning the Spiritual in Art* (1912) with great

admiration. Commentators have speculated about the influence on Benjamin of Wilhelm **Worringer**'s *Abstraction and Empathy* (1908), whose ideas were closely associated with Kandinsky's up to that time, but there is little direct evidence to analyse. In 1912, as a twenty-year-old student, Benjamin had expressed enthusiasm for Heinrich **Wölfflin**'s book on classical art (*Die klassische Kunst*, 1899) but, by 1915, when he had an opportunity to hear Wölfflin lecture at the University of Munich, his opinion of this highly regarded art historian fell abruptly, and with it any reservation in the scepticism he now brought to the classical tradition in the arts.

The source of art-historical ideas that did turn out to be most directly fruitful for him came from the previous generation, the Viennese School, and the writings of Alois Riegl and Franz Wickhoff. Scholem reports that Benjamin had already begun to discuss Riegl's *Late Roman Art Industry* (1901) while they were studying in Bern, in 1918. Riegl, of course, was also the major figure on whom Worringer based his work, and a very significant factor in the development of expressionism. Riegl's powerful arguments undermined the classical idea in aesthetics and presented a serious reappraisal of periods that such established aesthetics dismissed as stages of decline. This, and his interest in ornament and the significance of lesser objects rather than the monumental work of grand individual achievement, would all continue to work their way through Benjamin's critical perspective. Benjamin develops Riegl's concept of *Kunstwollen*, or artistic volition, from its vague function as an expression of a society's spiritual tendency, and produces a new technique – isolating images from the complex of material expression among the phenomena of modern production, and identifying them as dialectical images of the social and economic forces determining a catastrophic political order.

Though this technique reached its full development during the 1930s in the great 'Passages Project' on the Parisian arcades, which also included his study of Baudelaire, its growth from the period prior to his materialist political undertaking can easily be followed in the way he draws on Riegl in the study of the Baroque he completed in 1925, *The Origin of German Tragic Drama*. The interest in emblematic imagery from the sixteenth and seventeenth centuries began, as Scholem observed, during their studies in Bern. This led to Benjamin's important revision of the approach to allegory in both the visual and the literary expression of the Baroque. Subsequently recognizing allegory as a crucial element in Baudelaire's response to the impenetrability or obscurity of modern phenomena would also come

to open up the full allegorizing vision of that exceptional eye which Benjamin casts on the objects of cultural modernity.

Biography

Walter Benjamin Born Berlin 15 July 1892, son of a prosperous middle-class Jewish family. Benjamin studied philosophy 1912–19, first at Freiburg University, then at Berlin, Munich and Bern, where he completed his dissertation, *The Concept of Art Criticism in German Romanticism*. He worked for several years as an independent writer for literary journals, then in 1923 began the *Origin of German Tragic Drama*, his 'habilitation' thesis for Frankfurt University, enabling him to embark on an academic career. He became intensely involved with Marxism in 1924, later meeting Bertolt Brecht. The habilitation attempt failed in 1925, making a university appointment impossible. *One Way Street* was published in 1928. When Hitler came to power in 1933, Benjamin went into exile in Paris, devoting himself to his 'Passages Project'. He produced 'The Work of Art in the Age of Mechanical Reproduction' in 1936. While trying to flee France, he committed suicide in Spain on 27 September 1940.

Bibliography

Main texts

The Concept of Criticism in German Romanticism (*Der Begriff der Kunstkritik in der deutschen Romantik*, 1920), trans. Rodney Livingstone, in Marcus Bullock and Michael Jennings (eds), *Walter Benjamin: Selected Writings I – 1913–26*, Cambridge, Mass. and London: The Belknap Press, 1996.

One-Way Street (*Einbahnstraße*, 1928), trans. Edmund Jephcott, in Howard Eiland and Gary Smith (eds), *Walter Benjamin: Selected Writings II – 1927–34*, Cambridge, Mass. and London: Harvard University Press, 1999.

The Origin of German Tragic Drama (*Ursprung des deutschen Trauerspiels*, 1928), trans. John Osborne, London: Verso, 1985.

'Surrealism: The Last Snapshot of the European Intelligentsia' ('Der Sürrealismus: Die letzte Momentaufnahme der europäischen Intelligenz', 1929), trans. Edmund Jephcott, in Peter Demetz (ed.), *Reflections: Essays, Aphorisms, Autobiographical Writings*, New York: Harcourt, Brace, Jovanovich, 1978 (reprinted in *Selected Writings II*).

'Berlin Chronicle' ('Berliner Chronik', written 1932, published in German 1970), trans. Edmund Jephcott, in Peter Demetz (ed.), *Reflections: Essays, Aphorisms, Autobiographical Writings*, New York: Harcourt, Brace, Jovanovich, 1978.

'The Work of Art in the Age of Mechanical Reproduction' ('Das Kunstwerk im Zeitalter seiner technischen Reproduzierbarkeit', 1936), trans. Harry Zohn in Hannah Arendt (ed.), *Illuminations*, New York: Harcourt, Brace, and Jovanovich, 1968.

'Central Park' ('Zentralpark', written 1938, published in German 1955), trans. Lloyd Spencer in collaboration with Mark Harrington, *New German Critique*, 34 (1985), 32–58.

'On some Motifs in Baudelaire' ('Über einige Motive bei Baudelaire', 1939), trans. Harry Zohn, in Hannah Arendt (ed.), *Illuminations*, New York: Harcourt, Brace, and Jovanovich, 1968.

Charles Baudelaire: A Lyric Poet in the Era of High Capitalism (*Charles Baudelaire: Ein Lyriker im Zeitalter des Hochkapitalismus*, written 1939, published in German 1969), trans. Edmund Jephcott and Quintin Hoare, London: NLB/Verso, 1973. This edition also includes 'Paris, Capital of the Nineteenth Century' ('Paris, Hauptstadt des neunzehten Jahrhunderts', written 1935, published in German 1955).

The Arcades Project (*Das Passagen-Werk*, written 1929–40, published in German 1982), trans. Howard Eiland and Kevin McLaughlin, Cambridge Mass. and London: Harvard University Press, 1999.

Secondary literature

Adorno, T., 'A Portrait of Walter Benjamin', in *Prisms*, trans. Samuel Weber and Shierry Weber, Cambridge, Mass.: MIT Press, 1981.

Buck-Morss, S., *The Dialectics of Seeing: Walter Benjamin and the Arcades Project*, Cambridge, Mass.: The MIT Press, 1989.

Eagleton, T., *Walter Benjamin, or Towards a Revolutionary Criticism*, London: Verso, 1981.

Hansen, M., 'Benjamin, Cinema, and Experience: "The Blue Flower in the Land of Technology" ', *New German Critique* 40 (1987), 179–224.

Hanssen, B., *Walter Benjamin's Other History: Of Stones, Animals, Human Beings, and Angels*, Berkeley: University of California Press, 1998.

Jacobs, C., *In the Language of Walter Benjamin*, Baltimore: The Johns Hopkins University Press, 1999.

Jennings, M., 'Walter Benjamin and the Theory of Art History', in Uwe Steiner (ed.), *Walter Benjamin, 1892–1940. Zum 100. Geburtstag*, Bern: Lang, 1992.

Scholem, G., *Walter Benjamin: The Story of a Friendship* (*Walter Benjamin: Die Geschichte einer Freundschaft*, 1975), trans. Harry Zohn, Philadelphia: Jewish Publication Society of America, 1981.

Witte, B., *Walter Benjamin: An Intellectual Biography* (*Walter Benjamin*, 1985), trans. James Rolleston, Detroit: Wayne State University Press, 1991.

Wohlfarth, I., 'On Some Jewish Motifs in Benjamin', in Andrew Benjamin (ed.), *The Problems of Modernity*, London: Routledge, 1989.

MARCUS BULLOCK

JOHN BERGER (1926–)
BRITISH ART CRITIC, ARTIST AND NOVELIST

In a preface written for the 1979 edition of *Permanent Red* (first published in 1960), John Berger observed that 'the recurring theme of

the present book is the disastrous relation between art and property'. If one idea animates Berger's work as a critic, it is this. For Berger, art ultimately represents humanity's creative potential. Property, by contrast, stands for capitalist relations of ownership and production. Berger thus locates the central problem of art in the contemporary world as the conflict between human creativity and the oppression inherent in the capitalist system.

Such a view, far removed from that of his contemporaries in the London art world during the 1950s and 1960s, points to the enduring value of Berger's critical project. Like other writers of the period, Berger celebrated artistic achievement. But, uniquely for his generation of art critics in the English-speaking world, he never lost sight of the relation between the aesthetic and the social. His efforts to work through that relation made him 'political' at a time when critics and art historians claimed to be neutral or above politics. Berger did not hesitate to acknowledge his political aims. As he wrote in the 1979 introduction to *Permanent Red*:

> Ever since I was a student, I have been aware of the injustice, hypocrisy, cruelty, wastefulness and alienation of our bourgeois society as reflected and expressed in the field of art. And my aim has been to help, in however small a way, to destroy this society. It exists to frustrate the best man. I know this profoundly and am immune to the apologetics of liberals. Liberalism is always for the alternative *ruling* class: never for the exploited class.

This statement underscores Berger's radical ambition as a critic – an ambition that was from the early 1950s on enriched by contact with a broad range of Marxist thinkers, among them the expatriate art historian Frederick Antal, a connoisseur and also a pioneering writer on the social history of art, who, Berger later said, 'more than any other man taught me how to write about art'. Another important influence was the Austrian Marxist philosopher Ernst Fischer, author of *The Necessity of Art* (1963), which developed a socialist–humanist concept of art that provided a clear way of distinguishing between form and content, realism and naturalism – terms Berger had struggled with throughout the 1950s. During the 1960s Berger also discovered the writings of Max Raphael, whose analysis of Picasso's development deeply influenced his own *Success and Failure of Picasso* (1965); and also the work of Walter **Benjamin**, whose now famous essay 'The Work of

Art in the Age of Mechanical Reproduction' (1936) was crucial for Berger's *Ways of Seeing* (1972).

Success and Failure of Picasso and *Ways of Seeing* represent Berger's most important contributions to the literature of art. Before considering these books, however, two additional issues require attention: Berger's writing style; and the relation between his criticism and his approach to history.

In the 1979 preface to *Permanent Red*, Berger recalled that during the 1950s, when the essays that made up the volume were written, he needed . . .

> to formulate swift but sharp generalizations and to cultivate certain long-term insights in order to transcend the pressures and escape the confines of the genre [of the journalistic review]. Today most of these generalizations and insights strike me as still valid.

This comment provides a clue to the strengths as well as the limitations of Berger's criticism. By cultivating a style that depended upon an aphoristic mode of expression, Berger could within a small space say, or at least imply, a great deal. Sentences pared down to essentials allowed for extraordinary lucidity. Yet lucidity sometimes came at a price, since Berger's arguments rested on generalizations that did not always stand up to scrutiny. Berger's criticism alternated between powerful general statements about art and history and close analyses of individual artists. Perhaps because he was trained as a painter, Berger could, as few other critics, evoke the appearance of a work of art or the way an artist works. This made for an often unsettling combination of broad historical arguments pursued with polemical intensity and subtle aesthetic insights.

Berger wrote as a critic who comprehended the historical dimension of art – a dimension critics and art historians during the 1950s and 1960s often deliberately ignored or repressed. Where they turned the history of art into redemptive fictions of cultural triumph, Berger pointed to the often painful historical circumstances under which art was produced and seen. Although not an art historian, he often employed historical generalizations to good effect. Simply by pointing out circumstances overlooked or deliberately neglected by critics and art historians – the way Dutch capitalism circumscribed Frans Hals's career, for instance, or how a pervasive ideology of technological progress formed an essential precondition for Cubism – Berger could develop insights unavailable to other writers.

Success and Failure of Picasso begins with a meditation on Picasso's reputation. By 1965 the artist's fame had so far eclipsed his achievement that, in Berger's estimate, 'not more than one out of every hundred who know the name of Picasso would be able to recognize a single picture by him'. Picasso is famous for his wealth, for his mistresses and for being an artistic genius. Yet his extraordinary celebrity coincided with artistic failure – a failure that Picasso alone was aware of. Isolated in his villas, protected by sycophantic friends, the King of La Californie 'has nothing of his own to work on'. But far from being unusual, his condition is typical in a society that 'is now essentially unreal'. Picasso has been true to his experience, but that experience, Berger maintained, now demonstrates that what bourgeois society offers as success is not worth having.

Writing about Jackson Pollock in *Permanent Red*, he insisted that, in a period of cultural disintegration, an artist will be defeated 'if he does not think beyond or question the decadence of the cultural situation to which he belongs'. Pollock's failure, like Picasso's, resulted from his acceptance of unreality – his willingness to live by and subscribe to 'all our profound illusions'. Here Berger develops two themes found in earlier Marxist criticism. First, that bourgeois society has entered a period of cultural decline that makes genuine artistic achievement extremely difficult. Second, that to be successful under these circumstances an artist must struggle to portray or represent 'reality'. And yet, despite the familiarity of these ideas, *Success and Failure of Picasso* represented a considerable critical advance over earlier commentaries on the artist which, with the exception of Raphael's *Proudhon, Marx, Picasso* (1980), tended to be either philistine or hagiographic. Berger's book was neither: his historical and aesthetic argument for Picasso's failure during the years following World War Two and at other times in the artist's career was plausible because it was balanced against a powerful appreciation of Picasso's success.

Berger lauded Picasso's achievement in paintings of the period 1931–43 that share 'a preoccupation with physical sensations so strong and deep that they destroy all objectivity and reassemble reality as a complement to pain or pleasure'. Employing a new painterly language of empathetic sensuality, the artist succeeded because he 'found his subjects' – in other words, he made contact with an inner as well as an outer reality.

Picasso achieved a very different sort of success in the years 1907–14 when, in partnership with Georges Braque, he created Cubism. For Berger, Cubism's historical importance cannot be overstated. In *Success and Failure of Picasso* and in a later essay 'The Moment of Cubism',

Berger maintained that Cubism was a revolution in the visual arts comparable to the changes that marked the art of the early Renaissance. In both, a sense of newness and new possibilities appeared. The heir to the revolutionary art of the nineteenth century, Cubism brought together the materialism of Courbet and the 'dialectic' of Cézanne, becoming 'the only example of dialectical materialism in painting' – an embarrassingly literal claim which none the less underscored Berger's focus upon materiality and a visual process in which the viewer is obliged to take an active part. Cubism offered a paradigm of modernity by revealing interlocking phenomena, a visual world of endless interaction. It was 'an art of dynamic liberation from all static categories' that paralleled the discoveries made by such contemporary physicists as Max Planck and Albert Einstein.

Success and Failure of Picasso signalled a new emphasis in Berger's criticism on art as 'process'. In 'The Historical Function of the Museum' (1966), Berger insisted that 'process has swept away all fixed states; the supreme human attribute is no longer knowledge as such but the self-conscious awareness of process.' And in the same essay:

> ... it is necessary to make an imaginative effort which runs contrary to the whole contemporary trend of the art world: it is necessary to see works of art freed from all the mystique which is attached to them as property objects. It then becomes possible to see them as testimony to the process of their own making instead of as products; to see them in terms of action instead of finished achievement.

In a sense, Cubism of the period 1907–14 became Berger's model for all visual imagery. In 'Understanding a Photograph' (1968), Berger announced that 'every photograph is in fact a means of testing, confirming and constructing a total view of reality'.

These arguments lay the groundwork for *Ways of Seeing*. Originally a series of programmes produced for BBC television, Berger and his collaborators conceived of *Ways of Seeing* as a critical riposte to Kenneth Clark's complacent TV series *Civilisation* (1969). The book *Ways of Seeing*, which consisted of four essays combining text and images and three using images only, quickly became a classic.

Ways of Seeing can be read as an extended critique of both the European tradition of oil painting and the way that tradition has been used in contemporary society. Walter Benjamin analysed how mechanical reproduction modified the status of art, how it stripped art of its traditional 'aura' and hence its traditional authority. In the first

essay in *Ways of Seeing*, Berger draws upon Benjamin's analysis to question the ongoing use of art 'to glorify the present social system and its priorities'. Mechanical reproduction – especially cheap colour printing – makes images ubiquitous. What is now available is a 'new language of images'. Berger argued that this new language of images could help us redefine our personal and historical experience. But because our society defines works of art as property, as so many objects to be bought and sold, it esteems them not for what they represent but for what they are. Commodity fetishism reduces the likelihood of a 'new language of images'. For this reason, we are less able to use works of art to construct what Berger had earlier called 'a total view of reality'.

The three remaining essays also opened what were in 1972 new areas of inquiry. In the second essay, Berger took a close look at how traditional oil painting represented women as objects of male desire. The 'ideal' spectator, Berger wrote, 'is always assumed to be male and the image of the woman is designed to flatter him'. The 'male gaze' has become a commonplace of art-historical discourse, but Berger's analysis was path-breaking in 1972.

In his third essay, Berger argued that oil painting was uniquely adaptable to the representation of private property. Itself the product of new social relations that accompanied the rise of capitalism, oil painting 'did to appearances what capital did to social relations. It reduced everything to the equality of objects.' Consequently, the great works of the oil painting tradition, the ones familiar to students of the history of art, were exceptions, in crucial ways undermining the object fetishism which was oil painting's historical *raison d'être*.

The book's final and perhaps most daring essay begins by examining the continuity between contemporary publicity (advertising) imagery and the visual language of oil painting. Drawing upon his three earlier chapters, Berger argued that 'publicity is a language in itself' – another way of seeing. But that way of seeing 'relies to a very large extent on the language of oil painting. It speaks in the same voice about the same things.' Publicity doesn't supplant 'the visual art of post-Renaissance Europe; it is the last moribund form of that art.' None the less, it has a different purpose. Oil painting typically celebrated possessions and the owner's lifestyle. Publicity, by contrast, creates marginal dissatisfaction, prompting the belief that a purchase will improve the spectator's life. Publicity is itself a way of seeing: 'It explains everything in its own terms. It interprets the world.'

Berger's principal aim in *Ways of Seeing* was 'to start a process of questioning'. In this respect he may have succeeded beyond his wildest

imaginings. Indeed, if any one publication could be said to have initiated what later came to be known as 'the new art history', it would be *Ways of Seeing* – this despite the book's sketchiness and lack of academic rigour. *Ways of Seeing*, along with *Permanent Red*, *Success and Failure of Picasso* and Berger's other writings on art, attests the strengths of a critical Marxist approach. Although untouched by recent developments in academic Marxist and post-structuralist theory, Berger's work remains a crucial contribution to the study of art history and to the ongoing re-evaluation of artistic culture.

Biography

John Berger Born London, 5 November 1926. Berger served in the British army during 1944–6, and subsequently attended the Central School of Art and the Chelsea School of Art in London. In 1952 he began a decade of writing art criticism for *The New Statesman*, and published *Permanent Red: Essays in Seeing* in 1960, *Success and Failure of Picasso* in 1965, and *Ways of Seeing* in 1972. Besides his books on art, he has published ten novels including *G.*, which won the Booker Prize in 1972, and several documentary essays with the Swiss photographer Jean Mohr. Berger has written three screenplays in collaboration with the Swiss filmmaker Alain Tanner, and is the author of several plays. In 1990 he completed *Into Their Labours*, a trilogy of novels that traces today's peasant migrations from countryside to city. Berger left England in 1962 and has for many years lived in a small village in France's Haute Savoie.

Bibliography

Main texts

A Painter of Our Time, London: Secker and Warburg, 1958.

Permanent Red: Essays in Seeing, London: Methuen, 1960 (published in the USA under the title *Toward Reality*); London: Writers & Readers, 1979.

Success and Failure of Picasso, Harmondsworth: Penguin, 1965.

The Moment of Cubism and Other Essays, London: Weidenfeld and Nicholson, 1969.

Art and Revolution, New York: Pantheon Books, 1969.

Ways of Seeing, Harmondsworth: Penguin, 1972.

The Look of Things, Harmondsworth: Penguin, 1972.

About Looking, London: Writers and Readers, 1980.

The White Bird, London: Chatto and Windus, 1985 (published in the USA under the title *The Sense of Sight*).

Selected Essays, Geoff Dyer (ed.), New York: Pantheon Books, 2001.

Secondary literature

Antal, F., *Florentine Painting and its Social Background*, London: Kegan Paul, 1948.

Benjamin, W., 'The Work of Art in the Age of Mechanical Reproduction' ('Das Kunstwerk im Zeitalter seiner technischen Reproduzierbarkeit', 1936), in *Illuminations*, trans. Harry Zohn, New York: Schocken Books, 1968.

Dyer, G., *Ways of Telling: The Work of John Berger*, London: Pluto Press, 1986.

Fischer, E., *The Necessity of Art, A Marxist Approach* (*Von der Notwendigkeit der Kunst*, 1959), trans. Anna Bostock, Baltimore: Penguin Books, 1963.

Fuller, P., *Seeing Berger: A Revaluation*, London: Writers and Readers, 1980.

Raphael, M., *Proudhon, Marx, Picasso*, trans. Inge Marcuse, Atlantic Highlands, NJ: Humanities Press, 1980.

Read, D. [pseud. of Anthony Barnett], 'Oil Painting and Its Class', *New Left Review* 80 (July–August 1973), 109–11 (reprinted in P. Fuller, *Seeing Berger: A Revaluation*, London: Writers and Readers, 1980).

ALAN WALLACH

PIERRE BOURDIEU (1930–2002)

FRENCH SOCIOLOGIST

Bourdieu's importance lies in his demystification of the modern myths or cult of art. He holds that, as the capitalist economy emerged in modernity, dedicated to the pursuit of productivity for its own sake, so a cult of art emerged as the systematic reversal of this principle. Within the aesthetic arena were to be valued activities that were being increasingly eradicated elsewhere: production which could not be justified immediately by reference to material usefulness or mass pleasure; paintings or sculpture which responded to social needs rather than to a commercial logic; in brief, artistic production dedicated to use-values, rather than to monetary or exchange-values. In contrast with workers' compliance with highly specialized tasks in the industrial economy, artists were to be conceived as doubly free – free from patronage but also free from the needs of the people. They were thus emancipated to live within a state of visionary social isolation. Yet, as Bourdieu notes, in the Kabylean villages of Algeria and amongst the peasantry of the French Béarn – where agriculture was still semi-artistic – the cult of art has been strikingly absent.

Bourdieu's skill is in clarifying the deep structures or taken-for-granted orthodoxies of the art lovers' cult, in much the same way that **Lévi-Strauss** reads the structural oppositions of Bororo myths. We should address, first, the charismatic 'invention of the artist', whose Christ-like existence is the source of their claimed material

disinterestedness. Second, we note that the cultivated minority of art lovers, with its supposedly innate subjective taste, makes universal aesthetic value-judgements. Third, the modern cult of art favours a mode of reception which is particularly responsive to avant-garde works: it appeals to the 'fresh eye' rather than the 'academic eye'. Bourdieu's claim is that the spiritual soul of the contemporary bourgeoisie is in fact now identified with this cult of artistic production and consumption, which depends so extensively on the appeal to natural or innate gifts.

He discovers a further paradox. Modernist art forms, which have been shaped by the twin influences of an anti-capitalist ethos and the denial of money, have today become installed at the heart of the academic curriculum. As such they play a crucial role in legitimating the bourgeoisie itself, which now justifies its domination by its certified knowledge. Ironically, it is the children of professionals or well-established bourgeois families who are best equipped with route-maps in advance for the hazards of the school cultural terrain, having participated in family visits to art galleries and museums from infancy.

Moreover, Bourdieu demonstrates that there is a major structural division in the mode of reception of symbolic goods. The *naive gaze* privileges the political/moral ideas of artistic works and relishes a carnivalesque unmasking of the great and the good. It reaffirms the community in its perception of traditional sights and objects as beautiful (the rosy dawn, the nubile young woman). In opposition to this, the *aesthetic attitude* addresses the mode of representation or style, differentiating its artistic response from objects which are merely charming. Behind these divergent modes of reception, there are differences in what Bourdieu calls 'habitus', or group dispositions to perceive, evaluate and act within the world in a specific way. These variations in habitus are explicable by the amount of education possessed, which in turn is related to one's degree of freedom from material urgencies. The naive gaze corresponds to the subordinate classes of workers and peasants and the aesthetic attitude – its dialectical reversal – to the haute bourgeoisie.

The cult of art was fostered in the 1850s' bohemian origins of heroic modernism, especially through the work of Baudelaire, Flaubert and Manet. The bohemian enclave of the aesthetic was one major mode of rejecting the world. Art thus offered an absolute ethic as well as an aesthetic which countered the disenchantment of the world elsewhere. In the restricted field of the visual arts, where the artist is free from the taste of the masses and from political dictation, the producer exhibits freely, establishing his worth solely through the

respect of other artists and, ultimately, the judgement of posterity. Yet, while thus liberated from the censure of the uneducated and protected by the reinterpretation of material success as artistic weakness, the artist suffers a perpetual angst, unequally suffered. His or her initial failure to find a public may in fact turn into failure as such. Bourdieu's significance is thus in providing the instruments for a realist understanding or 'socio-analysis' of the bohemian artistic field. By this method, Bourdieu forces us to recognize that there is in fact a social and economic logic which conditions the artistic game. It is being dealt a good hand in the artistic stakes that determines artists' chances of gaining more enduring recognition. This applies both to their chances of grasping the whole history of the artistic field, and to their chances of suspending other needs so as to experiment.

At one level, we might see Bourdieu as a latter-day Luther or a prophetic figure, who reveals the comfortable sinecures and venal material interests behind the otherworldly facade of the Church. Bourdieu's sociology of art serves to interpose a similar ethic of suspicion vis-à-vis avant-garde producers and their cultural inter-mediaries, critics and gallery owners. He reveals the 'alchemy' or magical techniques by which the select few, tacitly accommodating themselves to the art market, may in practice do very well out of it. Equally, his critique of hidden interests unveils the rhetoric in which 'an aristocracy of culture' proclaims, front-stage, the right of everyone to the cultural access they themselves possess – but, backstage, maintains the cultural game as a site for individual distinction and, more tragically, for social exclusion.

A socio-analysis aims to avoid the twin weaknesses of either the undue denigration or the effusive celebration of the works of great artists. It will include an internal account of the artistic field which addresses painters' position-takings in relation to earlier painters, noting in particular the structural antagonism of newly established artists to the previous generation. It also incorporates an analysis of artists within their families and, more crucially, their families' experience over several generations within the field of power. The artistic habitus, which is picked up, body-to-body, through a physical style of handling paint, is moulded by both these settings.

The avant-garde bohemia of the 1850s, from Manet onwards, was based on a rigorous but revolutionary professional ethic. In art, this meant a break with the 'academic eye', a rupture which Bourdieu sees as being as significant historically as the Protestant Reformation. It removed the orthodox ways of seeing the world and the wider cosmos, which were implicit in the Academy's hierarchy of genres: from the

lower still life, to more elevated Biblical depiction. It replaced also the Academic and Salon monopoly on the commission, selection and exhibition of works of art.

At its most accentuated, the underlying modernist notion of 'truth to medium' implied a break with the political or moral meanings implicit in the narrative concerns of the writer, and an exclusive concern with the distinctive painterly forms of the visual arts. Both Manet and Redon refused to make a painting 'say' something, thus liberating themselves from the need to provide an exegesis or gloss. Marcel Duchamp, Bourdieu argues, went a step further. His 'ready-mades' signalled a new consciousness of the shift in artistic authority itself: from the artist (backed by the church-like sanctions of the Academy) to the *pure contingency* of the new, unregulated structures. At this point, the spectator's interpretations of the work become an essential aspect of the art and indeed of the art institution itself. One consequence is the rejection of the sacred Academic Rule or 'nomos', and its replacement by proliferating cults with *rival rules of art*; another is the installation of a 'permanent revolution' in which each succeeding generational group seeks to make their mark by a struggle against the established avant-garde. An insurrectionary transgression is the condition of entering the consecrated field. From now on, one of the most disputed stakes of this bitter struggle is over the definition of what is art.

For Bourdieu the struggles between new and old avant-garde generations – and between new artists and the critics – cannot be understood solely in terms of the artistic field itself. Rather, the triumph of artistic autonomy is accompanied by two linked developments, concerning both space and time. Thus it is only in the metropolitan cities that the experimental prerequisites for the modernist revolutions are possible. Artists initially of provincial origin, who settle back in the country, lack the innovatory principles of vision and division implicit in urban modernism. Second, the only artists who acquire recognition in the new experimental field are those who can withstand the austere rigours of the period in the wilderness. This implies that, in the absence of profits from selling their work, they must have another source of income: rents, or an allowance from their family; hence the significance of the first modernists' social origins in the minor aristocracy.

Since those who gain recognition can now only do so through education and family protection from material disasters, art becomes closed to the working class and the peasantry. The cost of the preservation of art from purely market criteria through the institution of peer review turns out to be the dispossession of the subordinate class

from the means of decoding art, and ultimately from the collective artistic inheritance as such. Bourdieu shows this empirically through his various interview-based studies of the uses of photography. He reveals that photography in the hands of peasants or workers is valued as a family-based art that celebrates the joys of the social group. For them, modernist photography, which focuses on the aesthetic innovativeness of techniques, such as camera angle, rather than the intrinsic interest of the subject, is totally mystifying.

Finally, Bourdieu comes to discuss contemporary practices in the visual arts. He sees the current bureaucratization and commercialization of the restricted modernist field as a threat to artistic autonomy. He registers with disquiet certain recent developments which jeopardize the precious conquests of the elitist artists – the interpenetration of art and money, through new patterns of patronage, the growing reliance of art on bureaucratic control, and the consecration through prizes or honours of works successful only with the wider public, alongside the long-cycle modernist works cherished by artists themselves.

Bourdieu's critique of idealized artistic disinterestedness has been mistakenly reinterpreted as a theory of widespread egoistic domination, not least by the 'consecrated' avant-garde. Bourdieu's socio-analysis of the artists has shown, despite charismatic ideology, that in practice the Impressionists and subsequent modernists lived a comfortable existence by the time of their middle age, and that usually gallery owners or dealers sold their works on their behalf, thus relieving them of attention to the 'vulgar' needs of material existence.

Bourdieu also accounts for certain recurrent features of the closed worlds of art, such as the social reality of artists' struggles over cultural politics, which the spiritualistic account cannot explain. Contrary to the orthodox expectations of sublimated suffering, Bourdieu cites many instances where the conflicts between artists over their specifically artistic interests led to open violence: the Surrealists' fight, in which André Breton broke a fellow artist's arm, is a case in point. Nor did the idealized expectations of art stop many cultural producers collaborating with the Vichy regime in the 1940s.

Although Bourdieu's vocabulary of 'cultural capital' and 'symbolic profits' has sometimes misled his readers, his insistence on the complex motives in artists' desire to make a mark does not allow him to forget the vital differences between the artistic field and the field of capitalist power. Bourdieu argues that the distinctive nature of artistic and other cultural fields is that they exist in the form of reciprocal gift exchange rather than being animated by money. Further, he does not reduce artists to their class position, nor does he deny that artists may indeed

be singular figures. Indeed, the comparison across the restricted and expanded artistic fields sharpens appreciation of the differences between the autonomous artists and others. The sociological analysis of the artworks, which shows how they are necessitated by social situation and artistic position-taking, can thus become a 'piquant sauce' which serves to heighten the pleasures of the works.

Biography

Pierre Bourdieu Born 1 August 1930, Denguin, Béarn, France, the son of a postman. He became a licentiate of the Faculté des Lettres de Paris; agrégé in philosophy at the École Normale Supérieure in 1954; and taught philosophy at the *lycée* at Moulins in 1955. After military service in Algeria between 1955 and 1957, he became assistant in the Faculté des Lettres, University of Algiers in 1958–60. Bourdieu was assistant to Raymond Aron at the Sorbonne in 1960–61, and lecturer in sociology, University of Lille, between 1961 and 1964, from where he was also Secretary of the Centre de Sociologie Européenne. He was directeur d'études at the Haute École en Sciences Sociales in Paris from 1964 and Professor of Sociology at the Collège de France, Paris, between 1981 and 2001. In 1993 he was awarded the Gold Medal from the Centre National de Recherches Scientifiques (CNRS) for outstanding contributions to scientific research. Bourdieu died in Paris on 23 January 2002.

Bibliography

Main texts

Photography: A Middlebrow Art (*Un art moyen: essai sur les usages sociales de la photographie*, with L. Boltanski *et al.*, 1965), trans. S. Whiteside, Cambridge: Polity Press, 1990.

Postface to E. Panofsky, *Architecture Gothique et Pensée Scholastique*, trans. P. Bourdieu, Paris: Editions de Minuit, 1967.

The Love of Art: European Art Museums and their Public (*L'Amour de l'art: les musées d'art européens et leur public*, with A. Darbel and D. Schnapper, 1969), trans. C. Beattie and N. Merriman, Cambridge: Polity Press, 1991.

Distinction: A Social Critique of the Judgement of Taste (*La distinction, critique sociale du jugement*, 1979), trans. R. Nice, London: Routledge and Kegan Paul, 1984

The Field of Cultural Production: Essays on Art and Literature, R. Johnson (ed.), Cambridge: Polity Press, 1993.

The Rules of Art: the Genesis and Structure of the Literary Field (*Les règles de l'art: genèse et structure du champs littéraire*, 1992), trans. S. Emmanuel, Cambridge: Polity Press, 1996.

Practical Reason: on the Theory of Action (*Raisons pratiques: sur la théorie de l'action,*
1994), various translators, Cambridge: Polity Press, 1998.
Pascalian Meditations (*Méditations Pascaliennes,* 1997), trans. R. Nice, Cambridge:
Polity Press, 2000.

Secondary literature

Calhoun, C., LiPuma, E. and Postone, M. (eds), *Bourdieu: Critical Perspectives,*
Cambridge: Polity Press, 1993.
Crowther, P., 'Sociological Imperialism and the Field of Cultural Production: The
case of Bourdieu', *Theory, Culture and Society,* 11, 1 (February 1994), 155–69.
Fowler, B., *Pierre Bourdieu and Cultural Theory: Critical Investigations,* London: Sage,
1997.
—— (ed.), *Reading Bourdieu on Society and Culture,* Oxford: Blackwell, 2000
(especially contributions by Roger Cook, Richard Hooker, Dominic Paterson,
Paul Stirton and Nick Prior).
Guillory, J., *Cultural Capital: the Problem of Literary Canon Formation,* Chicago:
University of Chicago Press, 1993.
Lamont, M., *Money, Morals and Manners: The Culture of the French and American
Upper Middle Class,* Chicago: University of Chicago Press, 1992.
Lane, J.F., *Pierre Bourdieu: A Critical Introduction,* London: Pluto, 2000.
Pinto, L., *Pierre Bourdieu et la Théorie du Monde Social,* Paris: Albin Michel, 1998.
Rigby, B., *Popular Culture in Modern France: a Study in Cultural Discourse,* London:
Routledge, 1991.
Shusterman, R., *Pragmatist Aesthetics: Living Beauty, Rethinking Art,* Oxford and
Cambridge, Mass.: Blackwell, 1992.

BRIDGET FOWLER

NORMAN BRYSON (1949–)

BRITISH HISTORIAN OF ART AND VISUAL CULTURE

'Painting is an art made not only of pigments on a surface, but of signs in semantic space.' It sounds so simple. But the discipline of art history had not been very successful in handling this basic fact. Norman Bryson, trained and active as a literary scholar, was one of those who walked into art history in the 1980s, looked around, and found it wanting. As a discipline it was both naively steeped in visual purism and, in its iconographic dogmatism, iconophobic at the same time. Only outsiders could thus shake up what was, perhaps, the most traditionalist of humanistic disciplines. Bryson took stock, and proceeded to write three pioneering books, published between 1981 and 1984.

He wasn't speaking lightly when he wrote, in the Foreword to his *Looking at the Overlooked* (1990), that reading is 'as fundamental an

element as paint'. The consequences of this view are far-reaching. But it is not about language, the 'stuff' of reading. Bryson's notion of reading is more visually based than many of those iconographic practices that claim to be concerned with images only. Instead of the optical field, it is the messy but also hierarchized mixture of discourses that is constitutive of visuality. In it, instead of the I/eye as witness to what is immutably there, power relations reign supreme. Instead of pure form, images are domains saturated by events of meaning-making. Instead of sight bathed in light, the primary material of such events is semiosis in a luminous form. But the signs are not luminous in and of themselves. Exploring the consequences of this basic insight, Bryson's work is unique in the following ways (among others).

The first statement in which Bryson's position was elaborated took on the tricky issue of 'word and image' relations. These he gave a decisive new turn. Radically overcoming the tenacious notion that visual images 'illustrate' prior texts, he set out to theorize and analyse the discursivity of painting itself. Paradoxically only for visual purists, the secret of Bryson's success is the convincing integration of theoretical reflection and persuasive analyses of painting primarily from the century and a half that preceded Impressionism in France. Where the habits of the discipline as it was practised in the last three decades of the twentieth century include a resistance to theory but also, and more surprisingly, a lack of visual engagement with the primary material it was supposed to serve, this combination could not fail to attract a great deal of interest.

Bryson's theory and practice of visual reading have led him in three different but related directions: theorizing vision, the development of a number of theoretical themes, and cultural politics. The first direction is the re-conceptualization of vision 'after' such positivism traps as the belief in the realist adequacy and 'naturalness' of linear perspective, art as an optical machine and the Popper-based Gombrichian version of 'realism' as the ongoing ideal of visual art. In *Vision and Painting* (1983), Bryson takes **Gombrich** to task for not delivering for scrutiny the 'original' perception that Gombrich claims painting seeks to reproduce. Bryson develops a range of alternative concepts, each providing new tools for an analysis that both seriously engages with the visual object and brings into view the spectator's accountability. With 'deixis', he theorizes the signs of the making – rather than the maker – of the image. With the distinction between 'gaze' and 'glance', he pries open the monolithic view of looking as disembodied gazing, critiques the colonizing nature of such gazing and

offers an alternative in the form of the stealthy, shy, self-conscious 'glance'.

The second unique direction is the development, through the close reading of artworks throughout history, of *theoretical themes* of great currency and, hence, enormous range. These themes have in common that they each open up a theoretical field, along with a body of work that lends itself particularly well to analysis through it. One such theme is the 'discursivity' that permeates painting, and of which Bryson unpacks the base in power relations. A second theme is the 'narrativity' that permeates such an ostensibly immobile genre as still-life. A third is 'desire' and its tense relationship to tradition. We will look first at narrativity.

In four essays, each of which sweeps through history yet clings to a short and specific historical situation, *Looking at the Overlooked* emancipates still-life from its low rank among the genres and its alleged futility in comparison to the grander genre of history painting. Both genres are semantically filled with the same amount of narrativity. It is this narrativity – its kinds, its manifestations – that distinguishes still-lifes from each other as well. Still-lifes may be ostensive, displaying the riches of their owner in order performatively to impress the latter's visitors, but they might just as well be what Bryson calls 'anorexic'. As Bryson has presented it, the genre of still-life is defined in the first place by the absence of the human figure. This absence, then, takes centre stage. He writes: 'Still-life is the world minus its narratives, or, better, the world minus its capacity for generating narrative interest.' Interpreting Juan Sánchez Cotán's (1561–1627) still-life paintings, which the artist himself called *bodegones*, Bryson sees in these extremely frugal ('anorexic', meaning 'without desire') representations of humble vegetables, displayed according to a mathematically calculated geometry of *hyperbola*, a lesson in unlearning narrative interest. To narrate, he says, 'is to name what is unique: the singular actions of individual persons'. Such narrativity is the equivalent of monumentality. Still-life trains the eye to unlearn the trap of such narrative.

In the Catholic seventeenth century, such exercises belonged to the cultivation of Loyolan spirituality. These exercises rested both on the paradoxical use of the senses to concentrate on spirituality, and on the elimination of monumentalizing narrative in favour of a narrative of concentration. Cotán's still-life paintings engage the senses in a bare narrative of bodiliness. The arrangement of the vegetables is carefully calculated for balance yet not narratively motivated. The cabbages, quinces or leeks in Cotán's bare, grey larders are all but unique. As

elements of creation, they are contingent, empty of meaning, tokens of endlessly repeatable production, of an infinite series. No individual is attached to them: not in their being, not in their production, and not in their use, which they, temporarily, do not have, and from which they are, literally, suspended.

Bryson calls the depiction of such utter ordinariness 'rhopography', the depiction of 'those things which lack importance, the unassuming material base of life that "importance" constantly overlooks'. This humiliation of attention offers as its counterpart the power to transfigure the common, the ordinary, into a radiant novelty, like cells seen through a microscope that suddenly spring into life. Such painting aims to persuade vision

> ... to shed its worldly education – both the eye's enslavement to the world's ideas of what is worthy of attention, and the eye's sloth, the blurs and entropies of vision that screen out everything in creation except what the world presents as spectacular.

The subject of this narrativity, then, is the viewer engaged in training to look differently: sharper, more attentively, in admiration of and gratitude for the object seen. In this sense – of the elevation of the object to the status of subject and interlocutor – Cotán's still-lifes are just as baroque as Caravaggio's paintings of sexy young men. And, like the latter, they are just as narrative, unfolding, performatively, like narrative 'in the second person'.

Whereas this historically specific form of still-life can properly be called 'anorexic' for its deprivation of desire, Bryson had earlier analysed a body of painting that emanates desire: French painting of the post-revolutionary period – specifically David, Ingres and Delacroix. In his detailed study of Ingres's relationship to Raphael, he describes desire not as an object of representation but as a flow across the images, floating around the sitter. Desire is the hunger of one image moving into the next. Ingres gives you not the object of desire but the flow itself, a chain of images. This is where 'tradition' comes in.

Against the pressure exercised on painters to define themselves in relation to prestigious predecessors and their styles, an artist like Ingres, Bryson observes, intensifies the references to earlier paintings as a way of claiming his work to be uniquely his own. Here, the mutual exclusion but equally mutual presupposition of tradition and desire – the former leading to imitation, the latter to individual signature styles

– leads to a self-deconstructive practice. 'What the citation of Raphael signals,' Bryson writes, on the way the *Portrait of Philibert Rivière* is permeated both by Raphaelesque solutions and images of 'woman', is 'not origin, but the opposite: the separation of signs from origin, their sliding free from base, in a movement where authority over vision gives way to vision under desire'.

This view leads Bryson to posit for Ingres's *Bain Turc*, with its swarming naked women, a second meaning grafted on to the first, obvious one that turns the painting into a representation of male desire. This second meaning is that of the *extinction* of desire: 'the abolition of individuality as the individual yields, in dying, to the inevitable return to the inorganic state'. Thus this ostensibly sensuous image shows an unexpected kinship with Cotán's anorexic ones. Still-life as a genre, especially in its Dutch variant, can undercut the masculinist discourse that obliterates the feminine while also invoking it. Both these themes, then, lead Bryson in the third important direction of his work. The critique of perceptualism, and the terse characterizations of tradition, desire and desire's opposite in still-life, inexorably lead to a conception of visuality that stands at the opposite end of Gombrich's attempts to ground vision scientifically. For Bryson, looking, and the visual representational domain that caters to it, is steeped in politics; indeed, it *is* a political practice.

And so is teaching. To leave a university like Harvard to go and teach, as Bryson did recently, at an art school, is a commitment to practice conceived as political in and of itself. He is weary of the resistance to theory in contemporary art practice as well as in art history. A lack of critical theory facilitates a complicity with the market. This situation makes reflection on the political aspect of looking all the more urgent. For this aspect of Bryson's work it is best to look at his writings on contemporary art. He has written many essays on photography, painting, sculpture and video. The entrance into the work is always the question of political meaning produced in a medium and mode, and mood, that play with ideas. Politics, here, is far from moralizing heavy-handedness.

It is defined first of all by Bryson's own commitment to the work under discussion. His essays are replete with beautiful close descriptions. But then, those descriptions are oriented towards what difference that particular work makes in a long series of attempts to master the social fabric. Towards the end of his essay on photographer Thomas Struth's portraits, for example, after probing the way these works lure, then undermine, the novelistic detail of archival ambition so that they question the possibility of visibility even in their perfectly

adequate portraits, Bryson suddenly swirls to the overall epistemological model that subtends that ambition:

> Yet the presence of stray or random information is at the same time what constitutes the central problem of archival reading, since without the elaborate controls on which the archive depends ... the *profile* of knowledge that is sought constantly risks being engulfed by and disappearing into the surrounding welter of non-significance.

This statement itself engulfs semiotics in an analysis that is based on it. It becomes, then, a political issue in the following sentence:

> In order to win this battle against the entropy of the archival image, its creators must accordingly heighten the conditions of legibility, must produce – in the theatrical sense of the word – the legible bodies that social management requires.

It is against the grain of this archival impulse that Struth makes his portraits – and his other works – forms of 'resistance of the image to narrative capture', a resistance that then energizes 'the dense, nescient surface'.

Art history thus becomes the history of art in its entanglement with, or resistance to, social structures where power inequality defines the kind of semiosis that is possible. Bryson's work is not confined to a historical period, genre, medium or region. Yet it is in this sense – of integrating social history, close analysis and theoretical reflection on aesthetics and meaning making – that his work is always rigorously historical. It is also rigorously committed to keeping theory, history and practice together. Hence his teaching is unorthodox, demanding and generous. Perhaps art history cannot survive it. Perhaps it can transform itself through it.

Biography

Norman Bryson Born 1949. Bryson began his career in literary studies as a Fellow of King's College, Cambridge (from 1977). In 1988 he moved to the USA where, at the University of Rochester, he was a co-founder of the doctoral Program in Visual and Cultural Studies. From 1990 until 1998 he was Professor of Art History at Harvard. Returning to the UK in 1998, he is currently Professor of the History and Theory of Art at the Slade School of Fine Art, University College London.

Bibliography

Main texts

Word and Image: French Painting of the Ancien Régime, Cambridge: Cambridge University Press, 1981.
Vision and Painting: The Logic of the Gaze, London: Macmillan, 1983.
Tradition and Desire: from David to Delacroix, Cambridge: Cambridge University Press, 1984.
Looking at the Overlooked: Four Essays on Still Life Painting, London: Reaktion Books, 1990.
Visual Theory: Painting and Interpretation, co-edited with Michael Ann Holly and Keith Moxey, New York: Harper & Row, 1991.
Visual Culture: Images and Interpretations, co-edited with Michael Ann Holly and Keith Moxey, Middletown, CT: Wesleyan University Press, 1993.
Cindy Sherman, with Rosalind Krauss, New York: Rizzoli, 1993.
'Introduction' to *Looking In – The Art of Viewing* by Mieke Bal, Amsterdam: G+B Arts International, 2001.
Gender and Power in the Japanese Visual Field, co-edited with Maribeth Graybill and Joshua Mostow, Honolulu: Hawaii University Press, 2002.
Hiroshi Sugimoto, London: Reaktion Books, 2002.
The Project of Enlightenment, London: Routledge, 2002.

Secondary literature

Carrier, D., *Principles of Art History Writing*, University Park, Penn.: Pennsylvania State University Press, 1991.
Heller, S., 'What Are They Doing to Art History', *Artnews* 96, 1 (January 1997), 102–5.
Minor, V.H., *Art History's History*, New York: Harry N. Abrams, 1994.
Neiva, E., *Mythologies of Vision: Image, Culture, and Visuality*, New York: Peter Lang, 1999.
Preziosi, D. (ed.), *The Language of Art History: A Critical Anthology*, Oxford: Oxford University Press, 1998.
van Alphen, E., Response to N. Bryce, 'Géricault and "Masculinity" ', in *Visual Culture: Images and Interpretations*, Hanover, NH: Wesleyan University Press, 1994.

MIEKE BAL

T.J. CLARK (1943–)

BRITISH ART HISTORIAN

Timothy J. Clark (usually identified as T.J. Clark) is the most significant Marxist art historian of the post-1945 period. He has also done more than any other scholar to question and redefine, both theoretically and through empirical studies, what 'Marxist art history'

might actually mean. In two books published in 1973 concerned with Gustave Courbet and French painting in the mid-nineteenth century, Clark established the ground-rules for the 'social history of art'. Based on his PhD completed at the Courtauld Institute of Art, University of London, the better-known of these two studies, *Image of the People: Gustave Courbet and the 1848 Revolution* (1973), rapidly became the paradigm for a theoretically-informed yet empirically-rooted Marxist account of art practice. Its companion volume, *The Absolute Bourgeois: Artists and Politics in France 1848–1851* (1973), extended Clark's analysis of the social and historical conditions in which art was made in that country at the time of the 1848 Revolution.

Clark's studies were premised on two interrelated propositions. The first of these was that art should be understood always as the product, in and out of a particular conjuncture of conditions and relations of production. These were economic, social, ideological, but also specifically aesthetic and material: based, that is, on the particular artistic practice that a certain artist undertook in an identifiable historical moment. Second, Clark claimed that great modern art was necessarily negative or critical of prevailing conventions and conditions in a specific society – that such art was a work against dominating artistic–aesthetic and socio-political orders. Clark's book on Courbet pursued these ideas through a dense web of empirical and socio-historical sources, insisting that the theoretical basis of his work had to be married to, and revised in the light of, such a rigorous analysis. Clark's detailed consideration of key paintings by Courbet produced in the 1848–51 conjuncture – *The Stonebreakers, Burial at Ornans, Peasants of Flagey Returning from the Fair* – examined their relation to, and departure from, the conventions (and implicit political meanings) of traditionally idealist academic French art. Clark established Courbet's 'realism' in these works as based in conjuncture, and meaningful only in this context of reference to other past and contemporary art. Clark also presented a groundbreaking analysis of contemporary critical responses to Courbet's works by those writing about the exhibitions of art held annually at the Salon in Paris. This study anchored Clark's analysis of Courbet's artworks in the forms of mediation that such historically-specific institutional circumstances and critical response represented.

Clark's significance in the development of Marxist art history since World War Two was secured because his study of Courbet operated, first, as a decisive critique of earlier prevailing Marxist accounts of art, and, second, because it offered a devastatingly powerful challenge to

contemporary conventional art-historical practices that had always claimed a superior knowledge of the actual nature and meaning of art and artistic tradition ('the art works themselves'). The critique and challenge were bound up together. Clark attacked, mostly implicitly, the weaknesses of antecedent Marxist art history on two grounds: first, that it was hardly really 'historical' at all in that it reduced art, artists and social development to a set of highly crude and reductive formulae (an example being Arnold **Hauser's** *The Social History of Art*, 1951); second, that this Marxism in particular could not adequately understand (indeed could not even really recognize) the specific and irreducible qualities and materials of art at all. Clark's notion of Courbet's 'realism' was based not on any simplistic sense that such paintings showed actual real life, or mobilized a set of pictorial conventions that had an essentially truthful character to them, but rather on the principle that their realist affect, or charge, lay in how they 'disappointed' and differed from – critically negated – the prevailing artistic and socio-political conventions, practices, institutions and values of the day.

With this emphasis on the analysis of specific artworks and their materiality (understood as medium, as pictorial convention, as a core element in a tradition of art practice), Clark went for the ground of central scholarly activity that non-Marxist art historians had seen as theirs for several decades. But, as Clark indicated in a highly influential essay published in the *Times Literary Supplement* in 1974 ('The Conditions of Artistic Creation'), such contemporary 'ordinary' art history had destructively supplanted the work of the most important 'cultural art historians' of the first part of the twentieth century. Though Aby **Warburg** and Heinrich **Wölfflin**, Clark noted, had certainly not been Marxists, they had been concerned to place the meaning and value of art in social and historical circumstances, not in a vacuously idealist tradition of 'great artists' abstracted from any place in actual cultures and societies. Clark, therefore, projected his studies of art and artists as the continuation of this tradition, which he called the 'social history of art', and absolutely not as the heir to a reductive Marxism from the 1950s. This social history of art would also be the scathing enemy of all the forms of deracinated contemporary art history practised by connoisseurs, formalists and mere 'symbol-hunters'.

Through the later 1970s and 1980s Clark's interests moved forward historically, though he continued also to research and write on the origins of 'the modern' in art and society at the end of the eighteenth century in France. But it was modernism that became Clark's specific

and enduring concern from the mid-1980s to 1999. Modernism became, for Clark, the name for the critical, negating art practice he had identified in the key paintings of Courbet, a socialist and 'realist' artist concerned with modern French society: if not yet a modernist, then certainly moving rapidly towards such a stance, composed of complex and interwoven artistic, social, political and intellectual elements. Clark's study of Edouard Manet (1984) draws the study of the socio-historical 'modern' and the fully-fledged 'modernist' artist together, yet the title of the Manet book maintains the decisive significance of conjunctural analysis. Clark's subject is *The Painting of Modern Life: Paris in the Art of Manet and His Followers*. Once again, Clark's dual concern is with sustained, extraordinarily careful and perceptive readings of specific paintings – for example, Manet's *Olympia* and *Bar at the Folies-Bergère* – along with analyses of the relations between these works and their critical interlocutors, such as Charles Baudelaire.

In a series of essays written around the time of the publication of *The Painting of Modern Life*, Clark began to make it plain that, though a Marxist in intellectual perspective and political persuasion, he thought extremely highly of some of the contemporary critics supportive of Modernism in the visual arts. This had, of course, been true, though it had remained mostly implicit in Clark's earlier studies, where Baudelaire, for example, had figured largely. But Baudelaire had been an overt critic of art and social life in France in the mid-nineteenth century – there was a clear, if complex, political character to his writing. In a 1982 essay about Clement **Greenberg**, and in subsequent replies to criticism from Michael Fried on this piece (two post-1945 critics usually identified derogatively as 'formalists'), Clark allied himself to what might be called the critical modernist tradition in art and writing. The novelty of these essays should certainly not be overplayed. Clark had been interested in Greenberg's criticism and had taught twentieth-century modernist art (particularly that of Jackson Pollock, Greenberg's favoured Abstract Expressionist) for many years before publishing these essays on abstract painting and formalist criticism in the 1940s, 1950s and 1960s in the United States.

But the original essay on Greenberg and the resulting exchange with Fried dramatized and clarified three issues which dominate Clark's apparently summative study *Farewell to an Idea: Episodes from a History of Modernism*, published in 1999. These issues concern, first, the selection and evaluation of certain art works as 'great', and how Clark has defined and justified this practice in his work; second, the complex relationship between Marxist analytic principles and evaluative

protocols in critical writing on modernist art; and third, the diagnostic potential within Clark's intellectual perspective, in terms of the likely future of both art and capitalist society at the end of the twentieth century. Clark's analysis of Greenberg's account of modernist art, in the highly influential essays the latter produced between 1939 and the 1960s, indicated that the critical modernist tradition Clark sees as beginning with Manet can be tracked in the artworks of artists active between the late nineteenth century and the early 1950s – the tradition, that is, of 'Manet to Pollock'.

Though Clark agrees with Greenberg – and is quite open about this – that the critics and historians usually identified as 'formalist' did correctly select the truly great painters in the modernist tradition, Clark believes their artworks achieved 'greatness' (that is, they were significantly historically affective in particular conjunctures) because they continued critically to negate prevailing fabrication techniques, pictorial conventions, iconographic schemas and implicated socio-political ideologies. This is as true of Courbet's *Burial at Ornans*, as it is true, Clark believes, of Paul Cézanne's *The Large Bathers*, Pablo Picasso's *Man with a Pipe* or Pollock's *Autumn Rhythm: Number 30*. Not that all of these pictures had the same degree of political significance: the reverse in fact. Clark's 'farewell' is precisely to the possibility of art making a difference socially and politically within the culture of advanced capitalism, the 'society of the spectacle' identified by Guy Debord, one of Clark's formative influences from the 1960s. Modernism for Clark, therefore, is always (and increasingly as he moves through the twentieth century) a 'failure' to change the world, or to change it in desirable ways. The socialist and anarchist modern artists Clark mostly writes about want their art to be a representation of an alternative social, post-capitalist, order: they 'figure' this in their paintings in different ways. And they want the social order to be transformed. But art cannot change the world. Clark bids farewell to this utopian idea, then, as much as to Modernism's critical project.

Clark's Marxism, like his understanding of Modernism, is equally interrogated and revalued in his essays and books of the 1980s and 1990s. If *Image of the People: Gustave Courbet and the 1848 Revolution* had offered a learnable model of analytic principles and protocols which could be adapted by others within a tradition of 'social history of art' writing, then by 1999 Clark is saying goodbye also to the idea that he can – or wants to – supply a method or argument for anyone else to use. Marxist theory, in the period between 1973 and 1999, developed and diversified radically, spawning at least several distinct kinds of perspective, conceptual systems and evaluative mechanisms.

Gone was 'Stalinist' Marxism, as the USSR itself disappeared by 1991, but gone also was any single or certain set of definitions for Marxism: 'culture', 'the state', 'ideology', 'politics', 'materialism', 'aesthetics' and many other concepts attained an opacity that rendered them inimical to any one explanation or system of meanings. Clark's *Farewell to an Idea* (1999) reflects this development and is, amongst other things, a record of a brilliant individual consciousness, not the textbook for a movement.

Clark's contribution to art history, however, remains constant. From the early study of Courbet, through that of Manet, to the later analyses of Camille Pissarro, Picasso and Pollock, Clark has produced extraordinarily insightful readings of particular artworks and made strikingly original claims for the significance of these works. Indeed, Clark's readings have been so influential (especially in producing creatively antagonistic responses – from feminists, for example) because he has valued these artworks so highly and has attempted to explain, to himself and to others, why he has felt them to be so compelling. His analysis of some paintings, particularly Manet's *Olympia*, has become virtually synonymous with the works themselves. That is to say, his accounts match, as far as Clark is concerned, the brilliance of touch these paintings demonstrate.

Biography

Timothy J. Clark Born 1943. Clark studied at the Universities of Cambridge (Modern History) and London (where he took his PhD). He has held lectureships at the University of Essex and at Camberwell Art School, and professorships at the University of Leeds (where he established the MA in the Social History of Art in 1978), the University of California at Los Angeles, Harvard University, and the University of California at Berkeley.

Bibliography

Main texts

Image of the People: Gustave Courbet and the 1848 Revolution, London: Thames and Hudson, 1973.

The Absolute Bourgeois: Artists and Politics in France 1848–1851, London: Thames and Hudson, 1973.

'The Conditions of Artistic Creation', *Times Literary Supplement*, 24 May 1974, 561–2.

'Clement Greenberg's Theory of Art', *Critical Inquiry* 9, 1 (September 1982), 139–56.

'Arguments about Modernism: A Reply to Michael Fried', in W.J.T. Mitchell (ed.), *The Politics of Interpretation*, Chicago and London: University of Chicago Press, 1983.

The Painting of Modern Life: Paris in the Art of Manet and His Followers, Princeton, NJ: Princeton University Press, 1984.

Farewell to an Idea: Episodes from a History of Modernism, New Haven, CT and London: Yale University Press, 1999.

Secondary literature

Day, G., 'Persisting and Mediating: T.J. Clark and the Pain of "the Unattainable Beyond" ', *Art History* 23, 1 (March 2000), 1–18.

Harris, J., ' "Stuck in the Post"? Abstract Expressionism, T.J. Clark and Modernist History Painting', in David Green and Peter Seddon (eds), *History Painting Reassessed*, Manchester: Manchester University Press, 2000.

——, *The New Art History*, London: Routledge, 2001 (ch. 2: 'Capitalist Modernity, the Nation-State and Visual Representation').

JONATHAN HARRIS

R.G. COLLINGWOOD (1889–1943)

BRITISH PHILOSOPHER AND HISTORIAN

Many aestheticians have held that art's capacity to express emotion is both distinctive of it and one of its main sources of value. It is R.G. Collingwood's achievement, however, to have spelt out that thought in a way that makes it compelling. The view he arrives at in *The Principles of Art* (1938) is encapsulated in the following, perhaps surprising, sentence: 'Expression', he says, 'is an activity of which there can be no technique.' The present contribution constitutes an attempt to explain what he meant by that.

Collingwood introduces his position as a critique of something he calls 'the technical theory of art'. According to this, works of art function, instrumentally, as means towards certain kinds of ends – the end of entertaining, for instance, or the end of giving audiences particular sorts of experience. This way of thinking about art is regarded by Collingwood as fundamentally misconceived. Instead of getting to grips with the concept 'art', he holds, the technical theory unwittingly assimilates art to a very different concept, that of craft. Art and craft differ from one another in several crucial respects, but the most important of them is that in craft, but not in art, there is always a distinction to be drawn between planning and execution. The craftsman 'knows what he wants to make before he makes it', and

knows precisely: 'If a person sets out to make a table, but conceives the table only vaguely, as somewhere between two by four feet and three by six ... he is no craftsman.' The artist, by contrast, need have no clear plan which he intends to execute. Suppose that a sculptor 'were simply playing about with clay, and found the clay under his fingers turning into a little dancing man': this might be a work of art, despite the fact that 'it was done without being planned in advance'. Collingwood is not claiming that art *never* involves a distinction between planning and execution; clearly quite a lot of art does. He is merely claiming that, because art need not always involve that distinction, while craft always must, the distinction between planning and execution cannot be part of the essence of art in the way that it is part of the essence of craft.

If this is so, the technical theory of art must be false. To suggest, as the technical theory suggests, that it is of the essence of art to function as a means towards specified ends is to suggest that it is of the essence of art to involve a distinction between planning – that is, the specification of ends – and execution – that is, the production of works of art. From the falsity of the technical theory, then, Collingwood concludes that no successful account of art can construe art as involving the realization of any end that has been (fully) specified in advance. (Collingwood does not conclude, incidentally, that *technique* is irrelevant to the nature of art: he invites us to consider 'the vast amount of intelligent and purposeful labour, the painful and conscientious self-discipline, that has gone to the making of a man who can write a line as Pope writes it, or knock a single chip off a single stone like Michelangelo.' His point is simply that, to the extent that a technique is a means for realizing a preconceived end, technique cannot be the essence of art.)

We are now in a position to begin to appreciate what Collingwood means when he says that 'Expression is an activity of which there can be no technique': he means that a person expressing himself cannot set out with a definite preconceived end – a plan – in mind. All a person is conscious of at the beginning, Collingwood says, 'is a perturbation or excitement, which he feels going on within him, but of whose nature he is ignorant. While in this state, all he can say about his emotion is "I feel ... I don't know what I feel." From this helpless and oppressed condition he extricates himself by doing something which we call expressing himself.' And Collingwood underlines the point: 'Until a man has expressed his emotion, he does not yet know what emotion it is'; which means that 'the expression of emotion is not' something 'made to fit an emotion already existing,

but is an activity without which the experience of that emotion cannot exist'. Collingwood's claim, then, is two-fold. First, the activity of expressing oneself is a matter of finding out what it *is* that one feels, rather than, as the technical theory might have it, knowing in advance precisely what one feels and then setting out to express that feeling in some more or less successful way. And second, the expression of emotion is the transformation of emotion: from an initial state of inchoate confusion, the emotion is clarified and given form. In effect, therefore, an emotion cannot be said to be revealed for what it is through being expressed – rather, it must be said to *become* what it is through being expressed.

It may, of course, be the case that at the beginning of the process of expression one does have *some* idea of what it is that one is going to express. One might know, for instance, that one's feeling is on the unhappy side, with perhaps a touch of bitterness about it. But this is merely to be able to offer a description of the feeling. It is not to have expressed the feeling, and it is not to have in mind a fully worked out plan of what, once the process has been completed, will be expressed. Collingwood insists on this distinction: some people, he says, 'have thought that a poet who wishes to express a great variety of subtly differentiated emotions might be hampered by the lack of a vocabulary rich in words referring to the distinctions between them … This is the opposite of the truth. The poet needs no such words at all … To describe a thing is to call it a thing of such and such a kind: to bring it under a conception, to classify it. Expression, on the contrary, individualizes' – and it is in his pursuit of the individualization of emotion that the true artist is to be recognized. 'The artist proper', says Collingwood, 'is a person who, grappling with the problem of expressing a certain emotion, says, "I want to get this clear." It is of no use to him to get something else clear, however like it this other thing may be. He does not want a thing of a certain kind, he wants a certain thing.' Which is to say, he does not want, and will not settle for, a mere descriptive classification of his feeling. He wants an individualized clarification of it – an expression of its unique character.

It may sound from this – from the fact that one cannot say in advance precisely what a work of art will express – that the process of expression must be a random one, or at the very least an utterly spontaneous one. But Collingwood doesn't intend that. 'There is certainly here a directed process', he says, 'an effort, that is, directed upon a certain end; but the end is not something foreseen and preconceived, to which an appropriate means can be thought in the light of our knowledge of its special character' – since knowledge of its

special character is precisely the end upon which that effort is directed. What he has in mind here is in fact something entirely familiar from ordinary, everyday cases of expression. Think of a person trying to say – to express – exactly what he means. He tries out one form of words, and is dissatisfied with the result; he tries another – perhaps it's better; he fine-tunes and modifies, experiments with alternatives until, at last, if he is successful in seeing the effort through, he can say: 'Yes! *That's* what I mean. That gets it exactly.' There is no question that his efforts are purposeful (as opposed to random or spontaneous): his dissatisfaction with his preliminary attempts shows clearly that he hasn't yet achieved the result he intends. But equally, until he *has* achieved the result he intends, neither he nor anyone else can say precisely what thought it is that he is attempting to express (if the thought could be stated in advance, as it were, the process of expression would already be complete). To this extent, artistic expression – involving just the same sort of effort, and directed in the same way upon an end that cannot be specified in advance – is simply a special case of ordinary, everyday expression. At one point, indeed, Collingwood goes so far as to make the (surely exaggerated) claim that 'Every utterance and every gesture that each one of us makes is a work of art'.

'Expression', then, 'is an activity of which there can be no technique': no one engaged in expression, as Collingwood conceives it, sets out to execute a plan which has been fully and precisely specified in advance. Rather, in expressing oneself, one discovers what it was that one wanted to express. And that is not the only thing one discovers. In ordinary, everyday cases of spoken expression, one finds out, through the effort to say what it is that one means, the kinds of things that words can be used to do, and how they can be used to do them; and in just the same way, the artist, when he expresses himself, also explores and makes discoveries about the nature, possibilities and limits of the medium in which he works. The medium is, as one might put it, inseparable from the message expressed in it – 'Take away the language, and you take away what is expressed'.

The artist's exploration of his medium, when driven by his efforts to express himself, can result in some strikingly intense effects, as Collingwood's magnificent description of Cézanne makes clear:

> His still-life studies ... are like groups of things that have been groped over with the hands ... So with his interiors; the spectator finds himself bumping about those rooms, circum-navigating with caution those menacingly angular tables, coming up to the persons that so massively occupy those

chairs and fending them off with his hands. It is the same when Cézanne takes us into the open air ... A bridge is no longer a pattern of colour ... it is a perplexing mixture of projections and recessions, over and round which we find ourselves feeling our way as one can imagine an infant feeling its way ... And over the landscape broods the obsession of Mont Saint-Victoire, never looked at, but always felt, as the child feels the table over the back of its head.

This passage – itself an expression, a work of art – brings out in a thrillingly immediate way what Collingwood means when, a few pages later, he describes artist and audience alike as enjoying an imaginative 'experience of total activity'.

The point of expression, as Collingwood construes it, is self-knowledge. In clarifying and individualizing one's feelings (and thoughts: Collingwood includes these under the notion of expression) one comes to appreciate them for what they are, and so to understand oneself better. The artist is like everyone else in this respect, except for one thing. The artist 'is not singular', according to Collingwood, 'either in his having [a given] emotion or in his power of expressing it; he is singular [only] in his ability to take the initiative in expressing what all feel and all can express.' It is because of this that the artist's expressive activities are in the end so significant; for, in Collingwood's view, the genuine artist is always a prophet, 'not in the sense that he foretells things to come, but in the sense that he tells his audience, at the risk of their displeasure, the secrets of their own hearts.' And prophecy, as Collingwood might have put it, is an activity of which there can be no technique.

Biography

Robin George Collingwood Born Cartmel Fell, Lake District, 22 February 1889, son of William Gershom Collingwood, writer, archaeologist and antiquary, and Edith Mary Collingwood, painter and musician. He studied philosophy at Oxford between 1908 and 1912, was elected fellow of Pembroke College in 1912, and of Magdalen College in 1935. He was Waynflete Professor of Metaphysical Philosophy at Oxford between 1935 and 1941. *The Principles of Art* appeared in 1938, and *The Idea of History* in 1946. Collingwood died at Coniston on 9 January 1943.

Bibliography

Main texts

The Principles of Art, Oxford: Oxford University Press, 1938.
Outlines of a Philosophy of Art, Bristol: Thoemmes Press, 1994.
Essays in the Philosophy of Art, Alan Donagan (ed.), Bloomington: Indiana University Press, 1964.

Secondary literature

Anderson, D.R. and Hausman, C.R., 'The Role of Emotion in R.G. Collingwood's Conception of Creative Activity', *Journal of Aesthetics and Art Criticism* 50, 4 (1992), 299–305.
Janaway, C., 'Arts and Crafts in Plato and Collingwood', *Journal of Aesthetics and Art Criticism* 50, 1 (1992), 45–54.
Johnson, P., *R.G. Collingwood: an Introduction*, Bristol: Thoemmes Press, 1998.
Krausz, M. (ed.), *Critical Essays on the Philosophy of R.G. Collingwood*, Oxford: Oxford University Press, 1972.
Ridley, A., 'Not Ideal: Collingwood's Expression Theory', *Journal of Aesthetics and Art Criticism* 55, 3 (1997), 263–72.
——, *R.G. Collingwood: A Philosophy of Art*, London: Orion Books, 1998.
Smallwood, P., '"The True Creative Mind": R.G. Collingwood's Critical Humanism', *British Journal of Aesthetics* 41, 1 (2001), 293–311.
Wertz, S.K., 'The Role of Practice in Collingwood's Theory of Art', *Southwest Philosophical Review* 11, 1 (1995), 143–50.
Wollheim, R., *Art and its Objects*, 2nd edn, Cambridge: Cambridge University Press, 1980 (sections 22, 23, 45–52).

AARON RIDLEY

BENEDETTO CROCE (1866–1952)

ITALIAN PHILOSOPHER

Benedetto Croce was a founder and leading figure in the Idealism that dominated Italian philosophy in the first half of the twentieth century. Although well known internationally as a philosopher and statesman, it was his aesthetic theory that came to be most widely disseminated and most influential outside Italy.

Croce's aesthetics was part of a complete philosophy of humankind which owed much to Hegel, although a Hegel greatly modified by Croce's reflections on Giambattista Vico (1668–1744) and Francesco De Sanctis (1817–83), and by his discussions with another Italian philosopher, Giovanni Gentile (1875–1944). In outline this philosophy went as follows. Human beings engage in two broad classes of

activity: acquiring knowledge, and performing actions. These classes can be further subdivided: knowledge is either intuitive or conceptual, and action is either economic or moral. Each of these four 'moments of the spirit' (as Croce called them) is intimately connected with the others, being in part their precondition and in part their consequence. But intuition is the moment that is logically and psychologically the most fundamental.

Intuition, for Croce, is the process in which consciousness is born. It is a process in which the world and the self become distinct, and the world comes to be seen as a complex of objects and events suitable and available for examination, judgement, analysis, explanation, will, feeling and desire. At every instant of our conscious lives we are bombarded with myriad sensations – for instance, the multiple visual sensations which I experience if I turn my head from left to right with my eyes open. Along with these are an assortment of aural sensations, the tactual sensations of my feet on the ground and the clothes on my body, the kinetic sensation of my head moving, and the proprioceptive sensation of where the parts of my body are located. In addition to these sensations there may well be emotions (pleasure, depression, surprise, expectation) and also memory or imaginative associations which flourish unbidden in the mind. This great mass of material is overwhelmingly diffuse and random, but my consciousness responds by imposing upon it forms or structures which make it intelligible and identifiable. My mind thus helps to construct the objects and happenings of which it is aware, and this constructive process is 'intuition'.

Intuitive awareness, according to Croce, is indifferent to the reality or otherwise of its object. A mirage, or a mental image, is just as much an intuition when a real object is perceived by means of the senses. Intuition also excludes any kind of historical or conceptual judgement about its object (an intuition of a Pre-Raphaelite painting does not include the judgement 'This is a Pre-Raphaelite painting', nor even 'This is a painting'). And, since intuition is distinct from the economic and moral moments of the spirit, it excludes any awareness of the moral and practical character of its object. Intuition, in short, grasps its objects as unique individuals independent of existential character, conceptual categorization, practical or ethical significance, and context.

When Croce is explaining intuition, he does not usually say that intuition imposes an order, structure or form upon a disorderly mass of sensations and feelings. He prefers to say that every intuition is also an expression. In part he means by this that an intuition expresses the

personality, the history, and in particular the feelings, of the person whose intuition it is. He also means that an intuition expresses something of the universal forms of thought and feeling that are shared by all human beings.

Above all, however, the term 'expression' signifies that an intuition gives to its object a form that is in principle communicable to others – a form that is 'linguistic' because it is couched in an inner language of the human spirit. A fragment of birdsong might be intuited – formed or expressed within the mind – as a fragment of melody. A horizon at sunset might be intuited and so expressed as a configuration of line and colour. An insight into horror might be intuited as a word, or as a dissonance, or as a screaming face, or as a metaphor, or as *Heart of Darkness*, or as *Apocalypse Now.*

Intuitions, in short, are artistic. More radically still, all art is intuition; this is Croce's definition of art. Works of art and intuitions are one and the same. The intuitions of everyday life, the bread-and-butter intuitions that lie at the heart of consciousness, are no less artistic than the greatest works of art. The difference is one of degree. The great works of art are more complex, richer, more interesting and more revealing than the journeyman intuitions that fuel the mind in the ordinary course of life.

We tend to *call* 'works of art' certain kinds of material objects or events that we seek out in the gallery or the concert hall. But Croce will have none of this. Pictures, sculptures and concerts are not in themselves works of art. They are merely physical externalizations of works of art. Works of art are ideal, not material. An artwork that is not externalized is just as much an artwork as one that is, even though it may never be known by anyone else and may die with its creator.

This conception of art's mode of existence is most easily defensible in the case of literature, for it is hard to say what object or event we can identify with *War and Peace* or *Ulysses.* Croce in fact tended to take literature as the paradigm case of art, and his own artistic taste was predominantly literary. But his aesthetics was a theory of art as a whole, not just of literature, and he tirelessly repeated his view that the apparently diverse forms of artistic expression (words, sounds, volumes, lines and colours) did not in any way undermine the claim that all intuition is artistic and all art is intuition, and that the instruments of externalization – the lines and colours – are a different kind of thing.

A great many consequences followed from Croce's aesthetics, very radical consequences especially for the criticism and the history of art. Most of these consequences were negative, in the sense that they led to

a rejection of many critical and historiographical practices. The uniquely individual nature of each work of art meant that the study of artistic styles was no longer relevant; or, to be precise, that the study of style was *not* a study of art but of something else. For the concept of a 'style' is an abstraction from individual artworks, and thus avoids direct engagement with the real artworks themselves. In fact any kind of abstraction from works of art, Croce argued, is false to their nature as unique intuitions. History or criticism couched in terms of 'periods' or 'movements' or 'schools' was thus misguided. So too was the concept of genre. In fact the very division of art history and criticism into studies of particular art forms – painting, sculpture, music, poetry – was false to the nature of art, and was acceptable only as a pedagogic and bibliographic convenience.

Croce was particularly opposed to any discussion of art which focused upon artistic technique. Strictly speaking, it was impossible, on Crocean premises, that there should be *artistic* technique. There were techniques involved in the externalization of artworks, but these were externalization techniques, not artistic techniques. They were, no doubt, interesting enough as objects of study, but it was too often believed that such studies were studies of art, and they were no such thing.

Intuition, finally, is a non-conceptual or pre-conceptual process, so it is a mistake to search for conceptual content in works of art. Art has no philosophical content, no symbolic or historical references. Art as story, as truth, art as a call to action – these are to be excluded as well. Allegory is non-intuitive, non-artistic. There are many non-artistic parts or aspects in works of art, but these are not proper objects for art criticism or history. History and criticism are disciplines which should seek instead to describe the intuitions which, uniquely different in each work of art, constitute simultaneously their artistic content, form and identity.

Croce's refusal to think of craftsmanship as artistic attracted a great deal of criticism, both in his lifetime and thereafter. His purist conception of art history and criticism has proved to be too radical for general acceptance, and indeed would consign much of the literature in these areas to oblivion. His insistence that art is non-material is not in keeping with the materialist temper of the times. His rejection of any essential difference between the art forms is rarely understood or even discussed; and it is unquestionably hard to accept that differences in the expressive forms of art, even if they all belong to an 'inner language of the human spirit', play no part in our experience and understanding of artworks.

Croce was, none the less, one of the great art theorists of the twentieth century, and the revolutionary nature of his thinking is not yet fully appreciated. His stress upon the uniqueness of works of art – that they are, in a more recent idiom, *parole* rather than *langue*, that they evade rules and grammars, that the critical vocabularies of style, period, nation and genre may distort more than they explain – is too radical, and too opposed to the interests of the academy, to win easy acceptance. But he is too formidable a figure to ignore, and he will remain, for the foreseeable future, an uneasy and provocative presence in aesthetics and theory of art.

Biography

Benedetto Croce Born Pescassaroli (Abruzzi) 25 February 1866, the son of wealthy parents who died in an earthquake when he was 17. He attended lectures in Rome during 1883–86, but never took a degree, and in 1886 he returned to Naples where he lived for the rest of his life. In 1903 he founded the intellectual journal *La Critica* (which ran until 1944). He was Italian Minister of Education in 1920–21, breaking with Giovanni Gentile in 1925; and from then to the fall of Mussolini he became the foremost anti-Fascist intellectual in Italy. Croce took part in Liberal politics after World War Two, but in 1948 he resigned and returned to a life of scholarship. He died in Naples on 20 November 1952.

Bibliography

Main texts

The Aesthetic as the Science of Expression and of the Linguistic in General (*Estetica come scienza dell'espressione e linguistica generale*, 1901), trans. Colin Lyas, Cambridge: Cambridge University Press, 1992.
Guide to Aesthetics (*Breviario di estetica*, 1913), trans. Patrick Romanell, South Bend, Ind.: Regnery/Gateway, 1965.
'La critica e la storia delle arti figurative e le sue condizioni presenti', in *Nuove saggi di estetica*, Bari: Laterza, 1920.
Benedetto Croce's Poetry and Literature (*La poesia*, 1936), trans. Giovanni Gullace, Carbondale: Southern Illinois University Press, 1981.

Secondary literature

Brown, M.E., *Neo-Idealistic Aesthetics: Croce–Gentile–Collingwood*, Detroit: Wayne State University Press, 1966.
Carr, H.W., *The Philosophy of Benedetto Croce*, London: Macmillan, 1917
Carritt, E.F., *The Theory of Beauty*, London: Methuen, 1914.

Moss, M.E., *Benedetto Croce Reconsidered*, Hanover, University Press of New England, 1987.

Orsini, G.N.G., *Benedetto Croce: Philosopher of Art and Literary Critic*, Carbondale: Southern Illinois University Press, 1961.

Piccoli, R., *Benedetto Croce: an Introduction to his Philosophy*, London: Jonathan Cape, 1922.

Sprigge, C., *Benedetto Croce: Man and Thinker*, Cambridge: Bowes and Bowes, 1952.

Wellek, R., *Four Critics: Croce, Valéry, Lukács, and Ingarden*, Seattle: University of Washington Press, 1981.

HUGH BREDIN

HUBERT DAMISCH (1928–)

FRENCH PHILOSOPHER AND HISTORIAN OF ART AND ARCHITECTURE

All of the writings of Hubert Damisch are directed by the conviction that paintings and other cultural products perform, in one way or another, an intellectual or philosophical project. He never deals with paintings as mere illustrations, as passive manifestations of a culture or historical period, or as the product of the artist's intention. Rather, the painter thinks, and s/he does that in her/his paintings. A painting is therefore for Damisch actually a *reflection*: not in the sense of the passive definition of the word, as a mirror image, but in the sense of the active definition, as an act of thought.

Damisch, an emeritus professor of the history and theory of art at the École des Hautes Études en Sciences Sociales in Paris, has published on a great variety of artists, themes and problematics without limiting himself to one specific region or period. He has published articles on (among other things) Mondrian, Pollock, Gropius, Goya, Dubuffet, Viollet-Le-Duc, Giotto, Cézanne, Duchamp and chess, Gustave Eiffel, Paul Klee, art historians Meyer **Schapiro** and Erwin **Panofsky**, and structuralist anthropologist Claude **Lévi-Strauss**. Aside from several volumes of collected essays, he has published four voluminous studies which have received canonical status in art history in a very short time: *Théorie du /nuage/. Pour une histoire de la peinture* (1972), *l'Origine de la perspective* (1987), *Le jugement de Paris* (1992) and *Traité du trait* (1995). In France, Damisch's works are considered among the most important contributions to art history of recent years.

It is an axiom in the discipline devoted to the study of art that the meaning of art can only be formulated historically. An artwork, therefore, is always an expression of the historical period or figure that produced it. The importance attributed to the historical approach to the meaning of works of art has been so great that it even reflects itself in the name of the discipline: whereas disciplines which study cultural products like theatre, film or literature are called theatre, film, and literary *studies*, the discipline which studies art calls itself art *history*. Thus, many art historians are surprised by Damisch's conviction that works of art appear to full advantage only if we deal with them as a way of thinking. For, unlike art-historical interest in the artist's intention, Damisch's focus on thought does not refer to individual intention, but rather to what Alpers and **Baxandall** in their book on Tiepolo (*Tiepolo and the Pictorial Intelligence*, New Haven and London: Yale University Press, 1994) call 'pictorial intelligence', a term which refers to the intellectual thrust of the image *per se*. The question which is therefore unavoidable when we read Damisch's writings is whether his work is a-historical. In other words, is it art history after all, or does he locate himself, with his deviating approach and questions, outside the discipline of 'art history'?

It is obvious that Damisch has grown impatient with the way scholars claim history as the first and last word in the art historical tradition. In *Théorie du /nuage/* he characterizes the role of historical analysis in the study of art as a form of terror or tyranny that makes it impossible to ask questions which address transhistorical or more abstract issues.

> The problem for theory is how not to surrender to the tyranny of humanism which will only recognize the products and epochs of art in their singularity, their individuality; and which considers illegitimate, even inadmissible, any inquiry into the invariants, the historical and/or transhistorical constants from which the plastic fact lets itself be defined in its generality, its fundamental structure.

Damisch himself describes his works as 'structuralist'. But we should not take this label too narrowly. The structuralist approach as it flourished in the 1960s in disciplines like anthropology, linguistics and literary studies was often explicitly a-historical. Systematic questions were central, and questions about the meaning or function of text or culture were being treated as text-immanent problems on which history had no influence.

However, it is impossible to recognize such a radical bracketing of history in Damisch's moves. History – the historical context of a work

of art – has as always been an important function in his 'structuralist' analyses of art. Damisch's writings compel admiration by his extraordinary knowledge of history. He knows the smallest detail of the historical context in which an artist worked, and he knows even the most obscure art historical publications about an artist or period. The place of history in his analyses is, however, surprisingly different than what we are used to in traditional historical disciplines. He never lets the 'moves' of his thinking be dictated by scholarly convention. He will never allow 'history' to decide which questions are meaningful or legitimate. Nevertheless, Damisch fully acknowledges that whatever systematic, theoretical or trans-historical question he asks must be addressed within the parameters of specific historical contexts. This is one of the reasons why it is not correct to place his work outside of art history.

Damisch's relation to history can be clarified best by means of the question he poses in the opening pages of *The Origin of Perspective* (1993): 'If history there be, *of what* is it a history?' This question sounds simple, but it has far-reaching and disenchanting implications. Through his demand for specification – *of what* is it a history? – Damisch, in fact, rejects the absolute meaning of the term 'history'. In Western culture, but especially in art history, it is usual to talk about history without an object. I have in fact invoked the same discursive strategy here by asking questions like: 'what is the role of history in Damisch's work?' By doing that, 'history' becomes a reality. But for Damisch, history exists only in so far as it is the history *of something*. By using the term history in an absolute way, 'history' receives an almightiness that is only comparable with that of 'God'. By using 'history' in an absolute way, it becomes possible to imagine history as an active force which produces works of art. From this perspective, it is indeed legitimate to assume that the meaning of art can only be understood historically.

But Damisch assigns history to a more moderate but still important place, by consistently refusing an abstract or absolute meaning for it. Whereas the philosopher Damisch prefers to ask general or abstract questions, the historian Damisch allows only a concrete use of the term 'history'. For the study of art his conception of history leads to the following unexpected question: 'Of what is art a history?'

This question forces us to realize that the full significance of works of art cannot be appreciated in terms of history as an absolute concept. The 'subject' of art engenders general, transhistorical and philosophical questions. 'Historical' are the parameters within which a specific artist works, the idioms that have been passed to her and the specific articulation of her answer to a more general problematic. The more

general problematic cannot, however, be reduced to purely historical terms.

The implications of Damisch's assumptions that the meaning of art can only effectively be addressed by considering it as a form of thinking are twofold. As beholder, one should think 'with' the work of art, which means that one should start a dialogue by articulating questions of a general, philosophical nature. Only when the beholder of art poses these kind of questions will the work of art yield its ideas. Second, that which is historical about the work of art can only really be understood when one allows the work to be a historical articulation of a general, more fundamental problem. In *The Origin of Perspective*, Damisch formulates this as follows:

> Painting is a distinct object of historical study and must be dealt with as such: which means paradoxically that one must adopt a deliberately structuralist point of view, which only throws the historical dimension of phenomena into greater relief.

This quotation characterizes well the moves made by Damisch in all of his writings. The historical approach is not placed in opposition to a more theoretical, or − in his own words − structuralist approach. Rather, he re-defines the role of history in art history by showing again and again that only a theoretical perspective enables us to see works of art as a history of something.

But with what general questions does Damisch confront works of art? Diverse as his work may be, ultimately it all leads to the question of why do we look at art? What *pictorial* qualities attract us, as viewers, to art? Or, in more sensuous terms, what attracts us to art? It is, of course, not possible to give a single answer to this question. Works of art can evoke fascination and claim the attention of the viewer for different reasons, based on a great variety of pictorial qualities. In each of his main writings, Damisch focuses on a different pictorial element to demonstrate how that element in the history of Western or sometimes Eastern art has been developed to captivate the beholder in the most literal sense. This particular interaction between philosophical questions and historically inflected answers can only be shown at work in Damisch's concrete elaborations of each.

In *Théorie du /nuage/*, Damisch develops a history of painting of the Renaissance and the Baroque on the basis of a signifier which, again and again throughout the ages, occupies a modest, inconspicuous, but at the same time crucial place in that history: the /cloud/. Damisch

puts the signifier 'cloud' between slashes to indicate that he deals with clouds as signs (instead of realistic elements) which have different meanings in different pictorial contexts. Again and again the /cloud/ occupies an uncomfortable place within such pictorial systems. It never has an immanent function or meaning, but receives one only in the relations of opposition and substitution that the /cloud/ maintains with the other elements of the pictorial system. The /cloud/ always opens up another dimension than the one at first opened up by the pictorial system of which it is part. Thus the /cloud/ always functions as a kind of 'hinge' in the relation 'between earth and heaven, between here and there, between a world that is obedient to its own laws and a divine space that cannot be known by any science.' The /cloud/ has a value which is more than just decorative or picturesque. Damisch thus outlines an epistemology of the unknowable.

In *The Origin of Perspective* (1993), Damisch is not really interested in tracing the historical origin of perspective, although he does concentrate for many pages on the historical moment which in art history is usually considered to be the birth of perspective, that is, Brunelleschi's demonstration of it. None the less, the 'origin' from Damisch's title should rather be understood in a spatial sense. Damisch is interested in the precise status of the *point* of origin, that is, the subject, out of which the perspective is ordered. In this book he analyses the capacity of perspective paintings to confirm the viewer's precarious illusion of personal autonomy, which is the basis of subjectivity. He thus designs a visual theory of subjectivity.

In *The Judgement of Paris* (1992), Damisch shows how the beauty of art, in spite of Kant's view of it, draws the viewer somatically into the process of viewing it. Through a rigorous analysis of the concept of beauty in philosophy and psychoanalysis, and a consideration of the motif of beauty in Western myths and art, Damisch succeeds again in formulating an aspect of art that makes it *attractive*. Damisch offers this time what **Freud** himself did not venture: a psychoanalysis of aesthetics. The three theoretical constructions which he thus offers in these three studies outline the rules of interaction from which culture consists. They regulate three of the most fundamental domains of culture: knowability, subjectivity and desire.

Biography

Hubert Damisch Born Paris, April 28 1928. He studied Philosophy and Art History, and became assistant professor at the École des Hautes Études en Sciences Sociales, holding that post between 1958 and 1971.

He was Maître de Conférences à l'École Normale Supérieure between 1967 and 1973; and Directeur d'Études à l'École des Hautes Études en Sciences Sociales between 1974 and 1996. Damisch's teaching positions in USA included: Yale University, 1963; Cornell University, 1972; University of California, San Diego, 1978; Columbia University, 1985; University of California, Berkeley, 1986; Johns Hopkins University, 1987–88; University of California, Los Angeles, 1989. He held posts at the Center for Advanced Study in the Visual Arts, National Gallery of Art, Washington, 1982 and 1996–7; and the Getty Center, Los Angeles, 2000; and he was Guest Curator of the following exhibitions: 'Traité du Trait', Louvre, Paris, 1995; 'Moves: Playing Chess and Cards with the Museum', Boijmans Van Beuningen Museum, Rotterdam, 1997.

Bibliography

Main texts

Dubuffet. Prospectus et tous écrits suivants, réunis et présentés par Hubert Damisch, 2 vols, Paris: Gallimard, 1967.

Théorie du /nuage/. Pour une histoire de la peinture, Paris: Éditions du Seuil, 1972 (an English translation, to be published by Stanford University Press, is forthcoming).

Ruptures/Cultures, Paris: Éditions de Minuit, 1974.

Fenêtre jaune cadmium, Paris: Éditions du Seuil, Collection 'Fiction et Cie', 1984.

The Origin of Perspective ('L'origine de la perspective', 1993), trans. John Goodman, Cambridge, Mass.: The MIT Press, 1994.

Traité du trait, Paris, Éditions de la Réunion des musées nationaux, 1995.

The Judgement of Paris ('Le jugement de Pâris', 1992), trans. John Goodman, Chicago: University of Chicago Press, 1996.

Un souvenir d'enfance par Piero della Francesca, Paris: Éditions du Seuil, 1997 (an English translation, to be published by Stanford University Press, is forthcoming).

L'Amour m'expose: Le projet "Moves", Bruxelles: Yves Gevart Editeur, 2000.

Skyline: The Narcissistic City ('Skyline: la ville narcisse', 1995), trans. John Goodman, Stanford: Stanford University Press, 2001.

La Dénivelée: À l'épreuve de la photographie, Paris: Editions du Seuil, Collection 'Fiction et Cie', 2001.

La Peinture en écharpe, Delacroix, la photographie, Bruxelles: Yves Gevart Editeur, 2001.

Secondary literature

Bal, M., 'First Person, Second Person, Same Person', in *Double Exposures: The Subject of Cultural Analysis*, New York: Routledge, 1996.

Bois, Y.A., 'Painting as Model', *October*, 37 (Summer 1986), 125–37.

Bois, Y.A., Hollier, D. and Krauss, R., 'A conversation with Hubert Damisch', *October*, 85 (Summer 1998), 3–17.

Davis, W., 'Virtually Straight', *Art History,* 19, 3 (September 1996), 434–44.

Grosskurth, B., 'Drawing on Lacan', *Oxford Art Journal* 17, 2 (1994), 138–42.

Iversen, M., 'Orthodox and anamorphic perspectives', *Oxford Art Journal,* 18, 2 (1995), 81–4.

Van Alphen, E., 'Moves of Hubert Damisch: Thinking about Art in History', in Hubert Damisch, *Moves: schaken en kaarten met het museum/Playing Chess and Cards with the Museum,* Rotterdam: Museum Boijmans Van Beuningen, 1997.

Wood, C., 'Une perspective oblique: Hubert Damisch, la grammaire du tableau et la structuranalyse viennoise', *Cahiers du Musée National d'Art Moderne,* 58 (Winter 1996), 106–29.

ERNST VAN ALPHEN

ARTHUR C. DANTO (1924–)

AMERICAN PHILOSOPHER

As one of the most influential philosophers of art in the twentieth century, Arthur C. Danto has been concerned primarily with ontology – with what art really *is*. Art can be distinguished from non-art, he argues, despite the fact that a wide variety of objects have been considered to be art, some of them ordinary items taken from the everyday world. There are necessary and sufficient conditions for something to count as art, Danto believes; thus 'art' can be defined. Contrary to **Wittgenstein** and his followers, the concept of art is not really an 'open' one. In this respect, Danto is an *essentialist*.

On Danto's account, the essential features of art are these:

- Art is always *about* something, which it represents.
- It also expresses the attitude or point of view of the artist with respect to whatever it's about.
- It does this by means of metaphor.
- Metaphorical representation and expression always depend on a historical context.
- The contents of artistic representation and expression are largely constituted by interpretation.

It will be helpful to consider each of these ideas in turn.

Representation

Danto's theory of representation distinguishes the meaning of a work of art from its denotation or reference, and emphasizes the former over

the latter. We often speak as if an artwork represents what it denotes; for example, when we say that a painting is *of* a horse. In that case, the implication is that the painting represents what it stands for and what can be recognized in it. However, a painting of a horse need not be *about* horses. It might be about nobility or nature or any number of other things. What the painting is about in that sense is its content or meaning.

That is so despite the fact that denotation in a work of art can be complex. For example, by denoting a horse, the painting might refer to the stallion ridden by Napoleon on a certain occasion. Moreover, the horse might symbolize Napoleon the man. None the less, neither the type of thing denoted (a horse), nor the particular instance of that type referred to (Napoleon's horse), nor the person symbolized (Napoleon) is identical with the painting's meaning. We could say that the painting is about Napoleon; but in general that must be taken to be an elliptical statement. It is shorthand for the claim that the painting is about, for example, Napoleon's power and ambition. The horse does not merely stand for the man; its apparent strength and wilfulness are analogous to properties of the human heroic figure.

Danto's theory of representation is the basis for his rejection of two other traditional views: the theory of art as mimesis or imitation, and the view that art is a language, governed by special conventions. Against both mimesis and convention, Danto employs the method of indiscernibles. On this method, two objects or events identical to perception are shown to have distinct identities, differing either in ontological status or in meaning. In particular, artistic representations might be visually indistinguishable from non-artistic representations or mere real things, and two works of art may look exactly the same, yet have very different contents. In recent art history we have seen ordinary objects or their visual twins placed in museums and accepted as art: Andy Warhol's Brillo boxes and Marcel Duchamp's urinal, for example. What makes them works of art, Danto argues, cannot be their *perceptible* properties, because they are indistinguishable from non-art objects in that respect. The same point applies to artistic content. Danto imagines a gallery of perceptually identical paintings, the contents of which vary by virtue of their histories and the artists' intentions. Because they all resemble each other, what they represent cannot be a matter of mimesis.

The theory of art as imitation is thus false, according to Danto, because it appeals to appearances. The inadequacy of mimesis also implies the inadequacy of denotation, because in noticing similarities the perceiver recognizes the objects or events denoted by the work of

art. Conventionalism does not appeal to appearances; it treats all representations as arbitrary signs. But like imitation theory, it exaggerates and mischaracterizes the role of denotation. Nelson **Goodman**, for example, emphasizes denotation as central to representation, while denying that resemblance has any role to play in it. Danto thinks that resemblance can play a role in denotation; but he denies that denotation determines representational content.

Danto also rejects the claim, often cited in support of the conventionalist account, that perception is thoroughly plastic: what you perceive, the conventionalist says, depends on what you believe. What you perceive in art, in particular, depends on what you believe about art and its conventions. For Danto, how you *interpret* art depends on what you believe: artistic meaning depends on history, and, as he puts it, history supervenes on the artist's and perceiver's beliefs. However, history does not supervene on perception. Nor do knowledge and theory: while interpretation is theory-laden, perception is not. Perception is, rather, cognitively impenetrable. It is that fact that underwrites the method of indiscernibles. The knowledge that visually identical paintings have different histories does not prevent them from being visually identical; but then it is precisely because perception is cognitively impenetrable that it cannot tell us what a work of art represents. Meaning is invisible, even in visual art.

Expression

Representation in Danto's sense is only a necessary condition for art, and not a sufficient one. Ordinary discourse can represent the world and say things about it and still not be poetic; it need not be art. Likewise, even non-art pictures can be about more than what they stand for: a family photograph album contains non-art pictures that represent not just father and mother, but the good old days before the divorce. If so, then art will have to be distinguished from non-art by virtue of the way in which it is about something, not the mere fact of its aboutness. To become art, a further condition must be met. The representation must express the artist's beliefs, desires, or other attitudes towards the content that is represented. In this respect, Danto holds a symbolic expression theory. His emphasis is on the artist's embodiment of a *way of seeing* his subject. That may or may not include feelings; but where it does, it is not necessary for the artist to feel them as he paints. Thus Danto rejects one traditional view of expression. Likewise, for him, expression need not involve the

transmission of emotion to the perceiver. The perceiver's task is *understanding* an emotion, where it appears, not simply having it.

Metaphor

Danto has said that expression in art overlaps with metaphor: 'What a work expresses is what it is a metaphor for . . .' (*The Transfiguration of The Commonplace*, 1981). For example, the *Portrait of Madame Cézanne* denotes Mme Cézanne, it is about the art of painting, and it expresses the view that painting should reveal geometrical forms. The portrait is thus a metaphor for painting as Cézanne construes it. Relating expression to metaphor is important, because it helps to block counterexamples to Danto's theory. Political rhetoric, for instance, and photojournalism may express their user's point of view, but they are often quite literal. They can thus be ruled out as works of art. The appeal to metaphor is also continuous with Danto's emphasis on interpretation as a defining condition of art. Interpretation is necessary for the understanding of metaphor, which requires the perceiver to think of one thing in terms of another; artworks as real things, for instance, or the viewer herself as one of the figures in a painting.

Still, verbal and visual metaphors occur in expressive words and pictures, which do not thereby become art. A newspaper photograph of naked and crying children running from the bombs dropped on Vietnam might mean 'War is hell'. Is it therefore art? The answer depends more on how the use of the photograph is interpreted in a larger sense (that is, in light of the history of photography) than on the mere fact that it is a metaphor. This suggests that, as a category, art is dynamic. What can count as art depends on what has gone before, and that, of course, changes over time.

History

On Danto's view, historical relations constrain the ontology of art: the first Brillo box could not be a work of art, because it had to begin as an ordinary object. Moreover, certain developments in the art world had to transpire; notably there must have been an earlier concern with artistic imitation, which Warhol's work calls into question. Danto has thus described his theory of art as 'historicist'. This implies the following:

- The meaning of any work of art depends on the historical conditions under which it was produced. Thus a proper appreciation of the work requires an understanding of those conditions.

- Art is a mode of representation and knowledge; it serves a cognitive function. As such, it undergoes development, and its development is a process of self-definition.
- However, this development has an end. The end is determined by the relation between art and philosophy at a certain moment in history, namely when art poses clearly the philosophical question 'What is art?'
- The existence of this endpoint, a *telos* for the development of art, suggests that art historical events unfold in accordance with a kind of 'logic'. The development of art is part of an 'internal drive toward consciousness', in which alternative proposals – even radically different ones – had to 'occur in a certain order, and prepare the way for one another internally' ('Responses and Replies', 1993). The history of art is thus not as discontinuous as it may seem.

However, Danto's historicism is, as we might put it, domain-specific. It extends to art, but not to history *per se* or to philosophy. Art reached an end in the 1960s, Danto thinks, not in the sense that art could no longer continue to be made, but because art finally articulated in a revealing way the problem of self-definition. It did this by presenting ordinary objects as art: Brillo boxes, soup cans, urinals and snow shovels. This forced the issue of how to distinguish artworks from ordinary things. History, of course, did not end, nor could it; for history in general does not have a project that it can bring to completion. Philosophy did not end either. Philosophy might be said to have a project, but only if a project can consist in providing timeless answers to timeless questions. Danto's historicism and essentialism are thus reconciled. On Danto's view, the concept of art was 'always there'; yet it came to be articulated in philosophical consciousness only at a certain period in history.

Interpretation

Danto maintains that there is a correct interpretation of any artwork, and the measure of correctness is provided by the artist's intentions. However, strictly speaking, it is not the intentions themselves that constitute the artwork. It is constituted, rather, by the interpretation for which those intentions provide the standard. A thing is not a work of art, for Danto, because of its causal relation to the artist, but because of relations to a larger context in which both the artist and the work stand. Like art, intentions are historically conditioned.

Not all intentions are possible at all times. Thus intentions and meaning go hand in hand, but the latter cannot be identified with the former.

Nor can artistic meaning be identified with the perceiver's response. A constitutive interpretation must be context-sensitive, that is it must acknowledge the circumstances under which a work of art was produced. However, the identity of the artwork does not vary with conditions of the interpreter's time. Danto allows that interpretations may be warranted, even if they depend on concepts and theories to which the artist may not have had access; for example, a feminist understanding of Artemisia Gentilleschi's *Judith Slaying Holofernes*. None the less, these interpretations are not constitutive of the artwork. They may be appropriate or not, depending on how adroitly the theory is wielded; but they have no ontological clout. Danto maintains that something is seen as an artwork only in the context of an 'art world', the 'discourse of reasons' about art that is available at the time of its creation. However, art-world discourse only accounts for how things are *accepted* as art and *assigned* their meanings. It does not establish what an artwork actually means or what an artwork is.

Conclusion

Arthur Danto has himself been a leading participant in the discourse of reasons, as an art critic as well as a systematic philosopher of art. His rich repertoire of examples, his use of analytical tools, and the vigour and energy of his writing, have made a significant impact on the art world and on the philosophical discussions of art.

Biography

Arthur Coleman Danto Born 1 January 1924. Danto was educated at Wayne State University and Columbia University, and began teaching at Columbia in 1951, where he was appointed Professor in 1966 and is now Emeritus Johnsonian Professor of Philosophy. He was the recipient of numerous awards and fellowships, including two Guggenheims, an ACLS, and a Fulbright, as well as the National Book Critics Circle Prize in 1990 for *Encounters and Reflections*. He is an editor of *The Journal of Philosophy*, and past president of both the American Philosophical Association and the American Society of Aesthetics.

Bibliography

Main texts

'The Art world', *The Journal of Philosophy* 61 (October 15), 1964, 571–84.
'Moving Pictures', *Quarterly Review of Film Studies* (Winter 1969), 20–1.
The Transfiguration of the Commonplace, Cambridge, Mass.: Harvard University Press, 1981.
The Philosophical Disenfranchisement of Art, New York: Columbia University Press, 1986.
The State of the Art, New York: Prentice Hall, 1987.
'Andy Warhol', *The Nation*, 3 April 1989.
Encounters and Reflections: Art in the Historical Present, New York: Farrar, Straus, Giroux, 1990.
'Description and the Phenomenology of Perception', in Norman Bryson, Michael Ann Holly and Keith Moxey (eds) *Visual Theory: Painting and Interpretation*, London and New York: Harper-Collins, 1991.
Beyond the Brillo Box: The Visual Arts in Post-Historical Perspective, New York: Farrar, Straus, Giroux, 1992.
'Responses and Replies', in Mark Rollins (ed.) *Danto and His Critics*, Cambridge, Mass.: Blackwell, 1993.
Playing with the Edge: The Photographic Achievement of Robert Mapplethorpe, Los Angeles: University of California Press, 1996.
Philosophizing Art, Los Angeles: University of California Press, 1999.
'Seeing and Showing', *The Journal of Aesthetics and Art Criticism* 59, 1 (Winter 2001), 1–10.
'The Pigeon within Us All: A Reply to Three Critics', *The Journal of Aesthetics and Art Criticism,* 59, 1 (Winter 2001), 39–44.

Secondary literature

Carroll, N., 'Modernity and the Plasticity of Perception', *The Journal of Aesthetics and Art Criticism*, 59, 1 (Winter 2001), 11–17.
Davis, W., 'When Pictures Are Present: Arthur Danto and the Historicity of the Eye', *The Journal of Aesthetics and Art Criticism*, 59, 1 (Winter 2001), 29–36.
Rollins, M., 'The Invisible Content of Visual Art', *The Journal of Aesthetics and Art Criticism*, 59, 1 (Winter 2001), 19–27.
—— (ed.), *Arthur Danto and His Critics*, Cambridge, Mass.: Blackwell, 1993.

MARK ROLLINS

JACQUES DERRIDA (1930–)

FRENCH PHILOSOPHER

Few thinkers have had as dramatic an impact on recent cultural theory as Jacques Derrida, whose researches have taken him into diverse areas of enquiry, though in the first instance his concern has been language.

General principles can be distilled from his linguistic theories, and deconstruction, the philosophical movement associated with Derrida, has its own unique perspective to offer on almost any area of human endeavour, including art. We shall be considering Derrida's most sustained pieces of writing on the topic of art, *The Truth in Painting* (1978) and *Memoirs of the Blind* (1990). First, however, some general comments about the deconstructive project initiated by Derrida seem in order.

Deconstruction starts out as a theory of language; more precisely, a critique of the theories of language put forward by structuralist thinkers building on the work of the Swiss linguist Ferdinand de Saussure (1857–1913). Saussure had emphasized the system-bound nature of language, treating it as a self-contained domain with its own internal set of rules – or 'grammar'. Language constituted a model for how *all* systems operated, and structuralism appropriated that model as the basis for its analyses of cultural phenomena. Deconstruction turns many of the ideas of structuralism on their head, arguing against its notions of deep structures determining meaning within systems, or of signs communicating meaning in an unproblematical fashion over time. For Derrida, meaning is in a constant process of evolution, and signs always fail to achieve full meaning, given that they carry within them 'traces' of other contexts and thus other meanings (themselves carrying traces, and so on, seemingly, into infinity). Language is a much less ordered phenomenon in this reading, and any attempt to impose order, in the manner of structuralism, for example, is to be regarded as authoritarian. The deconstructive project sees itself as having a brief to unmask such authoritarianism, and of undermining the pretensions of all totalizing theories and systems.

This radicalism can also be seen in the objective to destabilize the binary relationships on which so much of structuralist thought is based (language being divided into either *langue*, the system, or *parole*, individual utterances, for Saussure, for example), on the grounds that these binaries always privilege one term over another: thus *langue*/system takes precedence over *parole*/utterances in any structuralist scheme. When such binaries are applied in more contentious cultural ways – man/woman, or North/South, for example – their ideological connotations become more sinister, and deconstruction wants to challenge all such cases. Deconstruction believes that identity, like the sign, is internally fractured (that is, never wholly present at any one time, and *incapable* of being so), and that fixed 'subject positions' such as man/woman are based on an illusion. This illusion is what Derrida refers to as the 'metaphysics of presence', and it underpins Western

culture. Neither meaning nor identity can be wholly present to itself, or exist in its entirety at any one point; rather, they are in a process of evolution, with totality always being deferred.

Deconstruction has enjoyed some of its greatest success in the domain of aesthetics, most notably on the subject of literature – an area highly susceptible to its radical theories of language. From such a perspective, no text can ever be considered as complete in itself, or as communicating a fixed meaning over time. Neither does it make any sense to speak of an author controlling meaning or interpretation over time, or a critic offering a definitive reading of an author's supposed intentions. The lack of unity in signs and identity renders this an activity doomed to failure from the outset.

Art is another area where such theories have significant implications, since it, too, has its language, texts and assumptions about meaning and artistic intention; not to mention critical analyses claiming to reveal the 'truth' about individual works and artists. Derrida plunges into such debates in *The Truth in Painting* (1978), a fascinating series of meditations on the meaning of art. The study takes as its theme a remark of Paul Cézanne to Émile Bernard that 'I owe you the truth in painting and I will tell it to you', which turns into a practical demonstration on the impossibility of making any authoritative critical statement, or aesthetic judgement, at all – let alone being able to render truth itself (whatever that may be) in the act of painting.

Derrida's answer to the problem is to write '*around* painting'. We are offered a series of impressions, rather than any specific account of the nature of art. Deconstruction is never going to be a specific account of *anything*, never mind what anything *means*; what it will be instead is an exercise in pointing out the gaps in our theories, where we are unjustified in making assumptions, etc. No work of art is ever going to have full presence, because full presence is a myth. Questions about truth and meaning in painting become questions about truth and meaning in language, and that leads us into an infinite regress of questions that prevent us from ever establishing a solid base from which to make critical pronouncements.

What *The Truth in Painting* will show us is how we can never arrive at any decision as to what would constitute the 'truth in painting'. Traditional criticism, of the kind that tried to arrive at the truth in painting, or at criteria by which this might be determined, can only appear authoritarian and totalitarian to the deconstructionist, who will swerve away from any such activity. Deconstructive writing aims at being a *supplement* to the object of enquiry rather than an *explanation* of

it, with Derrida warning us that he has no intention of providing 'a transcendental pass, a password to open all doors, decipher all texts and keep their chains under surveillance'. The implied target of attack is structuralism, which, in its deployment of the linguistic model, did seem to promise that facility to its practitioners.

When Derrida turns his attention to actual works of art, rather than the problem of commenting on them, the effect is much the same, as in his contribution to a debate on the theme of 'Martin **Heidegger** and the Shoes of Van Gogh'. *Van Gogh's Old Shoes with Laces* (1886) receives the following treatment from Derrida: 'Here they are. I'll begin. What of shoes? What, shoes? Whose are the shoes? What are they made of? And even, who are they? Here they are, the questions, that's all.' It is typical of deconstruction that what Derrida comes up with is a clutch of questions of this nature (and there are many more to follow), in order to delay the process of critical judgement. In fact, much of the essay is concerned with the issues raised for deconstruction by the readings of the painting in question by Heidegger and Meyer Schapiro.

To Heidegger the shoes were those of a peasant; to Shapiro those of a city-dweller, possibly those of the artist himself. To opt for one side or the other in this debate is to impute a particular *meaning* to the painting, in that the shoes would be taken to reveal something about the country or the city, to have an *attitude* to one or the other context supposedly encoded in their representation, as well as to the owner of the shoes. Heidegger, Shapiro and the painting become locked in a closed circle of debate, where there is only one question of note to be answered, after which one's reading can proceed to unfold. Derrida undermines such a standard art-historical debate about meaning by enquiring 'what makes him so sure they are a *pair of* shoes? What is a pair?' Immediately we find ourselves outside the closed circle, reflecting on matters peripheral to criticism, which is precisely what Derrida wants. He sets out to frustrate 'the desire for attribution' that lies behind both the Heidegger and Shapiro readings, the aim being to prove instead that the shoes 'might well be made in order to remain-there': that is, to escape, not just the question of attribution to a particular person, but the attribution of *meaning*.

Memoirs of the Blind (1990), based on the catalogue Derrida wrote for an exhibition he organized, examines the theme of blindness in a range of drawings and paintings in the Louvre's collection. The paradox of blindness as a theme for a visual art suggests another paradox at the heart of art itself, where representation finds itself confronted by the unrepresentable: 'it is less a matter of telling it like it

is ... than of *observing* the law beyond sight'. There are Kantian echoes here, with 'the law beyond sight' sounding like a reference to a noumenal world which representation can never capture. Drawing, like writing, is for Derrida a leap into the unknown, with the draftsman being 'blind' as to where his efforts are leading. The theme of blindness becomes symbolic of the draftsman's own situation within the process of creation: 'a drawing of the *blind* is a drawing *of* the blind.' Yet again we find the artworks being not so much analysed, as used as a basis for philosophical speculation.

What legacy does deconstruction leave art? In the first place it problematizes structuralist notions that we can isolate the deep structural grammar of painting, and sub-divide this neatly into various genres such that we can lay bare the meaning and function of painting within its particular cultural context. The language of art is no more amenable to the ordering of its future than is ordinary language: perhaps we could say that deconstruction helps to retain the mystery of each, their ability to develop in unpredictable ways and endlessly to create new effects. Traditional art history has a question mark hanging over it if deconstruction's linguistic theories are correct. The discipline's preten-sions to explanation become hard to sustain if full presence is unachievable, and its search for system and pattern will seem an example of authoritarianism in action to a deconstructionist: an attempt to close off the act of individual interpretation. (For some Derrida-inspired writing on art, however, see Brunette and Wills, 1994.)

Deconstruction insists on the sheer contingency of both the work of art and its reception: that moment of individual reception can never be repeated, fits into no pattern, does not 'fix' the work in any way, and certainly does not involve any experience of unity.

The critique of unity is arguably the most significant aspect of deconstructionist aesthetics, in that unity is an abiding concern of much twentieth-century critical thought. Unity of purpose is often assumed of the creative artist, and unity of execution becomes one of the most sought-after characteristics of the artwork as well as one of the major ways of classifying artistic success. Deconstruction calls the notion of unity into question, and with it many of our assumptions about what is going on in the creative process. In line with various late-structuralist ideas such as 'the death of the author', deconstruction is more concerned with the *effect* of the work of art, its ability to generate chains of reasoning in the viewer, than the work of art in itself. Derrida's response to art, like his response to literature, is impressionistic, and anti-explanatory in intent. Artists have often complained about the critical desire to explain their work, to reduce it

to a set of restricting meanings, and we are all familiar with viewpoints of the 'a work of art doesn't *mean* anything, it just *is*' variety. It could be argued that deconstruction is an aesthetic which embraces this belief, with the qualification that what the work *is*, for deconstruction, is an entry into a network of traces, the unpredictable pattern of which is a practical illustration of the deconstructive world-view. In the case of Van Gogh, for example, this would lead us, not just to Heidegger and Schapiro, but even further afield: 'we should have to let this debate between the two great professors resonate with so many other texts. Marx, Nietzsche, Freud' (*The Truth in Painting*).

Whether creative artists would appreciate their work being used as a pretext for the exploration of traces is a moot point, but they ought to be attracted by deconstruction's anti-critical bias. Deconstruction does not interpose a definitive interpretation between the viewer and the artwork, and, if anything, is encouraging *pre*-critical responses – which one suspects most artists would quite like. The critical industry, on the other hand, is likely to remain unimpressed by this rejection of its very reason for existence. Nevertheless, deconstruction does invite us to think about art, and particularly our *reception* of art, in a new way – one oriented towards the creative potential of the 'moment', where both viewer and artwork are, as Derrida puts it, 'in the mode of contingency' (*The Truth in Painting*).

Biography

Jacques Derrida Born El Biar, Algiers, 15 July 1930, of Sephardic-Jewish parents. Derrida moved to Paris 1950, and studied philosophy at the École Normale Supérieure, where he became a lecturer in 1955. He lectured at Sorbonne between 1960 and 1964. He became visiting Professor at Johns Hopkins and Yale Universities from 1972, and at the University of California, Irvine, from 1987. He was a founder-member of the International College of Philosophy, Paris, in 1983. Derrida published *Of Grammatology* and *Writing and Difference* in 1967; *The Truth in Painting* in 1978; and *Memoirs of the Blind: The Self-Portrait and Other Ruins* in 1990.

Bibliography

Main texts

Of Grammatology (*De la grammatologie*, 1967), trans. Gayatri Chakravorty Spivak, Baltimore: Johns Hopkins University Press, 1976.

Writing and Difference (*L'Écriture et la différence*, 1967), trans. Alan Bass, Chicago: Chicago University Press, 1978.

The Truth in Painting (*La vérité en peinture*, 1978), trans. Geoff Bennington and Ian McLeod, Chicago: University of Chicago Press, 1987.

Memoirs of the Blind: The Self-Portrait and Other Ruins (*Mémoires d'aveugle: L'Autobiographie et autres ruines,* 1990), trans. Pascale-Anne Brault and Michael Naas, Chicago and London: University of Chicago Press, 1993.

Secondary literature

Brunette, P. and Wills, D. (eds), *Deconstruction and the Visual Arts: Art, Media, Architecture,* Cambridge: Cambridge University Press, 1994.

Gasché, R., *The Tain of the Mirror: Derrida and the Philosophy of Reflection,* Cambridge, Mass.: Harvard University Press, 1986.

Llewelyn, J., *Derrida on the Threshold of Sense,* London: Macmillan, 1986.

Norris, C., *Derrida,* London: Fontana, 1987.

Ryan, M., *Marxism and Deconstruction: A Critical Articulation,* Baltimore: Johns Hopkins University Press, 1982.

Sallis, J. (ed.), *Deconstruction and Philosophy: The Texts of Jacques Derrida,* Chicago: University of Chicago Press, 1987.

Silverman, H. (ed.), *Continental Philosophy II: Derrida and Deconstruction,* London: Routledge, 1989.

Sim, S., *Beyond Aesthetics: Confrontations with Poststructuralism and Postmodernism,* Hemel Hempstead: Harvester Wheatsheaf, 1992.

——, *Derrida and the End of History,* Cambridge: Icon Press, 1999.

Staten, H., *Wittgenstein and Derrida,* Lincoln: University of Nebraska Press, 1984.

Wood, D. and Bernasconi, R., *Derrida and Difference,* Evanston, Ill.: Northwestern University Press, 1988.

STUART SIM

JOHN DEWEY (1859–1952)

AMERICAN PHILOSOPHER

One of the seminal thinkers of the twentieth century and a co-founder (with C.S. Peirce and William James) of the Pragmatist movement in philosophy, John Dewey also wrote *Art as Experience* (1934), arguably the most influential work in American philosophy of art of the twentieth century. Dewey's philosophy of art deals with many of the subjects treated by the modern Idealist tradition of aesthetic reflection since Kant, including the formal and expressive dimensions of art and the nature of aesthetic perception. And, like Idealist aesthetic theories, it has much to say about the contributions of the fine arts to modern life. But it decisively departs from that tradition's tendency to portray fine art as an institution set off from the causes, histories and values of

everyday experience. Art, according to Dewey, is in its most fundamental sense not a special type of product or practice; it is a 'quality of doing and of what is done' that appears not only in the practice of fine art but in a wider range of productive activities, from crafts, athletics and various kinds of blue-collar work, to politics, science and philosophy.

Deweyan pragmatism

A dominant theme of Dewey's philosophy as a whole, set forth in numerous books and articles published throughout his seventy-year career, is the continuity between culture and nature. To this extent, his philosophy offers a sustained argument against a larger Western tradition that viewed the intellectual and spiritual dimensions of human nature as metaphysically separate from, and elevated above, the historical world of physical causation and contingency. Born into a Congregationalist family, Dewey took a secular turn as he discovered Darwinian evolutionary theory and Hegel's account of the deeper reciprocities binding various dualisms of Western thought, such as subject–object, mind–body, thought–action, culture–nature, fact–value and art–life. Eventually rejecting the absolute idealism of Hegel, he came to view all such oppositions as products not of metaphysical or transcendental necessity but of contingent intellectual dynamics within the history of a culture continually engaged in self-reconstruction. Dewey was also an avid reader of Romantic writers such as Wordsworth, Shelley, Coleridge, Emerson and Whitman, who provided inspiration for his mature naturalistic critique of the disenchanting effects of secular modernity. In *Art as Experience* and other works, he would follow this critique with a positive account of the powers of experimental, creative intelligence to diagnose and repair human problems on a variety of scales.

Dewey referred to his mature philosophy variously as 'instrumentalism' and the 'experimental philosophy'. It is commonly known now as Deweyan pragmatism, a label that reflects Dewey's belief that all ideas and theories derive their value ultimately from how they contribute to the resolution of problems rooted in the practical life of their surrounding culture. This belief is in turn rooted in Dewey's view that all forms of experience and intelligent endeavour emerge from the ongoing interactions between biologically-based human intelligence and a natural and cultural world that is by turns friendly and hostile to its interests. In this spirit, he would argue that our biological constitution supports a profound social plasticity (*Human*

Nature and Conduct, 1922), that we make our own histories, and that a healthy society will encourage human growth and the deep involvement of the individual in the life of the community. These ideas served as underpinnings for Dewey's socialist politics. Unlike Marxists, however, he rejected all totalizing and deterministic visions of history, and throughout his life was a staunch defender of democracy as the ideal setting for intellectual and moral community in the modern world.

Art as experience

Some central themes of *Art as Experience* can be found in Dewey's earlier work, *Experience and Nature* (1925). There he argued that art is a form of experience that represents the culmination of certain developmental tendencies inherent in human intelligence and more fundamentally in nature; that art embodies both intrinsic and instrumental qualities of value to a marked degree; and that experience-as-art may be realized in a wide spectrum of human endeavours, even in scientific practice. Dewey went on to argue in *Art as Experience* that traditional aesthetic theories (chiefly, those in the Idealist tradition running from Kant through early twentieth-century writers like Clive **Bell** and Benedetto **Croce**) suffer from a tendency to over-compartmentalize their subject. In so doing, they are symptomatic of Western philosophy's traditional tendency to confer metaphysical legitimacy on leisured activities involving the mind and 'higher' senses. Within this tradition, such activities are portrayed as 'final' or intrinsic values (or ends in themselves), at the expense of other activities involving physical labour and practical reasoning, which are supposed to possess merely utilitarian or instrumental value.

In proposing to reconstruct this tradition, Dewey argued in *Art as Experience* that human experience possesses a qualitative richness that is rooted in our basic biological nature – a richness that is the source of our deepest values in a way that is not captured by crude final-versus-instrumental dualisms. When we speak, misleadingly, of 'things' as the repositories of final or instrumental values, he maintains, what we are really referring to are 'qualities' or 'phases' of experience; and what traditional philosophies of value have failed to appreciate is how the final and instrumental phases admit of further integration in what Dewey terms experience's 'consummatory' phase. Consummatory experience is a special sort of phenomenologically rich interaction with the world, an event in the life of an intelligent individual which is felt as a special achievement within that individual's continually

developing life-narrative. It is marked by a heightened imaginative and sensory awareness, along with a sense that what one is doing is charged with a meaning that derives not only from one's immediate circumstances but also from the present moment's narrative connection to a larger remembered and projected individual history of striving and attainment. Such experiences, Dewey says, can occur in a wide range of circumstances – a special trip, a momentous acquaintance or decision, a walk in the woods, or, last but not least, in the creation or appreciation of a work of art. Consummatory experience is literally life at its fullest and it epitomizes how phenomenology and valuation are, for Dewey, of a piece, in so far as we prize such moments for themselves in the present (and to this extent they possess final value) even while they contribute instrumentally to our future.

It is also to consummatory experience, Dewey says, that we must look to understand art, a 'refined and intensified form of experience' that 'celebrates with peculiar intensity the way in which the past reinforces the present and in which the future is a quickening of what now is'. The 'work of art', in his sense, is not a static object but literally an aesthetically charged episode of consummatory human agency whose product (what is conventionally called the art product) is instrumental to the generation of potentially consummatory experience in others. Although, again, Dewey is concerned to show how experience can develop into art in a wide spectrum of settings, he also takes pains to illustrate this process at work in the fine arts. In a visual medium like painting or sculpture, for example, an artist, drawing upon a meaningful piece of personal experience, is moved to constitute a new experience through the manipulation of expressive conventions involving lines, colours and volumes. In the new experience, the artist's psychic and physical energies are organized in new ways, resulting in novel configurations of sensuous form and symbolic meaning, as expressed in the product. The product, in turn, retains traces of the experience that guided the artist's original activity, and to this extent it can communicate that experience in ways that transcend the limits of ordinary discourse. At the same time, it can serve as a touchstone for new experiences on the audience side. A similar situation obtains in the creation and appreciation of film, literature, music, dance and other media.

Dewey's theory of art may be generally categorized as an 'expression theory' in so far as it emphasizes expression over representation as a characteristic function of artworks, as well as the role of form in organizing a work's expressive energies. To this extent

it falls within the general orbit of the literature of aesthetic modernism, yet at the same time it resists the tendency, central to much of that literature (for example, in the writings of Clive **Bell**, Roger **Fry** and Clement **Greenberg**) which emphasizes form at the expense of meaning. Dewey never goes so far as to assert that art is a 'language' or a form of knowledge; however, his emphasis on how an artwork refines and intensifies the meanings of experience hints in the direction of more full-blooded cognitive theories of art such as that of the later pragmatist philosopher, Nelson **Goodman**.

In *Art as Experience*'s concluding chapter, Dewey turns his reconstructive attention to another topic over which he parts company with the more formalist elements of modernist theory: the art–morality relationship. Citing Shelley's dictum that poets are the 'unacknowledged legislators of mankind', he notes that a poem, painting or other artwork that is morally suggestive need not and should not be didactic; moral efficacy, rather, is best achieved in art indirectly, through the broadening of our imaginative grasp of human situations beyond the confines of conventional moral rules and standards of praise and blame. In this sense, 'art is more moral than moralities'. This position bears some affinities with Nietzsche's more radically aestheticist view that a life is a work of art and all moral judgements are aesthetic interpretations of life; but in the end it is tempered by Dewey's un-Nietzschean insistence on the importance of integrating all the consummatory fruits of human intelligence, to the extent possible, into a democratic culture.

In the Preface to *Art as Experience*, Dewey made clear his indebtedness to Albert C. Barnes, the collector and author of *The Art in Painting* (1925), and to the young art historian Meyer **Schapiro**. Dewey's dynamic vision of experience and creativity would go on to exert influence upon many quarters of American artistic culture, especially in the years following World War Two. Visual artists who have acknowledged *Art as Experience* as an influence include Josef Albers, Roberto Matta Echaurren (a Surrealist painter who influenced Robert Motherwell, William Baziotes, and Jackson Pollock), Wolfgang Paalen, and Thomas Hart Benton, another noted influence on Pollock. (Some critics have suggested affinities between Dewey's theory of art as a quality of action and Pollock's 'action painting'.) Other artists known to have been exposed to Dewey's ideas include John Cage and Merce Cunningham. Recent years have seen a renewed interest among artists, critics and philosophers in the implications of Deweyan 'pragmatist aesthetics' for understanding not only the traditional visual arts but a wider spectrum of high and

popular cultural practices including film, rap music and jazz. Such developments suggest that *Art as Experience*'s account of the evolution of aesthetic experience in culture, and of the dynamic nature of culture itself, remains a rich resource for philosophical reflection on postmodern art and beyond.

Biography

John Dewey Born Burlington, Vermont, 20 October 1859. Dewey was educated at public schools in Burlington and studied philosophy at Johns Hopkins University in 1882–4. He taught philosophy at the University of Michigan between 1884 and 1894, and became professor of philosophy and chairman of the department of philosophy, psychology and pedagogy at the University of Chicago, 1894–1904. Between 1904 and 1930 Dewey taught at Columbia University. He founded the Laboratory School in Chicago with Jane Addams, and was founder member of New School of Social Research in 1919. Author of many books and articles in philosophy and the human studies, Dewey published *Reconstruction in Philosophy* in 1920, *Human Nature and Conduct* in 1922, *Experience and Nature* in 1925, *The Quest for Certainty* in 1929, and *Experience and Education* in 1938. He died in New York on 1 June 1952.

Bibliography

Main texts

Experience and Nature, 1925 (reprinted as Vol. 1 of Jo Ann Boydston (ed.), *John Dewey: The Later Works*, Carbondale: Southern Illinois University Press, 1981).
Art as Experience, 1934 (reprinted as Vol. 10 of Jo Ann Boydston (ed.), *John Dewey: The Later Works*, Carbondale: Southern Illinois University Press, 1987).

Secondary literature

Alexander, T., *John Dewey's Theory of Art, Experience, and Nature: The Horizons of Feeling*, New York: State University of New York Press, 1987.
Buettner, S., 'John Dewey and the Visual Arts in America', *The Journal of Aesthetics and Art Criticism*, 33 (1975), 383–91.
Croce, B., 'On the Aesthetics of Dewey', *The Journal of Aesthetics and Art Criticism*, VI (1948), 203–7.
Haskins, C., 'Dewey's Romanticism', in C. Haskins and D.I. Seiple (eds), *Dewey Reconfigured: Essays on Deweyan Pragmatism*, New York: State University of New York Press, 1999.
Jackson, P.W., *John Dewey and the Lessons of Art*, New Haven: Yale University Press, 1998.

Kultermann, U., 'John Dewey's "Art as Experience": A Revaluation of Aesthetic Pragmatism', *Art Criticism*, 6, 3, 17–27.

Pepper, S.C., 'Some Questions on Dewey's Aesthetics', in P.A. Schillp, *The Philosophy of John Dewey*, La Salle, Ill.: Open Court, 1970 (Dewey's response to Pepper follows).

Shusterman, R., *Pragmatist Aesthetics: Rethinking Beauty, Reliving Art*, Oxford: Blackwell, 1992.

Singer, I., *Reality Transformed: Film as Meaning and Technique*, Cambridge, Mass.: The MIT Press, 1998.

CASEY HASKINS

HENRI FOCILLON (1881–1943)

FRENCH ART HISTORIAN

The work of Henri Focillon is characterized by a diversity of interests and ideas that escapes easy categorization. He is best known for his writings and his teaching of medieval art, although this was a subject he only came to in the later parts of his career. Focillon's main publications in the field date to after 1924, but his intellectual roots lay in the nineteenth century. He was influenced by both the empirical approach of writers like Jacob Burckhardt, and by metaphysical studies, particularly those of German thinkers such as Hegel. He did not follow one of the more traditional paths to becoming a medieval art historian, and he was neither an archaeologist nor an iconographer. Instead, he was interested in questions of technique and form. From the moment he began to publish on medieval art, he also turned to the theory of art history. His own approach remained highly individualistic. He rejected the strict application to art history of Hegel's linear, evolutionary view of history, and suggested a more flexible and open model. He believed in the existence of an internal, organizing logic of all forms of art and the principle of a unitary development, but he modulated his views by an insistence on the possibilities of invention through the experimental vigour of the individual.

Throughout his life, Focillon's work was informed by his early experiences in his parental home. His father, Victor Focillon, was an artist and engraver, and Henri spent much time in his father's studio. Later, he was able to describe these early experiences: 'In my father's studio I learned the touch of all the tools of art, to recognize them, name them, handle them and love them. Warm with humanity and bright with use, they were in my eyes not inanimate instruments but

forms endowed with life, not the curious apparatus of a laboratory but powers of magical sophistication.' From this period, Focillon derived an interest in both the material of the object and the artist involved in its creation. Throughout his life, he loved to draw and engrave. Focillon was one of the first art historians to show a keen interest in the role of technique and the material used in the creative process. He also maintained an unwavering belief in the power of invention and the 'revolutionary energy' of creativity. According to Focillon, forms changed their quality according to the material, the tool and the hand.

The path of Focillon's career was itself marked by incidental moves, and his later position as an eminent art historian and theorist could not have been foreseen at the beginning of his career. After studying philology at an École Normale Supérieure, he started life as a teacher at a number of *lycées*. Later, he was to say that the positions he held in the cathedral towns of Chartres and Bourges directed him towards a love of medieval architecture. While he was a professor at Lyon University, he initially directed his attention to engraving, the medium with which he was so well acquainted. He wrote several books on engravers, notably on Piranesi, as well as essays on Dürer, Elsheimer, Rembrandt and Daumier. He also published on subjects as diverse as Raphael, nineteenth-century painting, Hokusai and Buddhist art, as well as writing a study of modern art. He career took a turn when in 1924 he was elected to succeed Émile **Mâle** in the chair of medieval studies at the Sorbonne. For the first five years after his appointment his publications continued to follow his established interests.

In 1929 his first article on a medieval subject appeared with the suggestive title 'Apostles and Jugglers: studies in movement', on the way Romanesque sculpture relates to its architectural framework and how figurative sculpture moves within it.

From this article it became clear that Focillon was not going to step into the shoes of his distinguished predecessor. For Mâle, medieval art spoke of Christian spirituality through the content of its imagery, and he devoted his life to decoding the meaning of medieval images. Focillon's article made it clear that iconography and theology were not issues that were close to his heart. Neither did he turn to archaeology, for which French studies had an impressive ancestry in Arcisse de Caumont and Eugène Viollet-le-Duc. Focillon, by contrast, was fascinated by the visual aesthetics of the object. His principal insight was that Romanesque sculpture was subordinated to architecture, and that architecture represented the law that governed its existence. From this point onwards, Focillon attempted to uncover the internal logic of art which he believed to exist in the abstract nature of form itself.

Instead of the Christian iconography of Mâle, Focillon offered a rationalist approach. On 30 March 1933 Mâle wrote to Focillon: 'In *The legend of the centuries*, Victor Hugo says that two sculptors were needed to decorate the temple of Jerusalem: one who sculpted what is ideal and another who sculpted what is real. It also takes, I believe, two historians to interpret the art of the past. Let us be those two.'

Focillon's fascination with Romanesque sculpture continued. In 1931 he published *The art of Romanesque sculptors; an examination of the history of forms*. The title refers clearly to his main spheres of interest: the individual and potentially irrational response of the anonymous artist to the creative task to which he was appointed, and the created form itself. Here he further developed his views on the architectural geometry of Romanesque sculpture, for him a law within the disorder of the decoration. Focillon's approach was directly opposed to that of his younger contemporary at Columbia University in the United States, Meyer **Schapiro**, for whom the disorder of Romanesque sculpture was a sign for its expressivity and its primitivism. Both Focillon's and Shapiro's responses form part of their reaction to contemporary developments in the art scene. The younger man was intrigued by Expressionism. For Focillon it was a question of finding harmony to counteract the modern aesthetic of the fragment, and a return to order.

In 1934 in *The Life of Forms in Art*, Focillon further defined his views and expanded them into a theory extending to all periods. In 1938 he applied his theory to the objects themselves in a survey of medieval art, *The Art of the West*. He argued that forms metamorphose endlessly, but when they are coordinated into a coherent group they represent the style of a period. Within the period style, the forms pass through successive phases, which he identified as the experimental age, the classic age, the age of refinement and the baroque age. He admitted that these distinctions were not entirely new. Since antiquity, works of art had been grouped in periods and cycles. However, Focillon's categories presented a new understanding of the cycle of styles, in particular of the first and the last phase. The use of the impartial terms 'experimental age' and 'baroque age' take account of the fact that since the nineteenth century scholars had moved away from the biological concepts of rise, maturity and decline. For Alois Riegl, for example, no one period was more important than the other. Focillon's classifications also suggest an unprejudiced attitude to the early and late phases of a style. However, for Focillon, some amount of negative value remained attached to the last phase. For him, the forms of the baroque age, of which the medieval Rayonnant Style was an

example, have 'either abandoned or denatured the principle of intimate propriety'. Focillon classified the first age as the experimental age, rejecting the more pejorative term 'archaic', as this phase was often described. By changing the emphasis from highlighting the primitive nature of this phase to highlighting its creative nature, Focillon revealed his central interest in the history of art: the creative energy of the often unnamed individual artist.

Focillon made it quite clear that he did not believe that experimental vigour was restricted to the first age of his cycle of styles. Rather, he argued, it was a crucial element in the development of styles of all ages. This emphasis on the freedom of artistic choice sits somewhat uneasily with the other concepts of Focillon's theory: the notion of a period style and of a law that governs the nature of forms, which both imply a form of historical determinism. But like the juggler which first attracted Focillon's attention to medieval sculpture, he managed to keep his theoretical balls in the air. In *The Art of the West* he argued that 'Evolution was as beautiful in its reasoning as the proof of a theorem.' And for him the thirteenth-century Rayonnant style was already incipient in the use of rib vaults in the twelfth century. But Focillon never overlooked the 'thoughtful workmen'. For him, the rules that the forms obey are inherent in 'the minds in which they are located and centred'. It is the rationality of the artists that invests the object with its logic. Focillon could point to the 'dangers of "evolution": its deceptive orderliness, its single-minded directness', because he believed that the experimental vigour of the artists could produce different effects within a style. While he believed that works of art carry within themselves 'the principle of unitary development', he was convinced that different schools and artists might work out a style at different moments of time. In this way he saw medieval architecture as 'a single intellectual order', but also as a 'language spoken with various accents', and he defined Gothic as both guesswork and reasoning, empirical research and inner logic 'all at once'.

The uncertainties of the period after World War One would made their impression on Focillon's work. Focillon was a socialist and republican and avoided theories of racial superiority. His work contains, nevertheless, a strong Francophile element. In *The Art of the West*, and in his posthumously published *The Year One Thousand*, he highlighted the centrality of France in the development of medieval art just as Mâle had done before him, emphasizing the important role Paris and France played in the creation of Gothic architecture. But Focillon went further than other scholars, and strongly rejected

attaching any significance to the role of the German Empire in the history of medieval art. Carolingian art, for example, was 'weighed down by an inert mass of ... primitive ideas'. During World War Two, Focillon avoided Europe; in 1937 he moved to Yale University in the United States, where he stayed until his death in 1943.

Biography

Henri Focillon Born Dijon, 7 September 1881, son of Victor Focillon, an engraver, and Anne Focillon. Between 1901 and 1906 he studied philology at an École Normale Supérieure. He taught at *lycées* at Chaumont, Bourges and Chartres between 1906 and 1910. From 1913 until 1924 he was Professor of Art History at Lyons University and director of the city's municipal museums. From 1924 to 1937 Focillon was at the Sorbonne, taking an appointment at the Collège de France in 1937; and between 1937 and 1943 he was Professor of Art History at Yale University, a chair held in association with M. Aubert. Focillon died at Yale on 3 March 1943.

Bibliography

Main texts

Benvenuto Cellini (Les grands artistes), Paris: Henri Laurens, 1911.
Hokousaï (Art et esthétique), Paris: Librairie Félix Alcan, 1914.
Giovanni Battista Piranesi (1720–1778), Paris: Henri Laurens, 1918.
Technique et sentiment, études sur l'art moderne, Paris: Henri Laurens, 1919.
Raphaël, Paris: Éditions Nilsson, 1926.
'Apôtres et Jongleurs (études de mouvement)', *Revue de l'Art ancien et moderne*, 55 (1929), 13–28.
L'Art des sculpteurs romans, recherches sur l'histoire des formes, Paris: Librairie Ernest Leroux, 1931.
The Life of Forms in Art (*Vie des formes*, 1934), trans. Charles Beecher Hogan and George Kubler, New Haven: Yale University Press, 1942.
The Art of the West I: Romanesque Art, and *The Art of the West II: Gothic Art* (*L'art d'Occident, le Môyen Âge roman et gothique*, 1938), trans. D. King, 2 vols, London: Phaidon Press, 1963 (2nd edn 1969 has a forward by Jean Bony).
L'An Mil (*The Year One Thousand*). Paris: Armand Colin, 1952.

Secondary literature

Fernie, E. (ed.), *Art History and its Methods, a critical anthology*, London: Phaidon Press, 1995.
Bony, J., Foreword to *The Art of the West*, trans. D. King, 2 vols, 2nd edn, London: Phaidon Press, 1969.
Grodecki, L. and Prinet, J., *Bibliographie Henri Focillon*, New Haven and London: Yale University Press, 1963.

Kubler, G. *et al.*, *Relire Focillon* (*Cycle de conférences organisé au musée du Louvre par le service culturel du 27 novembre au 18 décembre 1995 sous la direction de Matthias Waschek*), *Collection Principes et théories de l'histoire de l'art*, Paris: ensb-a, 1988.

ALEXANDRA GAJEWSKI-KENNEDY

MICHEL FOUCAULT (1926–84)

FRENCH PHILOSOPHER AND HISTORIAN

Although he is commonly described as a French philosopher, Foucault's chair at the Collège de France was in the 'History of Systems of Thought'. His work covers an enormous variety of topics, ranging from the history of science and medicine to psychology, from the history of madness to that of the development of the modern penal system, and finally to that of sexuality and subjectivity. When he first achieved public celebrity in 1966 with *Les Mots et les choses* (*The Order of things*), his name was closely associated with the structuralism of the day; he is now more usually associated with a relativistic postmodernism. It is perhaps more accurate to see him as working in the tradition of the historical epistemology of Gaston Bachelard and Georges Canguilhem, which studies the historical breaks and discontinuities that allow the sciences to emerge from their pre-scientific and ideological past.

Foucault's work is punctuated by many breaks and sudden changes of direction. In 1966, he was the prophet of the 'death of man' who contended than 'man' and 'humanism' were no more than the discursive products of an era that was coming to an end; in the last two volumes of his unfinished *History of Sexuality* (1984), he begins to elaborate an aesthetics of existence based upon ancient Stoicism and implying a new form of humanism. There are, however, a number of constants running through all his many publications. Foucault is constantly asking what it is that makes a system of thought possible, what are the underlying assumptions that inform the modes of thought that govern our lives. He describes his mode of investigation as 'archaeology' or, later, borrowing from Nietzsche, 'genealogy'. The goal of the investigation is to find the conditions of existence that produce objects of knowledge such as madness or sexuality, and disciplines such as criminology and 'the criminal', and to trace the historical discontinuities that produce categories such as homosexuality. Such objects are not natural, but the products of determinate

discourses and practices, objects that are largely created by the statements that are made about them. Prior to the nineteenth century, for example, a variety of actions could be described by the remarkably ill-defined term 'sodomy'. 'Homosexuality', Foucault argues, is the final product of medical and psychiatric discourses, of legal and confessional practices, of conflicting definitions of heterosexuality, of changing sexual practices and forms of personal identity, and so on. An ill-defined category of acts has been replaced by a precise category of individuals. Foucault is constantly asking questions about what makes it possible, even necessary, to think in certain ways. The questions asked by his *History of Sexuality* are: 'Do we need a sexual identity?' and 'Do we need sexual liberation, or do we need to be liberated from sexuality?'

The broad historical framework used by Foucault also remains quite constant. It is only in his final works that he turns to the ancient world; from *Histoire de la folie* (*Madness and Civilization*, 1961; the translation is heavily abridged) onwards, Foucault habitually contrasts a medieval and early Renaissance period with a somewhat elastic 'classical age' going from the seventeenth to the nineteenth centuries. These periods are categorized not, as Marxism would have it, by modes of production, but by their modes of knowledge.

Foucault is a strikingly 'visual' writer, whose books often open with almost painterly passages illustrating what demarcates the classical age from what went before it. One thinks, for instance, of the image of the Ship of Fools drifting along the canals of Northern Europe in the centuries before 'the great confinement' that inaugurated the incarceration of the 'mad', in *Histoire de la folie*. Similarly, *Surveiller et punir* (*Discipline and Punish*, 1975) opens with a detailed, almost loving, description of the public torture and execution of a regicide in 1757, which is contrasted with a description of the disciplined and silent prisons of the nineteenth century. Although he had no formal training in art history, Foucault frequently refers to paintings and painters to illustrate his points. Goya, Bosch, Bruegel and Van Gogh are evoked, together with poets like Gérard de Nerval and Antonin Artaud; whilst they are not analysed in any detail, they are cast as silent witnesses of what lies beyond the realm of reason, or of what happens when reason sleeps. Most of Foucault's writings on aesthetics are, however, concerned with literature, even though he does suggest in *L'Archéologie du savoir* (*The Archaeology of Knowledge*, 1969) that painting is a 'way of speaking' that can do without words. His writings on literature are concerned mainly with works that describe or even offer an experience of transgression that challenges conventional notions of

individuality or personhood, or that, as in the case of Georges Bataille, take eroticism to extremes of a transgressive ecstasy that challenges the experience of bodily identity. In formal terms, his main interest is in the classical avant-garde techniques of repetition, reproduction and *mise en abyme* (the reproduction within the text of its own structure). His concerns are best illustrated by his book-length study of the French novelist and poet Raymond Roussel (*Raymond Roussel: Death and the Labyrinth*, 1963), and an essay on the work of his friend the writer and artist Pierre Klossowski ('La Prose d'Actéon', 1963).

Foucault's literary essays received relatively little attention prior to the publication of During's *Foucault and Literature* (1992). His brief and scattered pieces on the visual arts have received even less attention from commentators. The exception is, of course, the famous description of Velázquez's painting *Las Meninas* (1656, Madrid, Museo del Prado), but that is part of a larger epistemological essay rather than a study in aesthetics. Originally published as an essay, the piece was slightly reworked to become the first chapter of *Les mots et les choses*, and it illustrates the transition from 'resemblance' to 'representation', or the beginnings of the classical age. According to Foucault, the pre-classical period was dominated by a theory of resemblance, in which the world was a book to be read or a picture to be deciphered on the basis of the comparisons that existed between microcosm and macrocosm. Resemblance is a natural phenomenon: aconite has an affinity with the eyes *because* its seeds are dark globes in white coverings, and those seeds are what the pupil is to the eyes. For the classical age, the central issue is that of representation, or of the relationship between words and the objects they represent. Representation is, however, only part of the classical mode of knowledge, and has to be analysed along with 'speaking', 'classifying' and 'exchanging', or, in other words, philology, natural history and political economy, which together provide the foundations of the modern human sciences. *Las Meninas* is, according to Foucault, a 'representation of representation'. It depicts the painter painting the court of Philip IV and Queen Mariana Teresa, who are seen only in a mirror reflecting the image Velásquez is painting on the canvas we see from behind. For Foucault, this magnificent painting illustrates the paradox of the classical age: it involves what he calls the disappearance of its foundation: 'the person it resembles and the person in whose eyes it is only a resemblance'. The assumption here is that art can reflect the intellectual or epistemological temperament of an era.

Whilst Foucault's analysis of the Velázquez is now quite familiar, the related analysis of René Magritte is less well known ('Ceci n'est pas

une pipe', 1973; 'This is not a Pipe'), even though the works it discusses are almost over-familiar. Magritte's canvas of 1926 (there are many later variants) depicts an easel bearing a canvas displaying a pipe and inscribed with the legend 'This is not a pipe'; above the easel, there is a larger but otherwise identical pipe. This is an obvious example of *mise en abyme*, but for Foucault it is a challenge to the rules of painting that have prevailed since the fifteenth century and which subordinated words to images, and images to the objects they depict. Here, word and image are given equal, if ambiguous, status in a sort of calligram, normally defined as a poem in which the words are arranged in the shape of the object they describe. For Foucault, the image shatters and breaks up the space of painting. He hints in passing that Magritte is working on the lines pioneered by Kandinsky and Klee, and may have something in common with Andy Warhol's 'serial' paintings and prints, but does not elaborate any further.

Foucault planned to write a major study of Manet, but it was never completed and all that apparently remains is a pile of fragmentary and unpublished notes. His other comments on the visual arts occur in short reviews and, more significantly in essays in catalogue to exhibitions by Paul Rebeyrolle ('La force de fuir'; 'Force of Flight', 1973) and Gérard Fromanger ('La peinture photogénique', 1975; 'Photogenic Painting'). Rebeyrolle (1926–) is a highly political artist whose work often depicts scenes of great violence, including torture. Rebeyrolle's 1973 show at Galerie Maeght was an installation of ten mixed-media works dominated by whites and greys which replaced the windows that allowed the depiction of 'an interior in the outside world' in classical painting with closed widows. The wood and wire grills glued to the canvas constituted the carceral world of a prison in which dogs were confined. The confined space gave the viewer of being with them inside their prison. The dogs tore at the wire in a frustrated attempt to break free. In the final canvas, entitled *Inside*, a dog had broken out and is seen on top of a wall. The white is suddenly interrupted by a flash of blue that shatters the prison wall from top to bottom. At this time, Foucault was actively involved in campaigns for prisoners' rights, and Rebeyrolle's violent work had an obvious appeal at the referential level. It also accomplishes a political act in its own right; in his 1975 study of the origins of the prison system, Foucault describes verticality as the dimension of oppression and repression ('keeping down'); here, it becomes the dimension of freedom. Fromanger (1939–) is associated with the 'figuration narrative' group, and his work has a lot in common with both pop art and hyperrealism. Foucault describes Fromanger's working

methods: slides made from black-and-white photographs are projected on to the canvas, and the image is transcribed in acrylic. There are no intermediate drawings and no preparatory work; the artist works in semi-darkness. The final image is a simulacrum, or in other words a copy of which there is no original (Foucault explores literary simulacra in his essay on Klossowski). The images on display at the Galerie Jeanne Bucher included those of prisoners on the roof during a mutiny, and multiple image of a black street sweeper, each in a different colour and inscribed 'street of my village', 'street of wild animals', etc. For Foucault, they both reflected the politics of the day and created 'an obligation to look', whilst their serial nature represented a further shattering and multiplication of the traditional space of painting.

Biography

Michel Foucault Born Poitiers, France, 15 October 1926. Foucault was educated at the École Normale Supérieure and the University of Paris. He taught philosophy and literature at the universities of Lille, Uppsala, Warsaw, Hamburg, Clermont-Ferrand, São Paolo, and Tunis between 1960 and 1968; and at the University of Paris–Vincennes in 1968–70; he taught history of the systems of thought at the Collège de France, Paris, between 1970 and 1984. *Les mots et les choses* (1966) established Foucault as one of the most celebrated – and controversial – of French intellectuals. He travelled widely, visiting the USA often, and was an active campaigner for political and social reform. Foucault died in Paris on 25 June 1984.

Bibliography

Main texts

Madness and Civilisation: A History of Insanity in the Age of Reason (*Histoire de la folie à l'âge classique*, 1961), London: Tavistock, 1967.
Death and the Labyrinth: The World of Raymond Roussel (*Raymond Roussel*, 1963), trans. Charles Ruas, London: Athlone Press, 1987.
'The Prose of Actaeon' ('La prose d'Actéon', 1963), trans. Robert Hurley, in J.D. Faubion (ed.), *Aesthetics, Method and Epistemology: Essential Works of Foucault 1954–1984*, vol. 2, Harmondsworth: Penguin, 2000.
The Order of Things (*Les mots et les choses*, 1966), London: Tavistock, 1971.
The Archaeology of Knowledge (*L'Archéologie du savoir*, 1969), trans. Alan Sheridan, London: Tavistock, 1972.
'La Force de fuir' (1973), in *Dits et écrits 1954–1988*, vol. II, Paris: Gallimard, 1994.
'This is Not a Pipe' ('Ceci n'est pas une pipe', 1973), trans. James Harkness,

Berkeley: University of California Press, 1983. (Also in J.D. Faubion (ed.), *Aesthetics, Method and Epistemology: Essential Works of Foucault 1954–1984*, vol. 2, Harmondsworth: Penguin, 2000.

'Photogenic Painting' ('La Peinture photogénique', 1975), in G. Deleuze and M. Foucault, *Gérard Fromanger: Photogenic Painting/La peinture photogenique*, introduction by Adrian Rifkin, London: Black Dog Publishing, 1999.

Discipline and Punish (*Punir et surveiller*, 1975), trans. Alan Sheridan, London: Tavistock, 1977.

The Use of Pleasure: The History of Sexuality Volume 2 (*L'Usage des plaisirs*, 1984), trans. Robert Hurley, Harmondsworth: Penguin, 1987.

The Care of the Self: The History of Sexuality Volume 3 (*Le Souci de soi*, 1984), trans. Robert Hurley: Harmondsworth, Penguin, 1987.

Collections:

Aesthetics, Method and Epistemology: Essential Works of Foucault 1954–1984, vol. 2, trans. Robert Hurley and others, ed. J.D. Faubion, Harmondsworth: Penguin, 2000.

Secondary literature

Bernauer, J.W., *Michel Foucault's Force of Flight: Toward an Ethics for Thought*, Atlantic Highlands, NJ: Humanities Press, 1990.

During, S., *Foucault and Literature: Towards a Genealogy of Writing*, London: Routledge, 1992.

Gutting, G., *Michel Foucault's Archaeology of Scientific Reason*, Cambridge: Cambridge University Press, 1989.

——, *The Cambridge Companion to Foucault*, Cambridge and New York: Cambridge University Press, 1994.

Jay, M., *Downcast Eyes: The Denigration of Vision in Twentieth-Century French Thought*, Berkeley: University of California Press, 1993.

Macey, D., *The Lives of Michel Foucault*, London: Hutchinson, 1993.

DAVID MACEY

SIGMUND FREUD (1856–1939)

AUSTRIAN PSYCHOANALYST

Freud defines his psychoanalysis as consisting of three elements: a procedure for investigating unconscious mental processes; a therapeutic method for treating disorders such as neurosis; and a body of psychological data obtained from its investigations and constituting a new science. It also provides a theory of mind (structured around the conscious/unconscious opposition in Freud's early work and, after 1920, around the triple structure of super-ego, ego and unconscious, or 'id'); and a model of both 'normal' and 'pathological' development, the difference between the two being one of degree rather than nature. The new science he refers to includes his writings on culture

and art, which in turn provide the foundations for the many varieties of psychoanalytic criticism, often referred to as 'applied psychoanalysis'.

Clinical psychoanalysis developed out of Freud's early work on hysteria and other neuroses, and his development of the 'talking cure'. Hysteria, in which the patient presents inexplicable physical symptoms, can be investigated by listening to his or her accounts of dreams, by analysing slips of the tongue, jokes or bungled actions, all of which reveal motives and wishes that are contrary to the patient's conscious intentions, as when the reluctant chairman of a meeting opens proceedings by declaring it closed. Dreams – 'the royal road to the unconscious' – are a form of wish-fulfilment allowing the subject to give disguised expression to desires that are unacceptable to the ego and which have therefore been repressed into the unconscious. The hysteric's persistent cough, which cannot be cured by physical medicine, may, that is, be an unconscious wish for oral intercourse that has been repressed and converted into a distressing physical symptom. The unconscious is described as having no notion of the principle of non-contradiction and as being timeless: conflicting wishes can therefore coexist and childhood memories can merge with recent memories. The unconscious is the realm of drives or instincts, which are described as forms of circulating energy. Freud's theory is dualistic in that he speaks of self-preservative drives and sexual drives on the one hand, but he also, in his later work, speculates as to the existence of a destructive drive, or a wish to return to the state of inanimate matter. A further duality is introduced with the concepts of the conflicting pleasure and reality principles, one seeking immediate gratification, the other subordinating that principle to the demands of external reality.

The content of dreams is obviously determined by the circumstances and events of an individual life, but Freud also speaks of 'typical' dreams that appear to be universal. At times he speculates that they represent actual events that occurred in humanity's early history or prehistory. For the most part, however, he relates them to the development of mental structures. Typical Classical dreams relate to the Oedipus complex. In the Greek legend, Oedipus unknowingly murders his father and marries his mother. When he realizes what he has done, he blinds himself in a symbolic act of self-castration. According to Freud, the myth is an expression of a universal desire to have sexual relations with the parent of the opposite sex. Negotiating and ultimately dissolving the Oedipus complex is regarded as a crucial stage in individual development, and indeed in the development of

civilization itself. This involves a successful identification with the parent of the same sex, a renunciation of incestuous desires for the mother, or father in the case of a girl, and, most crucially, the acceptance of sexual difference or the realization that it is the father and not the mother who has a penis. The hysteric's symptoms arise from his or her failure and inability to negotiate this difficult transition.

Although Freud's writings abound in literary references and allusions (mainly to classical German and English literature), references to the visual arts are surprisingly rare (there are virtually no references to music). Psychoanalysis is a 'talking cure', with the speech of the patient and the interpretations of the analyst as it sole medium, and so it does privilege the verbal over the visual, even though Freud often describes dreams as picture puzzles. The terms of Freud's analyses of art are as conventional as his personal tastes: traditional notions of 'genius' are invoked, and the concepts of form, content and expression are quite traditional and unproblematic. His frequent references to the 'mystery' of artistic creativity reflect, for instance, a common theme in Romantic and post-Romantic thought. He admits in his 'Moses' paper that he is no art connoisseur; his tastes are those of a man of his day and his class. His general approach to works of art is to use them to explore the psychology of creation or the psychobiography of the individual artists, rather than to elaborate a formal aesthetics.

Freud's most substantial discussions of art are to be found in the long essay on *Leonardo da Vinci and a Memory of his Childhood* (1910) and the shorter 'The Moses of Michelangelo' (1914). The brief paper on 'Creative Writers and Day-Dreaming' (1907) supplies a lucid introduction to Freud's thinking about the arts and culture, and establishes an important parallel between the creative play of a child and the phantasy or daydreaming of the artist. Freud likens art to a dream, and so follows a path that leads him from the investigation of the dream to the analysis of the work, and then to the analysis of its creator. The underlying mechanism behind all creativity is that of sublimation, the transfer or displacement of sexual energy or libido into more socially or aesthetically acceptable forms. Leonardo's infantile curiosity about sexuality, for instance, first finds expression in his intense desire to look (described as an erotic instinctual activity) and is then sublimated into the adult artist's inexhaustible scientific curiosity and thirst for knowledge. The sublimation of the artist's libido also leads, however, to a declining interest in sexuality itself and to the stunting or atrophy of Leonardo's sexual life. It also explains the austerity of his lifestyle and his well-known inability to complete his

innumerable projects. Here, Freud's analysis of an individual artist overlaps with this more general thesis that the price to be paid for the progress of civilization is the renunciation of the instinctual urge to satisfy sexual and other instincts. The study of Michelangelo's statue *Moses* (in the church of S. Pietro in Vincoli, Rome) effectively makes the statue an allegory of the process of sublimation. Concentrating on the pose of the prophet, Freud argues that the statue depicts Moses at the point when he has held back from destroying the Tablets of the Law, despite his rage at seeing the Israelites worshipping the golden calf. The statue thus depicts a refusal to surrender to the passions of the moment and a resolve to devote mental energy to higher things.

Freud's analysis of Leonardo begins with the artist's 'childhood memory', as recorded in his notebooks, of being repeatedly struck on the lips by the tail (*coda*) of a vulture. Freud interprets the so-called memory as a phantasy about passive oral intercourse, developed at a later period of life (*coda* is also slang for 'penis', and 'to bird' is a common expression for male sexual activity) and grafted on to a memory of the oral gratification of being suckled. The same blissful memory is put forward as an explanation for the *Mona Lisa*'s enigmatic smile. Thanks to a series of associations and analyses of mythology, Freud is thus able to explore the unconscious oral sexual phantasies that, when sublimated, enable Leonardo to create his art. Critics point out that Freud is relying upon a mistranslation: the 'vulture' is in fact a kite, but it is only the word 'vulture' that allows Freud to relate Leonardo's phantasy to myths about a bisexual Egyptian mother-goddess. The imagery of the painting *Madonna and Child with St Anne* (Paris, Louvre) is analysed as a fusion of two female figures, reflecting the fact that the artist had two mothers, having been brought up by his biological mother and then by a stepmother. The folds in the clothes of one are then described by Freud (following the suggestion of a colleague) as reproducing the shape of the vulture in the notebooks. The painting can thus be said to contain a synthesis of the childhood of Leonardo; to be a record of his attempts to come to terms with his infantile sexual experiences and phantasies.

The major trends in post-Freudian psychoanalysis are ego-psychology, object-relations theory, and Lacanian psychoanalysis (an important figure here is Julia **Kristeva**), and all have developed their own theories of artistic creativity, though they again tend to apply primarily to literature rather than to the visual arts. Ego-psychology holds that the content of the unconscious can be made conscious and integrated into a rational ego, which is then amenable to integration into social norms. This is achieved at the cost of resistance to the

instinctual demands of the unconscious and their repression. For ego-psychologists such as Ernst Kris, art is one of the activities that help the ego master the unconscious. It allows, that is, the relaxation of controls on the unconscious or a form of regression that serves the interests of the ego. Art allows the creator to experience forms of pleasure or gratification that are not permissible in real life thanks to the ego's manipulation of the mechanisms of sublimation and a sort of vicarious regression. The reader's or viewer's vicarious identification with the artist is, in its turn, the source of his or her pleasure.

Object-relations theory, derived largely from the work of Melanie Klein and now the dominant tendency within British psychoanalysis, concentrates largely upon the mother–child relationship. The mother is an object to the child in the sense that one speaks of the 'object of one's affections', and one of the child's overwhelming fears is that its aggressive feeling towards the mother and phantasies of destroying her may have done her real damage. The process of reparation or 'making good' that damage is seen as the source of creativity. Adrian **Stokes** is one of the leading figures in the application of Klein's ideas to the visual arts.

Freud's essay on Leonardo posits the existence within a painting of an unconscious meaning of which the artist is unaware but which can be recovered through an applied psychoanalysis. It is that meaning, and the unconscious resonance it has for the viewer, that explains the emotional power of the work of art. The idea that there can be a correspondence between an unconscious inner world and a conscious world, and that creative activity can provide access to the former, is integral to the many forms of art therapy used in clinical psychiatry. It is also basic to forms of play therapy developed (by both Anna Freud and Melanie Klein) for use with children whose verbal skills are insufficiently developed for a true 'talking cure'. In that sense, the play of the preverbal child is quite literally an equivalent to the phantasy of the adult and the creativity of the artist.

Although Freud himself showed no interest in the contemporary arts, psychoanalysis has had considerable influence on the visual arts, from the Surrealists and their attempts to use automatic writing and drawing to liberate and explore unconscious desires and meanings, to the dreamlike scenes painted by Paola Rego. The collaborative work undertaken by the psychoanalyst Grace Pailthorpe and the artist Mednikoff from the 1930s onwards (*Sluice Gates of the Mind*), together with that of the analyst Marion Milner [Joanna Field] (1950), provides fascinating insights into the relationship between psychoanalysis and the visual arts.

In summary, then, Freudian psychoanalysis has been used, with varying degrees of success, in three principal ways: to provide insights into the personality of specific artists (and, it is presumed, their works); to explain the creative process; and, less commonly, to explore the ways in which viewers react to and interpret artworks (an aspect of reception theory). Among those who have developed Freud's ideas as tools of analysis for the visual arts are Ernst Kris, Anton Ehrenzweig, Peter Fuller, Sarah Kofman and Richard **Wollheim**. Jacques **Lacan**'s version of Freudian psychoanalysis has influenced such figures as Julia Kristeva, and has made an important impact of film theory. While psychoanalytical approaches to art have perhaps never been popular in academic circles, many early results seeming crudely reductive, there has been a revival of interest, this time led not by analysts using artworks merely to illustrate theories, but by art historians who in their use of psychoanalytical insights can also draw upon a keen appreciation of the art-historical contexts that condition the creation and the interpretation of artworks.

Biography

Sigmund Freud Born Freiburg, Moravia (now Slovakia), 6 May 1856. Freud studied medicine in Vienna between 1876 and 1882, and in Paris with Charcot in 1885–6. He worked at the Brücke Institute in 1881–2, and at Vienna General Hospital between 1882 and 1885. He collaborated with Joseph Breuer on the use of hypnotism in the late 1880s. Freud developed his private practice in Vienna from 1886, and was Professor of Neuropathology at the University of Vienna from 1902 to 1938. In 1902, with others, he formed a discussion group that in 1908 became the Vienna Psychoanalytical Society. He published *The Interpretation of Dreams* in 1900, *Three Essays on the Theory of Sexuality* in 1905, and *Leonardo da Vinci and a Memory of his Childhood* in 1910. He fled Nazi Germany in 1938 and spent the rest of his life in the UK. He died in London on 23 September 1939.

Bibliography

Main texts

The Interpretation of Dreams (*Die Traumdeutung*, 1900), Freud Library, vol. 4, Harmondsworth: Penguin 1976.
'Creative Writers and Day-Dreaming' (1907); *Leonardo da Vinci and a Memory of his Childhood* (1910); and 'The Moses of Michelangelo' (1914), all in *Art and Literature* (see Collected works below).

Collected works:
Art and Literature, Freud Library, vol. 14, Harmondsworth: Penguin, 1985.

Secondary literature

Adams, L.S., *Art and Psychoanalysis*, New York, HarperCollins, 1993

Bersani, L., *The Freudian Body: Psychoanalysis and Art*, New York: Columbia University Press, 1986.

Ehrenzweig, A., *The Hidden Order of Art*, Berkeley and Los Angeles: University of California Press, 1967.

Fuller, P., *Art and Psychoanalysis*, London: Readers and Writers, 1980

Gedo, M.M., *Looking at Art from the Inside Out: The Psychoiconographic Approach to Modern Art*, Cambridge: Cambridge University Press, 1994.

Gombrich, E., 'Psycho-analysis and the History of Art', in *Meditations on a Hobby Horse*, London: Phaidon, 1963.

Kris, E., *Psychoanalytical Explorations in Art*, New York: International Universities Press, 1952.

Kuhns, R., *Psychoanalytic Theory of Art: A Philosophy of Art on Developmental Principle*, New York: Columbia University Press, 1983.

Milner, M. ['Joanna Field'], *On Not Being Able to Paint*, London: Heinemann, 1950 (reprinted 1987).

Wollheim, R., 'Freud and the Understanding of Art', in *On Art and the Mind*, Oxford: Oxford University Press, 1974.

Special issues:
'Psychoanalysis in Art History', *Art History* 17, 3 (September 1994), edited by Margaret Iversen and Dana Arnold.

Exhibition catalogue:
Sluice Gates of the Mind: The Collaborative Work of Pailthorpe and Mednikoff, Leeds Museums and Galleries, 1998.

DAVID MACEY

ROGER FRY (1866–1934)

BRITISH CRITIC

Roger Fry was one of the most influential British art critics and theorists of the twentieth century, not only for the elite of the art world, but for the general public as well. In his introduction to Fry's *Last Lectures*, Kenneth Clark describes the extent of his influence as 'spread[ing] to quarters where his name was barely known' and to 'those who had never read a word of his writings'. First of all, Fry lectured and wrote voluminously about art, wielding with equal skill a broad historical brush and a fine analytical one. His interpretations and judgements about particular artworks reached a wide audience, and

many artists and collectors turned to him for advice, including J. Pierpont Morgan.

Though Fry began his intellectual life in science, he developed a passionate commitment to painting, which he began in earnest in his university days at Cambridge and pursued for most of his life. Though far less memorable as a painter than as a critic and theorist, his works are exhibited with those of other, better-known painters, especially members of the Bloomsbury group, with whom Fry was closely associated. Also noteworthy is his setting up in 1913 of the Omega Workshops, a collective studio where artists produced and sold pottery, furniture, hand-painted fabrics and other items created for the purpose of marrying artistic beauty and everyday utility. Each Omega creation is unique and thus, for Fry, superior to mass-produced objects of luxury. As many have pointed out (see Collins in *Art Made Modern: Roger Fry's Vision of Art*, 1999, edited by Christopher Green), he was deeply impressed by Thorstein Veblen's well-known ideas about 'conspicuous consumption'.

While Fry's interest in interior design was deeply felt and lifelong, he had another motivation for launching Omega, one connected to a more profound concern and to another project: for the Omega artists tended to support Fry's views about the nature of art and the primacy of 'design' over other aspects.

Fry was explicitly trying to reform the eye of his contemporaries. In 1910 and 1912, he assembled the First and Second Post-Impressionist Exhibitions at the Grafton Gallery in London, thus introducing to the public then unrecognized artists whose work he considered to have great aesthetic integrity. Such artists as Cézanne, Picasso, Van Gogh and Gauguin, venerated by Fry for their expressive use of design, seemed cryptic to a public accustomed to representational, sentimental art, art praised for its verisimilitude, technical skill, mythological subject, social content or emotional effect. He thus started conditioning the British eye to visual modernism, as well as to Asian and African art. Fry coined the term 'Post-Impressionist', which became part of the art critical *lingua franca*. Its meaning, however, is vague, and Fry generally applied it to painters he thought had transcended the interest in depicting appearances, artists who exemplified expressive use of form with originality. These concepts are key to understanding Fry's theory of art.

Fry is generally considered a formalist in aesthetic theory, and is often associated with Clive **Bell**; many aestheticians speak of Bell and Fry in the same breath when they discuss early formalism. Fry's aesthetic, however, is different from Bell's, especially regarding the role

and range of emotions involved in aesthetic experience, as Pierrette Jutras (1993) rightly points out. Fry's aesthetics brings art more closely to lived, shared human experience. Bell and Fry worked closely together, especially on the Second Post-Impressionist Exhibition, and had a passion for modernism. Fry was warmly accepted by the Bloomsbury group (Virginia Woolf wrote a sympathetic biography of him, and he was romantically involved with the painter Vanessa Bell). His formalism, however, has more affective dimensions than Bell's. Though his work, unlike Bell's, has not been included in the philosophical canon, it exemplifies more clearly the ethos of philosophical inquiry. Throughout his oeuvre one sees an ambivalence about segregating art entirely from the emotions of life, and Fry's early training in science (perhaps along with his formative childhood friendship with the philosopher John McTaggert) has given his work an analytic rigour of argument and acuity of observation that is distinctive.

Both his aesthetic theory and his criticism show the influence of his scientific training. He says in his essay 'Retrospect' (*Vision and Design*, 1920) that he has always been guided by some aesthetic theory which would 'attempt some sort of logical coordination of [his] impressions'. He describes this theory not as *a priori*, but more pragmatic, 'a tentative expedient'. Unlike Bell, he purports never to have known 'the ultimate nature of art'. That said, he speaks with an authoritative voice both on theory and on particular works and movements.

Moreover, even if he has not found the 'ultimate nature' of art – that is, its necessary and sufficient conditions – he clearly treats some features as necessary to art. For Fry, it is fair to say, an artwork is an artefact that originates in the artist's imagination and calls into play the spectator's. It evokes a constellation of emotional responses and does so by means of design, in conjunction with other formal qualities.

The foundation of his formalism is a commitment to the separation between imaginative and actual life, and thus between art and life. In disconnecting them, he is attacking the view that art is representation, and also the view that art is the expression or evocation of sentiment, both of which he finds inherently 'non-aesthetic'. For if art is so tied to the world, then its function would be duplicated by other endeavours; and it would make it impossible to explain how we can react so immediately to art that we do not understand cognitively. He argues further that, if the visual arts were simply the imitation of life, then they would have no relation to arts such as music or architecture, which he believes them to have. Art, for Fry, is chiefly form, albeit expressive form, and is part of the imaginative, not practical, life.

In 'An Essay In Aesthetics' (*Vision and Design*), he constructs his theory on the basis of psychological observations: in actual life, our perceptions lead us to action; in imaginative life, they do not. When we see a vicious animal, we retreat in fear. If we see the same animal in imagination, we have no instinctive reaction to flee. Because of the imagination's independence from pragmatic concerns, it allows us greater clarity of perception and 'greater purity and freedom of its emotion' than we have in perceiving the actual world. Because our perceptions are usually conditioned by our attitudes, instincts and interests, and often require us to act quickly, few among us really see what things look like or allow themselves to feel emotions life situations evoke. We perceive and react emotively to the world, but we do not scrutinize our perceptions and emotions; we rarely have that luxury, except perhaps on reflection.

Art deals with pure visual form and the emotions it can call forth. Art cannot, then, exist to serve morality, for art allows us to savour and to reflect on the elements of experience unfettered by a need to take action. As he remarks in the same essay, morality 'appreciates emotion by the standard of resultant action. Art appreciates emotion in and for itself.'

Artistic excellence, for Fry, is not beauty, but rather a fusion of formal and emotional vision. His notion of form has a variety of constituents, including subtlety of light and shade, rhythm of line, colour and plasticity. To appreciate a work of art requires that we strive disinterestedly for a sympathy with the artist's vision. This is not the same as trying to learn the artist's personal intentions. The spectator must, though, be aware that the object is an artefact, a human creation. In 'The Artist's Vision' (*Vision and Design*) he avers that the artist should adopt 'the most complete detachment from any of the meanings and implications of appearances'.

Fry's idea of emotional expression in art does not deal with emotions of life, as a thinker like Tolstoy or **Freud** would have it, but rather with emotions conjured by the grasp of visual reality. In *Cézanne: A Study of His Development*, Fry claims that

> the still-life ... [is] the purest self-revelation of the artist. In any other subject humanity intervenes ... the still-life ... guards the picture itself from the misconstructions of those [viewing] art as representation. In still-life the ideas and emotions associated with the objects represented are, for the most part, so utterly commonplace and insignificant ... It is this fact that makes the still-life so valuable to the critic as a gauge of the artist's personality.

Fry, with his focus on an artwork as showing 'plastic form' as a basis for emotional response, describes the Cézanne still-life as '[a drama] deprived of dramatic incident'.

It is an artistic achievement, he says, for the artist to find the ideal material for the 'embodiment of his feeling'. For instance, 'the refined and spiritualized sensuality of a Fra Angelico finds a perfect response in the opalescent washes of egg-tempera ...' (Cézanne, 1927). But it is Cézanne, in Fry's eyes, who fuses material, design and vision so magnificently. And again, it is in discussing Cézanne that Fry shows us the meaning of his own formalism.

He tells us that Cézanne, in his Compotier, expresses a dark, vital emotional sensibility, by emphasizing contour, which he 'draws with his brush, generally in a bluish grey'. Cézanne contrasts this 'curvature' with 'parallel hatchings', a disturbing pattern which he repeats in the picture space. This gives the effect of 'bold definition' which actually evades the attentive viewer. 'In spite of the austerity of the forms, all is vibration and movement.' Speaking of Cézanne's Still-life with a Ginger Jar, Fry explains that the 'inter-play of violet-rose and bluish tints' gives the work a luminous, happier tone. In his later, more expressive La Femme à la Cafetière, Cézanne also depicts 'vibration and movement of life'. Cézanne, Fry remarks, knows that 'a flat door could reveal as many complexities of movement, as great a play of surface, as any object whatever, under the play of light'. Later in his study, Fry discusses the way Cézanne uses volume and picture space to express also his own fearful eroticism. Thus, we see that an artwork is a panoply of emotional expressions. Some readers take this as an inconsistency in Fry's formalism; but it is rather his reflective expansion of the range of aesthetic emotion, his attempt to deepen the notion of 'significant form'.

In his Last Lectures (1939), presented during his short tenure as Slade Professor at Cambridge (1933–4), Fry argues that education should attend to the visual as well. His own carefully argued assessments of artworks are prophetically contrary to the views of his time. He disputed the value of many then-canonical works and artists, offering a new standard of judgement and art history.

Fry believes that interpretation of an artwork is not a subjective matter. From his earliest to his latest work, he changes the contours of his theory, but he never abandons the belief that one can give, indeed must give, reasons for aesthetic judgements and interpretative claims. He welcomed other interpretations than his own, but they had to fit the data; only a certain set of interpretations is acceptable. This may be the most salient manifestation of his scientific sensibility. But art, Fry

believes, is quite different from the phenomena explained by science. In his lecture 'Sensibility' (*Last Lectures*) he says, 'we shall always find the tendency at once to recognize a law or fixed principle and at the same time never to let the work of art become a mere enunciation of the law. It will perpetually approximate to a law and perpetually vary from it.'

Some might find his views offensively positivistic or patronizing towards earlier or non-Western cultures. But it is crucial to acknowledge how he assaults, in the idiom of his moment, the moral rigidity and materialism of the modern Western ethos, and how, Socratically, he examines his own assumptions. He had an intellectual audacity and readiness to refine his own theories. He also had a sometimes unfashionable conviction that art could speak across cultures and that it was more than a matter of subjectivity. Kenneth Clark is none the less correct about the range of his influence. With his erudition, insight and energy, Fry infused the twentieth-century landscape with 'vibration and light'.

Biography

Roger Fry Born London, 14 December 1866, to a British Quaker family of affluence. He studied science at Cambridge, and at the same time began to paint. In 1889 he studied painting in London and then travelled widely in Europe to study the Great Masters. He lectured widely, becoming known as a connoisseur in England and abroad. Between 1905 and 1910 Fry was Curator of the Metropolitan Museum, New York. He became co-editor of *Burlington Magazine* in 1909, and he set up the Omega Workshops in 1913 (closed 1919). With Clive Bell, he organized the First (1910) and Second (1912) Post-Impressionist Exhibitions in London. In 1933–34 Fry was Slade Professor of Art at Cambridge. He lectured and wrote widely, championing new artists and African, Asian and primitive art. Fry died in London on 9 September 1934.

Bibliography

Main texts

Giovanni Bellini, London, 1899. Later edition: David Alan Brown (Introduction) and Hilton Kramer (Afterword), New York: Ursus Press, 1995.
Vision and Design, London: Chatto and Windus, 1920. Later edition: J.B. Bullen (ed.), London and New York: Oxford University Press, 1981.
Transformations: Critical and Speculative Essays on Art, London: Chatto and Windus, 1926.
Cézanne: A Study of His Development, New York: Macmillan, 1927.

Henri Matisse, New York: E. Weyhe, 1935.

Last Lectures, with an introduction by Kenneth Clark, Cambridge and New York: Cambridge University Press, 1939.

Correspondence:

Letters of Roger Fry (2 vols), Denys Sutton (ed.), London: Chatto and Windus, 1972.

Readers:

A Roger Fry Reader, Christopher Reed (ed.), Chicago: University of Chicago Press, 1996.

Secondary literature

Banfield, A., *The Phantom Table*, Cambridge: Cambridge University Press, 2000.

Falkenheim, J.V., *Roger Fry and the beginnings of formalist art criticism*, Ann Arbor, Mich.: UMI Research Press, 1980.

Green, C. (ed.), *Art Made Modern: Roger Fry's Vision of Art*, London: Merrell Holberton Publishers, 1999.

Jutras, P., 'Roger Fry et Clive Bell: divergences fondamentales autour de la notion de "Significant Form" ', *Revue d'Art Canadienne/ Canadian Art Review* 20 (1993), 98–115.

Laing, D., *An Annotated Bibliography of the Published Writings of Roger Fry*, New York: Garland Publishing, 1979.

Lang, B., 'Significance or Form: The Dilemma of Roger Fry', *Journal of Aesthetics and Art Criticism* 20 (1962), 167–76.

Nicolson, B., 'Post-Impressionism and Roger Fry', *Burlington Magazine* 93 (January 1951), 11–15.

Reed, C., 'The Fry Collection at the Courtauld Institute Galleries', *Burlington Magazine* 132 (November 1990), 766–72.

Spalding, F., *Roger Fry: Art and Life*, Berkeley and Los Angeles: University of California Press, 1980.

Taylor, D., 'The Aesthetic Theories of Roger Fry Reconsidered', *Journal of Aesthetics and Art Criticism* 36 (1977), 63–72.

Woolf, V., *Roger Fry: A Biography*, London: Hogarth Press 1940.

CAROL S. GOULD

HANS-GEORG GADAMER (1900–2002)

GERMAN PHILOSOPHER

What happens to us in our experience of art?

Gadamer's aesthetics seeks to demonstrate that art does not re-present actuality but transforms it, and that what happens to us within our experience of art is best understood in terms of a linguistic analogy with conversation. These arguments have significant outcomes: they reconfigure the question of aesthetic subjectivity, and they hint at a

participatory epistemology of aesthetic response which is missing from post-structuralist approaches to art.

Gadamer's aesthetics turn on the pivotal concept of subject matter (*die Sache selbst*). This is not just the referent of a work of art but also refers to the inherited presuppositions (tradition) which structure an artist's pre-understanding of his or her chosen theme. A new rendition of a chosen subject can alter our received preconceptions of it. This underpins Gadamer's concept of art-historical tradition as an ever-evolving 'conversation' or exchange between how subjects have previously been conceived and how our contemporary society understands them. This commits Gadamer to opposing the representationalist theory of art.

Gadamer's thesis that art can transform actuality – the 'transformation into structure' argument – is central to his opposition. Representationalists hypostasize an external or transcendent reality as a primary truth which, in being prior to art, is esteemed as the proper object of art. This renders art secondary to an original truth and limits art to a reproduction of that truth. However, this reasoning actually prevents art from fulfilling its supposed task: artworks can only express a *particular* aspect of their subject, never the whole. Representationalists are aware that art can resist such subordination: art has the capacity to assert the primacy of appearance over truth. The danger in the representationalist's mind is that, though an artwork cannot afford a complete view of its subject matter, the view it does afford can be so aesthetically compelling as to seem complete: aesthetic completeness masquerades as epistemological adequacy. The advent of non-representational art has not, as might have been expected, made the representationalist position redundant. Analyses of how class and gender are represented in art are invariably premised upon dualist assumptions about a primary truth and its (secondary) manipulation by art. Gadamer's thinking is implacably opposed to the ontological dualism which characterizes these positions.

Gadamer speaks not of representation (*Vorstellung*) but of 'presentation' (*Darstellung*). Representation suggests an interpretation dependent upon a prior truth, whilst presentation speaks of a coming-forth of a subject which, though it may transcend its interpretation, nevertheless inheres within it. Art is no longer subordinate to its conceptual subject but becomes a vehicle of its sensuous appearance. Whether art distorts its subject matter is not to be settled by determining the relationship between an original truth and its interpretation, but by appraising the appropriateness and consistency

of an interpretation within the received corpus of approaches to that subject matter.

Though a subject inheres in its *Darstellung*, because of the historical particularity of the latter, it can never be given completely. Whereas for Plato a plurality of interpretations implies an ever-greater distanciation from the original subject matter (Form), for Gadamer it is precisely such a plurality which permits a more complete vision of the subject matter: its potentialities are brought to a fuller realization. Art does not cloak reality in appearance but allows actuality to reveal itself more extensively. Gadamer's dialectical precept disrupts the representationalist conception of an actuality ontologically prior to art. The open subject matters of art, art's history and its practice, maintain their being by achieving ever-new interpretations (partial closures) of *themselves*.

For certain critics, such 'closure' betrays the illusory character of art. An articulate work can present us with a closed circle of determinate meaning, whereas the indeterminacies of existence elude closure. Condemnation of closure as 'fantasy' returns us to the representationalist juxtaposition of a 'true' world and its artistic misrepresentation. It is, paradoxically, precisely this fictive element which, according to Gadamer, both draws us to art and also illuminates its transforming capacities. The indeterminacy of existence means tolerating a world in which the things (subject matters) which concern us – meaningfulness, goodness, love – remain uncertain in nature and outcome. The capacity of art to draw unresolved threads of concern into a coherent determinate pictorial or narrative structure allows a clearer vision of what in actuality remained unclear. Gadamer does a lot more than re-work the aesthetic language of Baumgarten. An artwork's capacity to present as a closed circle a set of meanings which, prior to the perception of the work, were not perceived as related at all, enables us to see that what we had either overlooked or grasped as fragmentary was potentially part of a coherent whole. Art often enables us to see clearly what we often only perceive indistinctly. The paradox of fiction and illusion is that, by bringing into structure that which seemed indeterminate and vague, we are empowered to see the potential truth within what we had only dimly apprehended or overlooked. By transforming indeterminate perceptions of a subject into a determinate structure, the artwork is capable of transforming how we understand ourselves and our world. Within this dialectical framework, the closure of a work (though never final) brings us (albeit temporarily) to understand differently both ourselves and the world we are in.

The ability of art to effect change in our understanding is premised on the claim that 'art addresses us'. This is a metaphor which is, in certain respects, misleading. If art were to function like a language, it could be reducible to a semiotic schema. Gadamer, however, is not in pursuit of a visual grammar. Although he accepts that understanding a visual communication pre-supposes a prior understanding of the conventions which enable it, understanding the content of that communication is not reducible to an understanding of the rules of its language. The thrust of Gadamer's metaphor is that art 'speaks' to us in the way that language 'speaks' to us; that is, as a 'dialogical event'. What happens to us when we are addressed by art is analogous to what takes place within conversational exchange. Conversations can bring things to mind and put things into play which the participants of an exchange would not have anticipated prior to their exchange. With equal force and sometimes quite contrary to 'our willing and doing', an artwork can effect a change in how we perceive ourselves or a subject. Such responses are occasioned by our 'participation' in the aesthetic exchange between the work and its subject matter. Gadamer insists that they are not to be rejected as subjective but must be appraised as different moments in the objective unfolding of a work's reception history. Just as a conversation can take an unexpected turn, involvement with a work's subject can lead our eye to see things that question the security of our expectancies. Gadamer identifies this not as a subjective response but as 'the activity of the thing itself' (*Tun der Sache selbst*) which we, in aesthetic reflection, give ourselves over to (*ekstasis*). Yet the dynamic of aesthetic understanding is centripetal as well as centrifugal. Accordingly, the theme of recognition fuses Gadamer's notion of art as a dialogical event with his transformation into structure argument.

To be a language speaker (oral or visual) requires not only a command of a certain grammar but also a participation in a language-world (a life-world). Such participation binds us to defining cultural concerns (subject matters) to whose historical shape and character we are profoundly susceptible. Participation in such a world is a pre-condition of any dialogical event. Gadamer follows **Heidegger** in believing that the temporally fragmented nature of our unreflective activities prevents us from grasping the extent to which we are formed by those values and prejudices which mediate our ordinary horizon from afar. The character of our unreflective existence is one of dispersal: we in fact reside beyond ourselves and remain cognitively unaware of that fact. However, just as a subtle joke or insightful remark can suddenly bring us to recognize that previously accepted

innocuous remarks are indeed indicative of deep prejudices, so too can an artwork bring indistinct, fragmented, or half-overlooked perceptions into a transfiguring structure. This allows us to recognize for the first time the explicit meaningfulness or truth of what was at play within experience of which, in its implicit or untransfigured state, we failed to be mindful. By transforming what was in play within experience, art allows us to *recognize* that which was before our eyes but which we had failed to see: the *truth* of experience as such. Thus, by bringing the potentialities at play within actuality to explicit realization, art does not re-present actuality at all but brings it to a greater reality.

A difficulty with the representationalist account of art is that its prioritization of a primary world renders any artistic re-presentation secondary, apparent, derivative and, indeed, subjective. A corollary to this is the 'objectivist' view of the artwork: the work is esteemed as *the* original, whilst interpretation and commentary are judged secondary. Gadamer's concept of *Darstellung* – the artwork as the springing-forth of its subject matter – resists such oppositions. Although he speaks of such springing-forth as the action of the subject matter itself, the concept of art as a dialogical event stresses its participatory nature (spontaneous, unanticipated conversational turns could not take place without the participants keeping the conversation in play). Individuals do not decide whether or not to start a conversation; they *fall into* conversation. An artist does not decide *ex nihilo* what his or her subject matter is going to be; the choice will already be influenced by how a given subject matter has been historically received. Just as conversation pre-supposes a prior mutual involvement in a life-world, so an artist's endeavours assume immersion in a defining cultural horizon. Thus, at the outset of such endeavours, the 'conversation' is already in play, the requisite *Sachen* (the historical ideas which articulate our cultural horizons) are already active. Just as a game or conversation maintains its effective being by being kept in play, so the constellation of concerns and concepts which form a tradition's subject matters maintain their being only by being kept in play by a community's artists and thinkers. A subject matter lies dormant the moment it ceases to be interpreted. Only in being addressed does it continue to function. Speaker and conversation, artist and subject matter are each ontologically dependent upon the other in order to spring forth.

Although the concept of *Darstellung* involves a participatory element, Gadamer insists that it is the *event* of art (the coming-forth of a subject matter) which is paramount, in just the sense that a conversation or game sweeps its participants along *despite* themselves.

Gadamer's dialogical conception of art is therefore a fundamentally *dialectical* one. The *Sachen* are not of our own willing and doing. Neither for that matter are they exhaustive: no presentation (interpretation) of a subject matter can claim to be definitive, for the potential content of a subject matter will always transcend its specific cultural instantiations. This is why the 'transformation-into-structure' argument is significant for, although there is in principle always more to be said of a subject matter, each historical coming-forth (*Darstellung*) allows that subject matter to accrue a greater temporal reality or presence. If a subject matter is always more than can be said or depicted of it, then every time an artwork attempts an interpretation of a *Sache*, a residual untranslatable space is opened between the subject matter and its rendering. This space, since it involves a residual tension between what has and has not yet been said or shown, is autopoietic in the sense that *it* drives the attempt of subsequent interpretations to close it. That which drives a cultural tradition forward is therefore an ineliminable tension between potentiality and actuality at the heart of its subject matters, a tension which each artwork marks and is marked by. By responding to that ineliminable tension, each artwork in fact perpetuates it. Our individual responses to an artwork are thus part of a much wider historical dialectic. Echoing both Heidegger and Hegel, Gadamer insists that what comes-forth in our experiences of an artwork is indicative not of our responses *per se* but of the life of the subject matter itself (*die Sache selbst*).

Biography

Hans-Georg Gadamer Born Marburg, Germany, 11 February 1900. Gadamer was educated at the University of Marburg and, after meeting Martin Heidegger, started to fuse classical philosophy with phenomenology, a theme which has characterized all of Gadamer's work. He was Professor of Philosophy at the Universities of Marburg (1937–9), Leipzig (1939–47), Frankfurt (1947–9) and Heidelberg (1949–68). His *magnum opus*, *Wahrheit und Methode* (*Truth and Method*, 1960), transformed his reputation from a relatively unknown German academic to a philosopher with an international reputation. After his retirement, Gadamer engaged upon a second teaching career in North America and published numerous essays on classical thought, philosophy and literature, aesthetics and phenomenology. Gadamer remained Emeritus Professor of Philosophy at the University of Heidelberg until his death on 13 March 2002.

Bibliography

Main texts

Truth and Method (*Wahrheit und Methode*, 1960), trans. William Glen-Doepel, London: Sheed and Ward, 1975.

The Relevance of the Beautiful and Other Essays (*Die Aktualität des Schönen*, 1977, and *Kleine Schriften* II, 1967, and IV, 1977), trans. N. Walker, London: Cambridge University Press, 1986.

Heidegger's Ways (*Heideggers Wege*, 1983), trans. J.W. Stanley, Albany: State University Press of New York, 1994.

Literature and Philosophy in Dialogue: Essays in German Literary Theory, Albany: State University of New York, 1994.

Collected works:

Gesammelte Werke, Tubingen: J.C.B. Mohr, 1993 (especially vol. 8, *Asthetik und Poetik*).

Secondary literature

Davey, N., 'The Hermeneutics of Seeing', in Ian Heywood and Barry Sandywell (eds) *Interpreting Visual Culture, Explorations in the Hermeneutics of the Visual*, London: Routledge, 1999.

——, 'Art, religion, and the hermeneutics of authenticity', in Salim Kemal and Ivan Gaskell (eds) *Performance and Authenticity in the Arts*, London: Cambridge University Press, 1999.

——, 'Hermeneutics and Art Theory', in P. Smith and C. Wilde (eds) *A Companion to Art Theory*, Oxford: Blackwell, 2002.

Grondin, J., *Introduction to Philosophical Hermeneutics*, New Haven: Yale University Press, 1994.

Hahn, L.E. (ed.), *The Philosophy of Hans-Georg Gadamer*, Chicago: Open Court, 1997.

Warnke, G., *Gadamer: Hermeneutics, Tradition and Reason*, Stanford: Stanford University Press, 1987.

Weinsheimer, J., *Gadamer's Hermeneutics, A Reading of Truth and Method*, New Haven: Yale University Press, 1985.

——, *Philosophical Hermeneutics and Literary Theory*, London: Yale University Press, 1991.

Wolff, J., *Hermeneutic Philosophy and the Sociology of Art*, London: Routledge and Kegan Paul, 1980.

NICHOLAS DAVEY

ERNST GOMBRICH (1909–2001)

AUSTRIAN-BORN ART HISTORIAN

Sir Ernst Gombrich received the highest honours that his adopted country, Britain, and the international academic community can award. Associated with the Warburg Institute throughout his career, he

served as its director for nearly two decades. He also held prestigious academic posts and continued to add to an impressive body of publications. As a Renaissance scholar he contributed much to this area of art history, but he steadfastly pursued broader interests as well. His first book, an introduction to art history entitled *The Story of Art* (1950), may well be the most popular book about art ever written; it has been translated into over twenty different languages. *The Story of Art* showcases Gombrich's ability to discuss the issues raised by the history of art in an accessible and often witty manner without diminishing their complexity. In his second book, *Art and Illusion* (1960), he ventures into the realm of psychology, believing that rapidly advancing studies of perception can do much to support our understanding of art. This endeavour is in many ways central to Gombrich's oeuvre. Admitting to his fascination with the 'how' and 'why' of art history, Gombrich was especially interested in trying to explain the phenomenon of style:

> Glancing through [a] variety of illustrations, we take in the subject of a picture together with its style; we see a Chinese landscape here and a Dutch landscape there, a Greek head and a seventeenth-century portrait. We have come to take such classifications so much for granted that we have almost stopped asking why it is so easy to tell whether a tree was painted by a Chinese or by a Dutch master. If art were only, or mainly, an expression of personal vision, there could be no history of art. We could have no reason to assume, as we do, that there must be a family likeness between pictures of trees produced in proximity.

When exploring the role of psychology in the creation and reception of art in *Art and Illusion*, Gombrich focuses in particular on the development of naturalism in art. It is usually assumed, he notes, that artists make their art look like an object or a natural scene by simply *looking* at the object or natural scene that they have chosen for their subject, and then imitating it. He questions this assumption and comes to the disconcerting conclusion that it is false. The problem, Gombrich points out, is that artists, just like the rest of us, don't see the object in front of them in any one specific way. 'The artist will be attracted by motifs which can be rendered in his idiom [and] will therefore tend to see what he paints rather than to paint what he sees.' Naturalistic art creates an illusion of verisimilitude, but it does not copy nature in a 'true' or 'real' sense. Instead, Gombrich believes, art is

created by means of a trial-and-error process of schema and corrections: 'Making comes before matching.' Artist's do not 'match' reality first; they start out – in keeping with basic modes of perception – by constructing 'minimum models' (or schema) which are gradually modified (or corrected) until they 'match' the impression that is desired.

Gombrich's pioneering efforts to combine art and psychology are unique, although he specifically acknowledges the influence of psychologist/philosophers Ernst Kris and Karl Popper. Others, even Sigmund **Freud**, have utilized psychoanalytic approaches to address the personal issues that may influence individual artists. Gombrich, however, is primarily concerned with psychology in the sense that it is a science centred on revealing the workings of the human mind and the physiological framework of human behaviour. In art-historical terms, his 'making-to-matching' theory is also unique. It is not a methodology as such, but it has brought about a reorientation of existing methodologies.

Another famous work, 'Meditations on a Hobby Horse or Roots of Artistic Form' (1951), is summarized here in some detail since it is a good example of Gombrich's approach, illustrating his interest in redefining the fundamental aspects of art-historical thought and his use of psychology.

Gombrich begins by deciding that a very ordinary hobby horse – with a broomstick body and crudely carved head – cannot be described as an *image* of a horse since the dictionary defines image as 'imitation of object's external form'. A hobby horse does, however, *represent* a horse. 'Represent' has two distinct meanings and, while it can be used in the sense of portrayal, it can also (as in this case of the hobby horse) be used as a 'substitute'. Having established this basic but significant definition, Gombrich embarks on a series of musings:

1 He points out that the line of reasoning implied by the dictionary definition of 'image' is not valid; an artist does not abstract the form from what he sees because our mind works by differentiation rather than by generalization. Even a child will identify all large four-footers as 'gee-gees' before he learns to distinguish breeds and 'forms'.

2 Another deeply rooted but ultimately false concept is the idea that abstraction applies to generalization (as in history painting of the eighteenth century) and that imitation applies to specific examples (eighteenth-century portraiture). A hobby horse is neither; it is a substitute. To a child it is a horse like all other horses and might

even merit its own name. Moreover, the degree to which an object adequately represents something is totally independent of the degree of differentiation.

3 Art as creation rather that imitation is not a new idea; the ancient Egyptians, for instance, do not 'distort' their motif or intend that their work be seen as the record of any specific experience. In many cases their images simply serve as substitutes, taking the place of a person or a god just as the hobby horse takes the place of a horse.

4 Since the 'first' hobby horse was probably just a stick – a rideable stick – the common factor between horse and stick was function rather than form. In considering a possible scenario for the origin of the hobby horse, Gombrich suggests that the owner of the rideable stick one day decided to add reins, eyes and a mane. Communication may not be a factor at all; the inventor may not have wanted to show his horse to anyone. It served his purposes of play well and that may well have been enough. Therefore, substitution may precede portrayal, and creation may precede communication.

5 From Pliny's time onward, the deception of animals has been considered proof that a painting is a completely objective illusion. Though a plausible idea, it has been proven to be wrong by recent developments in animal psychology. Animals, it turns out, respond to extremely abstract forms in the same way as fully developed naturalistic forms, if those forms are biologically significant to the animal. 'An "image" in this biological sense is not an imitation of an object's external form but an imitation of certain privileges or relevant aspects, and man is not exempt from this type of reaction.'

6 The same stick that was used for that early hobby horse could become a substitute for something else in another setting (for example, a sword, a sceptre, etc.). The same triangle shape, for instance, is a favourite pattern of many adjoining Native American tribes, but it is given different meanings by the different groups.

7 Consideration of the hobby horse can lead to a reformulation of the often-used term 'conceptual image' since it does not necessarily consist of features which make up the concept of a horse or reflect the memory image of horses seen. On 'the most primitive level, the conceptual image might be identified with what we have called the minimum image – the minimum, that is, which will make it fit into a psychological lock.'

8 When trying to account for the 'islands of illusionistic styles' that appear throughout art history, Gombrich points to one difference – a change in function. He reminds us that 'representation' has

two meanings: substitution and portrayal. When the latter concept was adopted, an image could be seen to represent something outside of itself and serve as a record of visual experience. Then, the completeness of essentials that dominated the creation of a substitute could be discarded and the viewer was able to participate in the process (by understanding that a hand or foot not in full view is meant to be in shadow, by endowing space around a form, etc.).

9 Gombrich does not hold that art moves in a strictly linear fashion, but he concludes his essay by noting that the process of art builds on itself and cannot be reversed. The hobby horse discussed here is not art, but if an artist like Picasso made one, it would be; conversely, in spite of a great artist's best efforts, the artist's hobby horse cannot mean to us what it meant to its first creator. 'No sooner is an image presented as art than, by this very act, a new frame of reference is created which it cannot escape.'

The ideas put forth by Gombrich in 'Meditations on a Hobby Horse' are applied directly to the development of naturalism as in *Art and Illusion*, and, since this application has become so closely associated with him, some critics have mistakenly believed that Gombrich advocates the primacy of naturalistic art. It is, therefore, important to note that Gombrich's theories apply to non-representational art just as they apply to illusionistic art. 'The contrast between primitive art and "naturalistic" or "illusionistic" art can easily be overdrawn. All art is "image-making" and all image-making is rooted in the creation of substitutes.' Art that has historically been more conceptual or abstract, such as the art of Ancient Egypt and the Middle Ages, is art that focuses on the use of schemata; naturalistic/illusionistic art such as that of Ancient Greece and the Renaissance uses schemata as its starting point.

Gombrich acknowledges that the movement towards naturalism is a process that interests him, but other movements and processes clearly interest him as well. 'Achievement in Medieval Art' (1937), 'The Primitive and its Value in Art' (1979) and 'Magic, Myth, and Metaphor: Reflections on Pictorial Satire' (1989) are just a few selections from his vast repertoire that attest to his wide-ranging interests. In *The Sense of Order* (1979) he applied his perception-based theories to the decorative arts with great success.

Gombrich has been a frequent commentator on both historio-graphic issues and contemporary trends in art history, and in this capacity has also drawn criticism. It is ironic that on the one hand he

has been charged with being too traditional and on the other with being radical, when, in fact, he consistently manages to find a balance between the two extremes. He is firm, for instance, in rejecting the idea that any art-historical period should be considered a period of decline (in accordance with his Vienna school training), and yet he is equally firm in his defence of the idea of a canon. He argues that, since artists strive for achievement, and art history is a record of achievement, a value system is therefore intrinsic to the discipline. He adds, however, that this value system can and should be continuously revised. Another example is provided by his championship of cultural history. In this he is justifiably identified with an art-historical method called iconology, the search for meaning in art through the study of art as symbol; he has nevertheless been publicly critical of this method, particularly because of its potential for excesses and also for certain linkages with Hegel's cultural model. Although Gombrich acknowledges that art, like other aspects of a culture, can be considered symptomatic of that culture, he believes that no single 'Spirit' is all-pervasive within a period. He points out that movements in art are distinct from the more abstract concept of periods in that they are instigated and maintained by individuals, and are not nearly as consistent as Hegel, Max Dvořák, and even Erwin **Panofsky** maintain. This line of thought reflects the influence of historians such as Benedetto **Croce**, who deny the history of art altogether, but Gombrich refuses to extend his arguments that far. He believes that art and cultural history should focus on individuals without forgetting that individuals belong – for various reasons and to varying degrees – to movements.

Gombrich's work defies categorization, but it has been profoundly influential. Whether fully accepted or not, Gombrich's approach has fundamentally shifted the manner in which modern art-historians work: traditional views are expanded through the use of psychology, consideration of scientific methods and the questioning of standard definitions. Given his belief that other disciplines should be used in art-historical studies, it is a fitting tribute that his work, in turn, has been utilized in many other fields, notably semiotics and linguistics.

Biography

Ernst Hans Josef Gombrich Born Vienna, 30 March 1909, his father a lawyer and his mother a pianist. Gombrich was educated at the Theresianum, Vienna, and between 1928 and 1933 he studied Art History at Vienna University under Julius von Schlosser. He emigrated

to England in 1936, becoming a Research Fellow at the Warburg Institute, University of London, 1936–39. During World War Two he worked for the BBC Monitoring Service. He taught at the Warburg Institute from 1936 to 1959, and at University College London from 1956 to 1976. He was Slade Professor of Fine Arts at Oxford, 1950–53; Visiting Professor at Harvard University in 1959; Slade Professor at Cambridge, 1961–63; Director of the Warburg Institute, 1959–76; and White Professor-at-Large, at Cornell University, 1970–77. Gombrich died in London on 3 November 2001.

Bibliography

Main texts

Caricature, with Ernst Kris, Harmondsworth: Penguin, 1940.

The Story of Art, London: Phaidon, 1950 (sixteenth edition, 1995).

'Meditations on a Hobby Horse or the Roots of Artistic Form', in L.L. Whyte (ed) *Aspects of Form: A Symposium on Form in Nature and Art*, New York: 1951 (reprinted in *Meditations on a Hobby Horse and Other Essays on the Theory of Art*, London: Phaidon, 1963).

Art and Illusion: a Study in the Psychology of Pictorial Representation, London: Phaidon, 1960.

Meditations on a Hobby Horse and Other Essays on the Theory of Art, London: Phaidon, 1963.

Norm and Form: Studies in the Art of the Renaissance I, London: Phaidon, 1966.

'Style', in the *International Encyclopaedia of the Social Sciences*, vol. 15, New York: 1968.

'In Search of Cultural History', the 1967 Philip Maurice Deneke Lecture, Oxford, 1969 (reprinted in *Ideals and Idols*, London: Phaidon, 1979).

Aby Warburg: an Intellectual Biography, London: Warburg Institute, 1970.

Symbolic Images: Studies in the Art of the Renaissance II, London: Phaidon, 1972.

Illusion in Nature and Art, edited with R. Gregory, New York: Scribner, 1973.

The Heritage of Apelles: Studies in the Art of the Renaissance III, London: Phaidon, 1976.

Means and Ends: Reflections on the History of Fresco Painting, London: Thames and Hudson, 1976.

Ideals and Idols: Essays on Values in History and in Art, London: Phaidon, 1979.

The Sense of Order: a Study in the Psychology of Decorative Art, London: Phaidon, 1979.

The Image and the Eye: Further Studies in the Psychology of Pictorial Representation, London: Phaidon, 1982.

Tributes: Interpreters of our Cultural Tradition, Oxford: Phaidon, 1984.

New Light on Old Masters: Studies in the Art of the Renaissance IV, Oxford: Phaidon, 1986.

Reflections on the History of Art: Views and Reviews, R. Woodfield (ed.), Oxford: Phaidon, 1987.

Topics of our Times: Twentieth Century Issues in Art and in Culture, London: Phaidon, 1991.

A Lifelong Interest: Conversations on Art and Science with Didier Eribon (*Ce que l'image nous dit*, 1991, with Didier Eribon), London: Thames and Hudson, 1993 (American edn, *Looking for Answers*, New York: Harry N. Abrams, 1993).

The Preference for the Primitive, London: Phaidon Press, 2002.

Selected writings:

The Essential Gombrich: Selected Writings on Art and Culture, R. Woodfield (ed.), London: Phaidon, 1996.

Ernst H. Gombrich: A Bibliography, J.B. Trapp (ed.), London: Phaidon, 2000.

Secondary literature

Goodman, N., *Languages of Art: An Approach to a Theory of Symbols*, Indianapolis: Bobbs-Merrill, 1968.

Gorak, J., 'Sir Ernst Gombrich and the Functionalist Canon', in *The Making of the Modern Canon: Genesis and Crisis of a Literary Idea*, London and Atlantic Heights, NJ: Athlone, 1991.

Lepsky, K., *Ernst H. Gombrich: Theorie und Methode*, Vienna: Bohlau, 1991.

Mitchell, W.J.T., 'Nature and Conversation: Gombrich's Illusions', in *Iconology: Image, Text, Ideology*, Chicago: University of Chicago Press, 1986.

Onions, J. (ed.), *Sight and Insight: Essays on Art and Culture in Honour of E.H. Gombrich at 85*, London: Phaidon, 1994.

Pavar, C.N., 'Restoring Cultural History: Beyond Gombrich', *Clio* 20 (1991), 157–67.

Pinto, E., 'Ernst Gombrich: La recherché d'une histoire culturelle et la decouverte de la logique des situations', *Revue de Synthese* 106 (1985), 61–80.

Richmond, S., *Aesthetic Criteria: Gombrich and the Philosophies of Science of Popper and Polanyi*, Amsterdam and Atlanta, GA: Rodopi, 1994.

JULIET GRAVER ISTRABADI

NELSON GOODMAN (1906–98)

AMERICAN PHILOSOPHER

Nelson Goodman made important contributions in three areas of philosophical inquiry: metaphysics and epistemology; inductive logic and the logic of confirmation in science; and aesthetics and philosophical semiotics. He cultivated a distinctively spare and astringent style of thought and expression, while displaying an exceptional, indeed startling, intellectual resoluteness and independence of thought. These qualities are nowhere more evident than in the semiotic theory of the arts he developed in the 1960s.

Goodman's is a semiotic theory because it construes a work of art as a character in a symbolism that must be properly 'read', rather than as an object merely to be contemplated. A character is a class of symbol tokens or 'marks'; and what makes something a symbol at all is its

incorporation into a scheme that is used to refer to objects. Goodman recognizes two modes of reference: denotation and exemplification. With each of these, the arrow of reference points, as it were, in the opposite direction. While denotation moves 'down' from symbol ('label') to object, exemplification moves 'up' from object (now used as an exemplifying symbol) to label. Anything at all may denote, provided it has been pressed into service as a mark: Monday-morning centre-forwards may use the salt and pepper shakers on the breakfast table to denote players in Saturday's game. But in order to exemplify, a label must already apply to or 'fit' the exemplifying symbol: someone lacking Goodman's nominalistic scruples would say that the exemplifying symbol must possess the exemplified property.

Goodman's nominalism is an ontological thesis (a thesis concerning what exists) that denies the existence of non-individuals like sets (collections of individual things) and properties (universals shared by individual things). Only individuals, understood to include both particular objects and the labels (that is, the label-tokens) applied to them are said to exist. In his earlier work, Goodman had also countenanced abstract individuals that are either repeatable (like a specific shade of colour) or not repeatable (like a location in space and time).

To exemplify a label metaphorically is to 'express' it. The expressed label is applied metaphorically because it belongs to a 'schema' of labels or, in the case of discursive language, predicates that denote foreign ranges and realms of objects. The range of the label 'is sad' in sad beings; its realm is emotional beings. Certain of Picasso's harlequin paintings literally exemplify the label 'is blue'. But they express sadness because 'is sad' belongs to a schema of labels (emotion predicates) that, unlike colour predicates, are not by way of habit or custom applied to inanimate objects like paintings. Yet the label 'is sad' properly applies to these paintings: it is 'appropriate'. As Goodman says with characteristic wit and precision, 'a metaphor might be regarded as a calculated category mistake – or rather as a happy and revitalizing, even if bigamous, second marriage' (*Languages of Art*, 1968). Pictures can also denote, although a title may be required to fix reference uniquely. Pictorial denotation Goodman terms 'representation' in contradistinction to linguistic denotation, which he terms 'description'.

Goodman distinguishes symbolic schemes and symbolic systems that are notational from those that are not, and this is a distinction of the first importance in his theory. (A *scheme* is a syntax-governed class of symbols; a *system* is a symbolic scheme that is semantically

interpreted, or 'correlated with a field of reference'.) Considering symbolic schemes first, a notational scheme is one whose tokens comprise classes whose members are syntactically 'character indifferent': any member of such a class may be substituted for another without change in the syntax of the expressions in which they occur. Character indifference requires that these classes be disjoint and finitely differentiated throughout ('articulate'). To say they are disjoint is to say that there is no intersection of membership between them. To say they are finitely differentiated throughout is to say that it is possible to determine (in other words, there is an effective decision procedure for determining) whether any mark not belonging to both of two characters does not belong to one or to the other. (Goodman's formulation of the criteria for finite differentiation has been criticised by Raffman, 1993.) Goodman extends these definitions from notational schemes to notational systems, from the syntactic to the semantic, by applying similar criteria to compliance classes, which are the denotations or extensions of the syntactic characters. A symbol system is notational if and only if it is a notational scheme (that is, it is syntactically notational) and the compliance classes of its characters are disjoint and finitely differentiated throughout. If a scheme is not articulate, and provides for an infinite number of characters which are ordered such that between any two there is a third less discriminable from each of them than they are from each other and, as a result, is such that a given mark cannot be excluded from an infinite number of characters, then that scheme is 'dense'. If there are, in addition, no gaps at all between groups of locally densely-ordered characters, then the scheme is 'dense throughout'. Similar relations holding between compliance classes and their members will make a *system* dense throughout. 'Density', therefore, implies but is not implied by a 'complete lack of finite differentiation' (*Languages of Art*).

With these distinctions in hand, Goodman proceeds to sort out the various arts in highly original ways. Only scored music is a fully notational system, for it alone amongst the arts makes use of a symbolism that is syntactically disjoint and articulate (the notational score consisting only of staves, notes, barlines and key and time signatures, without verbal instructions), as well as semantically disjoint and finitely differentiated throughout (the classes of performances compliant with the score). Musical compliance, note well, is *complete* compliance. A performance with even one wrong sound event is non-compliant, and not a performance of that scored work. Without this restriction, Goodman warns, a disturbing sorites paradox looms: Beethoven's *Fifth Symphony* could slide into *Three Blind Mice*. The

symbolism of literary art, on the other hand, is syntactically notational, but not semantically notational. The symbolism of literature is, therefore, a notational scheme but not a notational system. This is to say that the characters of discursive language are syntactically disjoint and articulate, but semantically non-disjoint and not finitely differentiated. The extensions (compliance classes) of terms in natural language tend to intersect (some Englishmen are doctors and some are not), thus violating the semantic disjointness requirement, and often are not finitely differentiated (is a certain individual to be excluded from the class of bald men or from the class of men who are not bald?). The symbolism of visual art is not notational at all, syntactically or semantically. On the syntactic side, classes of face-representations and person-representations in portraits intersect (violation of the disjointness requirement); and a landscape might contain the representation of a human figure in the distance that can be excluded neither from the class of male-figure representations nor from the class of female-figure representations (violation of the finite differentiation requirement). On the semantic side, the subject of a portrait may be Madame Cézanne, both a woman and a person (violation of the disjointness requirement). She cannot, in addition, be definitely excluded either from the class of persons under 5ft 4in tall or from the class of persons who are 5ft 4in or taller (violation of the finite differentiation requirement).

Because the symbolisms of music and literature are notational (scored music constituting a notational system and literature just a notational scheme), only music and literature are 'allographic': genuine instances of musical and literary works need only be compliant (correct) and need not have come from the artist's own hand. Painting and sculpture are, by contrast, 'autographic': a genuine instance must trace its causal provenance to the artist's hand or, as in the cases of cast sculpture and print work, to a model or template that has come from the artist's hand. This, Goodman believes, explains why a Vermeer can be forged, but a Haydn symphony cannot be. Allographic art can be one-stage (literature) or two-stage (music), just as autographic art can be one-stage (painting) or two-stage (cast sculpture). Musical art is two-stage because it requires composition and then performance; cast sculpture is two-stage because it requires making a cast and then using the cast to form the sculpture. (Levinson (1980) has offered a critique of Goodman's treatment of the allographic/autographic distinction.)

With regard to their *exemplificational* semantics, however, *all* aesthetic symbolisms are not disjoint and not finitely differentiated;

indeed, they are dense. The musical performance (*not* the musical score) exemplifies ranges of nuance properties; for example, those having to do with the graded intensity of tones and with their fine placement in pitch and time, properties that are (at least locally) densely ordered. The musical performance is also not exemplificationally disjoint: the heroism and the boldness expressed – that is, metaphorically exemplified – by a performance of the *Eroica* qualify some of the same passages and, considered as qualities, do not exclude one another. Precisely the same can be said concerning the qualities expressed by paintings and literary works of art. This density of exemplification, both literal and metaphorical, allows Goodman to develop one of his most powerful aesthetic conceptions: the distinction between repleteness and attenuation. While closely tied (respectively) to density and finite differentiation, repleteness and attenuation are further elaborations of these notions. They have to do with degree of symbolic significance: the more replete a symbol is, the more potentially significant its fine details are. A high degree of repleteness will require semantic density of exemplificational reference; sometimes it will also involve syntactic density, as in painting, drawing and sculpture. Semantic *denotational* density and lack of disjointness, on the other hand, are not relevant to repleteness, for they are characteristic of all discursive languages and pictorial representations, and not just literary and pictorial art.

In *Languages of Art* Goodman deftly illustrates these ideas by inviting his reader to consider two 'black wiggly lines' drawn on white backgrounds. The symbolic function of one line, a fragment of an electrocardiogram tracing, is entirely denotational, representing the behaviour of a patient's heart. It may exemplify certain properties of colour, thickness and intensity. But these are not symbolically significant. They do not matter, and to the extent they do not, the symbol is attenuated. With the other line, a Hokusai drawing of Mt Fujiyama, these aspects are highly significant. The drawing demands a different kind of looking: a looking of a more searching kind, a looking that takes into account all perceptually available aspects of the line and is sensitive to any and all of its exemplificational potentialities. Goodman ends by counting repleteness, along with exemplification and density, both syntactic and semantic, as 'symptoms of the aesthetic'. Although distrustful of definitions, and wishing to avoid as far as possible any pronouncements on questions of artistic merit (see Nozick (1972) for an amusing satire), Goodman is willing to allow that these four symptoms may constitute conjunctively sufficient and disjunctively necessary conditions of the aesthetic, in other words,

conditions for the attainment by a symbol of aesthetic significance. A symbol is aesthetically significant if it has all these attributes and only if it has at least one of them.

While Goodman was not the first philosopher to adopt a semiotic approach to works of art, the great merit of his writing on art was his ability to carry over to aesthetics the logical rigour, argumentative tenacity and technical ingenuity that had characterized his earlier work and that were until that point in time unimagined and perhaps unimaginable in aesthetics. The result was a permanent reconfiguration of the landscape of the discipline.

Biography

Nelson Goodman Born Somerville, Massachusetts, 7 August 1906. Goodman studied at Harvard University. Between 1929 and 1941 he was Director of the Walker-Goodman Art Gallery in Boston. He saw wartime service in the US Army from 1942 to 1945. He was Instructor in Philosophy at Tufts College in 1944–45; and became Associate Professor of Philosophy, 1946–51. He was Professor of Philosophy, 1951–64, at the University of Pennsylvania; Harry Austryn Wolfson Professor of Philosophy at Brandeis University 1964–67; and Professor of Philosophy at Harvard University 1968–77. Goodman was Founder and Director (1967–71) of the interdisciplinary Project Zero; Producer of the Arts Orientation Series 1969–71; Consultant in the Arts for Summer School 1971–77; and Director of the Dance Center – all at Harvard. He died at Needham, Massachusetts, on 25 November 1998.

Bibliography

Main texts

A Study of Qualities: An Essay in Elementary Constructional Theory, Cambridge, Mass.: Harvard Dissertations, 1940.
The Structure of Appearance, Cambridge, Mass.: Harvard University Press, 1951.
Fact, Fiction, and Forecast, Cambridge, Mass.: Harvard University Press, 1955.
Languages of Art: An Approach to a Theory of Symbols, Indianapolis: Bobbs-Merrill, 1968.
Problems and Projects, Indianapolis: Bobbs-Merrill, 1972.
Ways of Worldmaking, Indianapolis: Hackett Press, 1978.
Of Mind and Other Matters, Indianapolis: Hackett Press, 1984.
Reconceptions in Philosophy and Other Arts and Sciences (with Catherine Z. Elgin), Indianapolis: Hackett Press, 1988.

Secondary literature

Elgin, C., *With Reference to Reference*, Indianapolis: Hackett Press, 1983.

—— (ed.), *Nelson Goodman's Philosophy of Art*, New York: Garland Publishing, 1997.

Jones, R., Reed, E. and Hagen, M., 'A Three-Point Perspective on Pictorial Representation: Wartofsky, Goodman, and Gibson on Seeing Pictures', *Erkenntnis* 15 (1980), 55–64.

Levinson, J., 'Autographic and Allographic Art Revisited', *Philosophical Studies* 38 (1980), 367–83 (reprinted in *Music, Art, and Metaphysics*, Ithaca: Cornell University Press, 1990).

Nozick, R., 'Goodman, Nelson, on Merit, Aesthetic', *The Journal of Philosophy* LXIX, 21 (1972), 783–5.

Raffman, D., 'Naturalizing Nelson Goodman', in *Language, Mind, and Music*, Cambridge, Mass.: Bradford/MIT, 1993.

Robinson, J., 'Music as a Representational Art', in P. Alperson (ed.) *What Is Music: An Introduction to the Philosophy of Music*, University Park, PA: Penn State University Press, 1994.

Rudner, R. and Scheffler, I. (eds), *Logic and Art: Essays in Honor of Nelson Goodman*, Indianapolis, Bobbs-Merrill, 1972.

Sparshott, F., 'Goodman on Expression', *The Monist* 48 (1974), 187–202.

Wreen, M., 'Goodman on Forgery', *Philosophical Quarterly* 33 (1983), 340–53.

CHARLES NUSSBAUM

CLEMENT GREENBERG (1909–94)

AMERICAN CRITIC AND THEORIST

Clement Greenberg was the most influential theorizer and promoter of Modernism in America during the middle years of the twentieth century. His advocacy helped to bring about the institutionalization of Abstract Expressionism and to secure the dominance of American Modernist art in the immediate post-war period. However, Greenberg's subsequent rejection of Pop Art and Conceptualism led to a period in which his writings and his preferences were regularly condemned. These attacks arose from what was perceived as his dogmatic advocacy of abstraction, and his distaste for commercial popular culture – what he called 'kitsch' in one of his most famous essays, 'Avant Garde and Kitsch' (1939).

'Avant Garde and Kitsch' made Greenberg's name as a critic. Following his graduation from the University of Syracuse in 1930 he worked at a variety of temporary jobs, finally being employed by the New York Customs office. Throughout this period he read widely, and was much more interested in Modernist literature than in art. 'Avant

Garde and Kitsch' was an important departure, both because it signalled the future direction of his thought, and because it led to his direct participation in the world of cultural journalism as an editor of the Trotskyite journal *Partisan Review*, in which the essay was published.

The essay formulated his early thinking about the social character of Modernism. *Partisan Review* was at this time debating whether Modernism might ever achieve popular acceptance. Greenberg was sceptical about this, arguing that kitsch is an almost inescapable characteristic of mass culture in modern conditions. Under this concept Greenberg included Hollywood cinema, popular songs, sentimental poetry, magazines, advertisements and illustration. The academic art of the nineteenth century also counted as kitsch.

His central argument against kitsch was not new. It derived from ideas dating back to Whistler's *Ten O'Clock Lecture* (1885), in which Whistler argued that the authentic artist must stand apart from the commercial purveyors of 'the tawdry, the common, the gewgaw'. However, Greenberg provided both an historical explanation and a justification of this view within a broadly Trotskyite account of class struggle. For Greenberg, Capitalism, Stalinism and Fascism all tended to fall back on kitsch. This is because kitsch is defined by efficiency of communication, while 'avant-garde' culture examines the *conditions* of making and of meaning. For Greenberg, kitsch worked to maximize *effect*, while the avant-garde sought to address *cause*. Both commerce and totalitarian regimes sought maximum penetration of controllable information. They required a culture of kitsch. Mass culture will almost inevitably be kitsch, as passive consumers will comprehend accessible effects more readily than the self-conscious explorations of cause. Only in a truly socialist society will mass culture transcend the psychology of passive consumption. Despite important differences between the two men, Greenberg's attitude to popular culture is close to that of Theodor W. **Adorno**.

Greenberg expanded on these arguments the following year in 'Towards a Newer Laocoön' (1940). Here he concentrated on the avant-garde itself rather than on kitsch, formulating the conditions for the authentic culture that kitsch – in his view – undermined. Here Greenberg articulated his famous claim that resistance to kitsch requires that art 'emphasize the medium and its difficulties', adding that the history of the avant-garde is one of 'progressive surrender to the resistance of the medium'. The arts have been forced into this entrenchment within the medium in order to restore their identity from a position of internal strength. Greenberg does not claim that this purification of art is an end in itself, but that it is a reactive process

forced on art by kitsch. However, the language of 'progressive' assertion of the medium implies a developmental line with an inevitable conclusion – a problem with which Greenberg was forced to wrestle in his later critical work.

Greenberg's post-war writings abandoned Marxist rhetoric while retaining the essential arguments put forward in these two early essays. In fact, most of Greenberg's work was occasional – reviews, letters and short polemical essays, often written in response to critics with whom he disagreed. Greenberg's was a combative personality, and this tendency became more prominent in his later work, especially when he felt the ideas for which he had fought were losing ground. He never wrote a book, though many of his more substantial writings were published in book form as *Art and Culture* in 1961. It became a powerfully influential defence of Modernism, and also a substantial text against which critics and challengers could argue.

Because of the journalistic character of so much of Greenberg's writing, it is difficult to characterize the development of his thought fully. He always claimed that his explanation of Modernism was historical, but that his defence of specific works arose from judgements of taste. For this reason he reacted strongly to opinions that art 'should' serve this or that purpose, or adapt itself to suit a theory. For Greenberg, the *absolute* duty of art is to maintain its own quality. His aggressive dismissal of Harold Rosenberg's account of Abstract Expressionism as 'action painting' was based on his view that Rosenberg's claim implied that the active process of painting mattered more than the result. Rosenberg thus pandered to the philistine view that one chaotic combination of drips and splodges was as good as another. For Greenberg, Jackson Pollock was a serious artist whose work recognized the full implications of the formal experiments of Modernists from Cézanne to Picasso. Rosenberg's theory gave the green light to charlatans whose work was no more than 'stunts'. Such stunts came into prominence during the 1960s, as some artists accepted Rosenberg's claim that the moment of 'performance' could itself be art. This aspect of the art scene in the 1960s earned Greenberg's withering contempt. His objections were serious, but could all too easily be interpreted as the conservatism of a critic whose time had passed – the modern equivalent of Ruskin's attack on Whistler.

He had long expressed his strong reservations about Surrealism, which he had discussed in detail in the article 'Surrealist Painting', published in *The Nation* in 1944. Pop Art and Conceptualism seemed to him to be extrapolations from some of the worst aspects of the

earlier movement. For Greenberg, Surrealism followed the same methods as had Pre-Raphaelitism before it. Both movements 'revitalized academicism'. Surrealism and Pre-Raphaelitism were both literary, relying for effect on the connotations of the objects they juxtaposed, while painting in an academically conventional manner. Surrealism shocked because it sought to provoke. Authentic Modernists alienated some viewers simply because this was an inescapable by-product of their formal experiments and of their rejection of kitsch. Furthermore, Surrealism was based on a fundamental act of self-deception – the fantasy of automatism. Artists who claim access to the unconscious merely deceive themselves about their own acts of control. Again, in contrast, the *seemingly* wild manner of a Pollock was actually based on a profound practical understanding of the painting process, and of the extent of an artist's control over it.

This self-publicizing, stunt loving, aspect of both Dada and Surrealism provided the model for the 'novelty art', as Greenberg called it, that flourished in the 1960s; it was epitomized by Warhol, Lichtenstein, and the wider Pop Art movement. The direct references to Pre-Raphaelitism in British Pop Art merely confirmed Greenberg's view. Greenberg professed to enjoy such works, but insisted that Warhol was the Gérôme of his day, amusing but essentially trite. In asserting this, Greenberg remained true to his early opinion of the Hollywood movies and popular culture on which Warhol drew. Such things were to be *enjoyed*, but not to be mistaken for art.

These opinions followed from the mature restatement of Greenberg's views in his essay 'Modernist Painting', first published in 1960. In this article Greenberg most clearly articulated the change in the philosophical basis for his thinking – a move from Marx to Kant. Greenberg now asserted that Modernism was characterized by the act of self-criticism. This 'immanent' criticism of a discipline had first been fully undertaken by Kant himself, who provided critiques of the act and conditions for distinct forms of reasoning. For Greenberg, the essence of Modernism is 'the use of the characteristic methods of a discipline to criticise the discipline itself, not in order to subvert it, but in order to entrench it more firmly in its area of competence'. The rejection of the rhetoric of 'subversion' here is consistent with his distaste for the montage methods of Dada, and in particular the political Modernism of Berlin Dada and its successors.

Just as Kant used philosophy to examine the conditions for the very possibility of philosophy itself, so Modernism (for Greenberg) sought to identify what was distinctive to separate media. Greenberg was now less keen to emphasize that art must reject 'literary' values, and argued that

Modern painting sought to resist the characteristics of sculpture. This it did by asserting the 'ineluctable flatness' of the pictorial surface and of the enclosing frame. Greenberg came thereafter to be inextricably linked with this claim about the essential importance of 'flatness'.

Perhaps because of the importance he grants to Kant, Greenberg now wished to push the origins of Modernism back to Kant's contemporary Jacques-Louis David, though he acknowledges that David sought to *assert* sculptural modelling in reaction to the decorative characteristics of Rococo. However, for Greenberg, the Davidian legacy produced the 'flattest, least sculptural' paintings since the fourteenth century, in the work of Ingres. The same was true of Cubism, which mimicked the conventions of perspective and volumetric modelling nominally in the service of a fuller three-dimensionality. But the desire to include multiple positions in space merely drew attention to the flatness of the pictorial plane, which rendered such aspirations impossible. Only art that encourages the suspension of disbelief – academicism – can deny the flatness of the picture plane.

Greenberg was aware that this struggle with flatness is a dialectic: one that maintains itself precisely because no final synthesis can be achieved. The very process of painting is a violation of flatness; even the work of an artist such as Mondrian constructs 'optical illusions' of space. But the central point is that these illusions are defined by the character of the medium – its effect on the eye.

After 'Modernist Painting', Greenberg's writing takes on an increasingly defensive character, despite the continuing weight of his influence. He particularly resented the charge of 'formalism' that opponents were wont to level at him because of his emphasis on the self-validating nature of artistic activity. Greenberg's 'Complaints of an Art Critic', published in 1967, attempted to rebut the charge of formalism. He insisted once more that aesthetic judgements occur in the experience of art, and therefore 'leave no room for the conscious application of standards, criteria, rules or precepts'. However, the act of judgement is identical with the discovery of 'content', but that content cannot be translated into any readily legible message, as this would denude the artwork of its own identity, turning it once more into literature – the mere exemplification of a precept.

This essay indicates both the internal logic and the problematic character of Greenberg's own position as a critic and theorist. His insistence that art is itself a practical critique of pre-given ideas or assumptions leaves him with relatively little to say about the art of which he most approves. He insisted that judgements of taste and of

quality cannot be theorized, only discovered in the act of contemplation and criticism. However, he was also aware that taste is itself dynamic and unstable. His writings are full of the sense that taste depends on what is historically possible given the pressures operating within a culture. (Interviewed in 1982 by T.J. **Clark** for the Open University, Greenberg stated that he never expressed a *preference* for abstract art – he would have preferred Fantin-Latour's flowers – merely that he found that abstraction was the best art of his day. See also Thierry de Duve (1996) for similar remarks made at the University of Ottawa in 1987.) His reviews are by no means confined to discussion of Modernist art; they range widely over history. Nevertheless, his concern was always with what he called 'plastic values', and never with what he considered to be trivial social or iconographical readings of art.

After 1970 Greenberg wrote little, but continued to display a keen interest in the art world. The revival of interest in Walter **Benjamin**'s account of the avant-garde – which differed markedly from Greenberg's – led to a period of debate between 'Greenbergian' and 'Benjaminian' versions of Modernism, the latter reviving a boost from the cultural developments which flowed from the movements rejected by Greenberg: Surrealism and Pop. The 'postmodern' art scene seemed to have left Greenberg's avant-garde behind. It revelled in the very concept that Greenberg had, ironically, popularized: kitsch.

It was always difficult to reconcile the trajectory implied by the move towards 'flatness' with the claim that the avant-garde sought a space to keep culture 'moving', as Greenberg put it. But Greenberg at least remained consistent throughout his intellectual career, articulating one of the most thoroughly thought-through accounts of the nature and logic of Modernism.

Biography

Clement Greenberg Born New York, 16 January 1909. Greenberg studied at Syracuse University, and joined the New York Customs Service in 1936. In 1939 he published 'Avant Garde and Kitsch' in the journal *Partisan Review,* of which he became an editor in 1940. In 1944 he went on to become editor of the *Contemporary Jewish Record.* He was also associate editor of *Commentary.* Throughout the 1940s and 1950s he published essays and reviews in such journals as *Partisan Review, Commentary* and *The Nation* (and was *The Nation's* art critic between 1944 and 1949). In 1961 he published *Art and Culture,* a

revised selection of his essays; and in 1964 he organized the exhibition *Post Painterly Abstraction* for the Los Angeles County Museum of Art. Greenberg died on 7 May 1994.

Bibliography

Main texts

'Avant Garde and Kitsch', *Partisan Review* vi, 5 (Fall 1939), 34–9.
Joan Miro, New York: Quadrangle Press, 1948.
Matisse, New York: H.N. Abrams, 1953.
Art and Culture: Critical Essays, Boston: Beacon Press, 1961
Hans Hofmann, Paris: Georges Fall, 1961.
Homemade Esthetics: Observations on Art and Taste, New York: Oxford University Press, 1999.
Collected works:
The Collected Essays and Criticism: Perceptions and Judgments, 1939–1944 vol. 1, John O'Brian (ed.), Chicago: University of Chicago Press, 1986.
The Collected Essays and Criticism: Arrogant Purpose, 1945–1949 vol. 2, John O'Brian (ed.), Chicago: University of Chicago Press, 1986.
The Collected Essays and Criticism: Affirmations and Refusals, 1950–1956 vol. 3, John O'Brian (ed.), Chicago: University of Chicago Press, 1993.
The Collected Essays and Criticism: Modernism with a Vengeance, 1957–1969 vol. 4, John O'Brian (ed.), Chicago: University of Chicago Press, 1993.
Correspondence:
The Harold Letters, 1928–1943: The Making of an American Intellectual, Janice Van Horne (ed.), Washington, DC: Counterpoint, 2000.

Secondary literature

Duve, T. de, *Clement Greenberg Between the Lines. Including a Previously Unpublished Debate with Clement Greenberg*, trans. Brian Holmes, Paris: Editions Dis Voir, 1996.
Frascina, F. (ed.), *Pollock and After: The Critical Debate*, London and New York: Routledge, 1985.
Kuspit, D.B., *Clement Greenberg, Art Critic*, Madison: University of Wisconsin Press, 1979.
Rubenfeld, F., *Clement Greenberg: A Life*, New York: Scribner, 1997.

PAUL BARLOW

ARNOLD HAUSER (1892–1978)

HUNGARIAN-BORN ART HISTORIAN

Arnold Hauser is most famous for his monumental four-volume work *The Social History of Art* (1951), which attempts a historical materialist account of the Western tradition of art from cave paintings through to

what Hauser calls 'The Film Age'. Hauser expounded the philosophical basis for his thinking in *The Philosophy of Art History* (1959). He later expanded his work in publications on *Mannerism* (1965), and *The Sociology of Art* (1974).

The Social History of Art is a difficult book to assess. An epic undertaking, which seeks to explain every important manifestation of Western art by the psychological and social dynamics of broad historical eras, it is a hostage to critical fortune. Even at the time of publication, Hauser's sweeping statements were open to many criticisms. From a more modern perspective, Hauser's confidence can seem misplaced. However, it is the internal structure of Hauser's arguments that is most interesting today, rather than the details of particular claims.

Hauser's approach is broadly Marxist: he believes that art emerges from economic conditions which generate specific social relations and class structures, and which contain implicit conflicts; two important influences were Georg Lukács and Karl Mannheim, both of whom he met in Paris in 1916. He is, however, also influenced by the phenomenological tradition, though he rejects Bergson's vitalism (he studied under Bergson in Paris) in the final section of the *Social History of Art*, arguing that it is an expression of 'bourgeois consciousness', sanctifying its own social alienation.

Hauser differs from many other Marxist art historians because he does not interpret art primarily in terms of social ideologies. He is not very interested in explaining what interests art has served, or what social messages it has conveyed. He acknowledges this, especially in *The Philosophy of Art History*, but for Hauser the more important task is to understand art phenomenologically, as a product of forms of consciousness in an encounter with experience. In this respect, the *Social History of Art* involves a semi-Hegelian conception of the 'unfolding of the human mind'.

In his final volume, Hauser asserts that the purpose of studying the past is to understand the present. This is, however, evident throughout the book, in which explanations of historical events are regularly related to contemporary artistic phenomena – in particular to Modernism and mass culture. While such a view is consistent with the Marxist concept of the dialectics of 'praxis', Hauser's position is caught within one of the central paradoxes of the Marxist tradition: its claim to constitute a 'science' of history, and its need to construct a pragmatic ideology. There has been a longstanding debate within Marxism as to whether Marxism itself constitutes an ideology, or whether it transcends the false consciousness that allegedly defines

ideological thinking. Hauser never addresses this paradox openly, which leaves his judgements and explanations open to the charge that they are arbitrary and dogmatic. As it stands, Hauser's motivations have to be read 'between the lines' of his *ex cathedra* statements.

This approach is evident in Hauser's account of the origins of art. Hauser discusses the dispute between those who claim that art originated in abstract forms and those who argue that its first impulse was naturalistic. This historical debate follows the conflicting evidence of geometric pottery designs on the one hand, and of the Lascaux caves on the other. Hauser concludes that the first artistic impulses were naturalistic, which later modified into geometric designs. This modification occurs with the move from hunter-gatherer culture to settled agriculture.

This debate is clearly animated by the dispute between proponents of Social Realism and of Modernism at the time of his writing. Hauser is well aware of this, but he seeks to use prehistory as a means to understand the historical and material facts underlying the debates of his own day. The approach can be defended as a clear instance of historical materialism, or it can be condemned on the grounds that Hauser is creating a fantasy: a foundation myth to explain the cultural quirks of mid-twentieth-century Europe in terms of the universal origins of social history and human consciousness.

Hauser's debt to Hegel is evident in his account of the prehistorical experience of nature. For Hauser, Palaeolithic culture was expressive of a near-direct experience of nature: material facts and representations are undifferentiated. However, the creation of settled communities required planning and specialization. This produced a tendency to think in conceptual terms unavailable to Palaeolithic peoples. Human control *over* nature becomes significant, if precarious: dependent on forces over which only a fantasy of control can be obtained, in the form of magic amulets, totems and other signs. These signify access to a realm alien to nature. For Hauser, this form of social life represents a move towards communal living, and to communal control over the forces of production. In this respect it is progressive. However, it also implies an alienation from nature itself, the more fully to mark the act of mental control over it – hence abstraction.

Hauser notes that the art of present-day hunter-gatherer 'primitive races' does not resemble Lascaux, but he rejects this evidence. He concludes by attacking Wilhelm Hausenstein, who saw in Neolithic designs the aesthetics of primitive communism. Hauser here draws attention to the problems implicit in his own position. Hausenstein is

condemned for finding a too-neat correspondence between style and social forms, and for projecting such views into present conditions. For Hauser, the metaphorical use of concepts such as 'egalitarian' to apply to styles and to social values is unacceptable.

This section of his book, then, indicates in miniature Hauser's methodology, which he is to carry out in later volumes. He draws attention to the dynamics and paradoxes of social developments, connecting this to historically produced psychological states (the Neolithic 'mentality'), and drawing lessons for the present. But he is keenly aware of the pitfalls of this method. He seeks to maintain a methodological debate within the text, but does so by proxy, preserving the authority of his own voice.

The language of critical evaluation crops up regularly within the text, again often asserted rather than argued. Thus, the ancient Cretans did not have a very 'fastidious' taste. Their frescoes 'remind us, with their watery colours and straightforward drawing, of the decorations in modern luxury steamers and swimming baths.' It is unclear how seriously such comments are to be taken. Clearly Hauser sees an analogy between Cretan society and an aspect of leisure under modern capitalism. Equally, judgements of taste and social morality are intertwined here, but exactly how the past illuminates the present remains uncertain.

It is in the later sections of the book that these problems become most acute, as Hauser attempts to provide historical explanations for the emergence of the major movements in art, and of the 'great artists'. Hauser does not believe that evaluation is based on ideological imperatives or inherited prejudices. He takes the view that art communicates values of continuing human significance, which can be seen at work within history. In this respect Hauser is part of the humanist branch of Marxism, one that accepts it is meaningful to speak of a growth and a fulfilment of human consciousness *in* history, rather than of the continual reconstruction of consciousness *by* history.

The issue first emerges as Hauser discusses the art of classical Greece, which he praises for the usual reasons: harmony, poise, serenity. However, his discussion of Athenian culture at this time leads him to conclude that no adequate 'sociological recipe' can be given to explain art of such 'high artistic value'. Instead he attempts some tentative explanations. Here the specifically Marxist nature of Hauser's account becomes difficult to discern.

This is likewise evident in the discussion of the more differentiated individuals whose work constitutes the post-medieval history of art. He continues to comment on figures such as Michelangelo in the

terms initiated with the account of Hellenic art – the inexplicability of 'genius', combined with an historical account of the form of consciousness implied by the artist's works, or by stylistic developments.

Hauser's account of the growth of realism in art and literature in the nineteenth century is both extensive and sympathetic. He discusses the uses of archetypal characters to represent high capitalism and mass industrialism. He identifies a split emerging with Impressionism, in which he perceives a reification of sensation – so that the components of experiences become objects. Thus colours themselves are isolated as the true 'object' of visual experience, and the 'moment' when sensation occurs is itself frozen. This produces the conditions for Aestheticism and Modernism, both of which attempt to sanctify experience itself. The self-conscious evasiveness of Modernist art and literature is also to be understood as a product of the narcissistic self-affirmation of cultural alienation as a virtue.

For Hauser, Modernism sought to maintain the distinction between High and Popular culture. It did so because industrialization has produced conditions for the creation of a mass culture. Film provides the model for a modern, complex and accessible culture. The final section of *The Social History of Art* puts its faith in film as the art of the future, and argues for the development of more sophisticated methods within film. Hauser envisages a form of collectivized film production that will involve the pooling of talents, and will overcome the alienation of the intellectual from society. However, he also maintains a traditional liberal belief in education to improve mass taste.

Hauser's principal work after the completion of *The Social History of Art* was *The Philosophy of Art History*. It shares many of the features of *The Social History of Art*, but deals with objections by its critics, while modifying his own position in the light of them. He discusses ideology in the first chapter, favouring the view that art is ideological, though he takes this to mean that it encodes a 'world view'. Ideology is not understood principally in a negative way by Hauser – as an oppressive or misleading mode of thought – but as a sign that the formal properties of art are articulated within a complex consciousness. Hauser follows this with an account of 'psychodynamic' explanations of art. He accepts the validity of psychodynamics in general, but rejects aspects of Freudianism, which he believes fails adequately to acknowledge cognitive mental functions. He also rejects biographical explanations of art on the grounds that they are 'trite' – failing to grasp both formal and historical determinants. For Hauser, psychodynamics

is most useful for providing models to understand ambiguities within artworks.

Hauser proceeds to explore the opposite point of view: art history understood in terms of movements, without reference to individuals. This view he associates with **Wölfflin**'s attempts to claim an internal developmental logic to art. Hauser again accepts that such patterns do exist, and that fashion has its own dynamic, but he does not think that general conclusions can be drawn about the structures which define stylistically coherent movements.

His final sections again take the opposite point of view – indeed the book as a whole follows the formal structure of dialectical theses, antitheses and syntheses. He discusses folk art and popular art, especially the popular art of modern commercial culture, coming back to his favourite topic, film. He addresses the accusation that commercial culture is 'kitsch' (though Hauser does not use this term), a view he accepts while rejecting the 'vulgar Marxist' claim that this is a conspiracy to dull the minds of the proletariat. Hauser sees it as a product of the dynamics of commercial culture, and again puts his faith in education and socialism as intellectually elevating and liberating forces. Hauser concludes with an account of the tension between convention and originality, a tension he sees at work in the creation of good art, and in its capacity to communicate to humanity in general.

Hauser never indicates what the art of his ideal society would be, but he clearly hopes that film will be the model for communal modern art, and that the great art of the past will be better appreciated by a wider audience. In later publications he attempts to find in the historical crises of art models for the understanding of the tension between formalism and fully humanist forms of artistic practice, a problem he continued to debate with Lukács. Consistently, Hauser's approach is to define art as the product of unresolved dynamics, which the critic and historian seeks to unfold. Great art most fully embodies the complexities of these dynamics and provides a model for thinking about the conditions in which a fulfilled human life can be led.

Biography

Arnold Hauser Born Temesvar, Hungary, 1892. Hauser studied in Budapest, Vienna and Berlin, and in Paris under Henri Bergson; in Paris in 1916 he met Georg Lukács and Karl Mannheim. He worked in the film industry in Italy, Germany and Austria, and in 1938 he moved to Britain, where he lived until 1977. Following a request from

Mannheim, Hauser worked on *The Social History of Art*. Between 1951 and 1957 he lectured at the University of Leeds; 1957–59 he was Visiting Professor at the University of Brandeis; 1959–62 he taught theory at Hornsey College, London; and 1963–65 he was Visiting Professor at the State University of Ohio. Hauser returned to Hungary in 1977 as an honorary member of the Hungarian Academy of Sciences. He died in Budapest in 1978.

Bibliography

Main texts

The Social History of Art (*Sozialgeschichte der Kunst und Literatur*), 4 vols, trans. Godman, London: Routledge and Kegan Paul, 1951 (reprinted 1999 with an introduction by Jonathan Harris).
The Philosophy of Art History (*Philosophie der Künstgeschichte*), London: Routledge, 1959.
Mannerism: the Crisis of the Renaissance and the Origin of Modern Art (*Manierismus*), trans. (in collaboration with the author) Eric Mosbacher, London: Routledge and Kegan Paul, 1965.
The Sociology of Art (*Soziologie der Kunst*, 1974), trans. Kenneth J. Northcott, London: Routledge, 1982.
In Gespräch mit George Lucács, Munich: Oscar Beck, 1978.

Secondary literature

Gombrich, E.H., 'Social History of Art', *The Art Bulletin* (March 1953), reprinted in *Meditations on a Hobby Horse and Other Essays on the Theory of Art*, London: Phaidon, 1963.
Harris, J., Introductions to the four volumes of *The Social History of Art*, London: Routledge (1999 edition).

PAUL BARLOW

MARTIN HEIDEGGER (1889–1976)

GERMAN PHILOSOPHER

Heidegger's account of the nature of art is to be found in his 'The Origin of the Work of Art' (1950), based on lectures delivered in 1935 and 1936. In it he argues that the essence of the work of art is not to be found by approaching the work as an *object* which calls forth certain kinds of experience. For Heidegger, what works of art *essentially* have to do with is *truth*. In this he is at odds with most of modern aesthetics.

There is a sense in which works of art are clearly *things*; they can be

put somewhere, moved about. The tendency has been to overlook this *thingly* character of art. The *thingly* character of art has been regarded as simply a material substructure on which the real work of art rests. From this point of view, the thingly is in principle dispensable. For Heidegger, by contrast, it belongs to the essence of the work of art. The stony is in the statue, the wooden in the carving, the coloured in the painting. Indeed, we are compelled to say that the architectural work is in stone, the carving is in wood, the painting in colour, the linguistic work in speech, the musical composition in sound and so on.

To understand the relationship between thing and work we must, it seems, become clear about the thing-ness of things. Heidegger considers three accounts of this provided by the philosophical tradition: first, the conception of the thing as the bearer of properties; second, the thing as the unity of a manifold of sensations; and, third, the thing as formed stuff or matter. For Heidegger, none of these succeeds in capturing the essence of thing-hood, but the third yields an important clue to what it is to be a *work*. The conception of the thing as formed material derives from the production of artefacts. The conception of the *mere* thing is the conception of things which have lost their 'equipmentality' (*Zeugsein*). Heidegger uses a work of art to shed light on this equipmentality, which in turn sheds light on the 'work-being' (*Werk-sein*) of the work. The work of art he considers is a painting by Van Gogh of a pair of shoes. He writes:

> In the stiffly rugged heaviness of the shoes there is the accumulated tenacity of the slow trudge through the far-spreading and ever-uniform furrows of the field swept by a raw wind. On the leather lie the dampness and richness of the soil. Under the soles stretches the loneliness of the field-path as evening falls. In the shoes vibrates the silent call of the earth, its quiet gift of the ripening grain and its unexplained self-refusal in the fallow desolation of the wintry field. This equipment is pervaded by uncomplaining worry as to the certainty of bread, the wordless joy of having once more withstood want, the trembling before the impending childbed and shivering in the surrounding menace of death. This equipment belongs to the *earth* and it is protected in the *world* of the peasant woman.

It might seem that Heidegger is reading too much into the painting, that he is just projecting his own thoughts and imaginings into the painting (Meyer **Schapiro**'s attack on Heidegger's account of

this painting brought forth a third response from Jacques **Derrida**). All there is, we might say, is this thing, this canvas with patches of colour on it. These patches of colour depict a pair of shoes, peasant shoes (or, if some accounts are correct, Van Gogh's own shoes). But to view it in this way, Heidegger would say, is not to let it be as a *work*. If we do, then 'if anything is questionable it is rather that we experienced too little in the nearness of the work and that we expressed the experience too crudely and too literally'.

The painting, Heidegger maintains, is the disclosure of what the equipment, the pair of peasant shoes, *is* in truth. In the work this entity emerges into the 'unconcealment' of its being. Heidegger is emphatically not seeking to revive the view of art as *imitation*; he is emphatically not saying that it discloses by reproducing this entity. Nor is he saying that the work reproduces the general *essence* of this sort of entity. Works of art do have to do with essences, but not by way of *reproducing* them. The Van Gogh painting *discloses* what and how something is. What happens in the painting is that the being of an entity is disclosed. This goes some way to explaining the idea that works of art have to do with truth. Truth for Heidegger is not correspondence but 'unconcealedness' (*Unverborgenheit*). The work of art is true in the sense that it discloses entities in their being.

If we let the work be as a work rather than making it into an object, we find that there are two relations which are internal to the work of art itself: the relation to a *world* and the relation to *earth*. To illustrate these essential relations, Heidegger deliberately chooses a non-representational work of art: a Greek temple. Unlike the painting, it does not depict anything. Heidegger says of this work that it

> ... fits together and at the same time gathers around itself the unity of those paths and relations in which birth and death, disaster and blessing, victory and disgrace, endurance and decline acquire the shape of destiny for human being [*Menschenwesen*].

The work opens up the world of this historical people, that is, the ancient Greeks. It also discloses what Heidegger calls 'earth':

> Standing there, the building rests on the rocky ground. This resting of the work draws up out of the rock the obscurity of that rock's bulky but spontaneous support. Standing there, the building holds its ground against the storm raging above it and so first makes the storm itself manifest in its violence. The

lustre and gleam of the stone, though itself apparently glowing only by the grace of the sun, first brings to radiance the light of the day, the breadth of the sky, the darkness of the night. The temple's firm towering makes visible the invisible space of air.

The work sets forth the earth in the sense that the work lets the earth be the earth; the work sets forth the earth and opens up the world. World is never an object which stands before us and can be looked at. It is the ever non-objective (*das immer Ungegenständliche*) to which we are subject. It cannot be understood in terms of entities because it is neither an individual entity nor the all-embracing unity of entities. The world, he says, 'worlds' (*weltet*). The verb indicates that world has the character of a happening, albeit an *ontological* happening. It is historical.

But what is the world? Although not a whole of *entities*, it is a whole. It is a whole of what Heidegger calls *Sinnbezüge*, of sense-relations, meaning-relations, significance-relations. As what we live, move, and have our being in, this whole of sense-relations, this horizon of meaning, is never an object for us – it is what makes it possible for anything to be an object for us.

Heidegger writes: 'The setting up of a world and the setting forth of earth are two essential features in the work-being of the work. They belong together, however, in the unity of the work-being.' As regards the second of these features, the setting forth of earth, there appears to be an ambiguity in Heidegger's use of the term 'earth'. On the one hand, it seems to refer to nature, the native ground on which the world opened up by the work rests. On the other hand, it refers to the 'thingly element' of the work of art, for example, stone, wood, metal, colour, language, tone. The work discloses the thing-ness of the thing. In the case of *equipment* (*Zeug*), the thing as it were vanishes in the equipmental being of the equipment, which is determined by usefulness or serviceability. Stone is used in making an axe: it is 'used up' in the sense that it disappears in the use. The stone used in the equipment does not show itself in its stoniness. In the temple, by contrast, the stone does show itself in its stoniness. In works of art, metals come to glitter and shimmer, colours to glow, tones to sing, the word to say. The stone manifests itself in its massiveness and heaviness, wood in its firmness and pliancy, metal in its hardness and lustre, colour in its brightening and darkening, and so on.

But, paradoxically, what is thus manifested in the work of art (earth) is something whose special character is self-concealment (*Sichvers-*

chliessen: self-closing-off, self-seclusion). Heidegger explains this self-concealment as follows:

> A stone presses downwards and manifests its heaviness ... this heaviness denies any penetration into it. If we attempt such a penetration by breaking open the rock it still does not display in its fragments anything inward that has been opened up. The stone has instantly withdrawn again into the same dull pressure and bulk of its fragments.

In a painting the colour shines. When we analyse colour in rational terms by measuring its wavelengths, it is gone. Earth shatters every attempt to penetrate it. The objectivation of nature in science and technology looks like the mastery of nature, but in fact only demonstrates our impotence in the face of nature. For it only masters nature by turning it into something else, letting it escape: 'The earth appears openly cleared as itself only when it is perceived and preserved as that which is essentially undisclosable, that which shrinks from every disclosure and constantly keeps itself closed up.'

As the essentially self-secluding, earth can only show itself within the openness of a world. Earth shows itself in the work because the work opens up a world. It is the openness of a world in the work that enables the 'materials' of the work to manifest themselves in their thing-ness. Heidegger characterizes the relation between world and earth as that of *strife*: one seeks to overcome the other; the world, in resting upon the earth, strives to surmount it. As self-opening, the world cannot endure anything closed. As the horizon of sense (meaning, significance), it seeks to overcome the opaqueness of nature. The earth (nature) as self-concealing 'tends always to draw the world into itself and keep it there'.

Truth happens in the work of art, for the work of art embodies the strife between world and earth. So what does this strife between world and earth have to do with truth? For Heidegger, the essence of truth is unconcealedness. The traditional conception of truth sees truth as a relation, one of agreement or correspondence; truth pertains primarily to the judgement or statement (propositional truth): a true judgement is one which agrees with an actual state of affairs. Heidegger calls this truth correctness, correctness in the way things are represented. But for a judgement or statement to conform to the state of affairs, the latter must itself stand forth out of concealment. That with which the judgement or statement agrees must itself show itself, emerge from concealment. Truth as correctness is only possible on the basis of truth

as the unconcealment of beings. Unconcealment is not a state but a happening. It is a happening rather than something we do.

A distinctive feature of Heidegger's thinking is his insight into the inseparability of unconcealedness and concealedness. The concealedness of beings, what-is (*das Seiende*), is not merely a function of error and cognitive inadequacy on the part of human beings. Beings withhold themselves. In showing themselves, they at the same time conceal themselves. So the unconcealedness (*Unverborgenheit*) which is the truth of being involves both a bringing out of concealedness (*Entbergen*) and a concealing (*Verbergen*). The essence of truth is unconcealment, but because concealment belongs to the essence of truth we have to say that truth in its essence is un-truth.

As embodying the strife between world and earth, an artwork is a 'happening of truth': it shows forth the essence of truth as the primal strife between concealment and unconcealment. So, for Heidegger, works of art have to do with truth both in the sense that they disclose entities in their being (for example, the peasant shoes in their equipmentality), and in the sense that they embody truth as such or the essence of truth.

Biography

Martin Heidegger Born Messkirch, 26 September 1889, son of a cooper who was sexton of the local Catholic church. Heidegger studied at the University of Freiburg between 1909 and 1915. He became a private lecturer and assistant to Edmund Husserl at Freiburg from 1918 to 1923; Associate Professor at the University of Marburg, 1923–8; Full Professor at the University of Freiburg, 1929–64; and Rector of the University of Freiburg in 1933–4. In 1946 he appeared before the deNazification commission, and was banned from teaching from 1947 until 1951. Heidegger died at Messkirch on 26 May 1976.

Bibliography

Main texts

Being and Time (*Sein und Zeit*, 1927), trans. John Macquarrie and Edward Robinson, Oxford: Blackwell, 1993.

'The Origin of the Work of Art' ('Der Ursprung des Kunstwerkes', written 1935, published 1950), in David Farrell Krell (ed.) *Martin Heidegger: Basic Writings*, 1993. Also in *Poetry, Language, Thought*, trans. Albert Hofstadter, New York: Harper, 1971.

Selected works:

Krell, D.F. (ed.), *Martin Heidegger: Basic Writings*, London: Routledge, 1993.

Secondary literature

Biemel, W., *Martin Heidegger: An Illustrated Study*, London: Routledge, 1977.

Derrida, J., *The Truth in Painting* (*La Vérité en peinture*, 1978), trans. Geoff Bennington and Ian McLeod, Chicago: University of Chicago Press, 1987.

Gadamer, H.-G., Introduction to Heidegger's *Der Ursprung des Kunstwerkes*, Stuttgart: Reclam, 1960.

Guignon, C. (ed.), *The Cambridge Companion to Heidegger*, Cambridge and New York: Cambridge University Press, 1993.

Kockelmans, J., *Heidegger on Art and Art Works*, Dordrecht: Nijhoff, 1985.

Polt, R., *Heidegger: An Introduction*, London: UCL Press, 1999.

Schapiro, M., 'The Still Life as Personal Object', in *The Reach of the Mind; Essays in Memory of Kurt Goldstein*, New York: Springer, 1968.

von Herrmann, F.-W., *Heideggers Philosophie der Kunst*, Frankfurt: Klostermann, 1994.

Young, J., *Heidegger's Philosophy of Art,* Cambridge: University of Cambridge Press, 2001.

PAUL GORNER

JULIA KRISTEVA (1941–)

BULGARIAN-BORN FRENCH THEORIST

For the French theorist Julia Kristeva, whose ideas draw upon Freudian concepts, art is crucial both for the individual and for society. By allowing access to repressed materiality, and by challenging accepted forms of representation, art, like literature and psycho-analysis, allows the psyche constantly to renew itself through imagination. To understand Kristeva's contribution to theories of art, it is necessary to go back to her theory of the relation between representation and drives. Kristeva takes up Sigmund **Freud**'s theory of drives as instinctual energies that operate between biology and culture. Drives have their source in organic tissue and aim at psychological satisfaction. In *New Maladies of the Soul*, Kristeva describes these drives as 'a pivot between "soma" and "psyche"', between biology and representation'. Drives can be reduced neither to the biological nor to the social; they operate in between these two realms and bring one realm into the other. Drives are energies or forces that move between the body and representation.

For Kristeva, all representation – artistic and linguistic, from painting to logic – is composed of two elements, the *semiotic* and the *symbolic*. The semiotic element is the discharge of bodily drives through rhythms (in poetry or dance), tones (in language or music),

colours (in visual arts), and movement (in speech or film) in representation. The semiotic element is nonrepresentational and yet it has meaning for the human psyche. It motivates representation even as it challenges the stability of signifying structures. The discharge of drives into representation is not only essential for the process to succeed but also for the survival of the psyche. Semiotic drive force is the operator in any representational process.

The symbolic element of representation provides the stability always threatened by its semiotic counterpart. Symbolic stability ensures that representation doesn't give way to delirium or psychotic babble. The symbolic is representational and provides signification with linguistic meaning. The structures of grammar and syntax are the symbolic support of the process of representation. Like the semiotic element, the symbolic element is not only essential for the process of representation to succeed but also for the survival of the psyche.

Different forms of representation display different combinations of semiotic and symbolic elements. Logic and mathematics might be examples of representation in which the symbolic element is dominant, while music and dance might be examples where the semiotic element is dominant. All representation is a constant negotiation between semiotic and symbolic elements. The tension between semiotic and symbolic is what produces representation. For this reason, representation is always a process in which stability is but a precarious moment.

Art and the maternal body

For Kristeva, the semiotic aspect of representation is associated with the maternal body and the infant's first experiences in connection with it. Freudian psychoanalytic theory maintains that the process of becoming an individual subject requires the repression of those primary experiences so that the subject can leave the haven of the maternal body and enter the social. The semiotic rhythms, tones and movements that make their way into representation are expressions of the return of that repressed primary bond. So the semiotic elements in representation are expressions of tones, rhythms and movements first experienced in this primary bodily relationship. In one way or another, then, artistic representation, through its emphasis on the semiotic element in representation, always takes us back to the repressed maternal body.

Throughout her work, Kristeva's analyses of painting, music and literature take us back to the maternal body. For example, in

Revolution in Poetic Language (1974) she applauds the poetry of Stéphane Mallarmé and Lautréamont for its revolutionary movement, lifting inhibitions by breaking through prohibition to introduce liberating drives, drives which always bring us back to the primary relation with the maternal body. In *Desire in Language* (1980) she sees in Giotto di Bondone's use of colour the sublimation of *jouissance* or ecstasy, which is always related to the repressed maternal body and the pleasure that results from the discharge of drives into representation. There, too, she sees in the luminous colours of Jacopo Bellini's 'Madonna with Child' paintings an expression of the luminosity of the maternal space. She suggests that, even while displaying the split mother – both the object of desire and the object of fear – Bellini seeks reunion with the maternal body through painting.

In *Powers of Horror* (1980) she diagnoses Louis-Ferdinand Céline's writings as a struggle with an 'abject' maternal body which both fascinates and horrifies. There, Kristeva describes how both individual and social identity are formed through a process of 'abjection' aimed primarily and most fundamentally at the maternal body: prohibitions against unity with the maternal body found both social rituals and the boundaries of the individual psyche. The return of the repressed maternal body in literature, culture or the individual psyche threatens the borders of the always-precarious status quo, and thereby opens up the possibility of transformation, even revolution.

In *Tales of Love* (1983), figures from Wolfgang Amadeus Mozart, William Shakespeare, Christian mythology, tales of courtly love, Charles Baudelaire, Stendhal and Georges Bataille are analysed in terms of their relationship to the mother and her body; here Kristeva maintains that all love is ultimately love for the mother. In *Black Sun* (1987), the paintings of Hans Holbein, the poetry of Gérard de Nerval and the prose of Dostoyevsky and Marguerite Duras are interpreted in terms of their ability or inability to mourn the lost maternal body. And she begins her monumental study of Marcel Proust, *Time and Sense* (1994), with a discussion of the *petite madeleine* as a remembrance of lost maternal time and space.

Artistic production and revolution

The expression of the repressed connection to the maternal body is what makes art revolutionary. Art can present that which has been buried in the unconscious in a way that is both pleasurable and challenging. In *Revolution in Poetic Language*, Kristeva maintains that

there is an analogy between poetic revolution and political revolution. The influx of drives into language challenges syntax and grammar and revolutionizes language. More than this, the semiotic element in poetic language – or language as art – displays something crucial in the process of representation itself.

For Kristeva, the revolutionary function of poetic language at the end of the nineteenth century was the result of the way that this language pointed to the semiotic element of representation, even while discharging it. In this way, poetic language can show that the process of representation is always made up of both semiotic and symbolic elements; and that representation is a process that results from a constant tension between these two elements. Poetic language is revolutionary in so far as it displays the process of representation itself.

Kristeva also suggests that there can be no political revolution without a revolution in representation. In order to change the way that we act or think, we have to change the way that we represent ourselves. We have to change the relation between our drives, affects and words or artistic representations. In addition, since subjectivity is always essentially linked to language, in order to change our conceptions of ourselves we need to change language; and any change in language is necessarily a change in the status of the subject. If language is a process, so is the subject. If language is ever changing, an open system, so is the subject. Like language, and all forms of representation, Kristeva's subject is always in-process and on-trial.

In *Revolution in Poetic Language*, Kristeva seems to propose a dialectical relationship between politics and artistic practice. While, on the one hand, political revolution requires a revolution in signifying practices, on the other, artists are always the products of their socio-political situations. Art is always a response to the return of repressed unconscious elements on both an individual and social level. In this way art is often a response to psychic crises on both an individual and social level. For this reason, art needs to be analysed in relation to the social and individual history of the artist.

More than twenty years after the publication of her *Revolution in Poetic Language*, in *The Sense and Nonsense of Revolt* (1996), Kristeva proposes that all creativity is the result of revolt, psychic revolt, that takes us back to the most archaic psychic revolutions that initiate both individual and social identity. All artistic production and aesthetic experience require a revolt against, and an identification with, authority. Each artist makes the artistic medium and its logic his or

her own by rejecting the rules of the medium as a transcendent authority that restricts his or her freedom, and by incorporating the authority of the rules into his or her own artistic vocabulary in order to say something new. Artistic creation and all creativity involves rejecting and reincorporating authority; it requires revolt.

Creative revolt is necessary for the survival of psychic life. In this way, art responds to individual and cultural needs. Kristeva goes so far as to suggest that art and literature are other forms of religion. Just as religion provides us with a way to make our lives meaningful, so do art and literature. It is within the creative space opened up through revolt that meaning emerges. If our culture is plagued by feelings of meaninglessness and hopelessness, this is because we are losing our creative space. Kristeva sees hope for revitalizing this creative space through art, literature and psychoanalysis.

Even in seemingly anti-aesthetic art, or ugly art, Kristeva hears a response to the cultural need for meaning which comes through opening aesthetic space. For example, in *The Sense and Nonsense of Revolt*, Kristeva diagnoses installation pieces by Hans Hacke and Robert Wilson as meeting our need for foundations even as they attempt to shatter them. There, she says that these artists, without knowing it, are celebrating alternative foundations, broken ones. Instead of asking the viewer to relate to an object of art, these artists require the 'viewer' to be a participant engaging the entire body and all of the senses. In the place of the object of art, these artists are creating a space in which the 'viewer' contemplates not only the image but also his or her relation to being. In other words, these installation pieces ask the 'viewer' to dwell in the psychic space required to contemplate the meaning of life and our relation to our environment. Kristeva suggests that, in a time when psychic space is closing down, these artists have asked us to contemplate this precarious space; they have touched what Kristeva calls our 'new maladies of the soul'.

Imagination, meaning and ethics

Psychoanalysis, literature and art provide nourishment for a psyche that thrives on reinventing itself through imagination. It is through imagination that bodily drive force and affects are linked to representation. Without these creative links supplied through aesthetic experience, which is essential to psychic life, words and all forms of representation are cut off from affects; and this separation between representation and affect leaves us feeling dissatisfaction, if not despair.

Aesthetic experience is not superfluous to human experience. Rather, in Kristeva's analysis, aesthetic experience is essential to human experience. Aesthetic experience is what makes it possible for human begins to find, and create, meaning in our lives and in our representations of ourselves.

Ultimately for Kristeva it is this imaginative or aesthetic experience that makes ethics possible. Only through imagination can we enter into relations with others. Only through imagination can we embrace the return of the repressed within ourselves and within our culture. It is aesthetic experience that makes the embrace of difference possible. This is why we need to augment aesthetic experience in a culture that seems to be forgetting its importance.

In *New Maladies of the Soul*, Kristeva says that 'the role of aesthetic practices needs to be augmented, not only to counterbalance the mass-production and uniformity of the information age, but also to demystify the idea that the community of language is a universal, all-inclusive, and equalizing tool. Each artistic experience can also highlight the diversity of our identifications and the relativity of our symbolic and biological existence. Understood as such, aesthetics takes on the question of morality.' This new morality, born out of aesthetic experience through imagination, is not an ethics of law or reason *per se*. Rather, it is a pliable ethics that acknowledges its own sacrificial order. It is an ethics that reinvents the repressed by imagining it otherwise in order to embrace it, even while acknowledging the ultimate inaccessibility of the repressed unconscious other within each individual and the repressed other(s) within each culture.

Biography

Julia Kristeva Born Sliven, Bilgaria, Bulgaria, 24 June 1941. Educated by a French religious order, Kristeva went on to study linguistics at the University of Sofia. She moved to Paris in 1966, studying at the University of Paris and l'École Pratique des Hautes Études, publishing articles in the journals *Tel Quel*, *Critique* and *Languages*. She was a member of the editorial board of *Tel Quel* from 1970 to 1983. Her books include *La Révolution du langage poétique*, 1974, and *Soleil noir*, 1987. Kristeva began a second career as a psychoanalyst in 1979. She is now Professor of Linguistics at the University of Paris VII, and lectures regularly at New York's Columbia University.

Bibliography

Main texts

Revolution in Poetic Language (*La Révolution du langage poétique*, 1974), trans. Margaret Waller, New York: Columbia University Press, 1984.
Desire in Language: A Semiotic Approach to Literature and Art, Leon Roudiez (ed.), trans. Thomas Gora, Alice Jardine and Leon Roudiez, New York: Columbia University Press, 1980.
Powers of Horror: An Essay on Abjection (*Pouvoirs de l'horreur: Essai sur l'abjection*, 1980), trans. Leon Roudiez, New York: Columbia University Press, 1982.
Tales of Love (*Histoires d'amour*, 1983), trans. Leon Roudiez, New York: Columbia University Press, 1987.
Black Sun: Depression and Melancholy (*Soleil noir: Depression et mélancolie*, 1987), trans. Leon Roudiez, New York: Columbia University Press, 1989.
New Maladies of the Soul (*Les nouvelles maladies de l'ame*, 1993), trans. Ross Guberman, New York: Columbia University Press, 1995.
Time and Sense: Proust and the Experience of Literature (*Le temps sensible: Proust et l'experience litteraire*, 1994), trans. Ross Guberman, New York: Columbia University Press, 1996.
The Sense and Nonsense of Revolt (*Sens et non-sens de la révolte: Pouvoirs et limites de la psychanalyse I*, 1996), trans. Jeanine Herman, New York: Columbia University Press, 2000.
La révolte intime: Pouvoirs et limites de la psychanalyse II, Paris: Fayard, 1997.
Le Féminin et le Sacré (with Catherine Clément), Paris: Stock, 1998.
Readers:
The Portable Kristeva, Kelly Oliver (ed.), New York: Columbia University Press, 1998.

Secondary literature

Crownfield, D. (ed.), *Body/Text in Julia Kristeva: Religion, Women, and Psychoanalysis*, Albany: SUNY Press, 1992.
Fletcher, J. and Benjamin, A. (eds), *Abjection, Melancholia and Love*, New York: Routledge, 1990.
Guberman, R. (ed.), *Julia Kristeva Interviews*, New York: Columbia University Press, 1996.
Lechte, J., *Julia Kristeva*, New York: Routledge, 1990.
Oliver, K., *Reading Kristeva: Unraveling the Doublebind*, Bloomington: Indiana University Press, 1993.
—— (ed.), *Ethics, Politics and Difference in Kristeva's Writing*, New York: Routledge, 1993.
Smith, A., *Julia Kristeva: Readings of Exile and Estrangement*, New York: St Martins Press, 1996.
——, *Julia Kristeva: Speaking the Unspeakable*, New York: Stylus Press, 1998.

KELLY OLIVER

JACQUES LACAN (1901–81)

FRENCH PSYCHOANALYST

In the eyes of many, Lacan is the most influential and certainly the most controversial psychoanalyst since **Freud** himself. The difficulty and density of his style of writing merely add to the controversy surrounding him and have resulted in both extreme adulation and the dismissive claim that he is a mere charlatan with a considerable gift for rhetoric. The collection of papers published in 1966 as *Écrits* (literally 'Writings') established Lacan's reputation as one of France's leading intellectual figures and made psychoanalysis an essential point of reference for all the human sciences. At that time, Lacan was regarded as one of high priests of structuralism; now, as his debts to phenomenology and even Surrealism become more apparent, matters look more complex.

Lacan's only real book is a study of a psychotic woman patient published in 1932 (*De la psychose paranoïaque dans ses rapports avec la personnalité*); the texts collected in his *Écrits* (1966) are essays, transcripts of lectures, and occasional writings; less than half are included in the English translation (1977). The publication of transcripts of his seminar began in 1973 and continues. Lacan's primary concern is always with the theory of psychoanalysis, and his many literary and artistic references are always subordinate to or illustrative of his concerns as a teacher of psychoanalysis. Lacan broadly subscribes to Freud's view that creativity is largely the product of sublimation, or of the redirection of anarchic sexual drives into socially and intellectual valorized forms, but he rarely makes this explicit. The psychology of creativity and creative artists is, quite simply, not one of Lacan's major concerns. He does elaborate a complex theory of visual perception and experience (mainly in the seminar *The Four Fundamental Concepts of Psychoanalysis*) and of what he calls the 'imaginary' or *imaginaire*, one of the most coherent expositions being that given in sections of the seminar of 1954 ('Freud's Papers on Technique'). He cannot be said to have developed an aesthetics of the visual arts. He does, however, attach great importance to the visual realm, which he sees as a basic fact of human existence: we are beings who look, and who are looked at by other beings.

Although Lacan constantly insists that his work represents a 'return to Freud' (a slogan meant to promote a detailed reading and study of Freud's writings as well as to encourage rejection of both the Kleinian and object-relations schools of post-Freudian psychoanalysis, which

are, he claims, based on misreadings of Freud), it differs from and builds upon Freud in a number of important ways. Freud, for instance, habitually speaks of libido or sexual energy; Lacan speaks, rather, of 'desire', and thus introduces a much broader philosophical concept that owes a great deal to the Hegelianism that was so influential in post-war France (this is discussed in Butler's *Subjects of Desire*, 1987).

His first major contribution to psychoanalytic theory is his account of the so-called mirror phase, first outlined in an unpublished paper dating from 1936, but fully elaborated in the 1949 version of 'The Mirror Stage'. Drawing on the findings of both developmental psychology and ethology, or the study of animal behaviour, Lacan contrasts the behaviour of a young primate with that of a human child aged about eighteen months. When placed in front of a mirror, the primate, Lacan observes, has no particular reaction (contemporary research contests this), whilst the infant (*in-fans*, or 'without speech') reacts by pointing to the mirror image, smiling and displaying signs of jubilation. It has recognized itself. The image in the mirror is, according to Lacan, the child's first perception of its body as a whole, and helps to instil a sense of selfhood: it is a primitive or primal picture (*ein Urbild*) of the ego. The encounter with the mirror image is also, however, an encounter with alienation: the image is an illusion, not real. The recognition of the image necessarily goes hand in hand with a misrecognition of its illusory nature. It follows that the ego is neither, *pace* ego psychology, the central agency of the personality nor a structure that can be 'adapted' to the social world: it is a fundamentally imaginary structure. In Lacanian terminology, 'imaginary' does not simply mean 'fictional' but primarily 'pertaining to an image'. The imaginary is described as one of the three 'orders' that structure all human existence. To simplify greatly, the order of the 'symbolic' is that of language and culture, whilst 'the real' refers not simply to external reality but to those elements of reality that resist verbalization.

Although the paper on the mirror stage introduces important themes, it is the long paper of 1953, 'Function and Field of Language and Speech in Psychoanalysis', that is the first great manifesto of Lacanian psychoanalysis. Further elaborations are introduced in 'The Agency of the Letter in the Unconscious, or Reason since Freud' (1957) and 'The Subversion of the Subject and the Dialectic of Desire in the Freudian Unconscious' (1960), but 'Function and Field' remains the master text. With astounding ambition and erudition, Lacan begins to articulate Freudian theory with the findings of modern

anthropology and linguistics, outlining a vast panorama of human and cultural development. His main sources are **Lévi-Strauss's** *Elementary Structures of Kinship* (1949), and post-Saussurean linguistics. According to Lévi-Strauss, human kinship systems and the prohibitions they bring are the most basic form of civilization, signalling a transition from nature to culture, or from the indiscriminate couplings of animals to the structured networks of kinship and alliance. The exchange of women, that is, allows the establishment of social relations, because it overcomes the social closure established by endogamy (marriage within the kinship group or family). Both Lévi-Strauss and Lacan believed that these structures of exchange are universal, even though their specific forms will vary from one society to another (Lévi-Strauss adds that it would make no difference if the exchange involved men, but adds that this has never been observed in any known society). For Lacan, the emergence of exogamy is synonymous with that of the Oedipus complex, which can now been seen as a universal necessity and not a mere family drama. It is also synonymous with the child's entry (or insertion) into the 'symbolic order of language'.

Lacan's theory of language derives mainly from the Swiss linguist Ferdinand de Saussure's *Course on General Linguistics* (posthumously published in 1913 but little read outside specialist circles until the late 1940s). Lacan follows Saussure in contending that a natural language is not a nomenclature, or a catalogue of 'words' corresponding to 'things'. A language is, rather, a system of signs that are meaningful only to the extent that they differ from each other. This is true at the most basic level of the phoneme: 'box' and 'fox' are meaningful only because of the sound difference between /b/ and /f/. The sign itself is said to be a combination of a signifier (for example, a word) and a signified (its meaning), and its relationship with the extra-linguistic object or referent is arbitrary: there is no logical or natural connection between 'cow' and the bovine grazing in the field. Lacan takes this further by privileging the signifier, which is said to slide along chains of association. There would be no final meaning or end to the sliding were it not for the existence of so-called 'privileged' signifiers that establish at least some stability of meaning. The major privileged signifiers are the 'name of the father', and the phallus or symbol of both paternal authority and sexual difference. Entry into the symbolic is said to be dependent on the child's recognition of the authority of the name of the father, which disrupts the immediate (and imaginary) relationship between mother and child by introducing a third authority who is in possession of the symbolic phallus. In this reworked version of the Oedipal tale, accession to language allows the

child to acquire a position within a symbolic kinship network ('son of ...'), but deprives it of its omnipotent but imaginary possession of the mother. To that extent, it is equivalent to a symbolic castration that leaves the child nostalgic for a lost and potentially incestuous union with the mother.

Turning, finally, to the traditional art of rhetoric, Lacan establishes a parallel between the figures of metaphor (the substitution of one term for another, as in 'Juliet is the sun') and metonymy (the substitution of the whole for the part, and the contiguous relations between chains of signifiers). These are described as the two main axes of language, and they are likened to condensation and displacement (respectively the condensation of multiple meanings into a single dream image, and the transfer of libido from one image to another) that are, according to Freud, characteristic of the workings of the primary system or unconscious; Freud believed they play a key role in dreams, and therefore in art. In other words, for Lacan, the unconscious is structured like a language.

Lacan's many literary allusions are not designed to promote a theory of literature, but to illustrate psychoanalytic theory. Thus, the famous study (1955) of Poe's short story 'The Purloined Letter', with which *Écrits* opens, does not teach us anything about either Edgar Allen Poe or the origins of the detective story: it illustrates Lacan's views on the circulation of signifiers and on the return of the repressed. For Lacan, the fact that the Oedipus complex is the cornerstone of psychoanalysis does not give it any authority to discuss the aesthetic of *Oedipus Rex*, and certainly does not teach us anything about Sophocles. The frequent allusions to painting, sculpture, and even optics (optical experiments are often invoked to explain the concept of the imaginary) serve a similar purpose. Cézanne, Dürer, Arcimboldo, Goya and others are invoked by Lacan at various times, but he is illustrating theoretical arguments rather than discussing their art. The mirror phase is, for example, often accompanied by the terrifying fantasy of the 'body in pieces', in which the unity of the mirror image is shattered and dismembered. Here, the reference to the visual arts may be more than illustrative. Lacan frequently compares this fantasy to the tortured figures depicted by Bosch; it has been suggested by Bowie that his description of the fantasy may owe a lot to – or even be inspired by – Hans Belmer's scandalous images of dolls that have been dismembered with great sadism. Whilst it would be difficult to establish this point with any certainty, it is a reminder that Lacan was closely associated with the Surrealists in the 1930s (when he wrote

for Surrealist publications) and remained personally close to artists such as André Masson.

Lacan's most coherent discussion of the visual arts is to be found in the 1964 seminar *The Four Fundamental Concepts of Psychoanalysis* (first published in French in 1973), and in particular in 'What is a Picture?'. In this seminar Lacan draws heavily on **Merleau-Ponty**'s recently published *Le Visible et l'invisible* to make an important distinction between 'the eye' and 'the gaze'. The concept of the gaze also owes something to Sartre's *Being and Nothingness* (1943), in which being gazed at typified the mode of existence Sartre called 'being for an other', in which the subject is frozen and objectified when looked at; the gaze, that is, originates with 'the other'. Lacan uses similar formulae, and then describes 'the eye' as an attribute of the subject. The alienation and possible aggression involved here is captured by his formula: 'You never look at me from the place at which I see you.' To illustrate his thesis, Lacan discusses Hans Holbein's painting *The Ambassadors* (National Gallery, London). Two richly dressed diplomats look steadily at the viewer. The table between them is covered by emblems of worldly wealth, scientific knowledge and the arts but, in accordance with the Dutch tradition, they are also symbols of *vanitas* that say 'all this must pass away'. The foreground of the painting is taken up by a strange elongated object resembling a cuttlefish bone; seen from one angle (and only one angle) it proves to be a skull – the classic *memento mori*. For Lacan, it symbolizes both death and castration. The anamorphic device is the element that allows the picture to grasp or solicit the viewer, whose eye is constantly drawn to the empty gaze of the skull that stares back at it. For Lacan, a picture is a 'trap for the gaze'.

Lacan's influence on literary theory and literary studies has been immense, but it would be difficult to identify any specifically Lacanian strand in art criticism. In terms of the visual arts, his influence has mainly been on film studies. The US-based conceptual artist Mary Kelly uses his theory of psychoanalysis to explore the mother–child relationship in the mixed-media work known as *Post-Partum Document* (1973–9).

Biography

Jacques-Marie Émile Lacan Born Paris, 13 April 1901. Lacan began his studies at the Paris Medical Faculty in 1920, specializing in psychiatry from 1926. In 1932 he submitted his doctoral thesis:

'Paranoid Psychosis and its Relations to the Personality'. During the 1930s he contributed to Surrealist journals. He presented his first paper on 'The Mirror Phase' at the 1936 Congress of the International Psychoanalytical Association. He became a full member of the Société Psychanalytique de Paris in 1938, and subsequently worked in several Paris hospitals and also in private practice. Lacan served in a medical hospital during World War Two. He began a celebrated series of weekly seminars in 1951, in which he urged 'a return to Freud'; he founded his own École Freudienne de Paris in 1964 (dissolved in 1980); and in 1981 he founded l' École de la Cause Freudienne. He was a director of the publishing house Édition du Seuil between 1963 and 1981. Lacan died in Paris on 9 September 1981.

Bibliography

Main texts

'Seminar on the Purloined Letter' ('Séminaire sur la lettre volée'), trans. Geoffrey Mehlman, *Yale French Studies* 48 (1973). Also in *The Purloined Poe: Lacan, Derrida, and Psychoanalytic Reading*, John P. Muller and W. J. Richardson (eds), Baltimore: Johns Hopkins University Press, 1988.
Écrits: A Selection (*Écrits*, 1966), trans. Alan Sheridan, London: Tavistock, 1977.
The Four Fundamental Concepts of Psychoanalysis (*Les quatre concepts fondamentaux de la psychanalyse*, 1973), trans. Alan Sheridan, with a new introduction by David Macey, Harmondsworth: Penguin, 1994.
The Seminar of Jacques Lacan. Book 1: Freud's Papers on Technique (*Les Écrits techniques de Freud*, 1975), trans. John Forrester, ed. Jacques-Alain Miller, Cambridge: Cambridge University Press, 1988.

Secondary literature

Bowie, M., *Lacan*, London: Fontana, 1999.
Butler, J.P., *Subjects of Desire: Hegelian Reflections in Twentieth-Century France*, New York: Columbia University Press, 1987.
Evans, D., *An Introductory Dictionary of Lacanian Psychoanalysis*, London: Routledge, 1996.
Felman, S., *Jacques Lacan and the Adventure of Insight: Psychoanalysis in Contemporary Culture*, Cambridge, Mass.: The MIT Press, 1987.
Kelly, M., *Post-Partum Document*, Berkeley: University of California Press, 1999.
Macey, D., *Lacan in Contexts*, London: Verso, 1988.
Muller, J.P. and Williamson, W.J., *Lacan and Language: A Reader's Guide to 'Écrits'*, New York: International Universities Press, 1982.
Roudinesco, E., *Jacques Lacan,* Oxford: Blackwell, 1997.
Zizek, S., *Looking Awry: An Introduction to Jacques Lacan Through Popular Culture*, Cambridge, Mass.: The MIT Press, 1991.

DAVID MACEY

SUSANNE K. LANGER (1895–1985)

AMERICAN PHILOSOPHER

Susanne K. Langer developed a systematic and comprehensive theory of the arts while working out a naturalistic theory of mind to account for the uniquely human activities of language, dreaming, ritual, myth and art – a project she later expanded to include a conceptual framework for biological thought that would support an evolutionary account of the nature and origin of human mentality and human society.

Langer's contributions to a general philosophy of culture began with *Philosophy in a New Key* (1942) and developed into a mature philosophy of art with *Feeling and Form* (1953), *Problems of Art* (1957), and an edited volume, *Reflections on Art* (1958). A central theme of *Philosophy in a New Key*, and the basis for Langer's theory of art, was a distinction between 'discursive' and 'nondiscursive' symbolization that has recently reappeared in philosophy as the contrast between propositional and nonpropositional modes of cognition. Langer derived both from the more fundamental human capacity to perceive and manipulate patterns, *gestalten*, or forms in the most general sense, which she called 'the power of seeing one thing in another'. Similarly, George Lakoff and Mark Johnson have recently proposed that a fundamental principle of human experience and understanding is a capacity they call 'metaphorical projection' – the ability to establish connections within and across domains of experience on the basis of perceived similarities of pattern.

When we see that two things exhibit a common form or pattern, we may use one of them to formulate a 'conception' of the other – to serve as a vehicle for what Langer called 'symbolization'; and any medium in which we can construct and manipulate complex configurations of distinguishable elements can help us to formulate a conception of something else that exhibits a similar pattern. Speech and written language, for example, 'are collections of very uninteresting things (noises or marks)' that are none the less 'capable of various and highly complex relations'. We use such symbolic materials – which are 'usually of no intrinsic value whatever' and 'are easily perceived in all their relations to one another' – to symbolize things of real interest or value to us 'which are temporally or spatially too remote, or too big, or in themselves too complicated to be apprehended and analyzed by direct inspection'. We use the elements

of spoken or written language, for example, to formulate and express 'the order and connection of ideas in our minds'.

Under the influence of the German philosopher Ernst Cassirer (1874–1945), Langer argued that different kinds of 'symbolic forms' are appropriate to different objects of knowledge. Some domains of experience and understanding fall readily into the discursive forms of language; but we are also able to apprehend and manipulate patterns that have 'too many minute yet closely related parts, too many relations within relations' to be adequately expressed in words (except as they are used in poetry or other literary works). In a painting, for example, 'the balance of values, line and color and light ... is so highly adjusted that no verbal proposition could hope to embody its pattern'. Because of this potential richness and complexity, Langer believed that works created in the media of the various arts are uniquely suited to provide a means of insight into the intricate dynamic patterns of 'what we call the "inward life" of human beings' – 'the way feelings, emotions, and all other subjective experiences come and go'. More generally, Langer took the broadest possible view of the range of cultural resources that are utilized by human beings in the construction of knowledge and experience, and argued for the importance of language, myth, ritual and art in the characteristically human activity of 'conceiving the world' – a process she called the 'symbolic transformation of experiences'.

In Langer's mature philosophy of art, the general concept of symbolic form became further developed into the concept of 'expressive form'. The analogy of form, or correspondence of configuration between complex relational structures, which she had first proposed as the indispensable condition for symbolization, remained the basis for what she defined as the 'expressiveness' of works of art. And the theory that she had originally developed in *Philosophy in a New Key* to explain the significance of music was generalized to apply to all the arts – to 'painting, sculpture, architecture, music, dance, literature, drama, and film', whose works she defined as 'perceptible forms expressive of human feeling'. 'Feeling is *like* the dynamic and rhythmic structures created by artists' in every medium of expression that we recognize as artistic.

In Langer's definition of art, three terms must be singled out for special attention: 'feeling', 'form' and 'expression'. To begin with 'feeling', it is important to emphasize that Langer used the term in the most general sense to refer to what William James called 'all states of consciousness merely as such, and apart from their particular quality or cognitive function'. She stated unequivocally that she was not using

the word 'feeling' 'in the arbitrarily limited sense of "pleasure or displeasure" to which psychologists have often restricted it', but 'in [the] widest possible sense', to refer to 'what is sometimes called "inner life," "subjective reality," [or] "consciousness," ' which is 'woven of thought and emotion, imagination and sense perception' and includes everything from 'the sensibility of very low animals [to] the whole realm of human awareness and thought'.

Langer also used the term 'form' in its most general sense, to mean a 'complex relational structure' – 'a whole resulting from the relation of mutually dependent factors, or more precisely, the way the whole is put together'. In a painting, for example, 'a visible, individual form [is] produced by the interaction of colors, lines, surfaces, lights and shadows' (*Problems of Art*), or whatever else enters into the specific work. We can also talk about forms made by motion, as when we 'watch gnats weaving in the air, or flocks of birds wheeling overhead' (*Philosophical Sketches*). Among the arts, music and dance are characterized by such transient and dynamic forms. And in literary works, the form is given to imagination rather than perception, as a 'passage of purely imaginary, apparent events'.

In saying that a work of art is 'expressive' of feeling, Langer contrasted the 'symptomatic' expression of currently felt feeling with what she called 'conceptual' expression – the 'formulation of feeling for our conception' (*Philosophical Sketches*). In the former sense, a work of art would be like 'a confessional [or] a frozen tantrum' (*Problems of Art*), a meaning which Langer emphatically rejected. Instead, she argued (in *Philosophical Sketches*) that a work of art is expressive in the way that a sentence can be said to 'present' or 'express' an idea:

> If an idea is clearly conveyed by means of symbols we say it is well expressed. A person may work for a long time to give his statement the best possible form, to find the exact words for what he means to say, and to carry his account or his argument most directly from one point to another. But a discourse so worked out is certainly not a spontaneous reaction.

Similarly, in *Problems of Art*, a work of art sets some 'piece of inward life objectively before us so we may understand its intricacy, its rhythms and shifts of total appearance'; it is 'a perceptible form that expresses the nature of human feeling – the rhythms and connections, crises and breaks, the complexity and richness of what is sometimes called man's "inner life," the stream of direct experience, life as it feels to the living'.

Although it may seem that we perceive feeling itself in the work, strictly speaking 'the work does not contain feeling, any more than a proposition about the mortality of Socrates contains a philosopher' (*Mind*). Rather, what a work of art expresses 'is not actual feeling, but *ideas* of feeling; as language does not [convey] actual things and events but [expresses] ideas about them' (*Feeling and Form*; emphasis added). In a work of art, 'each aspect of feeling [is] developed as one develops an idea, fitted together for clearest presentation' (*Problems of Art*). In this way, 'art makes feeling apparent, objectively given so we may reflect on it and understand it'.

To use a more contemporary idiom, we might say that, in virtue of fundamental cognitive processes that give rise to the spontaneous metaphorical projection of nonpropositional structures from one domain of experience into another, 'music sounds as feelings feel'. And likewise, as Langer concluded, 'in good painting, sculpture, or building, balanced shapes and colors, lines and masses *look* as emotions, vital tensions and their resolutions *feel*' (*Problems of Art*; emphasis added). 'Artistic form is congruent with the dynamic forms of our direct sensuous, mental, and emotional life; works of art are projections of "felt life" ... into spatial, temporal, and poetic structures. They are images of feeling, that formulate it for our cognition' (*Problems of Art*). Because the insights of the artist are always worked out and embodied in an object, they are made publicly available – in this sense, objectified – and therefore publicly *knowable*.

Although Langer initially (in *Feeling and Form*) referred to the work of art as a 'symbol' of feeling, she recognized that it cannot be a symbol in the usual sense because it has no conventional 'reference', and so, she decided, cannot be properly said to have a 'meaning'. In Ernest Nagel's definition, a symbol is 'any occurrence (or type of occurrence), usually linguistic in status, which is taken to signify *something else* by way of tacit or explicit conventions or rules of language' (quoted in *Problems of Art*; emphasis added). In contrast, a work of art does not point beyond itself to something known by other means, for what is expressed in a work of art 'cannot be grasped apart from the sensuous or poetic form that expresses it' (*Problems of Art*), even if the work itself seems to be imbued with a significance that reaches beyond the mere physical datum with which we are presented. For these reasons, Langer realized that 'expressive form' was a better term than 'symbol', and that it was preferable to speak of the *import*, rather than the meaning, of the work (*Problems of Art*).

As a physical object, the work of art is just an arrangement of materials of some kind – pigments on a canvas in the case of a painting, gestures and other movements in a dance, words in a literary work, or tonal materials in a musical composition. What draws our attention, however, is something that seems to emerge from the arrangement of colours, gestures, words or tones – a complex array of qualities which seems to be charged with life and feeling. This 'artistic import' 'is perceived as something in the work itself, articulated by it but not further abstracted' (*Problems of Art*). As a complex relational structure, a work of art

> is a much more intricate thing than we usually think of as a form, because it involves *all* the relationships of its elements to one another, all similarities and differences of quality, not only geometric or other familiar relations. That is why qualities enter directly into the form itself, not as its contents, but as constitutive elements in it (*Feeling and Form*).

In a work of art, 'the import permeates the whole structure, because every articulation of the structure is an articulation of the idea it conveys' (*Feeling and Form*). Every work of art 'is a purified and simplified aspect of the outer world, composed by the laws of the inner world to express its nature' (*Problems of Art*). The primary function of art 'is to make the felt tensions of life, from the diffused somatic tonus of vital sense to the highest intensities of mental and emotional experience, "stand still to be looked at," as Bosanquet said, "and, in principle, to be looked at by everybody" ' (*Mind*).

Art is indispensable as both a product and an instrument of human insight because it makes possible the formulation of what is otherwise inaccessible to us through the discursive resources of language. The artist 'formulates that elusive aspect of reality that is commonly taken to be amorphous and chaotic; that is, he objectifies the subjective realm' (*Problems of Art*); and the work that he produces 'articulates what is verbally ineffable – the logic of consciousness itself'.

Biography

Susanne Katerina Knauth Langer Born New York, 20 December 1895 Langer was the daughter of a prosperous corporation lawyer who had moved to the USA from Germany in the 1880s. She took her

PhD in philosophy from Radcliffe College in 1926, where she studied with Henry Sheffer and Alfred North Whitehead. She married William L. Langer, later a prominent Harvard historian, in 1921 (they were divorced in 1942). Langer was tutor in philosophy at Radcliffe College between 1927 and 1942; and held a number of temporary academic appointments from 1942 to 1954. She became professor of philosophy at Connecticut College for the period 1954–62, but did full-time research and writing between 1956 and 1982 with the support of the Edgar J. Kauffman Foundation of Pittsburgh. Langer died at Old Lyme, Connecticut, on 17 July 1985.

Bibliography

Main texts

Philosophy in a New Key: A Study in the Symbolism of Reason, Rite, and Art, Cambridge, Mass.: Harvard University Press, 1942.

Feeling and Form: A Theory of Art, New York: Charles Scribner's Sons, 1953.

Problems of Art: Ten Philosophical Lectures, New York: Charles Scribner's Sons, 1957.

Reflections on Art: A Source Book of Writings by Artists, Critics, and Philosophers, Baltimore, MD: Johns Hopkins University Press, 1958.

Philosophical Sketches, Baltimore, MD: Johns Hopkins University Press, 1962.

Mind: An Essay on Human Feeling, 3 vols, Baltimore, MD: Johns Hopkins University Press, 1967, 1971, 1982.

Secondary literature

Alexander, T.M., 'Langer, Susanne (1895–1985)', in David E. Cooper (ed.) *A Companion to Aesthetics*, Oxford and Cambridge: Basil Blackwell, 1992.

Berthoff, A.E., 'Susanne K. Langer and the Process of Feeling', in *The Mysterious Barricades: Language and Its Limits*, Toronto: University of Toronto Press, 1999.

Colapietro, V., 'Susanne Langer on Artistic Creativity and Creations', in C.W. Spinks and John Deeley (eds) *Semiotics 1997*, New York: Peter Lang, 1998.

Dryden, D., 'Susanne K. Langer and American Philosophic Naturalism in the Twentieth Century', *Transactions of the Charles S. Peirce Society* 33, 1 (1997), 161–82.

——, 'Whitehead's Influence on Susanne Langer's Conception of Living Form', *Process Studies* 26, 1–2 (1997), 62–85.

——, 'Susanne Langer and William James: Art and the Dynamics of the Stream of Consciousness', *Journal of Speculative Philosophy* 15, 4 (2001), 272–85.

Hansen, F., 'Langer, Susanne Knauth (1895–1985)', in Michael Kelly (ed.) *Encyclopedia of Aesthetics* (vol. 3), New York: Oxford University Press, 1998.

Innis, R.E., 'Perception, Interpretation, and the Signs of Art', *Journal of Speculative Philosophy* 15, 1 (2001), 20–33.

Lachmann, R., 'Susanne K. Langer. Primär- und Sekundärbibliographie', *Studia Culturologica* 2 (1993), 91–114 (the most complete bibliography of works by and about Langer).

Lakoff, G., and Johnson, M., *Philosophy in the Flesh: The Embodied Mind and Its Challenge to Western Thought*, New York: Basic Books, 1999.

Nelson, B.K., 'Susanne K. Langer's Conception of "Symbol": Making Connections Through Ambiguity', in Cecile T. Tougas and Sara Ebenreck (eds) *Presenting Women Philosophers*, Philadelphia: Temple University Press, 2000.

DONALD DRYDEN

CLAUDE LÉVI-STRAUSS (1908–)

FRENCH ANTHROPOLOGIST

Claude Lévi-Strauss's works, predominantly known for their anthropological content, nevertheless contain many studies of individual works of art as well as theoretical developments that address some of the fundamental aesthetic problems, such as the nature of aesthetic emotion or the sources of creativity.

The first chapter of *La Pensée sauvage* (1962; *The Savage Mind*, 1966) – a book about the nature and function of classificatory systems in so-called primitive societies – concludes with a digression prompted by the contemplation of a detail in a portrait of Elizabeth of Austria (a lace ruff) painted by the seventeenth-century French miniaturist François Clouet. Similarly, his four-volume study of Amerindian mythology, *Mythologiques* (1964–71; *Introduction to a Science of Mythology*, 1970–81), starts not with an introduction but an 'Overture' in which Lévi-Strauss is as much concerned with the problem of the relationship between different art forms (in particular, myth, music and painting) as he is with expounding his method for interpreting myths.

In the past, aesthetics was concerned with understanding beauty in itself, as an ideal. It was thought that beauty was explicable in terms of universal and timeless values. Anthropology, by contrast, has shown the relativity of aesthetic values and that art and aesthetic perception are determined by many non-aesthetic factors, including economic, political and moral ones. Without doing away with aesthetics and the question of beauty altogether – as the anthropology of art has tended to do by offering a sociological interpretation of art – but without, either, resorting to metaphysical ideas about Beauty in the absolute, Lévi-Strauss has sought to integrate aesthetic and anthropological understanding, thus addressing some of the fundamental questions raised by philosophical aesthetics from the 'decentred' vantage point afforded by an ethnographic understanding of distant cultures.

The problem with which Lévi-Strauss is preoccupied in his digression about Clouet's lace ruff – reproduced thread by thread in a magnificent *trompe-l'oeil* – is why its contemplation is a source of aesthetic emotion. By way of an explanation, Lévi-Strauss offers his theory of the work of art as a *modèle réduit* or scale model.

Lévi-Strauss proposes that all works of art partake of the nature of miniatures or scale models, like a model airplane or a ship in a bottle. A work of art is a universe in miniature – in William Blake's words, 'a world in a grain of sand'. Even Michelangelo's paintings on the ceiling of the Sistine chapel, despite their size, are 'reductions' because they put the infinite in the finite. And it is from this transposition that aesthetic emotion derives.

Whatever the size of the work, Lévi-Strauss argues, when an artist transforms his/her model into an aesthetic object, he/she must necessarily forgo certain dimensions of the real object. Painting leaves out volume. And both painting and sculpture, in comparison to literature and music, leave out the dimension of time. And it is in this sense that works of art are always 'reductions' of the objects that they represent.

Why is this process of aesthetic reduction significant? It modifies the way in which we take in the object. Ordinarily, we identify the objects that we perceive by constructing a picture of the whole object from what we perceive of its parts. The work of art reverses this process. As a 'miniature', it offers less resistance to sense perception. As Lévi-Strauss puts it, because it is quantitatively reduced, it appears to be qualitatively simplified. And as a result we perceive, or think we perceive, *the whole before the parts*. The work of art is taken in at once as a totality.

This reversal, according to Lévi-Strauss, is one of the keys to aesthetic emotion. It creates an illusion of increased power over the represented object. Through the aesthetic object, the model 'may be grasped, weighed up in the hand, taken in at a single glance' (*Savage Mind*).

Furthermore, because the object that is reproduced in the work of art is sensorially simplified, the missing sensory dimensions are supplemented by the consumer of the work of art. The loss of sensory dimensions is thus compensated for by the acquisition of dimensions that are intellectually graspable. In this way, the work of art comes to fulfil the essential cognitive function that Lévi-Strauss attributes to it, adding to human understanding and knowledge.

The ideas about aesthetic emotion that Lévi-Strauss develops in *The Savage Mind* are best understood in the context of his anthropological

ideas about classification. Lévi-Strauss paints a portrait of primitive man absorbed in the task of trying to understand the natural world around him, which he does through acts of classification. What aesthetic creation and these acts of classification have in common is that they both satisfy the same fundamental human need to create order. And both art and primitive science in its classificatory function proceed in similar ways: through a process of mental *bricolage* (something like intellectual DIY) whereby seemingly disparate elements – essentially, percepts transformed into signs – are integrated into organized systems. Both art and classification fulfil the same totalizing ambition: to construct a global and systematic explanation of the world.

Much of Lévi-Strauss's work as an anthropologist has been devoted to the study of Amerindian mythology, and it is through his studies of mythical thought that he has arrived at some of his major aesthetic insights.

It was his theory about how primitive myths are created that provided him with one of the key concepts of his aesthetic thought, the concept of 'transformation'.

The basic hypothesis underlying the *Mythologiques* is that myths come into being by a process of transformation of one myth into another. For Lévi-Strauss, myths do not have any meaning in themselves but only in relation to each other and therefore have to be studied in the course of their transformation from one into another for their meaning to be understood.

For example, in *The Raw and the Cooked* (volume one of *Mythologiques*), Lévi-Strauss shows that a Bororo myth (the Bororo are an indigenous population of Central Brazil) about the origin of rain (the 'reference myth', M1) is related by transformation to another group of myths (M7–12) told by a neighbouring population, the Gé, which tell the story of how man obtained, from a jaguar, the fire with which he now cooks. The Bororo myth, Lévi-Strauss argues, is a myth about the origin of fire metamorphosed – through a process of inversion – into a myth about the origin of water (the myth treats rainwater as a kind of anti-fire).

Lévi-Strauss's aim in the *Mythologiques* is to bring to light the formal rules of transformation that account for the conversion of one myth into another. These are of different kinds: logical, mathematical, rhetorical and even musical. For Lévi-Strauss discovers, in the course of his analysis of Amerindian myths, that the patterns according to which some myths transform correspond to known musical forms, such as the fugue, the sonata or the rondo (Lévi-Strauss used manuals

on musical composition to understand how certain systems of interrelated myths were structured).

The primacy that Lévi-Strauss grants, in the act of creation, to the logical operations of the unconscious mind (as opposed to emotion, intuition or instinct) gives his aesthetic theories their distinctive colour. Whatever kind of artefact we create – whether a myth, a symphony or a painting – the basic *modus operandi* of the brain remains the same. Its elementary function is the endless combinatorial rearrangement of elements that come from elsewhere.

Myths taught Lévi-Strauss that human artefacts – whether 'primitive' myths or sophisticated works of art – are but elements in multi-dimensional systems of combinatorial transformations, most of which occur at an unconscious level. And the unravelling of the logic according to which mythical transformations occur provided Lévi-Strauss with a paradigm for understanding similar transformations in other kinds of creations and the hence structural relations that link one work to another.

In his latest work to date, *Regarder, écouter, lire* (1993; *Look, listen, read*, 1997), Lévi-Strauss offers a new interpretation of one of Poussin's most famous paintings: *The Arcadian Shepherds*. It shows that the painting came into being through a series of transformations similar to those which occur in primitive myths. Poussin produced two paintings on the theme of the *Arcadian Shepherds*, the first around 1630 and the second five or six years later. The earlier of the two versions drew its inspiration directly from a painting by Guercino on the same theme, which was painted at the beginning of the 1620s. Lévi-Strauss argues that the three paintings correspond to three stages in a sequence of transformations in the course of which Guercino's original composition is gradually assimilated by Poussin and reorganized, only to be re-born as Poussin's *Arcadian Shepherds*.

The title of all three paintings is the Latin formula 'Et in Arcadia ego'. This formula is normally translated as 'I, too, have lived in Arcadia'. The Guercino painting represents two shepherds absorbed in the observation of a skull (which occupies a prominent position in the foreground of the painting) placed on a rock. The painting may be interpreted as follows: it is the skull who is speaking, and who is saying: 'I too exist, even in Arcadia'. In the happiest of places man cannot escape his mortal destiny.

In Poussin's 1630 version of the *Arcadian Shepherds*, a first set of transformations has occurred. First, Guercino's rock has been replaced by a sarcophagus, and it is on the sarcophagus that the Latin formula 'Et in Arcadia ego' is engraved. But, more significantly still, the skull

has been much reduced in size, and from its prominent position in the foreground of the Guercino painting it has been moved to the background in the Poussin painting. Simultaneously, a shepherdess (absent from Guercino's version) appears in the background of Poussin's early painting. The significance of these transformations is borne out when one views them in the light of Poussin's second version of the *Arcadian Shepherds*. The skull has now entirely disappeared, as has the shepherdess, but the foreground of the painting is dominated by a mysterious female figure draped in Ancient Greek robes. As one passes from one version of the painting to another, Lévi-Strauss suggests, the skull gradually disappears, only to be replaced by the female figure who, in the final version, comes to occupy its position. Thus, according to Lévi-Strauss, in Poussin's second version, the female figure in the foreground is an embodiment of death, and it is she, therefore, who is speaking the words 'Et in Arcadia ego'. It is this figuration of death as a maiden which, according to Lévi-Strauss, explains the great appeal that this painting has always had.

Lévi-Strauss has also provided valuable theories for understanding the nature of the aesthetic sign. In his conversations with Charbonnier, Lévi-Strauss differentiates between two paths open to the artist, that of 'imitating' reality and that of 'signifying' it. Much Western art aims to create the illusion of the represented object. It is fundamentally mimetic in orientation. By contrast, the primitive artist creates objects that are signs of the things that they represent, rather than their mirror image. This characteristic of primitive art is partly explicable in terms of the material constraints that limit the primitive artist. But it is also due to the fact that the natural world in which primitive cultures live is one that is steeped in the supernatural and which, therefore, by definition escapes naturalistic representation. As Lévi-Strauss points out, the primitive artist does not aim to copy nature, because for him the 'model will always exceed its representation'.

This conception of the work of art as a system of signs is not something that Lévi-Strauss sees as a particularity of the art of primitive cultures alone but as an intermittently recurring feature of other artistic traditions, including the Western tradition. The style of early Greek sculpture which flourished until the fifth century BC, Lévi-Strauss argues, is an art of the signifier, whereas the style that replaced it – typified by the famous 'Discobolus' (Discus Thrower) of Myron – aimed to be more figurative or representational (the 'Discobolus' is also a stylized *transposition* of the human form, but it aims to reduce, as much as possible, the distance between the model and its representation). Italian painting until the *quattrocento*, that is, up

to and including the Siennese school, also emphasized the sign-value of the images it created. In terms of modern art, Impressionism belongs on the side of representation, whereas Cubism is on that of signification and is therefore close in spirit to the kind of art produced by primitive cultures.

It is curious, therefore, that Lévi-Strauss was so critical of Cubism. If art is to be construed as a system of signs, in other words as a kind of language, like every language its existence depends on the existence of a social group that shares and understands its codes and conventions. The problem for Lévi-Strauss is that in large-scale societies artists no longer create art for the group as a whole, but for a specialized public made up of art-lovers. This is what Lévi-Strauss calls 'the individualization of artistic output' and its result is that art ceases to function as an effective system of communication within the social group. This was the failure of Cubism in Lévi-Strauss's eyes. It wasn't a collectively meaningful aesthetic language – it remained an idiolect or private language.

Biography

Claude Lévi-Strauss Born Brussels 28 November 1908. Lévi-Strauss studied law and philosophy at the University of Paris (1927–32), turning to anthropology in the 1930s. He was professor of sociology at the University of São Paulo, Brazil (1934–7); conducted his first field research in 1935 among the Caduveo and Bororo Indians and later, in 1938, with the Nambikwara (Mato Grosso, Brazil). In 1941 he fled occupied France for New York, where he became visiting professor at the New School for Social Research in New York City (1941–5), and where he met the structural linguist Roman Jakobson. Lévi-Strauss's first major work was *The Elementary Structures of Kinship*, published in 1949, followed by *Totemism* in 1963. He was appointed to the Chair of Anthropology at the Collège de France in 1959, and in 1973 was elected to the Académie française. He also taught at the École Pratique des Hautes Études.

Bibliography

Main texts

The Savage Mind (*La Pensée sauvage*, 1962), London: Weidenfeld and Nicolson, 1966.
Conversations with Claude Lévi-Strauss (*Entretiens avec Claude Lévi-Strauss*, with G.

Charbonnier), trans. John Weightman and Doreen Weightman, London: Cape, 1969.

Introduction to a Science of Mythology (Mythologiques, 1964–71), trans. John Weightman and Doreen Weightman, 4 vols, London: Cape, 1970–81.

The Way of Masks (La Voie des masques, 1975), trans. Sylvia Modelski, Seattle: University of Washington Press, 1982.

Myth and Meaning: Five Talks for Radio, London: Routledge, 1978.

The View from Afar (Le Regard éloigné, 1983), trans. Joachim Neugroschel and Phoebe Hoss, Oxford: Blackwell, 1985.

Conversations with Claude Lévi-Strauss (De près et de loin; with Didier Eribon), trans. Paula Wissing, Chicago: University of Chicago Press, 1991.

Look, listen, read (Regarder, écouter, lire, 1993), trans. Brian C.J. Singer, New York: Basic Books, 1997.

Secondary literature

Boon, J., *From Symbolism to Structuralism: Lévi-Strauss in a Literary Tradition,* Oxford: Basil Blackwell, 1972.

Clement, C., *Lévi-Strauss ou la structure et le malheur,* Paris: Seghers, 1970.

Hayes, E.N. and T., *Claude Lévi-Strauss: The Anthropologist as Hero,* Cambridge, Mass.: The MIT Press, 1970 (includes essays by Edmund Leach, George Steiner and Susan Sontag).

Hénaff, M., *Claude Lévi-Strauss and the Making of Structural Anthropology,* translated by Mary Baker, Chicago: University of Minnesota Press, 1998.

Leach, E., *Claude Lévi-Strauss,* London: Fontana, 1996.

Merquior, J.G., *L'Esthétique de Lévi-Strauss,* Paris: Presses Universitaires de France, 1977.

Pace, D., *Claude Lévi-Strauss, The Bearer of Ashes,* Boston: Routledge and Kegan Paul, 1983.

Paz, O., *Claude Lévi-Strauss: an Introduction,* Ithaca: Cornell University Press, 1970.

——, *Deux Transparents: Marcel Duchamp et Claude Lévi-Strauss,* Paris: Gallimard, 1970.

Wiseman, B., *Introducing Lévi-Strauss and Structural Anthropology,* Cambridge: Icon Books, 1997.

Special issues:

Critique, 620–621 (January–February 1999), (looks in particular at Lévi-Strauss's ideas on art and aesthetics).

BORIS WISEMAN

ALAIN LEROY LOCKE (1886–1954)

AFRICAN-AMERICAN CULTURAL HISTORIAN

Alain Locke described himself as 'midwife' for a new generation of African-American artists and writers. A scholar devoted to the development of a group-conscious school of African-American art and literature, he believed African-Americans had already contributed

many native elements to the national culture in the areas of music, dance and folklore, but did not think full recognition would be granted until they also contributed to art forms such as the novel and drama in the literary field, or painting and sculpture in the fine arts. He organized support for African-American writers and became directly involved in the promotion of African-American art by arranging exhibitions, including some that were of African art.

Locke died before completing his magnum opus, *The Negro in American Culture*, which would have provided a single authoritative source for his aesthetic theory. In two scholarly treatments, *Negro Art: Past and Present* (1936) and *The Negro and His Music* (1936), he presented his view of African-American cultural progress, tracing the development of various forms of folk expression from their early manifestation in antebellum plantation life to their twentieth-century transformation. His analysis displays several basic rudiments of his aesthetic theory. Various stages of cultural development are represented by means of an historical schema that indicates progress in each phase by reference to folk forms having entered a process of transformation into high art. The uneven development of music and art is explained in terms of African retentions. Noting that advancement had occurred in those areas of cultural expression where there had been an early start in well-developed folk art forms, he concludes that faster progress has been made where African retentions were strongest. He remarks that 'there was some memory of beauty [in] song, graceful movement and poetic speech', a list he expands to include retentions in pantomime and folklore. By contrast with these forms, he observed that no such retentions existed in sculpture or the decorative arts, and appealed to environmental influences to explain both what was retained and what was lost of the African cultural heritage.

This view of retentions was a basis for Locke's advocacy of a Negro racial idiom in art. It was important that African-American artists gain inspiration from exposure to their lost African heritage – to creatively express racial themes in their art, as well as to acquire the advanced skill and technique of their ancestors. He promoted the restoration of a lost African tradition in sculpture and the decorative arts that literally had been erased by the toils of slavery. The crudeness of slave labour caused physical damage to the hands of the slave, consequently there was an eventual loss of the manual dexterity required for sculpting, carving and similar physical skills. By comparison with music, dance and poetry, slavery reduced African-Americans to a 'cultural zero' in visual art. He considered the uneven development of various art forms to be an indication of important differences between African and

African-American cultures with regard to artistic temperament. The ordeal of slavery had caused African-Americans to emphasize the 'emotional' forms of cultural expression. This lopsided development and neglect of the plastic and pictorial forms has resulted in a reversal of the African artistic temperament. Beneath the African-American's 'transplanted' artistic temperament, however, 'slumbers' an original, more basic, one waiting to be reawakened. According to Locke, since the African spirit is at its best in abstract decorative forms, it is this 'slumbering gift' that needs 'reachievement and reexpression' ('Art of the Ancestors', 1925).

Locke's appeal to an underlying Negro artistic temperament to account for the unique element in Negro art and music should not be taken to imply that the kinship between African and African-American cultures is rooted in genetics. He assumes only an emotional bond between peoples of African origin. When he remarks that 'we must believe that there still slumbers in the blood something which once stirred will react with peculiar emotional intensity toward African art', his use of the term 'blood' is misleading, since he only meant this bond to be understood in terms of a reconstructed social memory peculiar to those whose cultural roots trace back to Africa. While acknowledging that the African-American artist had not yet 'recaptured his ancestral gifts or recovered his ancient skills', he maintains that this recovery of a lost African tradition in the plastic arts will occur 'not as a carry-over of instinct', but instead as 'a formal revival of historical memory' based on 'the proud inspiration of the reconstructed past'. Because the rediscovery of an African tradition in art by African-American artists would be at second remove, through the work of European masters such as Picasso, Barlach, Lipchitz and Modigliani, the race tradition instituted by African-American artists will draw upon both European and African masters to produce uniquely African-American art.

Locke considered the self-conscious racialism and self-expression represented by the work of the Negro Renaissance artists to be a necessary phase of African-American cultural development. In the mature stages of development, Negro elements combine with various modes of European classical music, or modern art, to produce hybrid forms that are both racial and national. This objective of fusing the musical and artistic self-expression of black people with European music and art was a guiding principle for his conception of the aesthetic outcome of the Negro Renaissance and dictated the criteria by which he evaluated its success. He argues that the race consciousness of the Negro Renaissance is an important step toward the integration of the

Negro subject into American art. Once Negro art, and the Negro subject in art, have gained acceptance as representative American art, there will be a true cultural democracy in America. Art, therefore, can be a means of social change, given that cultural pluralism in art will pave the way for greater social equality. This pragmatic orientation of African-American art toward social change is perhaps the most prominent feature of Locke's aesthetic theory.

Locke's concept of cultural democracy can be understood in terms of his characterization of African-American art as both racial and national. Given the social outcome he envisioned, his commitment to this decidedly *political* objective seems to reduce African-American art to group propaganda. He touted the Negro Renaissance as 'a minority promotion move – an attempt to capitalize and bring one's own stock to par, and to have a quotable market rating and a recognized market standing' ('Beauty Instead of Ashes', 1928). He often spoke of African-American culture as a kind of capital that provides leverage for social change. He believed, however, that recognition and respect for the African-American contribution to the national culture would be achieved only on the basis of the aesthetic value of African-American music, literature and art. For this reason he insisted upon authentic forms of cultural expression, which he defined as self-expression representative of the group. He rejected well-intentioned 'positive' portrayals that lack aesthetic merit, along with other non-representative 'Nordicized' and 'minstrel' images. He argued that the capitalization of the race's endowments and particular inheritances of temperamental experience must eschew propaganda in favour of beauty ('Negro Portraiture', 1928). Art that meets the highest aesthetic standards is the best group propaganda.

Locke believed that folk elements drawn from black peasant culture would come to be viewed by both black and white artists as native material for a national high art. If, however, this process of cultural reciprocity between black and white artists is the primary social outcome of the cultural democracy Locke championed, what is the difference between the cultural democracy made possible by Negro Renaissance artists, in which black and white artists reciprocally employ both African-American and European idioms, and the situation of African-American artists such as Robert Duncanson and Henry Tanner prior to the Negro Renaissance? Locke cites Duncanson's successful career painting portraits and murals for Cincinnati's patrician families as an illustration of the fact that, even in the South, a talented black artist was given recognition. In a similar vein he claimed that Tanner's success was due to his talent.

Nonetheless, he was critical of African-American artists whose work evaded the black subject, maintaining that it was possible for an artist to be race-conscious and expressive without hindrance to his cosmopolitan scope ('Advance on the Art Front', 1939). His remark that the work of Tanner 'showed no racial path or social significance' indicates the connection between his view of African-American art and his conception of the Negro Renaissance as an important step towards cultural democracy. He maintained that a racially conscious art, produced by a group of African-American artists, would be 'less apologetic' and 'stultifyingly imitative' and would stimulate a more 'vigorous creativity' by introducing a decidedly black aesthetic into the work of African-American artists.

Although Locke endorsed the development of this racial idiom as a means of fostering group pride and self-respect, he also aimed to create a race tradition in African-American art. He argued that African-American self-expression requires a collective endeavour by artists interested in genuine Negro portraiture. The Negro Renaissance had succeeded in creating a group of African-American artists who had a common bond of race-consciousness in their work. Artists such as Aaron Douglas, Edouard Scott, Laura Wheeler Waring, Hale Woodruff, Archibald Motley and James Lesesne Wells ran the gamut of modern techniques and schools. Each, nonetheless, had 'a distinguishable note or accent that could as easily have a racial explanation as a national one'. For Locke, the difference between the racial and national aspects of African-American art is only a matter of relative degree. White and black artists can have almost the same 'depth of attitude', except that, perhaps, in most cases the white artist will display 'more technical and emotional detachment'. What accounts for this difference is the history of slavery and racial oppression. The African-American experience of racial discrimination has intensified emotionally and intellectually group feelings, reactions and traditions that have become an important part of African-American culture. This experience is the basis of what is of 'distinctive worth and originality' in African-American self-expression. According to Locke, 'The materials were all American, but the design and the pattern were different' ('Art of the Ancestors', 1925).

In addition to a high standard of technical skill, the most important lesson Locke wanted African-American artists to derive from African art had more to do with the essence of that tradition, namely, its vigorous simplicity and vitality (Foreword to *Contemporary Negro Art*, 1939). He worried that African-American artists would follow European art into an 'indirect inoculation of African abstraction and

simplification' which will only lead to 'slavish imitation and sterile sophistication' ('Up Till Now', 1945). He wanted the African influence on African-American art to be inspirational as well as technical. The racial aspect of African-American art would not necessarily invoke the memory of an anterior culture. Locke believed that, by dealing with the African-American experience, the younger generation of artists such as Ernest Crichlow, Jacob Lawrence, Elizabeth Catlett, Norman Lewis, Charles White and John Wiley had displayed their ability to blend a social message with the abstractly aesthetic into a balanced, mutually reinforcing synthesis.

This hybrid form of expression is a defining characteristic of African-American art. Of all the artists Locke promoted, the work of Jacob Lawrence most embodies his view. Lawrence's work is technically accomplished and deeply committed to social issues. He employs African principles of design and focuses on African-American history as his subject matter. With regard to the universal elements in works such as the *Toussant L'Ouverture* and the *Migration* series, Locke asks 'Which cause owed the greater debt to him? Haitian national history, Negro historical pride, or expressionism as idiom for interpreting tropics, peasant action and emotion' ('Advance on the Art Front', 1939). Locke's point regarding the universal aspects of African-American art is reflected in his remarks regarding the work of Richmond Barthes, a sculptor who dealt with subjects such as lynching (Foreword to *Contemporary Negro Art*, 1939). According to Locke, Barthes's famous sculpture of a mother cradling the broken-necked body of her lynched son displays several components of African-American art. It is striking enough to be more potent anti-lynching propaganda than an armful of pamphlets: a decidedly racial theme. It would move with pity a spectator who was unfamiliar with lynching: a universal response. It would be of interest to an art critic who merely has an appreciation of the problems of sculptural form and tradition: a technical achievement.

Locke distinguishes the Eurocentric traditionalist and modernist from the Africanist school. While only the latter represents a race tradition, race-conscious African-American artists are not precluded from creating non-racial art, and all African-American artists benefit from their success.

Locke's critical analysis of African-American cultural expression extended well beyond the field of the visual arts. He was a prolific commentator on developments in poetry, music, dance and theatre, to which he applied a robust theory of African-American culture that was well ahead of its time.

Biography

Alain LeRoy Locke Born Philadelphia, Pennsylvania, 13 September 1886, son of Pliny and Mary Hawkins Locke. He was educated at Harvard in 1904–7 (Phi Beta Kappa); was an Oxford Rhodes Scholar, 1907–10; and at the University of Berlin, 1910–11; The title of his PhD thesis from Harvard in 1918 was 'The Problem of Classification in the Theory of Value'. He was Professor at Howard University between 1912 and 1953, and published *Negro Art: Past and Present* in 1936. Locke died in New York on 9 June 1954.

Bibliography

Main texts

'Art of the Ancestors', *Survey Graphic* 53 (1 March 1925), 673.

'The Negro's Contribution to American Art and Literature', *Annals of the American Academy of Political and Social Science* 140 (1928), 234–47.

The New Negro, Alain L. Locke (ed.), New York: Albert and Charles Boni, 1925.

'Negro Portraiture', Review of *Portraits in Color*, by Mary White Ovington, *Nation* 126 (11 April 1928), 414.

'Beauty Instead of Ashes', *Nation* 126 (18 April 1928), 432–4.

'The American Negro as Artist', *American Magazine of Art* 23 (September 1931), 210–20.

'The Negro's Contribution in Art to American Culture', *Proceedings of the National Conference of Social Work*, New York: 1933, 315–22.

Negro Art: Past and Present, Washington, DC: Associates in Negro Folk Education, 1936.

The Negro and His Music, Washington, DC: Associates in Negro Folk Education, 1936.

'The Negro's Contribution to American Culture', *Journal of Negro Education* 8 (July 1939), 521–9.

'Advance on the Art Front', *Opportunity* 17 (May 1939) 132–6.

Foreword to *Contemporary Negro Art*, Baltimore Museum of Art, Exhibition of February 3–19 1939.

The Negro in Art: A Pictorial Record of the Negro Artist and of the Negro Theme in Art, Washington, DC: Associates in Negro Folk Education, 1940.

'Up Till Now', Introduction to *The Negro Artist Comes of Age: A National Survey of Contemporary American Artists*, Albany, NY: Albany Institute of History and Art, 1945.

'Negro Art', *Encyclopaedia Britannica*, vol. 16 (1951), 198–9.

Secondary literature

Baker, H.A. Jr, *Modernism and the Harlem Renaissance*, Chicago: University of Chicago Press, 1987.

Butcher, M.J., *The Negro in American Culture*, New York: Alfred A. Knopf, 1956.

Crane, C.B., 'Alain Locke and the Negro Renaissance', PhD dissertation, University of California, San Diego, 1971.

Harris, L. (ed.), *The Philosophy of Alain Locke: Harlem Renaissance and Beyond*, Philadelphia: Temple University Press, 1989.

Linnemann, R.J. (ed.), *Alain Locke: Reflection on a Modern Renaissance Man*, Baton Rouge: Louisiana State University Press, 1982.

Mason, E.D., 'An Introduction to Alain Locke's Theory of Values', PhD dissertation, Emory University, 1975.

Stewart, J.C., 'A Biography of Alain Locke: Philosopher of the Harlem Renaissance, 1886–1930', PhD dissertation, Yale University, 1979.

——, *The Critical Temper of Alain Locke: A Selection of His Essays on Art and Culture*, New York: Garland, 1983.

——, *Race Contacts and Interracial Relations: Lectures on the Theory and Practice of Race*, Washington, DC: Howard University Press, 1992.

Washington, J., *Alain Locke and Philosophy: A Quest for Cultural Pluralism*, Westport, Conn.: Greenwood Press, 1986.

TOMMY L. LOTT

JEAN-FRANÇOIS LYOTARD (1924–98)

FRENCH PHILOSOPHER

Jean-François Lyotard has long been recognized as one of the major figures in the development of postmodern thought. Although best known as a philosopher and cultural theorist, Lyotard also wrote extensively on the subject of art, producing numerous books, exhibition catalogues and essays over the course of his long career. His more general philosophical enquiries, particularly his concern with the concept of the sublime, also constitute important contributions to critical and aesthetic theory and artistic practice, and after considering the nature of those we shall move on to look at his writings on art in more detail.

Postmodernism is to be considered as a generalized cultural reaction to received authority in all its various forms – social, political, intellectual and artistic. For Lyotard, Western history since the Enlightenment has been dominated by a series of 'metanarratives' (or grand narratives) which have demanded our undivided loyalty. Both Marxism and liberal democracy are examples of such metanarratives in the political domain, although analogues can be found in other areas of discourse as well. Modernism, as a case in point, can be regarded as the metanarrative of artistic activity and aesthetic theory for the bulk of the twentieth century, and, in effect, claimed the right to legislate over artistic production during this period. Metanarratives command considerable authority, to the point

where they can become tyrannical by enforcing conformity to a norm. In order to be taken seriously by their peers in the art world, for example, most twentieth-century artists had to paint in a modernist rather than a realist style; and to experiment rather than to continue to develop traditional modes of expression. It is against such enforced conformity that postmodernism is directed, its objective being to encourage diversity of expression in all areas of discourse instead of adherence to one supposedly superior metanarrative. Postmodernists, in other words, are champions of the cause of difference.

Lyotard's concept of the 'differend' captures this commitment to difference very neatly. The differend is an irresolvable dispute between two parties: irresolvable because the parties are using incommensurable 'phrase regimens', or discourses, with their own internal criteria for deciding arguments. Put simply, their agendas are mutually exclusive, and the dispute will only be resolved if each agrees to respect the other and allow it to continue in its own way; or if, as more usually happens in the real world, one side imposes its will on the other and suppresses the opposing agenda. The overriding concern of Lyotard's work is to encourage us to respect the differend, and thus, in his eyes, significantly to reduce political conflict. Lyotard is also committed to what he calls the 'event'; that is, to the experience of the immediate moment, which is conceived always to be open and undetermined. It is one of the great failings of metanarratives that they are *not* open to the event, but claim to be able to forecast or determine its outcome (as in the case of Marxism's theory of a dialectic inexorably working through human history towards a specific end). Art at its best for Lyotard makes us aware of the event and of the fact of difference.

Lyotard displays an obsessive concern with the concept of the sublime over his later career, to the extent of writing an extended commentary on Kant's writings on the topic (particularly the *Critique of Judgement*, 1790) entitled *Lessons on the Analytic of the Sublime* (1991). Building on the work of Kant, and other eighteenth-century theorists of the sublime such as Edmund Burke, Lyotard regards the sublime as a manifestation of the unpresentable. He treats it as the role of art to be in dialogue with this phenomenon: 'that there is something which can be conceived and which can neither be seen nor made visible: this is what is at stake in modern painting' (*The Postmodern Condition: A Report on Knowledge*, 1979). For Kant and Burke, the sublime constituted that which lay beyond our human understanding (in Kant's case, the realm of the *noumenal* or 'thing-in-itself'). Concepts like infinity and totality could not, by definition, be represented – they were quite literally inconceivable. Our recognition of this failure of

our understanding was a potential source of pain in our desire to make sense of the world around us.

Burke in particular had a considerable impact on contemporary aesthetics, influencing a whole school of writers in later eighteenth- and early nineteenth-century Britain – the 'Gothic' novel tradition. Gothic novelists such as Ann Radcliffe made extensive use of Burke's theories, with the former's many descriptions of the 'sublime' landscape in her narratives drawing directly on Burke for inspiration. Burke had contended that, when confronted by objects of vast dimension or power, we were struck with a sense of awe; precisely what Radcliffe's heroines experience when they are exposed to brute nature in their travels through the Alps and the Apennines (in *The Mysteries of Udolpho* or *The Italian*, for example). Lightning storms, waterfalls and sheer precipices make the Radcliffe heroine aware of her vulnerability and insignificance in the general scheme of things: nature far outstrips human capabilities, particularly the capabilities of the lone individual.

The sublime constitutes a limit for both Kant and Burke, although the former is more exercised by this than the latter, given that it calls into question the overall viability of his philosophical project – to demonstrate how our world conforms to our concepts of it. Kant found himself wrestling with the problem that we can have a concept of, but not a conception of, infinity and totality. For Lyotard, too, the sublime is a limit, but it is one that we must accord respect rather than struggle against. Postmodernist thought in general is concerned to draw our attention to epistemological limits, and regards the faith placed in human reason by the 'Enlightenment project' and its followers as excessive. In its concern with demarcating limits, postmodernism reveals itself to be an updated form of scepticism, pointing out the gaps in our claims to knowledge. (For a detailed study of the latter phenomenon, see Sim, *Contemporary Continental Philosophy: The New Scepticism*, 2000.)

Lyotard's writings on art are extensive, and reveal a deep and life-long interest in the topic. Rather surprisingly for someone concerned to challenge the cultural dominance of modernity and the modern, he shows a marked preference for the work of ostensibly modernist artists. Marcel Duchamp, the subject of Lyotard's most extended study on the subject of art, is a case in point. *Duchamp's Trans/Formers* (1977) is a collection of essays concentrating on two works of that artist: *The Bride stripped bare by her Bachelors, even (The Large Glass)*, and *Given: 1. The Waterfall, 2. The Illuminating Gas*. 'It figures the unfigurable', Lyotard claims of the former, 'a figure that could not be intuited – at least that

of a woman having four dimensions'. Which is to say that the work presents the unpresentable. Lyotard goes on to praise the 'pointlessness' of Duchamp's work, the 'machinery' of which, he argues, challenges the notion of a 'totalizing and unifying machine' in any area of human endeavour. To resist totalization is to resist the project in which all metanarratives are engaged, thus bringing Duchamp under the heading of the postmodern. In his own way, Duchamp forces us to recognize the limits of our knowledge and the reach of our reason.

Duchamp's work is held to resist critical analysis, having for Lyotard 'something uncommentable' about it that defeats the critic. What critics traditionally strive to do is to place artworks in historico-cultural context, such that they can be said to 'mean' something in terms of the development of a particular metanarrative (the Enlight-enment project, for example). Duchamp's 'pointlessness' prevents us from doing that, frustrating the impulse to systematize that lies at the root of the metanarrative of modernity. Faced by an artist like Duchamp, who is plainly refusing to conform to what is culturally expected of the artist, modernist or otherwise, the critic must cease to speak for the metanarrative, and, instead, 'try not to understand and to show that you haven't understood'. The critic acknowledges the limits of understanding – yet another rejection of the Enlightenment ethos.

Various other artists are praised by Lyotard for their ability to bear witness to the event and the fact of the differend. Paul Cézanne's *Mont Sainte Victoire* paintings are claimed to capture events ' "directly" ... without the mediation or protection of a "pre-text" ' (*Peregrinations: Law, Event, Form*, 1988). Barnett Baruch Newman's paintings similarly seek to be 'the occurrence, the moment that has arrived' (*The Inhuman: Reflections on Time*, 1988). Valerio Adami is another Lyotard favourite, an artist who can be observed 'stripping himself of our collective imagery' in order to present us with a 'primal landscape' as yet unmarked by the designs of metanarratives (*The Lyotard Reader*). In each case the artist has managed to escape the constricting effect of his metanarrative, and to convey a sense of the openness of the future to us.

The ability to present the unpresentable becomes an index of aesthetic value for Lyotard. Modernism is no less capable of achieving this state than postmodernism; but modernism, Lyotard claims, does so reluctantly, communicating a feeling of nostalgia for a world where the fact of the unpresentable was not yet realized (or was ignored altogether), and organic unity was assumed to be achievable. In modern art, the unpresentable is 'put forward only as missing contents', whereas in postmodern art we realize that organic unity is

an illusion and that the unpresentable is of necessity always with us (*Postmodern Condition*). The presence of that nostalgia helps us to discriminate between the modern and the postmodern, although it is important to note that these are not historically specific terms for Lyotard. Modernism and postmodernism are, instead, to be understood as cyclical movements: there have been modernisms and postmodernisms in the past, and there will be again in the future. At the moment, however, we are deemed to be squarely within a postmodern period, where the entire concept of metanarrative is under attack, and art is for Lyotard a critical way of revealing the shortcomings of the metanarrative project. For the time being anyway, the sublime is firmly back on both the philosophical and artistic agenda.

Biography

Jean-François Lyotard Born Versailles 1924. He taught philosophy at a high school in Constantine, Algeria, 1950–52, and at the Prytanée Militaire de la Flèche, 1952–59. In 1954 he joined the *Socialisme ou barbarie* group, and became the main writer on Algerian issues for the group's journal in 1955. He became a lecturer at the University of Paris, 1959–66; the University of Nanterre, 1966–70; and the University of Paris VIII, Vincennes, 1970–87 (where he was Professor of Philosophy from 1972 to 1987). He published *The Postmodern Condition* in 1979. Lyotard was Visiting Professor at (amongst other places) the University of California at San Diego and Berkeley, and at Johns Hopkins University, Baltimore, 1974–6; and at Yale University, 1992. He was founder-member of the Collège International de Philosophie, Paris, 1983 (President 1984–6). He died on 21 April 1998.

Bibliography

Main texts

The Postmodern Condition: A Report on Knowledge (*La condition postmoderne: Rapport sur le savoir*, 1979), trans. Geoffrey Bennington and Brian Massumi, Manchester: Manchester University Press, 1984.

Duchamp's Trans/Formers (*Les Transformateurs Duchamp*, 1977), trans. I. McLeod, Venice, CA: Lapis Press, 1990.

The Inhuman: Reflections on Time (*L'inhumain: Causerie sur le temps*, 1988), trans. Geoffrey Bennington and Rachel Bowlby, Oxford: Blackwell, 1991.

Peregrinations: Law, Event, Form, New York: Columbia University Press, 1988.

Of the Sublime: Presence in Question (*Du sublime*, 1988; with others), trans. Jeffrey S. Librett, Albany, NY: SUNY Press, 1993.
Reader:
The Lyotard Reader, Andrew Benjamin (ed.), Oxford and Cambridge, Mass.: Blackwell, 1989.

Secondary literature

Benjamin, A. (ed.), *Judging Lyotard*, London and New York: Routledge, 1992.
Bennington, G., *Lyotard: Writing the Event*, Manchester: Manchester University Press, 1988.
Carroll, D., *Paraesthetics: Foucault, Lyotard, Derrida*, London: Methuen, 1987.
Descombes, V., *Modern French Philosophy* (*Le même et l'autre*, 1979), trans. L. Scott-Fox and J.M. Harding, Cambridge and New York: Cambridge University Press, 1980.
Pefanis, J., *Heterology and the Postmodern: Bataille, Baudrillard, and Lyotard*, Durham, NC and London: Duke University Press, 1991.
Raffel, S., *Habermas, Lyotard and the Concept of Justice*, Basingstoke: Macmillan, 1992.
Readings, B., *Introducing Lyotard: Art and Politics*, London and New York: Routledge, 1991.
Sim, S., *Beyond Aesthetics: Confrontations with Poststructuralism and Postmodernism*, Hemel Hempstead: Harvester Wheatsheaf, 1992.
——, *Modern Cultural Theorists: Jean-François Lyotard*, Hemel Hempstead: Prentice Hall, 1996.
——, *Lyotard and the Inhuman*, Cambridge: Icon Press, 2000.
——, *Contemporary Continental Philosophy: The New Scepticism*, Aldershot: Ashgate, 2000.

STUART SIM

ÉMILE MÂLE (1862–1954)

FRENCH ART HISTORIAN

Émile Mâle was the outstanding French member of the pioneering generation of scholars responsible for transforming art history from a nascent field of inquiry into an internationally recognized and respected discipline. Adolph Goldschmidt (1863–1944), Alois Riegl (1858–1905), Wilhelm Vöge (1868–1952), Aby **Warburg** (1866–1929) and Heinrich **Wölfflin** (1864–1945) stood alongside him in the vanguard. Mâle is best known as an iconographer of French religious art of the twelfth to the fifteenth centuries, although he published important studies of early medieval and Counter-Reformation art and architecture as well. He was also a committed educationalist who recognized the importance of making art broadly

accessible, both for the growth of his discipline and for the preservation of his country's artistic heritage. Mâle's scholarship was, on the whole, conservative. He remained an iconographer throughout his career, effectively uninfluenced by the methodologies developed during the first half of the twentieth century by art historians outside France. Indeed, his best-known and most influential publication, and the one usually taken to epitomize his conceptual approach, was also his doctoral dissertation. *L'art religieux du XIIIe siècle en France* (1898; translated as *Religious Art in France, The Thirteenth Century*) has earned Mâle the title of 'cultural historian' with many, as its primary goal is the recovery of thirteenth-century *mentalités* through the subject matter of High Gothic art (unlike many later scholars, for example André **Malraux**, Mâle thought this possible), rather than intrinsic artistic analysis. Furthermore, he is often considered in essence a nineteenth-century figure, because his methodology and scholarly interests were to a large extent conditioned by his art-historical predecessors. However, almost all of Mâle's publications appeared after 1900, and the most important of them still have a diverse international readership. He broke fresh ground with many of his investigations, and deserves to be regarded among the twentieth century's key writers on art.

It is difficult to provide a brief précis of the content of Mâle's writings, for they cover a very wide range of subject matter. He published 187 books, articles and shorter notices during his lifetime, and posthumous works continued to appear into the 1960s. With very few exceptions, these deal with art-historical topics; unlike a number of his colleagues (Henri **Focillon**, for example) he did not contribute to newspapers, nor did his interests in Greek archaeology and Classical mythology translate into published work. For a balanced picture of his prodigious oeuvre, the broad sweep of its chronology (late Antiquity to the eighteenth century) and object domain (which embraces textiles, woodwork, seals, metalwork and the graphic arts as well as the 'privileged' arts of architecture, monumental sculpture, wall and panel painting, stained glass and manuscript illumination) must be matched against Mâle's relatively superficial treatment of individual works and his preoccupation with French material of the high and later Middle Ages. Moreover, no fewer than sixty-five of his published articles were subsequently incorporated into books, occasionally recast but frequently with very little revision.

At the core of this output are four major iconographic studies, three explaining the sources of French religious art of the twelfth to the early sixteenth centuries, the other an analysis of Counter-

Reformation iconography (chiefly of the seventeenth century) in Flanders, France, Italy and Spain. *Religious Art in France, The Thirteenth Century* was followed by *L'art religieux de la fin du moyen âge en France* (*Religious Art in France, The Late Middle Ages,* 1908); *L'art religieux du XIIe siècle en France* (*Religious Art in France, The Twelfth Century,* 1922) and *L'art religieux après le concile de Trente* (Religious art after the Council of Trent, 1932). All are regarded as classics of art historical literature, the first generally being thought the most outstanding; André Grabar called it Mâle's masterpiece 'incontesté et incontestable'. While Mâle came, retrospectively, to consider the medieval volumes as a trilogy, *Religious Art in France, The Thirteenth Century* stands out in its concern with thought over art. It is usual to summarize Mâle's scholarship with reference to it, but in fact the two subsequent works are more generally representative. Without forsaking their precursor's concern with textual sources and *mentalités,* or its assertion that High Gothic constitutes the pinnacle of French artistic achievement, they demonstrate more interest in subjects that occupied their author throughout his career (as teacher as well as writer), in particular the foreign origins and development of the imagery they discuss.

None of these four volumes evidence Mâle's very strong interest in ecclesiastical architecture and early Christian and Byzantine art, nor his concern for the growth and implementation of his academic discipline. These subjects are covered in individually published papers (some of which are included in his *Art et artistes du moyen âge*), and late studies such as his *Rome et ses vieilles églises* (*The Early Churches of Rome,* 1942), *Nôtre-Dame de Chartres* (1948), and *La cathédrale d'Albi* (The Cathedral of Albi, 1950). His pedagogical concerns gave rise to a number of articles, the most frequently cited being 'L'art du moyen âge en France depuis vingt ans' (Medieval art over the past twenty years, 1901). Mâle's response to a League of Nations questionnaire on the preservation and dissemination of artistic taste in France, published in 1923 (*League of Nations Committee on Intellectual Co-operation, Brochure no. 15*), is also very revealing. The former is both historiographical review and manifesto on the advancement of research into medieval art and architecture, while the latter sets out in broader terms his vision for the promotion of art history generally in post-World War One France.

Mâle's monographs on Chartres and Albi exemplify his approach to medieval architecture. Eschewing what was a highly developed science in nineteenth-century France, he never analysed buildings from an architectural historian's point of view; moulding profiles, cross sections

and graphic reconstructions are absent from his published work. He preferred to discuss architecture in terms of stylistic development, or as a fundamental constituent of the *Gesamtkunstwerk* that he perceived in even the smallest medieval parish church. This concept of the 'total work of art' bears closely upon Mâle's methodology generally. Working with an idea adumbrated in Adolphe Napoléon Didron's *Iconographie chrétienne* (Christian Iconography, 1843), Mâle argued in *Religious Art in France, The Thirteenth Century* that the fully-furnished High Gothic cathedral was originally conceived as a pictorial encyclopedia approximating to a written one – Vincent of Beauvais's mid-thirteenth century *Speculum maius*, taken along with the Bible and the thirteenth-century *Legenda aurea* (*Golden Legend*), a collection of religious stories and saints' lives, served as his exemplar. All great thoughts and important facts were recorded in the imagery with which it was embellished, and all people, even the most ignorant, had once comprehended this symbolic language. Medieval art was didactic, and people could learn everything they needed to know by 'reading' and meditating upon it. While each subject was and is semantically autonomous, and may thus be read on its own, it is only when one observes the panoply as a whole that the true genius of the thirteenth-century French mind expresses itself. The 'total work of art' is effectively a 'total text', the cathedral a monumental book of stone, wood, glass, metal, fabric and parchment.

This is the classic statement of systematic iconography, and although Mâle did not develop the 'encyclopedic' metaphor further in subsequent writings (he thought it relevant only to the thirteenth century), he did continue to argue that, with the exception of some marginal imagery, pictorial art was effectively carved or painted text. 'Just as in the thirteenth century, there is not a single artistic work produced in the fifteenth century that cannot be explained by a book', he wrote in *Religious Art in France, The Late Middle Ages*; the opinion informs all his writings on art, appearing undiminished in the posthumous *Les saints compagnons du Christ* (The Holy Companions of Christ, 1958). This methodological conservatism is noteworthy given the developments in scholarly approach that occurred in German and American art history during his lifetime. Mâle was always thoroughly aware of these developments. Indeed, at the beginning of his career he had praised the 'scientific' study of French Early and High Gothic sculpture (involving rigorous analysis of formal characteristics and artistic processes with the goal of attributing works to individual 'masters') undertaken by Wilhelm Vöge, promoting its conceptual value and even writing an article (in 1895) conditioned by the same

methodology. In 1927, he introduced the term 'iconology' into art historical discourse (Warburg had previously used it adjectivally, but not as a noun), and is thus occasionally referred to as an iconologer. But the deep, contextual investigations of the sources of art conducted by Warburg, Fritz Saxl, Erwin **Panofsky** and others did not tempt him. Iconography was a popular and successful method, and Mâle had built his reputation upon it. It served his pedagogical aims because it explained otherwise opaque subject matter in relatively straightforward terms. This had the practical advantage (particularly when coupled with Mâle's exceptionally readable prose) of attracting people to the study of art history, and of firing their interest in their cultural heritage. As a Catholic it permitted him to linger over the most edifying material manifestations of his faith without having to examine the social conditions in which these objects were produced. As an ardent nationalist it could be used to bolster his claims for French cultural superiority and – with some assistance from stylistic analysis – deny those of other countries (particularly Germany, whose inhabitants Mâle styled 'barbarians' following the bombardment of the cathedrals of Rheims and Soissons in World War One). High Gothic, indisputably French in origin and character, represented the zenith of medieval art and thought, and it followed that thirteenth-century France could be likened to the Greece of Phidias. Mâle actually wrote (in 1907) that French thirteenth-century artists 'were the true inheritors of the spirit of Greece', thus earning himself the sobriquet 'Winckelmann of the study of medieval art' (although the equation of medieval France and ancient Greece on artistic grounds was not originally his idea). Thoroughgoing contextual analyses of individual works could only have interfered with such conclusions. Thus, iconography rather than iconology always remained Mâle's method of choice.

The influence exerted by Mâle's writings has been profound, largely due to their broad circulation. *Religious Art in France, The Thirteenth Century* is one of the few foundational art history texts still widely read. New editions have recently been published in English (1984, 1990, 2000), French (1993) and German (1994), and it exists in Dutch, Italian, Japanese and Spanish. The English edition of 1984 is part of a Bollingen Foundation project to publish fresh translations of all four of the main volumes on iconography (the final one is yet to appear), which has been complemented by the appearance (in 1986) of an English-language translation of *Art et artistes du moyen âge* (*Art and Artists of the Middle Ages*, 1927). This activity indicates that much of what Mâle wrote is still considered both correct and valuable, a

conclusion endorsed by the footnotes of current art-historical literature. Mâle's core writings have also been used extensively (if less critically) by scholars of other disciplines, medieval musicology being a notable example.

However, aspects of Mâle's scholarship have not escaped criticism. While many of his French colleagues extolled his work, there were dissenting voices – including some influential ones – from a relatively early stage, particularly concerning the perceived simplicity of Mâle's methodology. Largely, the criticisms were implied. Focillon, for example, suggested that, historically, medieval images were comprehended in different ways by different categories of viewer; it follows that an interpretation of art that designates to each image a single meaning is too narrow. Panofsky also went to some lengths to distance his iconology from the less complicated iconography practised by Mâle, which he considered insufficient for true insight. Grabar pointed out that Mâle's conception of the encyclopedic cathedral is overstated, not least because it makes inadequate allowance for secular thought. Further, he identified in his older colleague's writing a paternalistic, condescending strain concerning the medieval *illiterati* inconsistent with the 'diffused genius' which Mâle claimed was manifest in the cathedrals of Amiens, Chartres, Rheims, etc. Recently, questioning of iconography's ability to provide a sufficient account of the meanings of medieval art has increased. Michael Camille, in particular, has criticised Mâle in a number of publications, for underestimating the significance of marginal imagery, for relating image to text too rigidly (he argues for 'intervisual meanings which seek to subvert texts and to alter their meanings'), and, more seriously, for failing to recognize that medieval interpretation was multifarious, viewer response having been conditioned by personal experience. This last point recalls Focillon's objection, and indeed, Camille's criticisms encompass most of the general charges brought against Mâle's scholarship over the past seventy years. They also testify to the enduring influence of this scholarship, which would not otherwise require such individual scrutiny. For the large quantity of original and valid information they contain, and for their growing importance for the historiographers of art history, Mâle's publications on medieval art will remain key writings well into the twenty-first century.

Biography

Émile Mâle Born Commentry 2 June 1862, son of a miner. Mâle was educated at the École Normale Supérieure in 1883–6. During the

1880s he aspired to a career as a painter, then as a Classical archaeologist. He taught literature at secondary schools from 1886, and was a lecturer in art history from 1892. Mâle was Professor of Medieval Archaeology (later Professor of Art History) at the Sorbonne from 1908; and Director of the École Français in Rome from 1927. He retired in 1937. During World War One, he published *L'art allemand et l'art français du moyen âge* (German and French art of the Middle Ages). He was a member of many learned organizations, including the Society of Antiquaries in London. Mâle died at Chaalis on 6 October 1954.

Bibliography

Main texts

Religious Art in France, The Thirteenth Century: A Study of Medieval Iconography and Its Sources (*L'art religieux du XIIIe siècle en France. Étude sur l'iconographie du moyen âge et sur ses sources d'inspiration*, 1898), trans. Marthiel Mathews, ed. Harry Bober, Princeton: Princeton University Press, 1984. (A less scholarly edition of *L'art religieux du XIIIe siècle en France* is: *The Gothic Image*, trans. Dora Nussey, New York: Harper, 1958; and reissued as *Religious Art in France of the Thirteenth Century*, New York: Dover Publications, 2000.)

'L'art du moyen âge en France depuis vingt ans', *Revue de Synthèse Historique* 2 (1901), 81–108.

Religious Art in France, The Late Middle Ages: A Study of Medieval Iconography and Its Sources (*L'art religieux de la fin du moyen âge en France. Étude sur l'iconographie du moyen âge et sur ses sources d'inspiration*, 1908), trans. Marthiel Mathews, ed. Harry Bober, Princeton: Princeton University Press, 1986.

L'art allemand et l'art français du moyen âge, 1917.

Religious Art in France, The Twelfth Century: A Study of the Origins of Medieval Iconography (*L'art religieux du XIIe siècle en France. Étude sur les origines de l'iconographie du moyen âge*, 1922), trans. Marthiel Mathews, ed. Harry Bober, Princeton: Princeton University Press, 1978.

Art and Artists of the Middle Ages (*Art et artistes du moyen âge*, 1927), trans. and ed. Sylvia Stallings Lowe, Redding Ridge, Conn.: Black Swan, 1986.

L'art religieux après le concile de Trente. Étude sur l'iconographie de la fin du XVIe siècle, du XVIIe, du XVIIIe siècle. Italie, France, Espagne, Flandres, 1932.

The Early Churches of Rome (*Rome et ses vieilles églises*, 1942), trans. and ed. David Buxton, London: Ernest Benn, 1960.

Religious Art from the Twelfth to the Eighteenth Century (*L'art religieux du XIIe au XVIIIe siècle*, 1945), extracts chosen by the author, London: Routledge and Kegan Paul, 1949.

Secondary literature

Bober, H., Foreword to *Religious Art in France, The Twelfth Century: A Study of the Origins of Medieval Iconography*, Princeton: Princeton University Press, 1978.

Brush, K., *The Shaping of Art History: Wilhelm Vöge, Adolph Goldschmidt, and the Study of Medieval Art*, Cambridge: Cambridge University Press, 1996.

Camille, M., 'Art History in the Past and Future of Medieval Studies', in John Van Engen (ed.) *The Past and Future of Medieval Studies*, Notre Dame and London: University of Notre Dame Press, 1994.

Dilly, H., 'Émile Mâle (1862–1954)', in Heinrich Dilly (ed.) *Altmeister moderner Kunstgeschichte*, Berlin: Deitrich Reimer, 1990.

Émile Mâle et le symbolisme chrétien. Exposition organisée par la bibliothèque municipale de Vichy au Centre culturel et au Grand Casino de Vichy, 28 mai-20 juin 1983 (exhibition catalogue), Vichy: Wallon, 1983.

Grabar, A., 'Notice sur la vie et les travaux de M. Émile Mâle', in *Institut de France, Académe des Inscriptions et Belles-Lettres. Comptes rendus de séances de l'année 1962*, Paris: C. Klincksieck, 1963, 329–44.

Harvey, J.C., 'Mâle, Emile', in Jane Turner (ed.) *The Grove Dictionary of Art* vol. 20 (34 vols), London and New York: Macmillan, 1996.

Lambert, É., 'Bibliographie des travaux de Émile Mâle', *Cahiers de Civilisation Médiévale* 2 (1959), 69–84.

Sainte-Croix, L., 'Un grand historien de l'art au moyen âge: Émile Mâle', *Mercure de France* 690 (15 July 1927), 324–50.

Therrien, L., *L'histoire de l'art en France. Genèse d'une discipline universitaire*, Paris: Éditions du C.T.H.S., 1998.

JULIAN M. LUXFORD

ANDRÉ MALRAUX (1901–76)

FRENCH WRITER

For literary scholars Malraux's art essays constitute a logical extension of the metaphysical world-view underpinning his fiction and driven by a quest for a human permanence. For art historians they represent, more often than not, an unprofessional foray into their reserve. In 1954 Ernst **Gombrich** published his predominantly critical and now virtually canonical review of Malraux's best-known art essay, *Les Voix du silence* (1951), and its projection of art as a 'romantic saga'. Two years later the French art historian Georges Duthuit condemned Malraux's neglect of history in a three-volume rebuttal of the same study. In the 1980s and 1990s even Malraux's most sympathetic art-historian critics still alluded to his 'quirky insights' or prudently presented him as a 'novelistic historian'. However, by this time, except in the specialist Malrucian press, Malraux had all but disappeared from the art agenda. Arguably this has less to do with his ideas than with his florid style redolent of French political oratory at which, as a fervent Gaullist, he excelled. Unfortunately today's more intimist television-driven discourse can make Malraux read, for the uninitiated at least, like a rhetorical dinosaur.

Essentially, Malraux's art essays are anti-historical and pursue an emotively charged examination of a creative process in which each culture adapts the art of another filtered by its own priorities, a process defined as metamorphosis. The *raison d'être* of this examination is neither art-historical nor theoretically aesthetic but metaphysical. Malraux looks to art to testify to man's capacity to reject the human condition and particularly the passage of time. Evolved throughout his career, Malraux's reflections on art are remarkably consistent. The concept of 'metamorphosis' is outlined in his second novel, *La Voie royale* (1930), while in the later essays the figure of the artist resembles the final avatar of Malraux's novelistic heroes rebelling against their destiny. The artists who are centre-stage in the art essays, and who include Giotto, Michelangelo, Rembrandt, Goya, Manet and Picasso, share, as Malraux writes in his tribute to Picasso, a will to create 'pitted against the Creation' (all translations from Malraux's texts are my own). Published twenty-five years before his death, Malraux's *Les Voix du silence* remains the central reference for his art theories, although *La Métamorphose des dieux* (1957–77) and *L'Homme précaire et la littérature* (1977) expand the scope of these.

Three fundamental themes are expounded in the essays: the artist as the rival and not the transcriber of reality; the artist's gradual disengagement from Christianity and other external absolutes as art becomes its own supreme value; and, finally, the process of metamorphosis, best witnessed in the 'Museum without Walls', constituted by the multiplicity of unorthodox photographic juxtapositions in *Les Voix du silence* and subsequent volumes. 'For art, time is not historical time', writes Malraux, and metamorphosis testifies to the artist's denial of historical time, a process in which eventually, in *L'Homme précaire et la littérature*, although with reservations, literature would also participate: 'A major characteristic of artistic creation – and note that this applies to *Maldoror* as well as to Montaigne's *Essays*, to Manet's *Olympia* as well as to Sumerian statues – is to consign the work of art to metamorphosis thus making it genuinely alive.' These three themes are all essentially associated with three periods in art history which can be readily assimilated into Malraux's world-view: Greek antiquity, the Renaissance, and modern art.

For Malraux the Greeks were the first to challenge the divine order of things. Ancient Greece gave birth to the concept of art as a humanizing force. While Assyrian and Egyptian art had illustrated destiny's response to man's supplications, the Greeks not only created their gods but introduced man into their company, thus denying their omnipotence. Such defiance produced the first profane art. Greek

tragedy dominated man's destiny by portraying it, while Greek sculpture proposed a world created by gods who were man's accomplices. When rediscovered by fifteenth-century Rome, to cite one of Malraux's favourite examples of metamorphosis, the resultant statues were seen neither as representations of handsome men and women nor as tributes to an absolute situated outside art. Blanched by the passage of time and dispossessed of the divine, they appeared to embody a sovereign power once imparted by the divinities but now drawn from the 'poetry' of the plastic arts and defined in *La Métamorphose des dieux* as the 'unreal'. This supernatural world inspired by art allowed Renaissance artists, profoundly influenced by the metamorphosis of the Greek statues and imbued, like the Greeks, with a new faith in man, to intuit the potential autonomy of what, for centuries, had been considered a medium for a supreme truth extraneous to art. By the early fifteenth century, Western civilization was evolving rapidly as man pushed back scientific as well as geographical frontiers. Man was no longer simply God's creation, nor was the artist the anonymous purveyor of a supernatural which, towards the end of the Roman Empire, had become God. The medieval artist had worked in symbols, annexing the real world to the supernatural. A Romanesque sculptor's shepherd could only ever be a shepherd from the Nativity. As man moves out of the darkest Middle Ages, Malraux perceives a gradual 'humanization of the sacred'. The sculptor challenges conventions and feeds his own world-view into his service to God. Christian iconography becomes progressively more humanist and the sculptor less anonymous until, in the early 1430s, Donatello's statue of a pageboy consecrates the power of the artist. Although legitimized biblically by its name, Donatello's freestanding *David* demonstrates, in Malraux's perspective, a progressive secularization of art within a Christian imaginary.

By the Renaissance the divine had become a 'desacrilized divine' and, if the medieval religious subject – the saint, the Madonna – survived, it was only in a non-stereotyped form. Botticelli's *Spring*, Malraux suggests in the second volume of *La Métamorphose des dieux*, heralds a new world in which 'female figures stop being women without becoming saints and stop being saints without becoming women'. They are liberated from the human condition – and not by God's powers. For the great Renaissance artists from Botticelli to Michelangelo, art became synonymous with their ability to substitute their specific world for any world order. During the two hundred years between the deaths of Rembrandt and Delacroix, however, the potential of the work of art to be its own supreme value remained

unexploited. Only with Manet's *Olympia* (1896) did the era of the 'unreal', by then interpreted as an idealization of the real, come to an end. Manet's painting depicts a Venus, a symbol of the 'unreal' but now sustained by no suggestion of a spiritual absolute and ostentatiously devoid of all idealization. Malraux claims that Manet's female figure represents the 'first Venus from nowhere', in a painting which legitimized the specific language of colour and rejected the 'unreal' without yielding to reality. As in the Impressionists' landscapes, reality became subordinated to the painting. *Olympia* denotes the end of a period born at the Renaissance with the 'resurrection of the gods of antiquity' and, in the final volume of *La Métamorphose des dieux*, validates the main thrust of Malraux's argumentation: 'Painters witnessed the birth of a yet unknown domain, that of the succession of allusions to the real or to the imaginary which no longer came together through that real or imaginary but through the allusion itself, in other words through painting.' Progressively legitimized, from Cézanne to Picasso, art now serves art.

It is important to understand, however, that in Malraux's perspective this process is not restricted to modern art. It is the latter, now acting as a catalyst, and not historical research which has led 'to our understanding of El Greco's art'. Indeed, modern art's newly discovered autonomy facilitates the immediate assimilation of all past art into the specific world of art as religious art and that dedicated to the 'unreal' become subordinate to what Malraux terms, in *Les Voix du silence*, 'that obscure God ... which is called art'. The full impact of the resultant simultaneous presence of Tintoretto, Poussin, Goya, Manet and Picasso can only be appreciated in the 'Museum without Walls', that privileged site of metamorphosis. The latter was already a feature of the conventional museum where, without their historical context, exhibits survived independently and constituted a quintessence of the work of art. However, the artistic memory of today's visitor encompasses not only absent masterpieces but also mosaics and frescoes, while the traditional museum can only offer a truncated vision of man's creativity. A photographic museum – the 'Museum without Walls' – can now accommodate a potentially exhaustive display of the world's art. Within the Museum the process of metamorphosis is complex, involving, first, the displacement, by the common absolute of art, of those transcendental truths which inspired Greek, Romanesque and Gothic art, and the 'unreal' which inspired the Renaissance. Second, time may have transformed the appearance of the work displayed; and, third, the visitor imposes his own aesthetic

taste on the art exhibited. Assembling for the first time 'the art of the world', exhibiting Aztec idols alongside the Chartres *Kings*, the 'Museum without Walls' repudiates man's impermanence by displaying the timelessness of art. The 'Museum without Walls' demonstrates art's simultaneous ascendancy over the human condition. The scenario is familiar and underpins all Malraux's work: 'Like all my novels, like my *Antimémoires*, like *Les Voix du silence*, *La Métamorphose des dieux* is essentially about the relationship between man and destiny', we read in the introduction to the second volume of *La Métamorphose*.

Whatever Gombrich's misgivings about Malraux's subjective vision of the plastic arts, he would eventually admit that, at a time when art history was splintering into specialisms, Malraux's global enterprise would ensure that his essays would outlive the work of the professionals and bear 'witness to a civilization to which art still mattered'. It is also worth remembering that the 'Museum without Walls' embodied not only Malraux's desire to globalize the impact of art but also his ambition to democratize access to the latter. This aspiration drew him closer to one of his favourite artists, Goya, whose publication of the *Caprichos* in book form sought to release art from high culture and offer it to a wider audience. This was also the ambition of Malraux's 'Maisons-de-la-culture' programme at the Ministry of Culture; and, indeed, Malraux's whole approach to art is encapsulated in a brief extract from his speech inaugurating the first 'Maison de la culture', in Amiens in 1961: 'The university is here to teach you. We are here to teach you to love.'

Biography

Georges André Malraux Born Paris, 3 November 1901. He abandoned his formal education 1918. While on an archaeological expedition to Cambodia in 1923 he was arrested for pillaging a Khmer temple. He was co-editor of a French-language newspaper in Saigon, 1925–26, and published *La Condition humaine* in 1933. Malraux was the commander of a Republican air squadron in the Spanish Civil War in 1936–7, and a fundraiser for the Spanish Republican cause in Europe and North America in 1937. In 1939 he directed *Sierra de Teruel*, a film about the Spanish Civil War. During World War Two, Malraux was commander of the Alsace-Lorraine Brigade of the French Resistance, 1944–45. He became Information Minister in de Gaulle's first government, 1945–46; and Minister of State for Culture between 1959 and 1969. He published a series of major art essays, between 1947 and 1957, and a series of memorialist essays beginning

with *Antimémoires* between 1967 and 1976. Malraux died in Paris on 23 November 1976.

Bibliography

Main texts

'La Psychologie de l'art', *Verve* 1, 1 (December 1937), 41–8.
'Psychologie des Renaissances', *Verve* 1, 2 (Spring 1938), 21–5.
'De la représentation en Orient et en Occident', *Verve* 1, 3 (Summer 1938), 69–72.
La Psychologie de l'art, I, II, III, Geneva: Skira, 1947–50.
Saturn: An Essay on Goya (*Saturne: essai sur Goya*, 1950; revised as *Saturne: le destin, l'art et Goya*, 1978), trans. C.W. Chilton, London: Phaidon, 1957.
The Voices of Silence (*Les Voix du silence*, 1951), trans. Stuart Gilbert, London: Secker and Warburg, 1954.
Le musée imaginaire de la sculpture mondiale, 3 vols, Paris: Gallimard, 1952–4.
The Metamorphosis of the Gods (*La Métamorphose des dieux*, vol. 1, 1957), trans. Stuart Gilbert, London: Secker and Warburg, 1960.
Picasso's Mask (*La Tête d'Obsidienne*, 1974), trans. June Guicharnaud, New York: Holt, Rinehart and Winston, 1976.
La Métamorphose des dieux, vols 2 and 3, Paris: Gallimard, 1974–6.

Secondary literature

Bevan, D.G., *Invincible Dialogue: Malraux, Michelangelo and Michelet*, Amsterdam: Rodopi, 1991.
Chan, V., 'The Fatal Enticement of Religion and Revolution: Malraux, Goya and *Los caprichos*', *Revue André Malraux Review*, 21–22 (1998–9), 44–72.
Duthuit, G., *Le Musée inimaginable*, I, II, III, Paris: José Corti, 1956.
Glendinning, N., 'Malraux and Spanish Art', *Revue André Malraux Review*, 21–22 (1998–9), 28–43.
Gombrich, E.H., 'Malraux and the Crisis of Expressionism', in *Meditations on a Hobby Horse and Other Essays on the Theory of Art*, London: Phaidon, 1963 (article first published in 1954).
——, 'Malraux's Philosophy of Art in Historical Perspective', in Martine de Courcel (ed.) *Malraux's Life and Work*, London: Weidenfeld and Nicolson, 1976.
Machabéïs, J., 'From East to West and Beyond: Itinerary of the Eternal Pilgrim', in Geoffrey T. Harris (ed.) *André Malraux: Across Boundaries*, Amsterdam: Rodopi, 2000.
——, *Malraux et la tentation du sacré*, Amsterdam: Rodopi, 2002.
Tannery, C., *Malraux the Absolute Agnostic; or, Metamorphosis as Universal Law* (*Malraux, l'agnostique absolu, ou, La métamorphose comme loi du monde*, 1985), trans. Teresa Lavender Fagan, Chicago: University of Chicago Press, 1991.
Zarader, J.-P., *Malraux ou la pensée de l'art*, Paris: Ellipses, 1998.

GEOFFREY T. HARRIS

MAURICE MERLEAU-PONTY (1908–61)

FRENCH PHILOSOPHER

One of the primary concerns that directs much of the work of the French philosopher Maurice Merleau-Ponty is his effort to see philosophy and science grounded in a direct and pre-reflective contact with the world. For Merleau-Ponty, whose philosophy draws on the phenomenology of Husserl, our life is in constant interaction with a world that is always already present before any philosophical reflection can begin. This concern to portray our direct experience of the world opens his first major study of perception, *Phenomenology of Perception* (1945), as well as his last published work, the essay 'Eye and Mind' (see *The Primacy of Perception*, 1964).

Merleau-Ponty's understanding of perception as an opening unto and an interaction with the world places the human body at the centre of his philosophy. For him, our body is not simply an object among others to be studied abstractly, nor is it simply a machine for processing information received from our environment. It is a dynamic region of sensory awareness that is oriented towards the world. Consciousness reaches out to the world through the senses, and intermingles with the world to give it meaning and form. In turn, the world also acts upon us, for we perceive aspects of the world that call our attention. Of course, all that calls our attention and upon which we focus is outlined or framed by what is not perceived. Thus, Merleau-Ponty understands existence in terms of the visible and the invisible rather than in terms of being and nothing. The ex-centric and concentric directions mediating body and world give perception a to-and-fro character similar to that of a shuttle creating a fabric. The fabric of meaning that is woven from this interaction is what Merleau-Ponty calls the 'texture of Being', and this texture envelops both body and world. He insists that the resulting configuration of body and world should not be compared to a physical object but rather to a 'work of art' (*Phenomenology of Perception*). Of course, both perceiver and world are always framed by what is beyond our perception.

This notion of the body as a work of art, together with the phenomenon of visibility, give the visual arts a privileged position in Merleau-Ponty's project of endowing our pre-reflective involvement in the world with a philosophical status. An artist does not create a reproduction or resemblance of nature that already exists as a pre-configured entity. While creating a painting, the artist interacts with the world primarily through the sense of sight and, more than any

other sense, sight underscores the intertwining of human being and nature because there is no way to separate the act of seeing from the facet of the world that is seen. It is by lending his or her body to the world that the painter incorporates nature into a painting. While concentrating fully on different scenes, artists often become aware that the seeing and the seen overlap. This phenomenon is what Merleau-Ponty calls 'visibility', an undividedness of sensing and the world in which a painting takes on form.

Through the sense of vision, then, the visual artist opens to and intertwines with the world. The painter can look at the world without the writer's or philosopher's obligation to appraise what is seen and, therefore, is in a better position to offer the direct contact with the world that Merleau-Ponty seeks. In the warp and weft of nature and perception, it is not only the artist that reaches out to the world but also the world that passes through the artist onto the canvas. This often prompts the painter to feel that things are gazing at him or her, rather than the other way around. This sense of reversibility confirms that painting cannot be reduced to a technique for outlining and highlighting a facet of the world. It reproduces the very process whereby the world also comes to us through perception. When a painter becomes deeply engrossed in a work, visibility takes over and the overlapping of seer and seen dissolves the distinction between the two poles in perception.

An artist works with line, colour and depth of perspective in creating a work of art. The degree to which an artist is capable of incorporating the world into a work depends on his or her depth of awareness. Depth is a primary dimension of perception that also determines how well one can interact with the world at a distance. An in-depth review of the world will foster an awareness of facets that had been previously beyond our reach. According to Merleau-Ponty, Cartesian thought limits sight to the immediacy of the tactile world by intellectually modelling vision after the sense of touch. Merleau-Ponty's phenomenology seeks to free vision from the tactile so that it can wander through the world at a distance and allow the body to interact with its distant facets. Distance, however, is not only what we measure in geometric terms but also that which lies on the periphery of our field of consciousness. Colour and line come into play from the artist's depth of awareness. A colour is never perceived as something discrete. It emerges slowly through its interaction with the white of the canvas as well as with other colours to create different shades and shapes. As in nature, lines do not exist for the artist as things in themselves but as a medium that renders things visible.

The artist's effort, then, is to incorporate the world into a painting and make it available to others. Unlike a photograph, a painting does not capture a facet of the world as it was at any particular instant but rather calls the attention of its viewers to the process whereby the artist perceived the world. A photograph freezes an image exactly as it was at a specific instant, but a painting is achieved over a period of time. There is life in a painting and movement in its design precisely because the painter offers multiple glimpses over time of an ever-changing scene. While painting, the artist's rapid glimpses move from canvas to different facets of the world that call his or her attention, and then back to the canvas. Thus, painters links partial glimpses of their subject into a totality that it never was at any instant. Objects are always slightly out of place and it is this displacement that gives the painting a sense of movement. By attentively viewing a painting, the perceiver's eyes move back and forth over the canvas accommodating subtly displaced objects and giving unity to the multiple glimpses of different colours, lines, contrasts, masses, empty spaces and reliefs. By carefully linking its different parts, the viewer incorporates the scene into a whole. The phenomenon of visibility that overlapped painter and world, in turn, overlaps viewer and canvas and, in the to-and-fro movement of perception, the painting comes to life, making sense for and giving meaning to the body that perceives it. Merleau-Ponty underscores the notion that, contrary to popular belief, it is the painting that faithfully reproduces our everyday perception of the world and not the photograph. Perception does not freeze experiences in discrete instants but incessantly weaves multiple facets of our experience of the world into an ever-changing, meaningful whole.

Merleau-Ponty's philosophy, of course, speaks to visual art in general and Matisse, Klee, Leonardo da Vinci, Rodin, Van Gogh, Caravaggio, as well as others, have attracted his attention. However, Cézanne captures Merleau-Ponty's interest more than any other painter because he lends himself best to Merleau-Ponty's project of recovering a primitive contact with the world. A doubt that plagued Cézanne in his later years was whether the novelty of his work lay in some trouble with his eyes rather than in his style of painting. This doubt made evident the overlapping of seer and seen, as well as the role played by painting in revealing the very process whereby humans become aware of nature. Cézanne was not content to incorporate nature into his painting. He wanted to integrate his vision into nature so completely that his works would carry nature back to his viewers. This he achieved by focusing on how nature takes on form, and it is the birth of form itself that he offers to viewers through their

spontaneous organization of the coherent deformations that meet our eyes in his paintings. His works' apparent distortions result not from a physical impediment to his eyes but from his insistence that the painting carry with it the sense of things taking on order, of organizing themselves, and moving towards the significant totality, or motif, in nature that guided the work through his style of perception. In this way, Cézanne's style reasserts the classical understanding of art in which the human being stands within nature, not aloof from it. The unfolding of a painting's motif allows viewers to experience and review the manner of their primordial involvement with nature in life. In this way, Cézanne achieves in painting what remains a goal for Merleau-Ponty's philosophy.

Evidence of Hegelian thought and method is to be seen in Merleau-Ponty's notion of visibility and the dialectic of seer and seen. However, as Hubert and Patricia Dreyfus have pointed out in their introduction to *Sense and Non-sense*, Merleau-Ponty existentializes Hegel, and the direction of Hegelian thought towards an absolute ideal is counterbalanced by a reverse movement. In keeping with this discourse, Merleau-Ponty's philosophy of art does not see visual art as an object of philosophical inquiry but rather as a primary motivation for a project to reinsert philosophy into the 'fabric of brute meaning' (*Eye and Mind*). In that painting celebrates the coming into being of the world through our body's intertwining with it, art motivates a philosophy of primordial historicity that grounds itself upon things themselves and upon an awareness of its own processes.

Biography

Maurice Merleau-Ponty Born Rochefort-sur-Mer, Charente-Maritime, France, 14 March 1908. Merleau-Ponty was educated at the École Normale Supérieure in Paris. After *agrégation* in philosophy in 1930, he taught at lycées in Beauvais 1931–33 and Chartres 1934–35. He was active in the French Resistance while a Professor of Philosophy at the Lycée Carnot, Paris, between 1940 and 1944. He taught Philosophy at the University of Lyon from 1945–48; and was Professor of Child Psychology and Pedagogy at the Sorbonne, Paris, from 1949 to 1952 and Professor at the Collège de France, Paris, from 1952 to 1961. With Jean-Paul Sartre and Simone de Beauvoir, he was co-founder of the journal *Les Temps Modernes*. Merleau-Ponty died in Paris on 3 May 1961.

Bibliography

Main texts

The Structure of Behaviour (*La structure du comportement*, 1942), trans. Alden L. Fisher, Boston: Beacon Press, 1963.

Phenomenology of Perception (*Phénoménologie de la perception*, 1945), trans. Collin Smith, London: Routledge and Kegan Paul, 1962.

Sense and Non-Sense (*Sens et non-sens*, 1948), trans. Hubert L. Dreyfus and Patricia Allen Dreyfus, Evanston: Northwestern University Press, 1964 (see especially 'Cézanne's Doubt').

Signs (*Signes*, 1960), trans. Richard C. McClearly, Evanston: Northwestern University Press, 1964 (see especially 'Indirect Language and the Voices of Silence').

The Visible and the Invisible (*Le visible et l'invisible*, 1964), trans. Alphonso Lingis, Evanston: Northwestern University Press, 1968.

The Primacy of Perception (*L'Oeil et l'esprit*, 1964), trans. Carleton Dallery, ed. James M. Eddie, Evanston: Northwestern University Press, 1964 (see especially 'Eye and Mind').

Secondary literature

Burke, P. and van der Veken, J. (eds), *Merleau-Ponty in Contemporary Perspectives*, Dordrecht: Kluwer, 1993.

Kaelin, E.R., *An Existentialist Aesthetic*, Madison: University of Wisconsin Press, 1966.

Madison, G.B., *The Phenomenology of Merleau-Ponty: A Search for the Limits of Consciousness* (*Le phénoménologie de Merleau-Ponty: Une recherche des limites de la conscience*, 1973), trans. Gary Brent Madison, Athens: Ohio University Press, 1983.

Mallin, S.B., *Merleau-Ponty's Philosophy*, New Haven: Yale University Press, 1979.

Schmidt, J., *Maurice Merleau-Ponty: Between Phenomenology and Structuralism*, Houndmills: Macmillan, 1985.

DANIEL F. CHAMBERLAIN

ERWIN PANOFSKY (1892–1968)

GERMAN-BORN ART HISTORIAN

Erwin Panofsky was a specialist in Renaissance art, but – in keeping with the humanist tradition of the period – the term 'Renaissance' must be applied to his work in its broadest sense. His studies cover a remarkable range: Albrecht Dürer's art theory, the history of perspective, the theory of human proportion, early Netherlandish painting, Gothic architecture, Baroque art criticism, and the relationship between the Northern Renaissance, Italian Renaissance and

Classical Antiquity. His range is extended even further by several papers on 'style' in films. Much of Panofsky's research focused on Renaissance 'types'. Due to this primary interest, he is known as an iconographer; however, unlike most iconographers, he was not satisfied with identification alone. He was interested in how the proper identification of subject matter could be used to uncover deeper *meaning* in the work and could thus lead to greater understanding, not only of the work itself but of the culture in which it was created. The search for meaning, combined with the acknowledgment of a vital link between art and culture, is central to Panofsky's approach to art history and is his most important contribution to the field. His brilliant explication of the method used to achieve this end can be found in the introduction to *Studies in Iconology* (1939).

In *Studies in Iconology* he set up a system of three distinct levels. The first level, termed *pre-iconographical*, consists of primary or natural subject matter. At this initial stage, forms in a work are identified as representations of natural objects (motifs). Leonardo da Vinci's *Last Supper* is recognized only as thirteen figures around a dining table. Although identification on this level can generally be achieved through practical experience, accurate assessment of some kinds of representations, realistic versus unrealistic for instance, depends on an awareness of the conditions and principles related to a specific historical style. In a work whose orientation is realistic, a child floating in the air would be understood as an apparition or miraculous event; whereas, in a work in which the artist was unconcerned with realism *per se*, a city floating in the air would not be considered miraculous, but would simply be understood as a reference to the setting for the action. An understanding of the history of styles, therefore, provides the tools necessary to correct human error at this level.

The second level, *iconography* in its usual sense, consists of secondary or conventional subject matter, and is achieved by connecting artistic motifs with themes or concepts. Leonardo's *Last Supper* is recognized as the story from the New Testament. Since themes and concepts relevant to specific historical periods are not necessarily self-evident and are often revealed only in the literature and art of the historical period, the corrective vision necessary to secure proper identification of images is a knowledge of the history of types.

The third level is identified as Iconography in a deeper sense, or *iconology*. It consists of intrinsic meaning or content and is intent upon building an understanding of the relationship between one work and the larger context in which it was created. Recognizing that images are 'symptoms' of 'something else', and can be interpreted as

'symbolical values' (a concept borrowed from the German philosopher, Ernst Cassirer) is the business of the art historian on this level. Leonardo's *Last Supper*, then, can be understood as a document that reveals aspects of Leonardo's personality, the civilization of the Italian High Renaissance, and/or a religious attitude. Panofsky notes that the interpretation of symbolical values is a process of synthesis rather than analysis (as in the first two levels). Since this kind of interpretation depends on an individual's diagnostic skills, there is an even greater need for correctives on this level. Panofsky holds that the great susceptibility to errors on this level can be corrected by comparing the work in question to as many other documents of the same civilization as possible in an effort to see if perceived 'intrinsic meaning' holds true in all examples. An understanding of the history of 'cultural symptoms or symbols' is therefore required.

In his writings Panofsky provides many applications of his method. His study of Gothic architecture argues that the all-encompassing cathedral programmes parallel the all-encompassing vision of medieval scholasticism. His famous analysis of Jan Van Eyck's Arnolfini double portrait identifies the work as a pictorial marriage certificate. He discusses the manner in which the hidden meanings of objects realistically included in the contemporary room support this interpretation, and adds that this use of double meanings reflected the medieval tendency to view the entire visible world as symbol, a tendency that was still prevalent in Van Eyck's time. A third example, Panofsky's discussion of Dürer's *Melencolia I* in *The Life and Art of Albrecht Dürer* (1943, revised 1955), is summarized below as a clear illustration of 'iconology-in-action'.

Panofsky opens with observations of the compositional elements present in Dürer's well-known master engraving of 1514 – pre-iconographical analysis. Moving on to level two, identification of the figure is aided in this case by Dürer's label within the print itself. Panofsky points out, however, that in Dürer's time 'Melancholia' would not only have been defined as a state of depression, but would be immediately recognized as one of the four humours that govern life in general and human temperament in particular. After considering other medieval and early Renaissance images that personify Melancholy, Panofsky seeks to explain the presence of artistic and intellectually oriented objects and looks to personifications of the Arts. He concludes that Dürer's image is a fusion of two iconographic types: Melancholy and Geometry.

Panofsky ventures into his third level by noting that, although the presence of all motifs can be explained by reference to the two types,

Dürer invests them with additional expressiveness. Panofsky's thorough discussion includes the following examples. Tools are disarranged in order to create a feeling of 'discomfort and stagnation'. The bat and dog, traditional emblems of Melancholy, are presented so that they augment unpleasantness. The clenched fist, a reference to the 'tight-fistedness' that was traditionally a characteristic of the melancholic temperament, is given a different meaning when the clenched fist is made to support the head. In this way Dürer transforms the idea of miserliness into an expression of internal struggle; his Melancholia is 'a thinking being in perplexity'. Panofsky continues by tying the print's imagery to Dürer's theoretical writings and building the argument that Dürer's appropriation of these two types is meant to spotlight the internal struggle *of the artist*. Dürer, like many other Renaissance thinkers, held that consummate artistic mastery resulted from the perfect coordination of two accomplishments – *theoretical insight* on the one hand (especially the command of geometry), and *practical skill* on the other. Panofsky believes that this explains the two figures in the print: Dürer's figure of Melancholia typifies Theoretical Insight, which thinks but cannot act, and the child-like putto scribbling away on a tablet represents Practical Skill, which acts but cannot think.

Finally, as a corrective measure, Panofsky looks to other cultural documents to corroborate his interpretation of *Melencolia I*. He finds that, like Dürer, Neo-Platonic philosophers such as Marsilio Ficino also revised the concept of Melancholy, emancipating it from its pejorative role as the most unpleasant of the humours and closely connecting it to creative genius. The link between Melancholy and Geometry is justified by other Renaissance writers. Henry of Ghent, in particular, argued that some intellectuals are recognized by their great ability for imagination; however, since this ability is characterized as the need to understand everything in terms of location and space (the foundations of geometry), it also limits their ability to grasp spiritual and metaphysical issues, leading them to a melancholic state-of-mind. Yet another source, Cornelius Agrippa of Nettesheim, provides the specific connection between Melancholy and the Artist. Neo-Platonic philosophy had previously limited the dual tendency for melancholy and creative genius to theologians, poets and philosophers. Agrippa's tripartite reclassification of creative genius included artists endowed with imaginative reason on the first level, statesman with discursive reason on the second, while the third belonged to theologians and intuitive reason. This expanded view of genius corresponds with Dürer's presentation of Melancholia and also

explains the enigmatic 'I' in the title. The evidence provided by these sources adds fuel to Panofsky's thesis that Dürer is carefully addressing not only a personality type or a visual presentation of the Renaissance approach to art (via geometry), but is consciously illustrating the central irony of artistic creativity: intellect, imagination and skill, dependent upon each other but also at odds with each other. It is a condition that frequently leaves the artist in complete desolation and, according to his writings, was a condition with which Dürer identified. Panofsky concludes that Dürer's *Melencolia I* is an 'objective statement of general philosophy and the subjective confession of an individual man'.

Panofsky presents his iconological system with such clarity that it seems comfortably self-evident; and yet, its elegant simplicity is carefully crafted and it stands as a tour-de-force of theoretical thought. It is uniquely Panofskian, but is nevertheless firmly rooted in the pioneering developments of late nineteenth- and early twentieth-century art-historical theory. Influenced by the formalist systems developed by Heinrich **Wölfflin** and Alois Riegl, Panofsky utilized the basic model of thesis–antithesis–synthesis. Although he does not share their formal focus, he does not fully reject formalism either. Instead, Panofsky's approach is best seen as a forceful re-orientation towards content and cultural meaning. In this, Panofsky is more closely allied with Max Dvorák and Aby **Warburg**. His insistence on *underlying principles* which 'reveal the basic attitude of a nation, a period, a class, a religious or philosophical persuasion' is similar to their efforts to see art as manifestation of cultural history. Panofsky can be seen to stand, philosophically speaking, between the two. Dvorák portrayed art as simply a reflection of an all-powerful 'Spirit-of-the-Age'. Warburg, on the other hand, resisted placing art into any kind of framework at all, focusing instead on reconnecting individual creations with their own specific context. If Panofsky's system is less of a system than Wölfflin and Riegl's constructs are, it is more of a system than can be found in Dvorák and Warburg's work. As a system it can be criticised for not being comprehensive in terms of the entire history of art. It limits itself to a specific period within Western civilization and is not easily applicable to non-representational and non-Western art. But his system does not, in fact, attempt to be a complete methodology, and should not be judged as such.

More significant criticism relates to the manner in which Panofsky deals with the role of the artist. He calls attention to the artist's conscious use of cultural symbols (as is the case with Dürer and Van Eyck), but also acknowledges that cultural symbols are 'generally

unknown to the artist himself and may even emphatically differ from what he consciously intended to express'. Of course, the problem may lie in the fact that artists are sometimes conscious of their appropriations and at other times are not, but Panofsky does not clarify or attempt to resolve the discrepancy. Another major drawback to his iconological system centres on the search for hidden meanings – and the potential for finding symbols where they are not. Panofsky himself admitted that 'there is ... some danger that iconology will behave, not like ethnology as opposed to ethnography, but like astrology as opposed to astrography'. He attempted to address the issue by adding 'correctives' to each level of his system, but the problem persists.

In spite of the criticism, Panofsky's work and his approach remain important. Panofsky can be commended for his attempts to balance artists' individuality with their connectedness to a larger cultural/ ideological group, and for the recognition of a similar balancing act in the efforts of art historians. He also stands out as one who incorporated into his working method elements both intrinsic and extrinsic to the work of art. The heart of Panofsky's contribution to art history is his recognition that a single element in a single work *can* reveal the larger image of a culture. His work opened the door for a variety of other philosophical and psychological approaches that are significant to art history – the work of **Gombrich** and the development of semiotics in particular. His method influenced other fields as well, a development that would have pleased him since he strongly advocated interdisciplinary studies: 'It is in the search for intrinsic meanings or content that the various humanistic disciplines meet on a common plane instead of serving as handmaidens to each other.' Panofsky was a modern-day humanist, an approach to life that was rare enough in the early twentieth century let alone in recent times. His example, together with his writings, provide a unifying vision that continues to be valuable for the increasingly fragmented field of art history.

Biography

Erwin Panofsky Born Hanover, 30 March 1892, to a wealthy family. Panofsky was educated at the Joachimsthalsches Gymnasium, Berlin; the University of Munich; the University of Berlin; and the University of Freiberg (where he received his PhD in 1914). He became a private lecturer at the University of Hamburg in 1921, and a full professor, 1926–33 (dismissed by the Nazis). He emigrated to the United States,

1934, later becoming naturalized. He was visiting professor at New York University, 1931–5; and at Princeton in 1934–5. From 1935 to 1962 he was Professor, The Institute of Advanced Study, Princeton; and Samuel F. B. Morse Professor at New York University, 1962–8. Panofsky died at Princeton on 14 March 1968.

Bibliography

Main texts

'Das Problem des Stils in der bildenden Kunst', *Zeitschrift fur Asthetik und Allgemeine Kunstwissenschaft*, X (1915), 460–7 (reprinted in *Aufsätze zu Grundfragen de Kunstwissenschaft*).

'Der Begriff des Kunstwollens', *Zeitschrift fur Asthetik und Allgemeine Kunstwissenschaft*, XIV (1920), 321–39 (reprinted in *Aufsätze zu Grundfragen de Kunstwissenschaft*).

'Die Entwicklung der Proportionslehre als Abbild der Stilentwicklung', *Monatshefte fur Kunstwissenschaft*, XIV (1921), 188–219 (reprinted in *Aufsätze zu Grundfragen de Kunstwissenschaft*; English translation in *Meaning in the Visual Arts*).

Dürer's Stellung zur Antike, Vienna: 1922 (English translation in *Meaning in the Visual Arts*).

Dürer's 'Melencolia I', eine quellen- und typengeschichtliche Untersuchung (with Fritz Saxl), Leipzig: *Studien der Bibliothek Warburg* (2), 1923.

Idea: A Concept in Art Theory ('Idea': ein Beitrag zur Begriffsgeschichte der alteren Kunsttheorie, 1924), trans. J.J.S. Peake, New York: Harper and Row, 1968.

'Uber das Verhaltnis der Kunstgeschichte zur Kunsttheorie: ein Beitrag zu der Erorterung uber die Moglichkeit "kunstwissenschaftlicher Grundbegriffe" ', *Zeitschrift fur Asthetik und Allgemeine Kunstwissenschaft*, XVIII (1925), 129–61 (reprinted in *Aufsätze zu Grundfragen de Kunstwissenschaft*).

'Die Perspektive als "Symbolische Form" ', *Vortrage der Bibliothek Warburg*, 1924/25, Leipzig: 1927.

Herkules am Scheidewege und andere antike Bildstoffe in der neueren Kunst, Leipzig: Tübner, 1930.

'Jan van Eyck's *Arnolfini* Portrait', *Burlington Magazine*, LXIV (1934), 117–27.

'Et in Arcadia ego: on the Conception of Transience in Poussin and Watteau', in Raymond Klibansky and H.J. Paton (eds) *Philosophy and History, Essays Presented to Ernst Cassirer*, Oxford: Clarendon Press, 1936 (reprinted in *Meaning in the Visual Arts*).

Studies in Iconology: Humanist Themes in the Art of the Renaissance, New York: Oxford University Press, 1939 (reprinted 1962; Introduction also reprinted in *Meaning in the Visual Arts*).

'The History of Art as Humanistic Discipline', in T.M. Greene *The Meaning of the Humanities*, Princeton: Princeton University Press, 1940 (reprinted in *Meaning in the Visual Arts*).

Albrecht Dürer, Princeton: Princeton University Press, 1943 (reprinted 1945, 1948 and 1955 as *The Life and Art of Albrecht Dürer*).

Abbot Suger on the Abbey Church of St.-Denis and Its Art Treasures, trans., ed. and anno. Erwin Panofsky, Princeton: Princeton University Press, 1946.

Gothic Architecture and Scholasticism, Latrobe, Penn.: Archabbey Press, 1951.
Early Netherlandish Painting (2 vols), Cambridge, Mass.: Harvard University Press, 1953
Meaning in the Visual Arts: Papers in and on Art History, Garden City, New York: Doubleday, 1955.
Renaissance and Renascences in Western Art, Stockholm: Almqvist and Wiksell, 1960 (New York: Harper, 1972).
Aufsätze zu Grundfragen de Kunstwissenschaft, Hariolf Oberer and Egon Verheyen (eds), Berlin: Hessling, 1964 (includes bibliography of Panofsky's writings).

Secondary literature

Dittmann, L., *Stil, Symbol, Struktur*, Munich: Wilhelm Fink, 1967.
Emmens, J.A., 'Erwin Panofsky as a Humanist', *Simiolus* II (1967–8), 109–13.
Heidt, R., *Erwin Panofsky, Kunsttheorie und Einzelwerke*, Cologne and Vienna: Bohlau, 1977.
Holly, M.A,, *Panofsky and the Foundations of Art History*, Ithaca: Cornell University Press, 1984.
Meiss, M. (ed.), *De artibus opuscula XL, Essays in Honour of Panofsky*, New York: New York University Press, 1961 (includes bibliography of Panofsky's writings).
Podro, M., *Critical Historians of Art*, New Haven: Yale University Press, 1982.

JULIET GRAVER ISTRABADI

GRISELDA POLLOCK (1949–)

BRITISH ART HISTORIAN

In the *Historia* section of Mary Kelly's installation *Interim* (1990), the viewer encounters four stainless-steel pages opened like books containing a montage of text panels. On each panel is an autobiographical account by four women aged (in 1968) three, 14, 20, and 27, looking back on the origins of the Women's Liberation Movement. One of these voices was that of Griselda Pollock, a student at Oxford in 1968. She describes her participation in 1970s feminism and how she learned to write as part of a collective, followed by what seemed like amnesia in the 1980s and the threat that this activism would be erased: 'So I made myself its immediate archivist ...' As a work of art that is also about generations, histories and genealogies of women, *Historia* reveals several things about Pollock and other feminist writers of her generation. First, there was a close alliance between contemporary women artists and feminist art historians. Art history was addressed for its relevance to contemporary politics and issues. Second, feminist art history was formed in the activism of second-wave feminism and women's liberation in general. It was therefore always a

matter of many voices and multiple perspectives, and a critique of authorship and authority was one of its central projects. Feminist work was a challenge to the very foundations and paradigms of art history, because what you know and who controls access to knowledge are inescapably part of power. Feminist art history proposed new methods and new objects of inquiry, even new forms of writing.

There is more at stake than this, however. Pollock's own participation as a subject and an object in a work of art also demonstrates one of the key terms of the 1970s: the personal is the political. For art history, it means acknowledging that all forms of scholarship are motivated. Exposing the limitations and biases in the false neutrality and anonymity of conventional art history means reflecting on and making explicit the speaking position from which you write, for example as a gendered subject writing at a particular moment in a specific culture. One of art history's limitations was the exclusion of women artists from the canon of great artists which is its main focus of enquiry, as though women never made art. But asking about women artists also raises questions about gender as a whole, including, for example, the gender of audiences as well as issues of subordination, domination and representation in the visual field, including the mass media, even what counts as art and who counts as an artist. Feminist art history raised questions not just about which artists and whose works of art were to be studied but also about what was at stake and in whose interests boundaries, limits and canons had been drawn up and defined. As Lisa Tickner remarked in her article 'Feminism, Art History, and Sexual Difference' (in *Genders*, 1988), feminist art history could not stay in art history because the discipline's conventional premises blocked radical enquiry and because feminism needed interdisciplinary methods that were politically motivated. However, nor could feminism leave art history. There was too much at stake, too much work to do and too much invested where the terms 'art' and 'history' were conjoined.

An early influential text in feminist art history was Linda Nochlin's 'Why have there been no great women artists?', first published in 1971. Her explanation was that there were no great women artists not because of biology but because of discrimination and disadvantage. This was not an excuse but rather a vantage-point from which women could undertake a critique of the discipline of art history as a whole. These arguments were picked up on and analysed in the book Griselda Pollock co-authored with Rozsika Parker, *Old Mistresses: Women, Art and Ideology* (1981), and in an essay of Pollock's, 'Vision, voice and power: feminist art histories and Marxism' (1982), revised and

reprinted in her *Vision and Difference: Femininity, Feminism and the Histories of Art* (1988). Here she argued that the question was a false one, in that it implied only a negative answer. Discrimination was not a cause and therefore could not be an explanation. What she meant by this was that explaining women's exclusion as a product of discrimination implied that simply inserting women and women artists into existing institutions would be the tool for undoing women's oppression. Discrimination might be taken as a matter of mistaken bad faith and unequal representation. In effect, women artists' liberation seemed to consist in becoming like a man. Instead, Pollock argued that discrimination was a visible symptom or 'a revealed point of contradiction' in liberal bourgeois societies which structured inequalities through its economies and social order, and, most importantly for art history, through its agencies of representation and ideology such as the media and education. In effect, feminist art history had to address itself to analysing and also changing the very structures and systems of representation which produce discrimination and unequal power relations. This made even the term 'woman artist' problematic. *Old Mistresses* was so titled because there is no female equivalent of 'Old Masters'. Inverting the term produces a derogatory label implying a cast-off lover who once provided sexual favours. There is no male equivalent of 'woman artist' because the word 'artist' leaves its assumed masculinity unspoken. Feminism's paradox is that, speaking in the name of 'woman', it continuously has to deconstruct that term. As Pollock wrote in *Vision and Difference*:

> ... masculinity and femininity are not terms which designate a 'given' and separate entity, men and women, but are simply two terms of difference. In this sense patriarchy does not refer to the static oppressive domination of one sex over another, but to a web of psychosocial relationships which institute a socially significant difference on the axis of sex which is so deeply located in our very sense of lived, sexual, identity that it appears to us as natural and unalterable.

In the introduction to *Framing Feminism: Art and the Women's Movement 1970–85* (1987), which assembled and reprinted articles, documents and images, archiving the 1970s and early 1980s, Parker and Pollock defined the 1970s as a decade of 'practical strategies'. The Women's Movement struggled to make women's work visible and achieve recognition, to define new areas of practice and find new audiences. Women often worked in collectives, for example the

Women's Art History Collective, which Parker and Pollock joined, set up in 1972 and affiliated with The Women's Workshop of the Artists' Union. Women artists and art historians analysed and unpicked the divisions between professional and amateur, public and private, between high and low art, and between art and craft. The decade culminated in three exhibitions at the Institute of Contemporary Art, London, in 1980: 'Women's Images of Men'; 'About Time: Video, Performance and Installation by 21 Women Artists'; and 'Issue: Social Strategies in Women's Art'.

Parker and Pollock defined the 1980s as the era of 'strategic practices'. In this period, gender and sexual differences came to the foreground to be analysed as social constructions. Radical critiques of the myths of 'individualism', 'creativity' and 'artist' were undertaken. Art practice and art-making were debated in relationship to ideology using writers such as Louis Althusser and Michel **Foucault**. Assumptions about unified subjectivities and agency were undone using re-writings of psychoanalytic theory from **Freud** and Jacques **Lacan**. Where the collectivism of the 1970s women's movement came to be seen as one which had tended to essentialize femininity and to ghettoize women's work, thus reinforcing its marginalization, 1980s feminism worked to intervene in established art institutions and discourses, initiating debates about the politics of representation. It used sophisticated theories and was intentionally avant-garde rather than populist and accessible. It was sometimes seen as exclusive and elitist. Its focus was theories of differences in which it deployed and redefined the tools of semiotics and psychoanalysis.

Through the women's movement, women claimed the right to speak rather than be spoken for, but the debate on sexual differences also raised the question of differences between and within women. Black women artists voiced their exclusion from the women's movement and their double oppression on grounds of race as well as gender, for example in the exhibition 'The Thin Black Line' (ICA, 1985), including Lubaina Himid and Maud Sulter. By the 1990s, mapping the essentialism-versus-difference debate onto a chronology dividing the 1970s from the 1980s ceased to be productive. Julia **Kristeva**'s essay 'Women's Time' (1979; translated 1981), which had a formative influence on Pollock's own thinking, discussed two generations of the women's movement. The first, the Suffragettes, wanted to insert women into the linear time of history and nation; for example, achieving civic status by gaining the vote. The second, arising after 1968, wanted to give voice to an irreducible identity which has no equivalent in the opposite sex, and in effect to refuse the

limitations and boundaries imposed by patriarchal linear and historical time. Kristeva identified a third generation, understood not in chronological sequence to the other two but as a signifying space, linked to the body and to desire, into which she proposed the other two generations could be interwoven.

A third space for feminist generations can be imagined through the idea of trajectories describing looping traces across time and space. Such a notion was realized in the 1996 exhibition 'Inside The Visible. An elliptical traverse of twentieth century art: In, of and from the feminine', curated by Catherine de Zegher, to which Pollock contributed an introductory essay entitled 'Inscriptions in the feminine'. This was an inter-global, multi-authored and multicultural tracing of the work of thirty-seven women artists from Europe, South and North America, and the Far East, de-centring art history's concentration on Western Europe and America. It was not chronological, nor was it a survey. Questions about the canon or about inclusions and exclusions were irrelevant. Instead the exhibition, through four overlapping thematic sections, traced different connections between different generations of women from the 1920s and 1930s, the 1940s and 1950s, and the 1970s, 1980s and 1990s, all seen as moments of political crisis and reinvented beginnings. The exhibition was initiated at a former Béguinage in Belgium. The Béguine were religious women of the twelfth and thirteenth centuries who lived independent nomadic lives, took no permanent vows and followed no prescribed rule. The Béguine might be seen as a metaphor for this way of thinking across generations and spaces.

There is no definitive, authoritative definition of feminist art history. Pollock's own work has included monographic studies such as her two books on Mary Cassatt, and she has frequently contributed essays and books on the avant-garde in nineteenth-century France, including Degas and Van Gogh. Her book *Differencing the Canon: Feminist Desire and the Writing of Art's Histories* (1999) examines the desires and pleasures invested in artistic canons, biographies and readings of the feminine. Her most recent work has focused on Jewish identities, trauma and the Holocaust, including studies of Charlotte Salomon. In a recent edited volume of fifteen essays by feminist artists and writers of different ages and perspectives, *Generations and geographies in the visual arts: feminist readings* (1996), Pollock wrote in her introductory essay that

> ... feminism signifies a set of positions, not an essence; a
> critical practice not a doxa; a dynamic and self-critical

response and intervention not a platform. It is the precarious product of a paradox. Seeming to speak in the name of women, feminist analysis perpetually deconstructs the very term around which it is politically organized.

Biography

Griselda Pollock Born 1949. Pollock studied at Oxford University and the Courtauld Institute, University of London. She is Professor of Social and Critical Histories of Art in the Department of Fine Art at the University of Leeds; Director of *AHRB CentreCATH: Cultural Analysis Theory and History*; Co-director of the *Center for Cultural Studies*, executive member of the *Center for Jewish Studies*, and of the *Centre for Interdisciplinary Gender Studies*.

Bibliography

Main texts

Mary Cassatt, London: Jupiter Books, 1980.
Old Mistresses: Women, Art and Ideology with Rozsika Parker, London: Routledge and Kegan Paul, 1981.
Framing Feminism. Art and the Women's Movement 1970–85 with Rozsika Parker (eds), London and New York: Pandora, 1987.
Vision and Difference: Femininity, Feminism and the Histories of Art, London and New York: Routledge, 1988.
Avant-Garde Gambits: Gender and the Colour of Art History, London: Thames and Hudson, 1992.
Dealing with Degas: Representations of Women and the Politics of Vision with Richard Kendall (eds), London: Pandora, 1992.
Avant-gardes and partisans reviewed with Fred Orton, Manchester: Manchester University Press, 1996.
Generations and geographies in the visual arts: feminist readings (ed.), New York: Routledge, 1996
Mary Cassatt: painter of modern women, London: Thames and Hudson, 1998.
Differencing the Canon: Feminist Desire and the Writing of Art's Histories, London and New York: Routledge, 1999.

Secondary literature

Chadwick, W., *Women, Art and Society*, London: Thames and Hudson, 1990.
Isaak, J.A., *Feminism and Contemporary Art: The Revolutionary Power of Women's Laughter*, London, Routledge: 1996.
Kristeva, J., 'Women's Time', in Toril Moi (ed.) *The Kristeva Reader*, Oxford: Blackwell, 1986.
Lippard, L.P., *The Pink Glass Swan: Selected Feminist Essays on Art*, New York: The New Press, 1995.

Mulvey, L., *Visual and Other Pleasures*, Basingstoke: Macmillan, 1989.

Nochlin, L., 'Why have there been no great women artists?' (1971), reprinted in *Women, Art and Power and Other Essays*, London: Thames and Hudson, 1989.

Robinson, H. (ed.), *Feminism-art-theory*, Oxford, Blackwell: 2001.

Tickner, L., 'The body politic: female sexuality and women artists since 1970', *Art History*, 1, 2 (June 1978), 236–51.

——, 'Feminism, Art History, and Sexual Difference', *Genders*, 3 (Fall 1988), 92–128.

Zegher, C. de, *Inside The Visible. An elliptical traverse of twentieth century art. In, of and from the feminine*, Cambridge, Mass.: The MIT Press, 1996.

SUE MALVERN

HERBERT READ (1893–1968)

BRITISH CRITIC

Although Herbert Read is often thought of as an art critic, this is not an entirely accurate description. Read was also, amongst other things, a poet, novelist, literary critic, philosopher, economic and political theorist and educationalist. Indeed, to some, the breadth of his enquiry was his principal weakness, with even sympathetic critics suggesting Read spread his talents too thinly. Such a view might seem justified in retrospect, but at the peak of his influence, from the late 1940s to the mid-1960s, it was not considered a fault, and in art alone Read was lauded internationally as the most significant figure in the world of Modernist criticism. It was only in the revisionist, and often anachronistic, writings of later art historians that Read was de-throned, and Modernism came to be seen largely as synonymous with the ideas of the American art critic Clement **Greenberg**.

There is, however, another reason not to consider Read an art critic. Art was for Read an extremely important human activity, for reasons that will become clear, but it was only one human activity amongst many. Literature, psychology, education and politics were also important, not as distinct and separate disciplines, but as manifestations of a common human nature. It would be more accurate, therefore, not to consider Read an art critic, literary theorist or any other disciplinarian, but a philosopher who, in his search for an understanding of the nature of human existence, was willing and able to use all aspects of the culture and society that he saw around him. If not a philosopher, we should at least see Read as a founder of interdisciplinary cultural studies.

Does this mean that Read is of no use to us in trying to comprehend art? Certainly Read's writings do not readily translate into a system for judging either the quality or even the meaning of artworks, yet certain principles can be drawn out of them that do amount to a coherent attitude to art. For Read, art was something that operated at the centre of human existence to the extent that without art there would be no human existence. In this he saw art as functional, though unlike Marxist theorists this did not mean it was necessarily utilitarian. Indeed, even when he discussed practical objects, such as ceramics in *Icon and Idea* (1955), Read saw their functionality not primarily in their utilitarian usefulness but in their formal construction and decoration. In fact, in *The Meaning of Art* (1931), Read explicitly dismissed the idea that simple usefulness was an adequate measure for the quality of either art or design, a rebuke aimed most probably at the contemporary attempt in the Soviet Union to turn fine art into mere propaganda. The function of art was instead far more subtle than this, but also more fundamental, with paintings, sculpture, ceramics, design and so on acting as a mediator between the biology of the human body and the wider world in which the human body has to live.

Such ideas demonstrate how Read was willing to set himself up against some of the most dominant forms of Modernist criticism of his time. Whereas most radicals before World War Two adopted a Marxist perspective on culture that ignored the human being as a biological entity and elevated the role of capitalistic society in dictating what culture we have, Read rejected Marxism and adopted an anarchist political perspective which maintained the value of the individual within society. Most of all, Read rejected the Marxist claim that art history is the story of the oppression of one social class by another, and instead suggested that the history of art be seen as a record of the evolution of human consciousness over time. This is not to say that the social context of art was irrelevant to Read, as he accepted that society did maintain a grip on people, and that art is affected by the economic system into which it emerges. But Marxism was in itself both insufficient as a means to understand aesthetic processes and inadequate for explaining the historic changes to art.

To understand these one had to look at the psychology of individuals and the way they link to larger social groups. Read wrote that 'The practice and appreciation of art is individual; art begins as a solitary activity, and only in so far as society recognizes and absorbs such units of experience does art become woven into the social fabric.' In this, Read showed his debt to earlier critics such as John Ruskin,

and the German philosophers Friedrich Nietzsche and Wilhelm
Worringer. Read first encountered their works at meetings of the
Leeds Arts Club. Alfred Orage, the Club's founder, agreed with the
Marxists that most people passively accept the doctrines, mores and
cultural forms of the economically dominant class of their time; but he
also believed that some people manage, like Nietzsche's fictional
Zarathustra, to break out of their own socialization through a supreme
act of will-power. These are Nietzsche's *Übermenschen*, or 'Over-men'.
For Orage and other Club members the individuals most likely to
break out of the dominant mores of society included artists, who
would come to replace bourgeois politicians as leaders of the people.
Read did not use these ideas uncritically, but they influenced strongly
his later thinking, as can be seen when he wrote:

> The revolutionary artist is born into a world of clichés, of stale
> images and stale signs which no longer pierce the conscious-
> ness to express reality. He therefore invents new symbols,
> perhaps a whole new symbolic system.

Art is, then, a symbolic system through which humankind defines
and attempts to express a perception of reality. The problem is that
such a symbolic system is reliant on the subjective senses through
which we experience the world – sight, sound, smell, touch and taste
– and cannot provide an objective or true picture of reality. Therefore
the job of the artist is to suggest possible alternative interpretations of
the subjective information received by our senses, and create symbols
for it, which, if they ring true with the rest of society, become part of
the social construction of reality. The periodic re-evaluation of these
symbols allows our understanding of 'reality' to evolve over time, and
this is what art history is – or should be – about.

In addition to Nietzsche, Sigmund **Freud** and Carl Jung were also
important to Read. As early as 1918 Read was deliberating over
whether the ability of the artist-*Übermenschen* to see beyond their own
socialization was a spiritual or, as he believed, psychological trait. This
mirrors the contemporary shift in mainland Europe from spiritual
expressionism to what would become psychological Surrealism, and
prefigures Read's own later involvement with Surrealism. Read was in
fact a pioneer in applying psychology to criticism, with an article
entitled 'Psychoanalysis and the Critic', which appeared in 1924 in
T.S. Eliot's periodical *The Criterion*. Read made great use of the work
of Jung in particular, viewing the unconscious as a place where the
very biology of the human body, the *id*, communicated with itself.

Unlike our minds, however, our biology does not have the verbal language of society to communicate with itself, and so it has to communicate through other means, namely the symbolic language of images. In Read's criticism this gave primacy, not to socially constructed verbal language, but to image-based languages such as art and poetry, as these were closer in form to the most fundamental and primary method of communication of which our bodies are capable. It was this that Read meant when he said that he saw art as a basic biological process.

The logical connection of this to Read's belief that artists create symbols to represent possible reality is that, just as the outside world is perceived by human beings through the biological senses of the body, it is the biological organism of the body that is ultimately responsible for creating the symbols through which we understand reality. Thus artists are not conscious that they are re-evaluating reality; rather, they are compelled by their biological make-up to produce art-images which the body itself is generating through its sensual encounter with the outside world, an idea Read linked to what the artist Wassily Kandinsky had called the 'inner necessity' to produce art. An example of this, on which Read wrote extensively, was the poem *Kubla Khan* by Samuel Taylor Coleridge. *Kubla Khan* served Read well as an example of poetry being akin to visual art, as it operates not as a straightforward narrative but as a series of striking images that defy the logical narrative structures one expects to find in prose language. According to Coleridge's description of the genesis of the poem, however, it also appeared to be almost self-born, with images emerging from the unconscious of their own volition through something akin to 'inner necessity', without the intervention of the conscious mind.

Of all the artists that Read championed, however, it was the sculptor Henry Moore with whom he was most closely associated. Indeed, Moore was for Read the most perfect example of an artist who illustrated his ideas. Read suggested that somehow Moore had seen through his own socialization, and the current clichés about reality, and had created new possible symbols for reality. These symbols were rooted in the unconscious, but Read did not mean that they were of themselves a record of pure unconscious images; rather, that the unconscious, at a deep biological level, sought to comprehend and order the chaotic mass of data about the outside world it was receiving from the senses, and the way it did this was by creating symbolic images. As these worked their way through the onion-like layers of the unconscious and conscious mind, they solidified into 'concrete',

'crystallized' or 'real' forms, and at the same time were affected by the social and economic structures of the day. Thus a Henry Moore sculpture such as *Standing Figure* (1950) does not look like Donatello's standing figure *David*, as they come from different cultures and different times, which have influenced the final look of the work. Yet the origin or impulse for Moore and Donatello to create their sculptures was the same, rooted in the biological necessity of the body to comprehend the outside world, make symbolic images of that world, and re-evaluate those images when it is clear they are no longer adequate. For Read, this explained art by turning it into one of our mechanisms for survival in a potentially hostile world. Just as our biology enables us to run from danger or to safety, art symbolizes to us a world in which there is both danger and safety. Through this symbolism a world-view, which we call reality, is created, and human consciousness is born, because to be conscious is to be aware of this world-view.

This theory offered a radical explanation for human development that was, for Read, missing in Marxism. Whereas Marxist critics, and their descendants the social historians of art, might at best see art as merely the pastime for a leisured bourgeois class, for Read it was a crucial component of our humanity. Without it, we would lack consciousness of the world around us, and be incapable of the social evolution that is necessary for the very survival of our species. When stated like this, one can see why Read believed art to be so important.

Biography

Herbert Read Born Kirkbymoorside, Yorkshire, 4 December 1893, son of a tenant farmer. In 1909 he started work in a bank, and in 1912 enrolled at the University of Leeds. In 1915 he enlisted in the Army, becoming an officer. He became a regular columnist for the BBC's *Listener* magazine in 1929; and between 1933 and 1939 he was editor of the *Burlington Magazine*. He began teaching at the University of Edinburgh in 1931. In 1946 he co-founded the Institute of Contemporary Arts (ICA) in London and undertook a series of international lecture tours. From 1946 Read was advisor to the British Council, and was involved in the organization of a diverse series of other projects, including the Gregory Fellowships in Art at the University of Leeds from 1949 and the Competition for the Monument to the Unknown Political Prisoner 1952. He died at Stonegrave, Yorkshire, on 12 June 1968.

Bibliography

Main texts

The Meaning of Art, London: Faber and Faber, 1931.
Art Now, London: Faber and Faber, 1933.
Art and Industry, London: Faber and Faber, 1934.
Art and Society, London: Heinemann, 1937.
To Hell with Culture, London: Kegan Paul, 1942.
The Grass Roots of Art, London: Drummond, 1947.
The Philosophy of Modern Art, London: Faber and Faber, 1952.
The True Voice of Feeling, London: Faber and Faber, 1953.
Icon and Idea, London: Faber and Faber, 1955.
The Forms of Things Unknown, London: Faber and Faber, 1960.
Art and Alienation, London: Thames and Hudson, 1967.

Secondary literature

Goodway, D., *Herbert Read Reassessed*, Liverpool: Liverpool University Press, 1998.

King, J., *The Last Modern: A Life of Herbert Read*, London: Weidenfeld and Nicolson, 1990.

Read, B. and Thistlewood, D., *Herbert Read: A British Vision of World Art*, London: Lund Humphries, 1993.

Steele, T., *Alfred Orage and the Leeds Arts Club 1893–1923*, Aldershot: Scolar Press, 1990.

Thistlewood, D., *Herbert Read: Formlessness and Form*, London: Routledge and Kegan Paul, 1984.

Woodcock, G., *Herbert Read: The Stream and the Source*, London: Faber and Faber, 1972.

MICHAEL PARASKOS

MEYER SCHAPIRO (1904–96)

AMERICAN ART HISTORIAN

Meyer Schapiro remains *the* pre-eminent art historian educated in the United States. He mastered not one area of art history, but several, encompassing a broad expanse that extended from Late Antiquity and Early Christian Art through Byzantine and Medieval Art only to conclude with Modern Art from the West in the nineteenth and twentieth centuries (he was in fact a pioneering scholar in the field). In addition, he wrote with incisiveness about art-historical methodology, thus contributing to art theory in a key way.

More than any other art historian from the US, Schapiro rivalled the 'Old World' classical knowledge in the Liberal Arts of Erwin

Panofsky and the cosmopolitan political sophistication of Walter **Benjamin** or T.W. **Adorno**. (In fact, he was a friend, as well as a peer, of Panofsky and Adorno, besides being a brief acquaintance of Benjamin, with whom he shared an elective affinity.) As much as any scholar in America, Schapiro intensified the terms of visual (or formal) analysis by effortlessly absorbing **Wölfflin**'s landmark paradigm shift to one of seeing the arts as 'visual languages'. Charting the art object's visual syntax took on an unprecedented rigour with Schapiro.

Schapiro was also at home with the high-altitude thought of the major philosophers and theorists of his day. The telling examples of his critical engagement here include his seminal intellectual interchanges with John **Dewey**, Adorno, Leo Löwenthal, and **Merleau-Ponty** (he told me in a 1993 interview, 'Merleau-Ponty's thought was closest to my own'). These interchanges extended to comparably beneficial ones with Roman Jakobson, Claude **Lévi-Strauss**, Jean Paul Sartre, Bertolt Brecht, André Breton, Jacques **Lacan** and Max Wertheimer. Conversely, he more than held his own in his sharp (and often misunderstood) public polemics against **Heidegger**'s brand of existentialism.

These various sets of scholarly accomplishments and skills in expected fields must be grasped, though, in relation to yet another area of engagement that is unexpected for a world-class art historian: Schapiro's lifelong involvement with politics from a distinctly left wing position on the political spectrum. Some of Schapiro's most important pieces on art *and* politics were for journals as short-lived as *Marxist Quarterly* (1937) or as enduring as *Dissent: A Quarterly of Socialist Opinion* (1954–), and Schapiro played a well-documented role in mediating the relationship of Leon Trotsky and Surrealist author André Breton, leading up to their collaboration with Diego Rivera (also a friend of Schapiro's) on the momentous 1938 manifesto *Towards an Independent Revolutionary Art*.

There is something like a consensus among scholars that Schapiro changed the course of art-historical analysis on at least six different occasions, even though most art historians are only half-aware of his role in doing so. While inaugurating these half-dozen distinct 'moments' in the life of the discipline between the late 1920s and the late 1960s, Schapiro made four things into defining attributes of almost everything he wrote. These were: an intense 'looking', manifested through interrogative visual analysis; a conception of artistic practice as *a form of labour* both physical and intellectual, whether semi-alienated or non-alienated; a belief that meaning in art emerged from a *dialogue* that began but did *not* end with artistic

intention and also hinged heavily on the history of reception (it is here that **Derrida** utterly misread Schapiro's position, since he insisted in rigidly binary fashion that Schapiro invoked *only* the first half of this dialogue, while he himself stood for the other); and the deployment of a subtle yet jargon-free type of 'critical theory' that was not about system-building, but about systematic critique.

What, then, are these six different methodological shifts in his work? The *first* of Schapiro's transformations of art-historical practice was his most famous and often remarked renovation of the field. This was the tripartite approach, including several sub-sets of methods along the way, that was used in his monumental 400-page dissertation 'The Romanesque Sculpture of Moissac'. The first of the three methods appropriately dividing the study into three parts featured a fresh type of 'formal analysis'. As John Plummer and others have observed, this study entailed an entirely new sense of the sculptures as much more than dry archaeological documents. Rather, he saw them in relation to an inherited aesthetic language based on a mode of artistic production replete with *ad hoc* choices in the act of labour. In fact this first third of the dissertation is the only part that has ever been published – it appeared as two very lengthy articles in *The Art Bulletin* in 1931, then as a book in 1985. As a result, a very serious misconception about Schapiro's work has emerged: most people have assumed that his dissertation was primarily a novel exercise in the formal analysis of medieval art using a type of method found earlier only in the studies of Wölfflin on Renaissance/ Baroque and of Roger **Fry** on modern art. (Fry was actually Schapiro's favourite art critic in the 1920s.) In fact, this method was only the foundation for two other parts of his study that have never yet been published.

Part Two is a *tour de force* of iconographic analysis that dramatically transforms the method that he inherited from Émile **Mâle**. Mâle had assumed that medieval stone sculpture was merely a 'correct' illustration of Church doctrine mandated by institutional patronage. Although Schapiro did operate in 1929 with the notion that iconographic analysis was indeed about decoding the intended symbols inscribed in stone, he also introduced a new methodological conception into this conventional approach. At issue were competing sets of intentions involving both those of the commissioned workers, as well as those of the commissioning religious order. Moreover, he realized already that visual forms and literary texts could never exist in a one-to-one relationship. Thus, art production was always about an imperfect 'translation' entailing a series of negotiations over power, based on such considerations as those of class or region.

It is of course precisely this latter usage of iconographic analysis wedded to class analysis that was one of the key reasons why his later publication, 'From Mozarabic to Romanesque at Silos', was such a landmark article when it appeared in *The Art Bulletin* in 1939. Yet the research for this article, as well as most of the methodological ideas about how to approach the material, dated *in nucleo* from as early as 1927, when he concluded the research at Silos. Similarly, Part Three of Schapiro's dissertation – also never published – was a 'social history' of the institutional patronage (that Schapiro in 1993 said 'used a Marxist concept of historical development'). At issue were both class and 'ethnic' politics, as well as city-versus-country pressures. In other words, in 1929 Schapiro effected three interrelated historic shifts in the life of the discipline with a unique tripartite methodology – a type of 'total' art-historical analysis – that he would progressively consolidate over the next decade.

The *second* major moment in effecting a methodological shift in the practice of art history is one that is better known: the 'social history of art'. It began at least by 1935 with a little-known essay about Seurat's relation to modernity and modernization, and found brilliant articulation in Schapiro's now-legendary review essay 'The Nature of Abstract Art' for the first issue of an obscure publication, *Marxist Quarterly*, that would come out only twice more. Thomas Crow has summarized Schapiro's significance as follows:

> His effective invention of the social history of the French avant-garde lay undeveloped until entirely new generations of scholars took up his texts in the 60s and 70s: Linda Nochlin found her way to Courbet and Realism through a 1941 article; Robert Herbert prefaced *Impressionism* [1988], the summa of his research, with a simple dedication 'To Meyer Schapiro'; T.J. Clark began *The Painting of Modern Life* [1985] with the remark that his study 'had its beginnings, so far as I can tell, in some paragraphs by Meyer Schapiro, published first in January 1937 [and] still the best thing on the subject'.

The *third* interpretative shift that Schapiro triggered in the discipline of art history involved one of his key pieces of 'art criticism'. This was his watershed 1957 article for *Art News* about Abstract Expressionism – which flatly countered the orthodox formalist view of Clement **Greenberg** – by focusing on the new art neither as an example of medium self-definition nor as one of political engagement, but as a new form of *ideological critique* that implicitly countered the alienating

'ordinary experience of working' within a booming postwar corporate capitalism. In a more advanced way than in his 1937 discussion of early abstraction, Schapiro saw the social critique of the abstract artwork in the 1950s as coming from both the structural logic of the art object and the unique mode of artistic production whereby the art was executed – and not from any 'politically correct' content or evident social message to which the formal values were deemed subordinate, as in 'social realism'.

The *fourth* methodological turn he introduced into the discipline was nothing less than that of 'semiotics', though with a manifest debt to C.S. Peirce rather than to Saussure. Here he followed the lead of Roland **Barthes**'s work in literary theory from the 1950s. In fact, Schapiro's 1966 essay about semiotics dealt specifically with how the various 'frames' and 'grounds' of the visual arts signify in ways that both confirm the indexicality of the artist and appeal beyond it to the variegated modes of reception by spectators. (Only with T.J. Clark's 1980 essay 'Manet's *Olympia*' did art history see a sustained application of semiotics to the signifying reception of a single artwork.)

The *fifth* approach that Schapiro used at a notably early date (1968) was a psychoanalytic analysis of artistic intention. This method in fact rigorously applied **Freud**'s ideas on artistic production with more success than had Freud himself, in his studies either of Leonardo's childhood or of Michelangelo's *Moses*. Schapiro's method here emerged from his compelling 1955–6 critique of Freud's very flawed essay about Leonardo, in which Schapiro said, nevertheless, that a more historically astute usage of Freud's ideas could yield more plausible results. Such in fact was the case with Schapiro's magisterial re-interpretation of Cézanne's choice of apples in his still-life paintings, which were seen as the manifestation of a 'displaced erotic interest'. Schapiro also showed how Cézanne's unconscious choice was induced by a sublimated intertwinement of his considerable knowledge of classical poetry on the pastoral subjects of love and fruit, from Virgil and Ovid to Propertius.

Finally, in 1968, Schapiro published a much-needed, if rather too brief and seldom understood, critique of existentialism's inability to illuminate 'historical problems'. This was especially clear with respect to Heidegger's supposed revelation of 'essential' truths about a peasant woman's 'instrumental' relation to the world through a system of tools or 'equipment'. Such an epiphany was purportedly embedded in a painting by Van Gogh of old shoes. (These reflections on Van Gogh by Heidegger and Meyer led to Jacques Derrida's essay on the same theme

in *The Truth in Painting*, 1978.) Significantly, the methodological shift by Schapiro here was very much to the point in the late 1960s, and in keeping with contemporary critiques by Adorno and Althusser of existentialism's fetishism of individual agency, along with its equally untenable presumption concerning the intentional 'unity' of all great art.

Indeed, in 1966 Schapiro published a critique of the conventional view of organic compositional unity that also related to what he noted about the 'essentializing' tendency of Heidegger's vantage point. For Schapiro, artworks were more often characterized by an incompleteness and discoordination that attested to competing intentions and the 'contingencies of a protracted effort'. Moreover, an approach to art such as Schapiro's involved something very different from Heidegger's personal 'intuition'. Schapiro's method entailed instead 'critical seeing', which 'aware of the incompleteness of perception is explorative and dwells on details as well as on the larger aspects that we call the whole. It [critical seeing] takes into account other's seeing; it is collective and cooperative.' Such a dialogical and anti-essentializing approach in the 1960s was in many ways the logical culminating point for the consistent series of methodological shifts that Schapiro inaugurated into art history, starting so strikingly in the late 1920s.

Biography

Meyer Schapiro Born Shavly, Lithuania, 23 September 1904, the second child of secular Jewish socialists. The Schapiro family moved to the US when Meyer was three years old. He was educated in Brooklyn, and at Columbia University (Art History and Philosophy) 1916–20, and taught there from 1928. He eventually became Professor Emeritus at Columbia in 1973. He lectured at the New School for Social Research between 1936 and 1952. Schapiro was co-founder of the *Marxist Quarterly* in 1937, and founding editor of *Dissent: A Quarterly of Socialist Thought* in 1954. He delivered the Charles Eliot Norton Lectures at Harvard University in 1966–7, and the Slade Lectures at Oxford University in 1968. In 1978 he won the National Book Critics Circle Award, in 1979 the Mitchell Prize in Art History, and in 1984 the Aby Warburg Prize awarded by the Universität Hamburg. Schapiro died on 3 March 1996.

Bibliography

Main texts

For a comprehensive listing of all Meyer Schapiro's publications, see Lillian Milgram Schapiro (ed.), *Meyer Schapiro: The Bibliography*, New York: George Braziller, 1995.
To date, five volumes of Schapiro's selected writings have appeared in a series of publications begun in 1977 by New York publisher George Braziller:
Vol. I: *Romanesque Art* (1977).
Vol. II : *Late Antique, Early Christian and Medieval Art* (1979).
Vol. III: *Modern Art* (1979).
Vol. IV: *Theory and Philosophy of Art* (1994).
Vol. V: *World View in Painting: Art and Society* (1999).
Interviews:
Oxford Art Journal, 17, 1 (1994) (special issue on Meyer Schapiro, Guest Editor: David Craven).
'Meyer Schapiro and Lilian Milgram Schapiro with David Craven – A Series of Interviews (15 July 1992; 22 January 1995)', *RES*, 31 (Spring 1997), 159–68.

Secondary literature

Crow, T., 'Village Voice: Meyer Schapiro', *Artforum* 34, 10 (Summer 1996), 122.
Sauerländer, W., 'The Great Outsider: Meyer Schapiro', *The New York Review of Books*, (2 February 1995), 28.
Special issues:
The Journal of Aesthetics and Art Criticism, 55, 1 (Winter 1997) (contains notable contributions by such authors as Michael Ann Holly, Barry Schwabsky, Alan Wallach and Paul Mattick, Jr.).
Social Research, 45, 1 (Spring 1978) (includes eight insightful essays by such authors as Hubert **Damisch**, Donald Kuspit, Thomas B. Hess, David Rosand and John Plummer).

DAVID CRAVEN

GEORG SIMMEL (1858–1918)

GERMAN SOCIOLOGIST

A theorist primarily interested in forms of social relations and processes of differentiation, Georg Simmel is a thinker for whom aesthetics is not to be isolated from the totality of the phenomena of life but represents, instead, a key area for addressing the relation of culture and society. While Simmel's own writing and life reflect the sophisticated, refined aesthetics of the metropolitan culture of turn-of-the-century Berlin, his theory of art points beyond *l'art pour l'art* connoisseurship. Popular for their entertaining style, Simmel's lectures

attracted a large audience from the Berlin bourgeoisie. But his work also inspired students like Georg Lukàcs, Ernst Bloch, Martin Buber, Siegfried Kracauer, and Margarete Susman.

Informed by a Nietzschean appreciation of art critical of the reduction of art to aesthetic idealism, Simmel, however, resists an isolationist approach that would ignore the constitutive interdependence of art with other social systems. His studies of artists like Rembrandt, Michelangelo and Rodin, and authors like Goethe and Stefan George; his studies of the ornamental and functional aspects of art and artistic everyday objects such as the picture frame, handles, the door, jewellery and fashion; as well as his essays on the aesthetics of ruins, landscape and cityscapes, and the human face; all exemplify Simmel's interest in the social function of art. Expressing but also shaping, if not constituting, the forms of culture as they change through the ages, Simmel uses art to highlight the sociological dimension of culture, including the ramifications this has for epistemology.

Always faithful to his insight into the significance of the sociological aspects of any human manifestation of life, Simmel regards aesthetics as the intersection of the particular and the general, the subjective and the objective sides of social interaction. His comments on the social aspects of art — art as commodity and as a medium of self-expression — are less concerned with purely aesthetic issues of art *per se*. Rather, his approach aims at comprehending the particular ways in which art is produced, consumed and interpreted as social artefacts in a particular historico–cultural moment. This sociological approach allows Simmel to highlight the intrinsically social aspect of art without compromising attention to the importance of individual creativity that stands out as art's innermost essence. Addressing this double aspect of art makes it possible to articulate an aesthetics free of value judgements but endowed with a critical eye on art's profound social and cultural significance.

As a human creation, art, like other human activities, is rooted in two different spheres. If art is taken out of the context of its social reality, its dual nature is reductively simplified. In a short essay on the picture frame (1922), Simmel writes: 'The essence of the artwork is to be a whole for itself, in no need of a relationship to an external, spinning its threads back into its center. By being what otherwise is only possible for the world as a whole or the soul: a unity of singularities — the artwork separates itself as a world by itself from all externality.' But, he continues, it is framing alone that enables the artwork to express its contradictory nature: 'The artwork is in the

really contradictory situation to be supposed to arrive at a coherent whole with its surrounding while it is already itself a whole; it thus repeats the general difficulty of life that the elements of wholenesses nevertheless claim to be autonomous wholes for themselves.'

Yet Simmel remains critically aware that the origin of aesthetic feelings and the sense of beauty are to be found in the materiality of social life. While he notes that knowledge of the link between sensory stimulations and the particular aesthetic feelings they produce remains speculative, he points out that 'material utility of the objects, their purposiveness for the preservation and increase of the life of the species was the point of departure for assigning them the value of beauty'. Problematic as this may sound, Simmel's point allows for an intriguing observation. If our sense of the beautiful remains anchored and submerged in the archaic layers of our psychic life, this grounding allows Simmel to propose a striking explanation for the magically 'extraterrestrial' and 'irreal' effect of beauty: 'Maybe what is beautiful to us is what the species has proven useful and what, insofar as the species lives in us, gives us pleasure without us as individuals enjoying the real utility of the object it once had.'

Simmel thus sees the senses as constitutive for the production of the aesthetic effect of art. But while art emerges from the materiality of the senses, its particularity consists in addressing one sense exclusively. This limitation to one sense at a time provides the basis for the impression of unity the artwork projects and which leads to aesthetic intuition. Art, for Simmel, represents the human activity with the highest degree of closedness, a self-sufficient totality even more autonomous than the state. The work of art assimilates the meaning of all the elements it uses integrating them into its own framework: the individual work of art suspends the polyvalence of words and sounds, of colours and shapes, leaving only that aspect of meaning the particular work of art constructs. This closure derives from the psychic unity expressed in the work of art. Whereas the work of art speaks to the individual, the individual is at the same time addressed in her or his very being. In imitating the anthropocentric character of the intellectual world in general, the world of art produces a uniformity and spiritualization of appearance only possible through art. For Simmel, art is a language that gives form to the way we see the world. But this means that, while art expresses the highest form of a particular historical age, art, in turn, also provides a critical vantage-point on how we experience and construct the world. Art is thus part of the dynamic dialectic of culture.

For Simmel, the secret of form consists in it being a limit; form represents 'the thing itself and at the same time its end' ('Metaphysics of Death'). Art cannot be isolated from its specific cultural context, from and against which it emerges, as autonomous form. For the very significance of its aesthetic effect springs from its expressing a limit, i.e. a particular way to relate to the social relations while art's allure of standing for itself creates the illusion of beauty. Working in two opposite directions, the aesthetic effect owes its magic to the contradiction it expresses: 'All art changes the scope in which we originally and naturally relate to reality.' Art brings us thus closer to life: behind the cool strangeness of the external world, art spirits the being with its soul. Yet, at the same time, 'every art constitutes a distancing from the immediacy of things, has the concreteness of stimulation recede, spanning a veil between us and them, just like the fine bluish scent that enshrouds mountains in a distance'.

This double aspect of art makes aesthetics a fundamentally ambivalent experience. Representing the crystallization of social and cultural forces in one particular constellation of an individual's subjectivity, Simmel redefines aesthetics as a philosophical approach that defies any normative claims and liberates aesthetic discourse to a critical perspective constantly on the move; a never-ending attempt at grasping the aesthetic qualities of the diversity of social life forms through the ever-different unities the art world projects. This makes for a ground-breaking change of aesthetic theory that now opens its scope to infinity: 'Every point contains within itself the potential of being redeemed to absolute aesthetic importance. To the adequately trained eye, the totality of beauty, the complete meaning of the world as a whole, radiates from every single point' ('Social Aesthetics').

In critical fashion, this break with aesthetic idealism grounds the conviction 'that from each point on the surface of existence – however closely attached to the surface it might seem – one may drop a sounding into the depth of the psyche so that almost all the most banal externalities of life finally are connected with the ultimate decisions concerning the meaning and style of life' ('The Metropolis and Mental Life'). Heeding art's claim to aesthetic independence and autonomy, Simmel at the same time highlights the way in which art sociologically functions as a medium for expression and self-reflection that provides the vocabulary, if not grammar, for the social construction of culture. Simmel stands as one of the crucial forerunners and intellectual foundations for Critical Theory.

Biography

Georg Simmel Born Berlin, 1 March 1858, son of Jewish parents. He studied history, philosophy, social psychology (Völkerpsychologie), art history and Italian with Droysen, Mommsen, Steinthal, Lazarus and Hermann Grimm between 1876 and 1881, achieving his DPhil in 1881. In 1885 he was a private lecturer at the University of Berlin. For a time he was co-editor of the *American Journal of Sociology*. He published *Philosophy of Money* in 1900, and was co-founder of the German Association of Sociology in 1909. Between 1900 and 1914 he was an Associate Professor at the University of Berlin, and became a full professor at the University of Strassburg in 1914. Simmel died at Strassburg on 26 September 1918.

Bibliography

Main texts

The Philosophy of Money (*Philosophie des Geldes*, 1900), trans. T.B. Bottomore and David Frisby, London and Boston: Routledge, 1990.
Soziologie, Berlin: Duncker & Humblot, 1908.
Philosophische Kultur: Gesammelte Essays, Leipzig: Klinkhardt, 1911.
Zur Philosophie der Kunst, Potsdam: Kiepenheuer, 1922.
'The picture frame: an aesthetic study' ('Der Bildrahmen', 1922), *Theory, Culture and Society* 11 (1994), 11–17.
Collected works:
Gesamtausgabe, Otthein Rammstedt (ed.), Frankfurt: Suhrkamp, 1989.
Selections:
The Sociology of Georg Simmel, trans. and ed. K.H. Wolff, Glencoe, Ill.: Free Press, 1950.
Essays on Sociology, Philosophy and Aesthetics, K.H. Wolff (ed.), New York: Harper and Row, 1959.
The Conflict in Modern Culture and Other Essays, trans. K.P. Etzkorn, New York: Teacher's College, 1968.
Simmel on Culture, Selected Writings, David Frisby and Mike Featherstone (eds), London: Sage, 1997.

Secondary literature

Dahme, H.-J. and Rammstedt, O., *Georg Simmel und die Moderne. Neue Interpretationen und Materialien*, Frankfurt: Suhrkamp, 1984.
Dörr, F., *Die Kunst als Gegenstand der Kulturanalyse im Werk Georg Simmels*, Berlin: Duncker & Humblot, 1993.
Frisby, D., *Sociological impressionism: a reassessment of Georg Simmel's social theory*, London: Heinemann, 1981.
Kracauer, S., 'Georg Simmel', in Siegfried Kracauer *The Ornament of the Mass*, Cambridge, Mass.: Harvard, 1995.

Solies, D., *Natur in der Distanz. Zur Bedeutung von Georg Simmels Kulturphilosophie für die Landschaftsästhetik*, St Augustin: Gardez, 1998.
Weinstein, D. and Weinstein, M.A., *Postmodern(ized) Simmel*, London: Routledge, 1993.
Special issue:
Theory, Culture & Society 8 (1991) (special issue on Georg Simmel).

WILLI GOETSCHEL

SUSAN SONTAG (1933–)

AMERICAN CULTURAL CRITIC

Susan Sontag established her reputation as a key writer on art with the publication of her essay collection, *Against Interpretation* (1966). The volume collected twenty-six pieces published in a wide range of periodicals between 1962 and 1965. Although more than half of the volume concentrated on writers, several essays were devoted to film, and virtually all of her work discussed or at least alluded to the visual arts. Indeed, even in her explorations of literature, she de-emphasized the verbal – the content – and favoured an emphasis on form and style.

Sontag's most famous essay, 'Against Interpretation', announces an approach to art that would inform most of her critical work for the next decade. She observes that art has its origins in the incantatory, the magical, and in ritual. As such, art is autonomous and created for its own sake. But the Greeks proposed a theory of art as *mimesis*; that is, art imitated reality; it copied the world. Unfortunately, in Sontag's view, the theory resulted in making art subservient. If art is merely imitation, then it must be interpreted in relation to the world it imitates. Consequently, she points out, art itself is never viewed as a whole. Instead, art becomes a purveyor of content, of messages and themes, and matters such as style and form are seen merely as add-ons, as a kind of veneer separable from the substance of the work.

Sontag argues that, in her era, content-driven critics searching for symbols and meanings had destroyed the true value of art. By using the phrase 'against interpretation', she is employing the strongest possible polemical means to draw attention away from content and toward form and surface. She contends that the work's sensuous properties – what is available to the eye in a work of art – should command the critic's attention, not its so-called hidden meanings. She urges that the

artwork ought to be valued for the kind of presence it occupies in the world and not as a kind of adjunct to existence. Her position is reminiscent of Archibald Macleish's line in 'Ars Poetica' in which he writes that a poem 'should not mean but be'. 'Against Interpretation' ends with a characteristically provocative statement: 'In the place of a hermeneutics of art we need an erotics of art.'

'Notes on "Camp" ', the essay that brought Sontag to national attention when *Time* magazine commented on it, shows how her view of art's autonomy cuts across the boundaries of popular and elite culture to include references to the film *King Kong*, the actress Mae West, Tiffany lamps, and artists such as Jean Cocteau, Crivelli and Oscar Wilde. Sontag defines camp as 'love of the unnatural: of artifice and exaggeration'. Camp is a rococo phenomenon and linked with her definition of art, which includes the idea of artifice or construct – an alternative to or a transformation of real life.

In 'On Style' (*Against Interpretation*), Sontag elaborates on the form/content distinction, noting that even Leni Riefenstahl's Nazi propaganda epics, considered as art, merit the term 'masterpieces' because their grace and sensuousness, their beautiful forms, compel an aesthetic response. Her films 'return us to the world in some way more open and enriched' in spite of their evil ideology. Similarly, in her short essay on Jack Smith's film *Flaming Creatures*, she observes that he is not interested in ideas or characters but rather in presenting a profusion of direct and powerful images. His 'freedom from moralism' creates an aesthetic space, the 'space of pleasure'. She also praises Spanish architect Antoni Gaudi y Cornet for his surrealistic use of irregular shapes and unusual textures, which counter the Western traditions of geometrically planned buildings. She singles out Swiss sculptor Alberto Giacometti for his figures which are a 'thing in the world, not a text or commentary on the world'. Her many references to Mannerist artists such as Rosso, Pontomo and Parmigianino also imply how deeply rooted in the past is her sense that artists are not imitating life, but expressing their own vision.

Sontag's second collection of essays, *Styles of Radical Will* (1969), again devalued the idea of the verbal and of content in essays such as 'The Aesthetics of Silence', in which she argued that what the artist does not say requires attention. Artists such as Jasper Johns (she seems to be thinking of his paintings of objects such as flags and tins of paint) create silence by focusing on the thing itself. Here her position is reminiscent of poet William Carlos Williams's dictum: 'no ideas but in things'. As in her controversial endorsement of Leni Riefenstahl,

Sontag turns in 'The Pornographic Imagination' (a study of the French writer Georges Bataille) to a subject which is offensive and yet which can be treated in terms of its form and style as art.

Sontag's attack on critics who wish to view art as an imitation or commentary on the world culminates in her masterpiece, *On Photography* (1977). In this collection of essays, originally published in the mid-1970s in *The New York Review of Books*, she rejects the ideas that photographs are a realistic representation of reality. On the contrary, she regards photography as surrealistic, a term she defines in 'Happenings' (included in *Against Interpretation*) as the 'idea of destroying conventional meaning, and creating new meanings, or counter-meanings through radical juxtaposition ("the collage principle").' Thus photography includes or juxtaposes contrary elements – moving abruptly between different environments, time periods, cultures, classes, objects – and unites them in a 'realistic' frame. But this frame, she argues, is simply another aspect of form, not the reality itself, or even a representation of reality as so many photographers and writers on photography have presumed. Sontag does not deny that photography has a documentary quality – indeed arguments for its factuality and arguments for its artistic quality both have validity; yet these contrary claims cannot both be true. *On Photography* is Sontag's most fully developed work of art criticism, precisely because it continually sways between contrary arguments, keeping the subject of photography in a state of perpetual fluidity. It is one of the great books of American art criticism because it exemplifies so vividly the role of perception.

Some critics complained that she took a purely intellectual approach to photography; the book has no illustrations and the text is notable for her obvious lack of interest in interpreting specific images. But this was exactly Sontag's point: 'I came to realize that I wasn't writing about photography so much as I was writing about modernity, about the way we are now. The subject of photography is a form of access to contemporary ways of thinking and feeling. And writing about photography is like writing about the world.'

Perhaps the single most important influence on Sontag here was Walter **Benjamin**'s seminal essay 'The Work of Art in the Age of Mechanical Reproduction' (1936). Like Benjamin, she discusses technical devices such as the close-up to suggest that the human personality has been explored with an intimacy and psychological complexity unavailable to artists in previous centuries. At the same time, the mechanical quality of the reproductions has raised disturbing questions about the uniqueness of the work of art and about the way in

which human identity has been transformed by the very instruments that were intended simply to convey it.

On Photography is characteristic of Sontag's method, in that she convincingly summons up one's sense of the power of photography *per se*, as physical objects scarcely have a place in her criticism. Cary Nelson observes acutely:

> When we pair that decision not to quote and explicate with her commitment to evoke her own experience of her subject, we reach the curious conclusion that the things she describes constitute in each case an informing absence at the core of her essays. To be convinced by her analysis of a work is to be led to yearn for what is not 'there' in her prose.

Like much of Sontag's non-fiction, *On Photography* reads like a manifesto, a statement of principles. She has carefully eschewed the term 'critic', perhaps because it would obligate her not merely to construct a position but to work out its details in discussions of individual works of art. Very few of her essays address the issue of what we can say about a work of art while respecting the integrity of a work as something in the world rather than a commentary on it. 'The Pleasure of the Image', originally published in 1987 and collected in *Where the Stress Falls* (2001), is a rare example of what might be called Sontag's formalist criticism in practice. In describing her admiration for Bruegel and Dutch painting, she evokes the pleasure of 'falling forward into . . . a world'. Her ellipses, like the silences she praises in works of art, are apparently her effort to convey the entry in the separate realm of art, an art which creates its own world. She speaks of Gerard Houckgeest's painting *The Tomb of William the Silent in the Nieuwe Kerk in Delft* as an 'original account of space'. She shows how the interior of the church is presented photographically, in an 'illusionist method', simulating the real. The church's architecture, she observes, is 'depicted as framing, rather than filling, this deep space'. Indeed, 'architectural space' is the subject of the painting. Sontag is at pains to demonstrate how the picture is framed and configured, and how it is laid out, so to speak, for the eye. As she provides her visual account she also draws on her knowledge of other works of art, suggesting that the viewing of one piece of art depends very much on a knowledge of others. So, for her, the point is to compare one artist's presentation of architecture with another's:

> We see only a dull bit of high window, just below the arched top border of the panel; the potent light which strikes the

columns comes from a window beyond the picture's right edge. In contrast to the panoramic view usually sought by painters documenting an architecture (or a landscape), which takes in more than could be seen by a single viewer, and whose norm is a space that appears comprehensive, unabridged (if indoors, self-contained, wall-to-wall), the space depicted here is one framed and lit so as to refuse visual closure.

Although Sontag has been primarily identified with the formalist school of criticism, she reverses her position in 'Fascinating Fascism', first published in 1975 and collected in *Under the Sign of Saturn* (1980), and focuses squarely on the political content of Riefenstahl's films. Sontag is disturbed that the German director has been lionized by film critics and feminists, and that they have minimized the implications of Riefenstahl's obsession with beauty, form and the primitive. In her films and in her book of photographs, Riefenstahl promulgates a vision of the 'Noble Savage' which is a proto-fascist sensibility that rejects 'all this is reflective, critical, and pluralistic'. Riefenstahl's ideology, Sontag insists, remains fascist, since it revels in the 'victory of the stronger man over the weaker'. The 'virile' aesthetic actually denigrates women, extols submission to the all-powerful male, and turns people into things. Sontag does not deny the quality of Riefenstahl's films, but she now senses that discussion of form without any attention to content can be just as reductive as content-driven exegeses. In an oblique reference to her own earlier position, Sontag remarks: 'Art that seemed eminently worth defending ten years ago, as a minority or adversary taste, no longer seems defensible today, because the ethical and cultural issues it raises have become serious, even dangerous, in a way they were not then.' In other words, the growth in Riefenstahl's reputation requires Sontag herself to reverse her original assessment because what seemed daring in the 1960s has become a commonplace in the 1970s. As Sontag said in an interview, her later position takes into account the importance of history and of context. A close reading of 'Against Interpretation', however, shows that even early on Sontag had at least acknowledged that in certain periods questions of content may take precedence over questions of form.

Sontag has shown no interest whatsoever in trying to reconcile her earlier and later critical writings. She suggests as early as her essay on E.M. Cioran (collected in *Styles of Radical Will*) that there is an art to 'thinking against oneself', of adopting contrary positions as a way of

expanding one's thinking. She does not accept the idea that she holds fixed positions; the way she revises herself is by embarking on 'endless new beginnings'.

Biography

Susan Sontag Born New York City 16 January 1933. She studied at the University of California, Berkeley, 1948–9, the University of Chicago 1949–51, and at Harvard University 1954–7. She taught literature and philosophy at the University of Connecticut, Storrs, 1953–4, at Harvard University 1955–7, at City College of New York and Sarah Lawrence College, Bronxville, 1959–60, and at Columbia University, New York, 1960–4. Sontag became an editor of *Commentary* in 1959, and contributed to various periodicals, including *Atlantic Monthly, Partisan Review, Harper's, Nation* and the *New York Review of Books*. By 1963 she had become a full-time writer, producing plays, film scripts and novels, including *Death Kit* (1967) and *The Volcano Lover* (1992). Sontag's non-fiction includes *Illness as Metaphor* (1978) and *Aids and Its Metaphors* (1989). She was the winner of the National Book Critics Circle prize for Criticism in 1977, and President of PEN, American Center 1987–9.

Bibliography

Main texts

Against Interpretation, New York: Farrar, Straus & Giroux, 1966.
Styles of Radical Will, New York: Farrar, Straus & Giroux, 1969.
On Photography, New York: Farrar, Straus & Giroux, 1977.
Under the Sign of Saturn, New York: Farrar, Straus & Giroux, 1980.
Where the Stress Falls, New York: Farrar, Straus & Giroux, 2001.

Secondary literature

Bruss, E., *Beautiful Theories*, Baltimore: Johns Hopkins University Press, 1982
Hickman, L., 'Experiencing Photographs: Sontag, Barthes, and Beyond', *Journal of American Culture*, VII (Winter 1984), 69–73.
Kennedy, L., *Susan Sontag, Mind as Passion*, Manchester: Manchester University Press, 1995.
Nelson, C., 'Soliciting Self-Knowledge: The Rhetoric of Susan Sontag's Criticism', *Critical Inquiry*, VI (Summer 1980), 707–26.
Poague, L. (ed.), *Conversations with Susan Sontag*, Jackson: University Press of Mississippi, 1995.
Poague, L. and Parsons, K.A, (eds), *Susan Sontag: An Annotated Bibliography, 1948–1992*, New York: Garland, 2000.
Rollyson, C., *Reading Susan Sontag*, Chicago: Ivan R. Dee, 2001.

Rollyson, C. and Paddock, L., *Susan Sontag: The Making of an Icon*, New York: W.W. Norton, 2000.

Sayres, S., *Susan Sontag, Elegiac Modernist*, New York: Routledge, 1990.

CARL ROLLYSON

ADRIAN STOKES (1902–72)

BRITISH CRITIC

Adrian Stokes – aesthete, critic, painter and poet – is linked to John Ruskin and Walter Pater as one of the greatest English aesthetic writers. In this empirical English critical tradition, notions of art are not pre-conceived but arise out of intense responses to the facticity of material and form. Stokes's vision is intensely corporeal and humanist; art, he contends, is most profound when it emplaces in the concrete world some image of the body as a whole and distinct entity.

Stokes's reputation rests on over twenty critical books and numerous papers. Outstanding among them is the great series of books published in the 1930s: *The Quattro Cento* (1932), *Stones of Rimini* (1934), and *Colour and Form* (1937). His autobiographical *Inside Out* (1947) – written during World War Two – parallels Ruskin's *Praeterita* and Pater's *The Child in the House* as a key document of the growth of an aesthetic sensibility, and gives valuable insights into Stokes's own development. In the period following World War Two the experience of psychoanalysis – an undercurrent in the 1930s trilogy – becomes integral to the texts. At the same time the range of the criticism broadens greatly. Significant studies include *Michelangelo* (1955), *Greek Culture and the Ego* (1958), and *The Painting of our Time* (1961).

The poetics of Stokes's writings have the capacity permanently to enlarge perception; yet they elude normative modes of art analysis. At any point, issues of iconography, style, motif or period may be invoked within the intense scrutiny of the artefact, but only to amplify a wider aesthetic point about the integrity of the art-object in relation to the life of the mind. The modalities of his writing convey the dense accretion of meaning that art offers us, its overtones and resonance. Stokes was a notable factor in the formation of English Modernism in the 1930s, and figures in the biographies of the Sitwells, Ben Nicholson, Barbara Hepworth, Naum Gabo, William Coldstream, Alfred Wallis and numerous other artists and thinkers. His respect for

painting or sculpture's integrity and materiality remains a criterion, and many art-makers and art-writers have acknowledged their debts to Adrian Stokes – Richard **Wollheim**, Lawrence Gowing, Barbara Hepworth, Ben Nicholson and William Coldstream among them. This modernity became increasingly psychologized in interpretation; Stokes's works following World War Two represent a significant project to understand the creative dynamics of the psyche through the psychoanalysis of Sigmund **Freud** and Melanie Klein.

Any understanding of the themes of a writer as rooted in the concrete world as Stokes must begin with biography; with his rejection of the urban landscape of his Bayswater and Hyde Park childhood and adolescence, and his self-defining discovery of Italy as a young man. His accounts of London's Hyde Park present a fierce critique of the moral bankruptcy and eclecticism of Victorian–Edwardian art and architecture. The Albert Memorial – as omphalos of the Park and the Empire – becomes the focus of this revulsion: 'Bad Victorian ... architecture, like other academic art, for all its tameness, can be as shocking as a bad dream ... The very tameness is shocking because it is the ornament of a quite inhuman ruthlessness' (*The Quattro Cento*). Stokes needed to discover other landscapes on which to build a 'good' aesthetic. On New Year's Eve 1921 he travelled to Rapallo on the Italian Riviera, experiencing the passage through the Alps and the Mont Cenis tunnel into Italy as a re-birth into the 'counter-landscape' of the South where 'there was a revealing of things in the Mediterranean sunlight, beyond any previous experience; I had the new sensation that the air was touching things; that the space between things touched them, belonged in common; that space itself was utterly revealed' (*Inside Out*).

In the 1920s he travelled widely in Italy, discovering Venice, Rimini and Urbino. These sites of Renaissance culture became the revered centres of his aesthetic in their embodiment of this feeling for the object and the tangibility of space. At Urbino he was overwhelmed by Luciano Laurana's fifteenth-century courtyard in the Ducal Palace, and the affinities between this architecture and the artist invariably associated with the Urbino court, Piero della Francesca. Laurana's 'columns are brothers' (*The Quattro Cento*), he writes, and describes Piero della Francesca's forms as 'brothers and sisters at ease within the ancestral hall of space' (*Art and Science*). In terms such as this he attempts to isolate those aspects of fifteenth-century art and architecture that he most admires. In a Piero painting such as *The Flagellation* at Urbino, the figures, in their archaic stillness, conspire to become columns, and the columns are statuesque. All the elements in

the work are allowed full integrity, and the spaces between forms and figures are as significant and measured as the forms themselves. A similar sensibility permeates the arcades of Luciano Laurana's Palace courtyard. These artworks maintain the same distinctions between the observer as subject and the painting or architecture as object. Stokes called this quality of an artwork its 'otherness'. Unlike later Mannerist or Baroque art, in these *quattrocento* works no part of the composition subsumes another, and the observer is not called to surrender independence by being drawn into the orbit of the work of art. Stokes adopted the term 'identity in difference' to describe his predilection for the unaggressive, familial relationships epitomized in these key works of the early Renaissance – a term he took from a philosopher he had studied at Oxford in the 1920s, F. H. Bradley (1846–1924). In Bradley's view of reality, all apparent identities are merely appearances, for their specious existence relies on interdependent relations.

Equal to this Italian sense of 'brotherly' form in space is the Southern materiality, the 'love of stone', particularly the compacted sea-life that is limestone. In an organicist strategy of interpretation, Stokes employs the phrase 'stone-blossom' to describe how certain *quattrocento* artists made the stone 'bloom' by realizing, on the surface of the marble, the fantasies that they read in the depths of the medium. In his first book on art and architecture, *The Quattro Cento*, Stokes capitalizes the period as Quattro Cento, to delimit these spatial and material values:

> The highest achievement in architecture was a mass-effect in which every temporal or flux element was transformed into a spatial steadiness. Meanwhile in sculpture, all the fantasies of dynamic emergence, of birth and growth and physical grace had been projected within the stone. The stone is carved to flower, to bear infants, to give the fruit of land and sea. These emerge as a revelation or are encrusted there.

In his next important book, *The Stones of Rimini*, Stokes focuses these organicist notions by relating them to the psychologies of artistic process, to articulate one of his most central themes: the duality of 'carving–modelling':

> A figure carved in stone is fine carving when one feels that not the figure, but the stone through the medium of the figure, has come to life. Plastic conception [modelling], on the other

hand, is uppermost when the material ... from which a figure has been made, appears no more than as so much suitable stuff for this creation.

The *carver* does not approach the medium aggressively, but is an attentive lover who woos the stone. As the 'cultivator works the surface of the Mother Earth, so the sculptor rubs his stone to elicit the shapes that his eye has sown in the matrix'. *The Stones of Rimini* is a prolonged reflection on the encounter with Agostino di Duccio's low-relief sculptures in Alberti's Tempio Malatestiano at Rimini, first seen by Stokes in July 1925. These reliefs manifest Stokes's formal ideal of the 'flattened sphere'; shapes of a rubbed roundness like beach pebbles, or those Cycladic Bronze Age marble figurines whose 'particular sensitiveness to luminous gradations of marble ... is through and through Mediterranean'. Duccio's work at Rimini abounds in these flattened fish-like shapes that seem to issue from the depths of the marble through skeins of water, air and drapery. The artists Ben Nicholson and Barbara Hepworth, whom Stokes befriended in 1933 and championed in his writings, shared the 'carver's' respect for the integrity of the stone, or the surface of the canvas. Stokes's writings predicted Nicholson's turn to the carving of reliefs in December 1933, and inspired Hepworth's self-definition as a 'carver'.

The last of the 1930s series, *Colour and Form*, provides an account of colour that extends the concept of 'carving' into painting and 'the architecture of colour-form'. Stokes posits a syncretic theory of colour-form that rejects those critical traditions that tend to privilege form, that is, to elevate *disegno* above *colore*. As 'carving' aims to reveal forms immanent in the medium, so the 'carving colourist' does not merely 'tint' but 'describes colour that seems to come out of a form'. The notion of 'identity in difference' is maintained in the guise of colour-form when Stokes writes that 'the colours of a picture are fine when one feels that not the colours but *each and every* form through the medium of their colours has come to an *equal* fruition ... Colour is the ideal medium of carving conception.' Stokes illustrates 'carved colour' in an appendix to *Colour and Form* that describes four great Renaissance paintings in the National Gallery, London. A 'plastic' Florentine painting, Verrocchio's *Madonna and Child with Angels*, is contrasted to the 'carved' stillness and 'smoothness of colour and form' of Piero della Francesca's *Baptism*. The Verrochio's colour is characterized as discordant and 'bumping', whereas in the Piero we are invited to contemplate the 'total and equal insistence of the forms', a 'conception of form inseparable from the most profound attitude to

colour'. In 1936 Stokes also began to paint, and in 1937 he joined the Euston Road School. His landscapes and still-lifes are the works of a minor master that hang in an intriguing relation to the 'carving' thesis of the texts; from shimmery lacings of Bonnard-like strokes, the canvas is induced to accept similitudes of bottles, buildings and landscapes.

The psychoanalyst Melanie Klein played an important role in Stokes's creative outpouring of the 1930s. Stokes began a seven-year analysis with Klein in 1930 that helped to resolve depressions and unlocked a creative block. Her ideas, and the terminology of psychoanalysis, become increasingly evident in the later texts. Klein, a follower of Freud, concentrates on the early years of child development, maintaining that in the early stage of life – defined as the 'paranoid–schizoid' position – the infant is in a state of one-ness with the mother. At this stage the child relates only to part-objects, such as the mother's breast, which may be 'good' or 'bad', satisfying or frustrating. Gradually, in the first few weeks of life, the 'paranoid–schizoid' position matures to the 'depressive' stage of the ego where the child now recognizes both its own identity and that of the mother as a whole other person, and concurrently suffers guilt at the pain and aggression previously inflicted on the mother. Klein assumes an in-born flux of both love and destructive feelings; maturity entails coming to terms with this inherent polarity of drives. In Stokes's theories, art plays a fundamental role in the on-going process of maturation. Paintings or sculptures are acts of repair the artist makes in the outer world that correspond to processes of integration within the psyche. Stoke contends that the cardinal role of art is to ensure 'a milieu for adults, for true adults, for heroes of a well-integrated inner world to live in' (*The Invitation in Art*). The most significant development in Stokes's later books is his desire to map the dualism of 'carving–modelling' on to the two states identified by Klein in child development. So 'carving', reflecting the depressive position, represents a more mature stage of ego-development in regard to art-making than the 'modelling' aspects of the first, 'paranoid–schizoid', position. At the same time the logic of 'identity-in-difference' increasingly compels him to recognize that 'carving–modelling' and the two psychoanalytical positions are intercompensatory, both in the creation, and the contemplation, of art. In his books which came after World War Two the writing becomes more compacted and allusive, as it absorbs these complex psychoanalytical ideas. Concurrently, the range of artists and periods subjected to investigation broadens greatly to include, among others,

Cézanne (1947), Michelangelo (1955), Raphael (1956) and Monet (1958).

Biography

Adrian Durham Stokes Born London 27 October 1902, son of a wealthy stockbroker. Stokes studied at Oxford University, 1920–2. He travelled to India in 1923–4, and from 1925 began visiting Italy, influenced by Osbert and Sacheverell Sitwell and Ezra Pound; he was particularly moved by his experiences of architecture and sculpture in Venice, Rimini and Urbino. In 1930 began a seven-year period of psychoanalysis with Melanie Klein. He wrote his important early works in the 1930s, and in 1936 he began painting. He moved to Cornwall in 1939, and to Switzerland in 1947. In 1960 he was made trustee of the Tate Gallery. Stokes died in London on 15 December 1972.

Bibliography

Main texts

The Quattro Cento. A Different Conception of the Italian Renaissance. Part One – Florence and Verona. An Essay in Italian Fifteenth-Century Architecture and Sculpture, London: Faber and Faber, 1932.

Stones of Rimini, London: Faber and Faber, 1934.

Colour and Form, London: Faber and Faber, 1937 (rev. edn, 1950).

Venice: An Aspect of Art, London: Faber and Faber, 1945.

Inside Out. An Essay in the Psychology and Aesthetic Appeal of Space, London: Faber and Faber, 1947 (reprinted in: *England and its Aesthetes: Biography and Taste. John Ruskin, Walter Pater, Adrian Stokes – Essays*, commentary by David Carrier, Amsterdam: G+B Arts International, 1997).

Art and Science. A Study of Alberti, Piero della Francesca and Giorgione, London: Faber and Faber, 1949.

Smooth and Rough, London: Faber and Faber, 1951.

Michelangelo: A Study in the Nature of Art, London: Tavistock, 1955.

Raphael 1483–1520, London: Faber and Faber, 1956.

Monet 1840–1926, London: Faber and Faber, 1958.

Three Essays on the Painting of our Time, London: Tavistock, 1961.

Painting and the Inner World – including a dialogue with Donald Meltzer MD, London: Tavistock, 1963.

Greek Culture and the Ego: A Psycho-analytic Survey of an Aspect of Greek Civilisation and of Art, London: Tavistock, 1963.

The Invitation in Art. With a preface by Richard Wollheim, London: Tavistock, 1965.

Reflections on the Nude: London, Tavistock, 1967.

'Pisanello: First of four essays on the Tempio Malatestiano at Rimini, (R. Read, ed.)', (first publication of the complete text, and with an introduction by E. Read), in E.S. Shaffer (ed.) *Comparative Criticism: Walter Pater and the Culture of the fin-de-siècle*, Cambridge: Cambridge University Press, 1995.

Selected writings and collected essays:

The Image in Form. Selected Writings of Adrian Stokes, Richard Wollheim (ed.), Harmondsworth: Penguin Books, 1972.

A Game That Must be Lost. Collected Papers, Cheadle: Carcanet Press, 1973.

The Critical Writings of Adrian Stokes, 3 vols, Lawrence Gowing (ed.), London: Thames and Hudson, 1978.

Secondary literature

Casillo, R., 'The Stone Alive: Adrian Stokes and John Ruskin', *The Journal of Pre-Raphaelite Studies*7, 7 (1986), 1–28.

Deamer, P., 'Adrian Stokes and Critical Vision', *Assemblage*, 2 (February 1987), 118–33.

Gervais, D., 'Adrian Stokes and the Benignity of Form: Part One', *The Cambridge Quarterly*, 10 (1981), 40–64.

Kite, S., 'The Urban Landscape of Hyde Park: Adrian Stokes, Conrad and the *Topos* of Negation', *Art History* 23, 2 (2000), 205–32.

Potts, A., 'Carving and the Engendering of Sculpture: Stokes on Hepworth', in D. Thistlewood (ed.) *Barbara Hepworth Reconsidered*, Liverpool: Liverpool University Press and Tate Gallery Liverpool, 1996.

Read, R., 'Art Criticism Versus Poetry: An Introduction to Adrian Stokes's "Pisanello" ', in E.S. Shaffer (ed.) *Comparative Criticism: Walter Pater and the Culture of the fin-de-siècle*, Cambridge: Cambridge University Press, 1995.

——, 'The Unpublished Correspondence of Ezra Pound and Adrian Stokes: modernist myth making in sculpture, literature, aesthetics and psychoanalysis', in E.S. Shaffer (ed.) *Comparative Criticism: Myth and Mythologies*, Cambridge: Cambridge University Press, 1999.

Wagner, A., 'Miss Hepworth's Stone *is* a Mother', in D. Thistlewood (ed.) *Barbara Hepworth Reconsidered*, Liverpool: Liverpool University Press and Tate Gallery Liverpool, 1996.

Adrian Stokes 1902–72. A Retrospective, London: Arts Council of Great Britain, 1982 (contributions by Stephen Bann, John Golding, David Plante, Richard Read, David Sylvester).

'Adrian Stokes 1902–72: a supplement', Stephen Bann (ed.) *PN Review 15*, 7, 1 (1980), 30–54 (contributions from Richard Wollheim, Richard Read, Eric Rhode, Andrew Forge, Eric W. White, Colin St John Wilson, Peter Leech, David Carrier, Paul Smith, Peter Robinson and Adrian Stokes).

STEPHEN KITE

ABY WARBURG (1866–1933)

GERMAN ART HISTORIAN

Aby Warburg was an author more praised than read. His *fortuna* was deeply affected by an article published in 1933 by Fritz Saxl and Erwin

Panofsky, 'Classical Mythology in Medieval Art', which purported to offer an account of his 'method'. Taken together with Panofsky's 1939 publication *Studies in Iconology*, these two works have had a profound effect on Anglophone scholarship, resulting in the large-scale development of iconography. Warburg would hardly have recognized himself in Panofsky's work. If anything, Warburg could be described as a cultural pathologist. He called himself a psycho-historian, trying to diagnose the 'schizophrenia of Western civilization from its images in an autobiographic reflex'.

Far from being concerned simply with traditions of relationship between painting and text as a field of art history, Warburg disregarded its border police and involved himself in a wide and various range of intellectual disciplines. He had studied cultural history with Karl Lamprecht and anthropology with Hermann Usener, and had come into contact with the idea that images were symptomatic of variously developed states of mind. This was very different from a notion of *Kunstgeschichte als Geistesgeschichte*, the history of art as the history of an abstract 'spirit'. Lamprecht was interested in the use of images within a 'scientific social psychology', the jostling of mental associations in eras of dynamic change. What, he wondered, was 'the psychic scope within which dying and emergent civilisations may still prove to be compatible? ... if a particular culture is revived, what are the mental and psychological processes involved?' (**Gombrich**, 1986, 35). Hermann Usener was interested in mythology and its continued power to shape the mind. All manner of phenomena were grist to Warburg's mill besides traditional works of art: festivals, material culture, astrology and magic.

Warburg's teacher, the art historian Henry Thode, had argued that the Renaissance concern with Nature and Beauty had emerged from the religious ideals of Francis of Assisi. Noticing Botticelli's deviant concern from the path of idealizing naturalism by his use of accessories in motion, the fluttering garments of his nymphs, Warburg sought an explanation in terms of the Medici circle's interest in classical poetry. Virgil and Ovid offered an alternative to Winckelmann's 'noble simplicity and quiet grandeur'. Politian's *Orfeo* presented these literary themes to the visual imagination: 'Once we assume that festive performances set the characters before the artist's eyes as living, moving beings, then the creative process becomes easier to follow' (1932, 125). If, as Burkhardt had declared, 'Italian festive pageantry, in its higher form, is a true transition from life into art', one is entitled to wonder about the larger social and cultural values that the work celebrated.

Following his dissertation on Botticelli, Warburg investigated the 'Art of Portraiture and the Florentine Bourgeoisie' in Ghirlandaio's celebrated painting *The Confirmation of the Franciscan Rule*. Under what conditions could the families of the Sassetti and Medici occupy such a prominent position in a sacred painting? In the same way that life-sized wax images were allowed in the church of Santissima Annunziata: 'This lawful and persistent survival of barbarism, with wax effigies set up in church in their mouldering fashionable dress, begins to cast a truer and more favourable light on the inclusion of portrait likenesses on a church fresco of sacred scenes. By comparison with the magical fetishism of the waxwork cult, this was a comparatively discreet attempt to come closer to the Divine through a painted simulacrum' (1932, 190). The citizen of Medicean Florence united the idealism of Christianity, chivalry and neoplatonism with the 'worldly, practical, pagan Etruscan merchant'. These merchants were equally at home with Flemish painting in its celebration of material goods. Warburg examined this seemingly strange taste in his essay 'Flemish Art and the Florentine Early Renaissance'.

Warburg's interest extended to the personalities behind the production of paintings: 'The bourgeois public of the 1470s respected the artist as a master of technical tricks, born under the planet Mercury, who could do anything and supply anything; who painted and sculpted in his back workshop, but who had a front shop in which he sold all that people might need: belt buckles, painted marriage chests, church furnishings, votive waxes, engravings' (1932, 202). The artist had a moral responsibility for his work and, amongst weak artists, imagery could get out of balance: Botticelli succumbed to flying drapery, the Pollaiuoli to muscular rhetoric, and lesser painters produced images 'redolent of dry goods and theatrical wardrobes'. But the artists responded to the needs of the patrons who themselves had their weaknesses and were driven by conflicting feelings. Warburg analysed the psychological make-up of Francesco Sassetti in his study of his last will and testament. This worldly businessman fell out with the friars of S. Maria Novella over his desire to have a burial place decorated with the legend of St Francis; they were Dominicans. Rather than give in, he placed his tomb in the church of S. Trinita. But this was the same man who believed in the power of *Fortuna*, whose image played an important role in the Florentine *impresa*, 'the stylistic embodiment of worldly energy'. Courtly culture had produced a 'symbolic illustration of the life of the individual' (1932, 240). Sassetti could be pious and pagan at the same time.

Far from treat the development of Florentine *quattrocento* painting as pursuing a linear path towards idealizing naturalism, Warburg saw it as

the outcome of the competition of styles *alla franzese* (in the French style) and *all' antica* (in the antique style). He treated the conflict of styles as a psychological problem which was not straightforwardly resolvable, as we would gather from his notebooks:

> What was it that really happened behind this apparent conflict?
> A clash between a frenchified barbaric mediaeval attitude ... and classicizing modern ones? ...
> ... appropriation by touch ... is being replaced by a process of bodily empathy with the gesture ...
> ... Why was this so hard?
> Because the Florentines were both the masters and the slaves of their material culture: silks, weavers of brocade, goldsmiths, masons, colour-grinders.
> Their ability to dissociate themselves reinforced by an act of memory, is astonishing.
>
> (Gombrich, 1986, 156–7)

'The Entry of the Idealising Classical Style in the Painting of Early Renaissance' criticised the traditional view that the Renaissance could simply be explained by the renewal of classical learning. Not only were there resistances to be encountered, but antiquity itself offered fundamentally alternative possibilities: 'we are learning more and more to see antiquity as symbolised, as it were, in the two-faced herm of Apollo and Dionysus. Apollonian ethos together with Dionysian pathos grow like a double branch from one trunk, as it were, rooted in the mysterious depths of the Greek maternal earth' (Woodfield, 2000, 26). Hostile to a mere archaeological approach to the recovery of classical antiquity, he pursued its human dimensions in the conflicting uses of antique imagery. He gave Donatello the credit for rediscovering 'the gestural language and formulae used by the ancients for the expression of tragic pathos [*Pathosformel*]'.

But acknowledging the variety of practices amongst the fine and applied arts, Warburg identified the problem of its incorporation into monumental realistic painting. He recognized the strange figures disrupting Ghirlandaio's 'tranquil and noble world', unseemingly agitated by their expressions and apparel, as recoveries from classical sarcophagi and triumphal sculpture. Ghirlandaio's sketchbook contained a drawing of the Triumphal Arch of Constantine buried deep in earth, with the attic storey easily visible. Its depictions of battle and victory were used through the Middle Ages and resurfaced in the

Renaissance, the difference lying in the 'illustrative realism' of the former and the 'idealising classical style' of the latter. While Antonio Gaddi lacked the capacity to subordinate the detail to the whole, Piero della Francesca's *Dream of Constantine* functioned at an entirely different level. Although he was capable of depicting violent scenes, the *Dream* played to a different key:

> the 'monarco dei pintori,' no longer treated the dream of Constantine as one episode amongst many, in contrast to Gaddi. An entire wall is devoted to the mysterious power that sent the vision of the victorious cross to the sleeping Constantine. Three guards protect their ruler whilst asleep. They are on guard, but remain untouched by the light of the angelic apparition, which displays only to the dreaming Emperor, sleeping heavily, the cross that will lead him to victory.
>
> (Woodfield, 2000, 12)

Piero had the advantage over his contemporaries of working in the spirit of Masaccio; lesser artists would descend to banal description. The problem that idealizing classicism faced was the taste of Florentine patrons for the 'pleasant and reassuring realism of the arazzi combined with the intimate descriptive art of Gozzoli'. Furniture painting was littered with scenes from classical mythology portrayed *alla franzese*: 'Gozzoli painted such a congratulatory dish (or lid) with a classical theme, and he could undoubtedly be sure of the praise of his client when he painted the rape of Helen as if it was a racy affair drawn from the account of a contemporary scandal.' Paris carrying off Helen on his back 'looks more like an ecstatic postman than a passionate seducer'. And Helen is perched on his back 'as if in a box in the theatre' (Woodfield, 2000, 16). For the contemporary spectator this was quite in keeping with dramatic presentations of the same subject. Antonio Pollaiuolo's *Deeds of Hercules* adopted a rather different manner: '*if* his task is to depict a rape on a wedding chest, he chooses a wild centaur, not the elegant Paris, as the seducer, and the naked furious Heracles opposes this elemental symbol of animal violation, as the counterpart to untrammelled passion' (Woodfield, 18).

Secular art was one thing and Christian art yet another. A major change in attitude had to occur for the Church to allow the *decorum* of self-restraint and control to be ruptured by the classical pathos of gestures of mourning. They did intrude, however, *en grisaille* in Ghirlandaio's decoration of Francesco Sassetti's burial place and in his fresco of the Slaughter of the Innocents, pathos imagery surfaces in full

force and lapses into 'baroque gestural language'. Warburg noted Vasari's admiration for this work and his focus on a 'horrible motif: an infant that, while bleeding from a neck wound, is still drinking milk and blood from the breast of its fleeing mother' (Woodfield, 2000, 23). To a reader of Burckhardt's *Civilisation of the Renaissance in Italy* (1860), this taste for horror should come as no great surprise. On a lighter note, Warburg was fascinated by the Victoria who made her entry into Ghirlandaio's paintings 'in the guise of a Florentine housewife'; she would surface again in his final project on *Mnemosyne* in a screen dominated by *The Birth of the Virgin* as the 'fairytale of Miss Hurrybring'. A long footnote evidences Savonarola's distaste for the Florentine way of doing things: 'When the women of Florence marry off their young women they parade them and dress them up to appear like nymphs, and first take them to Santa Liberata. These are your idols, and you have introduced their kind into your world' (Woodfield, 2000, 29). If the influence of antiquity were simply to be found in 'the lawfulness of the ideal human type', it would have no role to play in the distinctive shaping of the *quattrocento*, which was concerned, rather, with the enjoyment of 'the primitive and completely self-reliant individual of modernity, for whom nothing could be more distant than to repeat the ossified formal language of past ages' (Woodfield, 2000, 27).

The transformation of the *quattrocento* into the High Renaissance was to come about through a battle for enlightenment that stripped the humanist heritage of Greece of 'all its accretions of traditional "practice", whether medieval, Oriental, or Latin' (1932, 586). Warburg pursued this trail through the study of the astrological imagery of the Palazzo Schifanoia and the humanist triumph over the superstitious mind. This is an area which is probably much better known, and has had a greater influence, than his studies of the interaction of artistic styles in the Florentine *quattrocento*. But it is the latter concern that deserves deeper investigation. Warburg saw the competing artistic tendencies through the lens of the controversies of his own day, and that gave his language its vitality, a vitality that was missed by the proponents of the 'Warburg method'.

Amongst contemporary theorists, the Warburgian work with the greatest currency is his posthumous (1995) *Images from the Pueblo Indians of North America*, based on a lecture he gave to an invited audience at the Kreuzlingen Sanatorium, a year before his release. In its original 1939 translation it was called 'A Lecture on Serpent Ritual', which was precisely what it was. Warburg felt that his own psychological condition gave him a special insight into the 'primitive' mind. Whatever its merits as an analysis of serpent ritual, it may be

criticised now for its understanding of the Pueblo Indians and the role of ritual in their cultural practices: they were neither primitive nor schizophrenic. Nevertheless it was consistent with his view of history as a 'psycho-drama' of the forces of reason and unreason, leading to the dangers of 'lack of distance' in modern culture.

Biography

Aby Moritz Warburg Born Hamburg, 13 June 1866, eldest son of a banker. He studied at the University of Bonn, the German Archaeological Institute in Rome, and the University of Strasbourg. In 1892 he studied psychology in Berlin preparatory to taking up medicine as a career. He visited America in 1895–6, and moved to Florence in 1897, establishing a career as an independent scholar. Warburg returned to Hamburg in 1909, where he continued to expand his library; in 1913 he was joined by Fritz Saxl, who in 1921 turned the library into a research institute (the library was transferred to London in 1933, forming the basis of the Warburg Institute Library). After mental breakdown, he was confined in a sanatorium from 1918 to 1924. Warburg died in Hamburg on 26 October 1929.

Bibliography

Main texts

The Renewal of Pagan Antiquity (A. Warburg, *Gesammelte Schriften*, hrsg. von der Bibliothek Warburg, Bd. I und II: Die Erneuerung der heidnischen Antike. Kulturwissenschaftliche Beiträge zur Geschichte der europäischen Renaissance. Mit einem Anhang unveröffentlichter Zusätze. Unter Mitarbeit von Fritz Rougemont, hrsg. von Gertrud Bing, Leipzig-Berlin, 1932); trans. David Britt, Introduction by Kurt W. Forster, Los Angeles: The Getty Research Institute Publications Program, 1999.

Images from the Region of the Pueblo Indians of North America, trans. Michael P. Steinberg, Ithaca and London: Cornell University Press, 1995.

Secondary literature

Barta-Fliedl, I., Geissmar-Brandi, C. and Sato, N., *Rhetorik der Leidenschaft: Zur Bildsprache der Kunst im Abendland*, Hamburg and Munich: Dölling and Galitz Verlag, 1999 (images from the Mnemosyne Project).

Bing, G., 'A.M. Warburg', *Journal of the Warburg and Courtauld Institutes*, XXVIII, (1965), 299–313.

Didi-Huberman, G., 'The Portrait, the Individual and the Singular: Remarks on the Legacy of Aby Warburg', in N. Mann and L. Syson, *The Image of the Individual: Portraits in the Renaissance*, London: The British Museum, 1998.

Gombrich, E.H., *Aby Warburg: An Intellectual Biography*, Oxford: Phaidon, 1986.

——, 'Aby Warburg: His Aims and Methods, an Anniversary Lecture', *Journal of the Warburg and Courtauld Institutes*, LXII, (1999), 268–82.

Guidi, B.C. and Mann, N., *Photographs at the Frontier: Aby Warburg in America 1895–1896*, London: Merrill Holberton and The Warburg Institute, 1998.

Woodfield, R. (ed.), *Art History as Cultural History: Warburg's Projects*, Amsterdam: G+B Arts, 2000 (includes a translation of Warburg's 'The Entry of the Idealising Classical Style in the Painting of the Early Renaissance' ('Der Eintritt des antikisierenden Idealstiles in die Malerie der Frührenaissance', 1914) by Matthew Rampley).

RICHARD WOODFIELD

LUDWIG WITTGENSTEIN (1889–1951)

AUSTRIAN-BORN PHILOSOPHER

Wittgenstein is one of the most important philosophers of the twentieth century; the bulk of his work and influence concerns logic, language and the nature of philosophy. His two seminal texts, *Tractatus Logico-Philosophicus* and *Philosophical Investigations*, have little to say directly on aesthetics or art. However, art, and music especially, was of immense significance in Wittgenstein's life. This is reflected in the numerous allusions and analogies to art that occur in his general philosophical writing. Thus, for example, in one of his notebooks, he declares that he finds a 'queer resemblance between a philosophical investigation and an aesthetic one.' In addition to notebooks, other sources of Wittgenstein's views on art are found in student notes of lectures he gave in Cambridge in the 1930s and in records of conversations with friends. Despite the paucity of writing directly about art, Wittgenstein's more general philosophical views of language and meaning have been influential in the development of philosophical aesthetics and literary theory at the end of the twentieth century.

First published in German in 1921 and in English translation in 1922, the *Tractatus Logico-Philosophicus*, the only philosophical book Wittgenstein published in his lifetime, is the fruit of Wittgenstein's work on logic with Bertrand Russell at Cambridge before World War One. The sentences of the *Tractatus*, numbered to reflect their relative importance, are striking for their condensed, oracular and obscure beauty, and have stimulated artists as well as philosophers – they were set to music by Elizabeth Lutyens and inspired a series of works by the British sculptor Eduardo Paolozzi. The *Tractatus* presents a conception of philosophy which Wittgenstein held throughout his life, that philosophy is not, as

traditionally understood, the discovery or statement of special truths about life and the world, but rather an activity of critical reflection aiming at the clarification of thought and the elimination of nonsense. Wittgenstein maintains that most philosophical problems, arising from misunderstanding the logic of language, result in the attempt to say what cannot be said. But Wittgenstein's attempt in the *Tractatus* to clarify the limits of language itself transgresses those limits. He thus famously concludes that 'anyone who understands me eventually recognizes [my propositions] as nonsensical ... (He must, so to speak, throw away the ladder after he has climbed up it.)'

The *Tractatus* employs an analogy with pictures to clarify the relation of language to the world. A proposition is a picture of reality in that it presents a possible state of affairs: to understand the proposition is to know how things are in the world if it is true – the proposition is true if the presented state of affairs exists, otherwise it is false. What propositions cannot picture is logical form, that which they have in common with reality and which makes it possible for them to picture states of affairs. Logical form is displayed or expressed, not represented, by propositions: it is shown rather than said. Ethics, aesthetics and the mystical are also shown, not said, for they are concerned not with presenting the facts but with one's relationship or attitudes to the facts of the world. How one values things is shown in one's actions; the significance of ordinary things is expressed through works of art. The attempt to say what can only be shown results in nonsense or, in the case of aesthetics, bad art. Wittgenstein criticised Tolstoy's novel *Resurrection* because of the way Tolstoy 'addresses the reader. When he turns his back to the reader [as in the short stories] then he seems to me *most* impressive.' Commenting on a poem by the German Romantic poet Ludwig Uhland, Wittgenstein wrote, ' ... if only you do not try to utter what is unutterable then *nothing* gets lost. But the unutterable will be – unutterably – *contained* in what has been uttered!'

The *Tractatus* greatly influenced the philosophers of the Vienna Circle (1925–35) who, nevertheless, misunderstood the spirit in which it was written. They took Wittgenstein's view that 'what is higher' cannot be put into words as an affirmation of scientific positivism. But rather than debunking the inexpressible, Wittgenstein was underlining its importance: as he put it, 'the book's point is an ethical one'. In a manner reminiscent of Kant, who restricted knowledge in order to make room for faith, he aimed to indicate the significance of what cannot be said by clearly presenting what can be said. Wittgenstein's antagonism to the science-dominated culture of the time became more explicit in notebooks he kept on his return to philosophy in

1929. He says of the book he was writing (*Culture and Value*) that '[it] has nothing to do with the progressive civilization of Europe and America', which typically aimed at constructing 'a more and more complicated structure', whereas he himself is 'not interested in erecting a building but in having the foundations of possible buildings transparently before me'. That is to say, for Wittgenstein philosophy is about achieving clarity in one's situation – 'clarity, transparency is an end in itself' – rather than about developing theories. 'So I am aiming at something different than are the scientists & my thoughts move differently than theirs.' In this respect, he compares work in philosophy to work in architecture, reflecting his experience as an architect when, inspired by the anti-decorative style of the modernist architect Adolf Loos, he took over the design and construction of a house in Vienna in 1926–8: '... really more work on oneself. On one's own conceptions. On how one sees things. (And what one expects of them.)' (*Culture and Value*). Thus, the solution of the problems of philosophy involves a change in one's way of seeing, the difficulty of achieving which, as in appreciating works of art, is 'not a difficulty for the intellect but one for the will that has to be overcome' (*Culture and Value*). For example (and one which illustrates the affinity of Wittgenstein and Loos), a philosopher's demand for definitions is sometimes 'for the sake not of their content, but of their form. [The] requirement is an architectural one; the definition a kind of ornamental coping that supports nothing' (*Philosophical Investigations*). It was Wittgenstein's realization that the form of his 'old way of thinking' in the *Tractatus* was itself a source of its 'grave mistakes' which brought him back into philosophy and motivated his struggle throughout the 1930s and 1940s to elaborate new methods for eliminating philosophical problems.

Philosophical Investigations, published two years after Wittgenstein's death, engages with the same fundamental issues in logic and language as did the *Tractatus*, though the discussions range more widely to include, for example, the philosophy of mind. It also shares the view that philosophical problems have their source in misunderstandings of the logical grammar of language. But the later work makes clear that distinguishing sense from nonsense is a task of immense complexity that requires close attention to the actual uses of words. Replacing the analogy between language and pictures with that of an analogy between language and games, Wittgenstein argues that, just as the significance of a piece in chess is given by the use of the piece in accordance with the rules and practices of the game, so the meaning of a word in language is given by the use of the word in accordance with

the rules and practices which make up the numerous language-games of which language is constituted. '. . . [T]he term "language-*game*" is meant to bring into prominence the fact that the *speaking* of language is part of an activity, or of a form of life' (*Philosophical Investigations*). Wittgenstein emphasizes the multiplicity of language-games, in other words 'the multiplicity of kinds of word and sentence' and of 'the ways they are used'. Philosophical problems and philosophical perplexity are traced to a desire for simplistic generalizations, failure to observe differences between language-games, refusal to 'look and see' how words are used in practice. 'What *we* do', writes Wittgenstein, 'is to bring words back from their metaphysical to their everyday use.' That is to say, philosophical problems are solved 'by looking into the workings of our language, and that in such a way as to make us recognise those workings *in despite of* an urge to misunderstand them.'

Wittgenstein's later approach to meaning and method has numerous implications for aesthetics and art (for example, conceptual art), many of which are explored in Wittgenstein's lectures. For example, his concern to get us to 'look and see' how words are used in practice makes it possible to counter the essentialism endemic in art theory. Just as Wittgenstein denied that games must have an essential property which justifies us in calling them games, so too, he argued, it is a mistake to think that there must be something common to all the things we call beautiful. Philosophers influenced by Wittgenstein have applied this anti-essentialist, 'family-resemblance' view of general terms to the allegedly fundamental quest for the essence of art, arguing that there is no essence of art but rather that works of art are related to one another by multifarious similarities and differences. This anti-essentialism has also been significant for literary theory and proponents of deconstructionism. Wittgenstein's emphasis on practice leads him to criticise philosophers such as Kant who concentrate on forms of judgement or kinds of sentence (for example, 'This is beautiful') at the expense of what is done with such forms of words. By contrast, Wittgenstein stated that his interest was not on the words 'good' or 'beautiful' (or the sentences in which they are used), 'but on the occasions on which they are said – on the enormously complicated situation in which the aesthetic expression has a place, in which the expression has almost a negligible place' (*Lectures*, 1938). Both the creation and the appreciation of particular works of art have to be understood in terms of the conventions, practices and traditions of the historical period in which they occur. Thus, even though the *words* 'This is a fine Coronation robe!' might have been used in the Middle Ages in the same way as they would be used today, our

appreciation of a coronation robe now would be very different from that of the coronation robe of Edward II. Hence Wittgenstein's remark that 'architecture is a *gesture*' (*Culture and Value*), that is, something whose significance will be intelligible to, and displayed in the reactions of, those who are at home in the culture of a period. Although Wittgenstein stresses the importance of 'aesthetic reactions, e.g. discontent, disgust, discomfort' (*Lectures and Conversations*), he argues that it is seriously mistaken to think of aesthetics as a branch of psychology with causal laws that can be established by experiment. For this would be to ignore the intentional character of such reactions which are directed towards aspects of particular works of art and which are identifiable only in terms of the appreciator's contextually situated gestures and remarks. 'There is a "Why?" to aesthetic discomfort not a "cause" to it. The expression of discomfort takes the form a criticism ...' (*Lectures and Conversations*). The practice of art criticism consists in giving reasons whose aim is to enable another person 'to see what you see', and may take the form of further descriptions of the work but may also involve drawing attention to features of the work by making comparisons with other works or finding appropriate analogies. It is in this sense that reasons in aesthetics are like reasons in philosophy, in that they aim to change one's way of seeing things. Familiarity with the rules and standards, and immersion in the practices, of a culture are what make possible not only the mastery of critical vocabulary but also the capacity to react appropriately to works of art. As Wittgenstein puts it in his celebrated discussion of seeing aspects in Part Two of the *Philosophical Investigations*, 'The substratum of this experience is the mastery of a technique ... It is only if someone *can do*, has learnt, is master of such-and-such, that it makes sense to say he has had *this* experience.' Thus, only someone who is familiar with ducks and rabbits can enjoy the experience of switching from seeing now the duck, now the rabbit aspect of the 'duck–rabbit drawing'; similarly, only someone who is familiar with Paganini's theme can hear a passage of music as Rachmaninov's variations on that theme and only someone familiar with conventional styles of portrait painting can appreciate the inventiveness of Picasso's stylistic innovations in his portraits of the 1920s and 1930s. Wittgenstein's late (post-1945) discussions of aspects illuminate the role of imagination in perception and further extend the investigation of the internal relationships between language, thought and experience which is the enduring theme of his philosophical career.

Biography

Ludwig Josef Johann Wittgenstein Born Vienna, 26 April 1889, eighth child of Karl, head of the Austrian steel industry, and Leopoldine Kalmus. He studied mechanical engineering at the Technische Hochschule, Berlin, 1906–8, and became a research student in aeronautics at Manchester University, 1908–11. He went on to study philosophy under Bertrand Russell at the University of Cambridge, 1912–14. Wittgenstein was a member of the Austro-Hungarian army during World War One, and was taken prisoner by the Italians in 1918. After the war he trained as a school teacher in Vienna, 1919–20, and occupied various posts as teacher in village schools in Lower Austria between 1920 and 1926. He designed and supervised the construction of a house for his sister in the Kundmangasse, Vienna, 1926–28. He returned to philosophy as Research Fellow at Trinity College, Cambridge, in 1929, and in 1939 he succeeded G.E. Moore as Professor of Philosophy. He resigned his chair in 1947. Wittgenstein died at Cambridge on 29 April 1951.

Bibliography

Main texts

Tractatus Logico-Philosophicus (*Logisch-Philosophische Abhandlung*, 1921), trans. C.K. Ogden, London: Routledge, 1921; and trans. D.F. Pears and B. McGuinness, London: Routledge, 1961.

Philosophical Investigations (*Philosophische Untersuchungen*), trans. E. Anscombe, Oxford: Blackwell, 1953.

Lectures and Conversations on Aesthetics, Psychology and Religious Belief, C. Barrett (ed.), Oxford: Blackwell, 1966.

Culture and Value (*Vermischte Bermerkungen*), trans. Peter Winch, Oxford: Blackwell, 1980; 2nd ed. 1998.

Collections:

Ludwig Wittgenstein: Philosophical Occasions 1912–1951, J. Klagge and A. Nordmann (eds), Indianapolis: Hackett, 1993.

Secondary literature

Brenner, W.H. *Wittgenstein's Philosophical Investigations*, New York: SUNY Press, 1999.

Hacker, P.M.S., *Wittgenstein's Place in Twentieth-Century Analytic Philosophy*, Oxford: Blackwell, 1996.

Janik, A. and Toulmin, S. *Wittgenstein's Vienna*, London: Weidenfeld and Nicolson, 1973.

Lewis, P. (ed.), *Wittgenstein, Aesthetics and Philosophy*, Aldershot, Ashgate, 2002.

McGuinness, B., *Wittgenstein: A Life. Young Ludwig (1889–1921)*, London: Duckworth, 1988.

Monk, R., *Ludwig Wittgenstein: The Duty of Genius*, London: Jonathan Cape, 1990.

Rhees, R. (ed.), *Recollections of Wittgenstein*, Oxford: Oxford University Press, 1984.

Sluga, H. and Stern, D. (eds), *The Cambridge Companion to Wittgenstein*, Cambridge: Cambridge University Press, 1996.

Tilghman, B.R., *Wittgenstein, Ethics and Aesthetics*, London: Macmillan, 1991.

Wijdeveld, P., *Ludwig Wittgenstein, Architect*, London: Thames and Hudson, 1994.

PETER B. LEWIS

HEINRICH WÖLFFLIN (1864–1945)

SWISS ART HISTORIAN

During his first semester of undergraduate study at the University of Basel, Heinrich Wölfflin wrote an impassioned letter to his father in which he described the intellectual path he intended for his future. Wölfflin envisioned a history of culture that combined philosophy and artistry and that utilized the empiricism of the natural sciences. In formulating such an ideal, Wölfflin rejected the narrow focus on *experientia* that he identified with 'biographers, genealogists, ... anecdote collectors, and chronicle writers ...' He explicitly censured 'specialists in art, literature and history [who] work around the smallest fraction of the greatness they have undertaken to determine.' As his goal, Wölfflin aspired to no less than the 'extraction from the profusion of facts the great laws of spiritual development in the human race'. To Wölfflin this goal seemed attainable because he believed that the model of the natural sciences had generated a 'new moment' in intellectual endeavours. Soon after completing his undergraduate studies, Wölfflin began a career in teaching and writing through which he would reshape the discipline of art history.

Wölfflin's enduring influence on art history can be identified in at least three major ways. First, Wölfflin demonstrated a disciplinary breadth that combined both traditional and innovative theories. Second, he applied a comparative method of visual analysis. Third, he insisted upon the primacy of vision.

Disciplinary breadth

Wölfflin was keenly aware of many concepts and ideas current in the nineteenth-century disciplines of academia. He utilized theories and

approaches from philosophy, psychology and philology. Furthermore, within the area of art history, Wölfflin was a generalist rather than a specialist. Although his publications focused primarily on the Renaissance and Baroque periods, with some references to earlier periods, Wölfflin was fully aware of and interested in the modern art movements of the late nineteenth and early twentieth centuries. He commented on Impressionism, considered writing on contemporary art works that he characterized as Impressionism's 'opposite', and enjoyed spending time in the studios of contemporary artists.

Never dogmatic in his advocacy of a single theory, Wölfflin was consistent in pursuing a philosophical foundation for his history of art. The influence of many different philosophy movements can be detected in his writings, including the objectivity of the positivists, the dualism of Hegel, and the aesthetics of neo-Kantianism.

During Wölfflin's early career, a prominent concept in the psychology of aesthetics was empathy theory. According to this theory, humans empathize with objects by associating them with their bodies. Wölfflin's doctoral dissertation, *Prolegomena zu einer Psychologie der Architektur* ('Prolegomena to a Psychology of Architecture', 1886), focused on empathy specific to architecture. Wölfflin argued that proportions in architecture were perceived by beholders in relation to proportions in their own physiques. One assertion in Wölfflin's dissertation is that façades of buildings correspond to faces. Examples cited by Wölfflin include the empathetic correspondences that he claimed viewers felt between windows and human eyes and between architectural cornices and eyebrows.

Wölfflin borrowed his methodology primarily from the field of philology. Eduard Wölfflin, Heinrich Wölfflin's father, was a philologist. Considered in the nineteenth century to be a linguistic science, philology involved the investigation of the laws of human speech, the origin and combination of words, the affinities of different languages, and the criticism and interpretation of ancient authors. It is likely that comparative methods used in philology were the basis of Wölfflin's comparative methodology for art.

A comparative method of visual analysis

According to Wölfflin, there are two fundamental modes by which artists perceive and record the world. The terms 'linear' and 'painterly' were coined by Wölfflin to characterize these modes of visual perception. In Wölfflin's scheme, the linear mode emphasizes limits and solidity, while the painterly mode subsumes volumes into a

continuous composition. The linear mode distinguishes individual elements of design, while the painterly mode subordinates details within a more general tonality. The linear mode conveys stability and permanence, while the painterly mode suggests movement, transience and incompleteness. The linear mode represents things as they are in an objective, quantifiable sense, while the painterly mode alludes to things as they appear subjectively to the viewer.

In order to emphasize the oppositional nature of the linear and painterly modes of vision, Wölfflin defined five pairs of visual qualities. These are:

- 'linear' versus 'painterly';
- 'plane' versus 'recession';
- 'closed form' versus 'open form';
- 'multiplicity' versus 'unity'; and
- 'absolute clarity' versus 'relative clarity'.

The first term in each pair suggests a formal aspect of the broader category of the linear mode of vision, while the second term describes an aspect of the painterly mode of vision.

Wölfflin used the terms 'linear' and 'painterly' to apply both to modes of vision and to more specific visual qualities. 'Linear' visual qualities include the use of clear, unbroken outlines and sharp edges to delineate figures or objects, while 'painterly' visual qualities include blurred contours and merging shapes. The term 'plane' denotes compositions in which figures are separated from their surrounding settings and in which foregrounds and backgrounds are demarcated, while 'recession' denotes the continuous suggestion of depth, often by use of devices including foreshortening and dramatic diminutions in perspective. 'Closed form' typifies compositions which are self-contained and which appear complete, often through their emphasis on verticals and horizontals, symmetry and centrality. In contrast, 'open form' typifies compositions which are seemingly unlimited and which may seem incomplete, often through their reliance on diagonals, asymmetry and cropping. 'Multiplicity' describes the inclusion of multiple points of interest and independent elements within a single composition, and the term 'unity' describes the absorption of particular elements within a single visual impression. 'Absolute clarity' refers to the explicit depiction of precise features. In contrast, 'relative clarity' refers to an elusive and incomplete evocation of elements.

Principles of art history

Wölfflin's most influential work was *Principles of Art History* (1915), in which he applied his comparative scheme of vision to European art of the High Renaissance and Baroque periods (sixteenth and seventeenth centuries).

Wölfflin characterized High Renaissance art as linear in approach and Baroque art as painterly. He contrasted the outlines and parallel planes he saw in High Renaissance painting to the patchy brushwork and foreshortened forms he identified with Baroque painting. He differentiated the stable, symmetrical sculptures of the High Renaissance from the projecting, asymmetrical masses of Baroque sculpture. And he juxtaposed the low relief of High Renaissance architecture with the deeply shadowed shapes of Baroque buildings. Wölfflin argued that both styles aimed at unity, but that, in High Renaissance art, unity was achieved by a harmony of independent parts, while, in Baroque art, unity was accomplished by the subordination of parts to a dominant element.

Although *Principles of Art History* focuses on the major art forms of two time periods, Wölfflin argued elsewhere that the modes of visual perception are visible in all aspects of a culture, including utilitarian objects and the decorative arts. For example, he stated that the Gothic style is just as easily seen in Gothic shoes as in Gothic cathedrals.

Albrecht Dürer

Wölfflin applied his concept of visual perception to nationalities and to generations. Claiming that the people within different cultures operate with different modes of seeing, Wölfflin distinguished between the German and Italian senses of form. Wölfflin proposed that Germans are inherently painterly in their modes of perception and means of representation, and that Italians are inherently linear.

In his first edition of *Principles of Art History*, Wölfflin suggested developing art history 'without names'. Because he thought that the culture and the age determine the mode of vision through which an artist evolves an individual style, Wölfflin used artists' names principally to identify works of art, not to discuss the personalities, characters or lives of the artists themselves. In later editions of his book, Wölfflin retracted his proposal of an anonymous art history. While convinced that artists are constrained by predetermined modes of vision and that 'not everything is possible at all times ...'. Wölfflin

did acknowledge the importance of individual artists. In fact, Wölfflin argued that artists of genius define each period.

In 1905, Wölfflin had published his monograph *The Art of Albrecht Dürer*. Dürer, according to Wölfflin, was extraordinary because he became perceptually bi-cultural. Wölfflin argued that, at various points in his career, Dürer had created works of art that embody the German painterly mode and, at other points, had created works that embody the Italian linear mode. Dürer's late work was understood by Wölfflin as evidence that the artist had transcended both the Italian and German styles and had thereby formulated a unique synthesis.

The primacy of vision

In all his writings, Wölfflin concentrated upon what he considered to be the primary data of a work of art; that is, the visual structure. Wölfflin emphasized visual patterns in the work of art, rather than biographical accounts of artists and patrons or than investigations of symbols and subjects of art. Basing his concepts upon his lucid observations of paintings, sculpture and architecture, Wölfflin taught his students and readers a formal vocabulary of visual description that continues to be used today.

Despite the efficacy of his formal vocabulary, Wölfflin was ambivalent about being labelled a formalist. His belief that art history is a science led him to broaden the scope of his work beyond visual description. His search for the sources of the modes of visions and patterns of style led him to theorize that visual patterns arise from a 'national psychology of vision'.

Wölfflin sometimes resorted to the term *Zeitgeist* to invoke the elusive spirit of a national people and an age. He related modes of beholding to types of human psychology. He polarized the former into linear and painterly modes and the latter into Northern and Southern, German and Italian consciousness of form.

Conceived over a long period of time but written in the first months of World War One, *Principles of Art History* could easily have become a polemic reflecting the political exigencies of the day. At a time and in a country in which art and culture were increasingly appropriated into a nationalistic agenda, Wölfflin penned his strongest declaration of the autonomy of visual culture. This culture, according to Wölfflin, possesses its own integrity, its own forces, its own dynamics of beholding and of representing, of changing and of transforming. Wölfflin concluded *Principles of Art History* with a humanistic profession that 'However different national characters may be, the general human element which binds is stronger than all that separates.'

Martin Warnke (1989) has argued that a shift can be identified in Wölfflin's writing at the beginning of World War One – that, prior to the war, Wölfflin frequently referred to non-artistic influences in art, but that in the *Principles of Art History* he minimized discussion of all areas outside visual forms and aesthetics. Warnke attributes this shift to a deliberate refusal, though never explicitly articulated by Wölfflin, to subsume art history to the nationalistic agenda of the German state.

Legacy

Wölfflin's career spanned many decades, and his writings evinced many changes in ideas. None the less, the commitment to systematic inquiry that he espoused as an assertive undergraduate student remained consistent. The central thesis of Wölfflin's work – that the primary essence of a work of art consists of what is given visually – is fundamental to many contemporary analyses of works of art from all cultures and historical periods. The descriptive vocabulary employed in Wölfflin's work, including terms such as linear, painterly, plane, recession, open and closed form, is integral to contemporary discussions of art. The inductive process of Wölfflin's thought remains useful to the contemporary recognition of visual style. Through Wölfflin, viewers have been offered access not only to the artistic heritage of the Renaissance and Baroque periods in Europe but also to the richness of visual cultures throughout the world.

Biography

Heinrich Wölfflin Born Winterthur, Switzerland, 24 June 1864, the son of Eduard Wölfflin, Professor of Philology at the universities of Zürich, Erlangen, and Munich. He studied philosophy at the universities of Basel, Berlin and Munich from 1882 to 1886, and graduated from the University of Munich in 1886. He became Professor of Art History at the universities of Basel, 1893–1901; Berlin, 1901–12; Munich, 1912–24; and Zürich, 1924–34. He published *Renaissance and Baroque* in 1888, and *Principles of Art History* in 1915. Wölfflin died at Zürich on 19 July 1945.

Bibliography

Main texts

Prolegomena zu einer Psychologie der Architektur, 1886. Doctoral dissertation, University of Munich. Included in *Kleine Schriften*, Basel: 1946.

Renaissance and Baroque (*Renaissance und Barock*, 1888), trans. Kathrin Simon, Ithaca: Cornell University Press, 1964.

Classic Art; An Introduction to the Italian Renaissance (*Die klassische Kunst*, 1899), trans. Peter and Linda Murray, New York: Phaidon, 1952.

The Art of Albrecht Dürer (*Die Kunst Albrecht Dürers*, 1905), trans. Alastair and Heide Grieve, New York: Phaidon, 1971.

Principles of Art History: The Problem of the Development of Style in Later Art (*Kunstgeschichtliche Grundbegriffe: das Problem der Stilentwicklung in der neueren Kunst*, 1915), trans. M.D. Hottinger, New York: Dover, 1932.

The Sense of Form in Art: A Comparative Psychological Study (*Die Kunst der Renaissance; Italien und das deutsche Formgefühl*, 1931), trans. Alice Muehsam and Norma A. Shatan, New York: Chelsea, 1958.

Secondary literature

Hart, J.G., *Heinrich Wölfflin: An Intellectual Biography*, Dissertation, University of California, Berkeley, 1981.

——, 'Reinterpreting Wölfflin: Neo-Kantianism and Hermeneutics', *Art Journal* (1982), 292–300.

Hauser, A., *The Philosophy of Art History*, Cleveland: World Publishing, 1963.

Holly, M.A., 'Wölfflin and the Imagining of the Baroque', in Norman Bryson, Michael Ann Holly and Keith Moxey (eds) *Visual Culture: Images and Interpretations*, Hanover: Wesleyan University Press, 1994.

Minor, V.H., 'Heinrich Wölfflin (1864–1945)', *Art History's History*, Upper Saddle River: Prentice Hall, 2001.

Podro, M., *The Critical Historians of Art*, New Haven: Yale University Press, 1982.

Schwartz, F.J., 'Cathedrals and Shoes: Concepts of Style in Wölfflin and Adorno', *New German Critique* 76 (1999), 3–48.

Warnke, M, 'On Heinrich Wölfflin', *Representations* 0, 27 (1989), 172–87.

<div align="right">LINNEA WREN AND TRAVIS NYGARD</div>

RICHARD WOLLHEIM (1923–)

BRITISH PHILOSOPHER

Wollheim's writings in aesthetics include important general ideas, but his focus on the philosophy of art – more specifically on painting – is the finest achievement of this remarkable philosopher. No twentieth-century writer is so systematic across different domains of philosophy than Wollheim. That one of his collections of essays is called *Art and the Mind* (1973) is a clear indication of this. His suggestions about the ontological liaisons between a work of art and its matter are strikingly parallel to other philosophical ponderings and positions that concern the liaisons of the mind to the body. His ideas about the meaning and understanding of art are marked by his adherence to an essentially

Freudian conception of the unconscious. This adherence enables him to sustain theses about the making, experiencing and criticising of art that are widely believed to fail.

The idea that is most Wollheim's own about art concerns 'seeing-in' and its differences from 'seeing-as'. Wollheim developed his thinking here from his disagreement with Ernst **Gombrich**'s popular idea that when we see what we see in paintings, the experience is a species of illusion. It is likely this is so only with *trompe l'oeil* paintings, where we can undergo the experience of seeing a painting at the right distance and in the right light and think, just for a moment, that it might really be a bouquet of flowers.

For Wollheim, such a moment of illusion is a failure of what he calls the 'two-foldness' of seeing-in. When you see, say, an apple in a Cézanne still-life, you are simultaneously aware of the paint and the art of the painter. This simultaneity, so vital to experiencing the artist's work, is just not there when, say, you notice the two aspects of something like Jastrow's 'duck–rabbit drawing'. This noticing is done successively and you can deliberately switch back and forth. When you see the duck in the figure and are aware of the outlined portion of the blackboard, that is seeing-in and it is twofold. Thus the two 'folds' are not two aspects, in just the way that the duck and the rabbit are. And while it may dawn on you that some area of paint is a representation of a duck, it does not dawn on you that it is paint (except perhaps in the case where the *trompe l'oeil* stops fooling you).

Wollheim is trying here – and I think he succeeds – to elucidate the fact that when we experience representation in painting, it is much more like seeing that a man is in agony or that an arrow has wounded him, than it is like having an aspect dawn on you, especially an aspect that you can turn on and off at will. It is accommodating this involuntariness, I believe, that leads Wollheim to urge us to accept that seeing-in ought to be regarded as a mode of perception, as a way of experiencing something which, while it is not 'face-to-face' (as he puts it) it is as informative and revealing about what something is like as is the experience of face-to-face perception.

Whether it is representation or expression – that other main thing that goes on in art – it seems appropriate to speak of seeing-in. Perhaps more so with expression. And if Wollheim is right that seeing-in is experientially more akin to seeing, period, than is seeing-as, one might observe this: when we see, say, sombreness in a painting (and not just in someone's sombre face in the painting), it will be more convincing to say we have seen sombreness, period, than it will be

convincing to say, upon seeing a beheading in a painting, that we have seen a beheading, period.

Marking surfaces so as to bring about understandings that are grasps of meanings – that is what an artist may be said to be doing. But it is vital to Wollheim's theory that the artist is his own spectator. Artist and spectator are best understood as roles, though Wollheim is nowhere near those who seem to think that taking on the role requires suicide. The artist at work is engaged in continual interplay between making and responding. The artist continually accepts or rejects, revises and amends the markings he lays down, all the time striving to fulfil an intention, though this has to be understood in such a way that the artist may himself only realize adequately what his intention is when it is fulfilled before his 'spectating self'.

This conception of artistic and creative work goes with the classical idea of criticism as 'retrieval': critics are in the business of discovering what the artist was up to. Because that is their task, they are free to form hypotheses about it from anywhere, though the work before them will be a rich source of hypotheses. However – and this is where Wollheim makes a kind of concession to theorists who insist that the work itself is the only proper place to be snooping about for hypotheses – the confirmation or verification of hypotheses *must* be found in the work itself. For it is not just the intention of the artist as a something formed in his mind some time back and contributing causally to the effect on the canvas that counts, it is the intention as 'fulfilled intention' that is vital to the meaning of the work. To see that 'fulfilled intention' there before you is the key thing about understanding a work of art. Of course, this means you can also, with astuteness, see there that some intention has failed in its execution, you can see that an artist hasn't pulled off what he was up to. And critics are extremely useful when they get it right about such matters.

Retrieval, understood by Wollheim, is the retrieval of the relevant mental history of the artist; that is, finding out about whatever beliefs, desires, emotions, etc. went into forming whatever intentions are found fulfilled or failed in the finished work.

It clarifies this complex idea to focus on the expression of emotion in art, and on the spectator's recognition and response to that. For Wollheim, what distinguishes art from nature is that whatever emotion we find to be so powerfully there in the work of art, it may be the wrong one and may reveal more about oneself than about the work. There is an appropriate or a right response, and it is the one intended by the artist. If it is nature rather than art to which we

respond – to sunsets and forests (glorious, foreboding) – then there is no such thing as getting it wrong (though we may be bizarre in our reactions and they too may show a lot about us). But when it is art, it is *meant* some way or other and understanding it is grasping that meaning. This may take a lot of looking (or listening), and we may not be able to see X there without suggestions from elsewhere. The activity is fallible because it is subject to all the vicissitudes of pretending to see rightly or wrongly, due to fashion or snobbery, etc. That does not make it illegitimate – just subtle and delicate in many cases. Doing it well makes the difference between having taste and lacking it, more or less.

Wollheim's defence of this view that emotion lies behind art and is evoked by it, and that works succeed in expressing it and even communicating it, requires him to answer the standard objections. Artists surely seek to express sorrow in works and spectators find sadness – without it being so that the artists were actually sad during the making of the works, or that spectators are saddened by experiencing them. It is here that **Freud** comes to Wollheim's rescue, though some may think this is a desperate expedient.

Freud makes us aware that we are often limited in our conscious awareness of our own emotions, desires and beliefs. So the objection is weakened. Wollheim thinks it is also weakened by the fact that when I do find sadness in a work (or a scene in nature) without being actually saddened, I may still believe that I would have been saddened but for interfering reasons. The idea requires the psychoanalytically vital phenomenon of the splitting of consciousness. But it is at least as plausible as that is. It is similar on the production. This suggestion is effective at saving the (deeply intuitive) idea that artists are striving to express something that is really in them and deeper in them than just the desire to show that X or Y can be caught in paint or sound or words in this way or that. Unless X and Y mean a lot to you, why bother to try to get them on the canvas or into the music?

The thesis, in its old-fashionedness one of the most radical we find in Wollheim, is supported if you have a helpful theory of emotion. And in his most recent work, Wollheim has given himself (and us) just that. Emotions may indeed be said to be the prime occupants of the unconscious realms of our minds. If this is so, they can be allowed to do the work they so naturally seem to want to do in understanding our understanding of art.

This account has concentrated on what are judged to be the most important ideas about making and experiencing and criticising of works of art to be found in Wollheim. It has been necessary to pass

over the many excellent contributions Wollheim has made to the more metaphysical issues surrounding art, as well as the socio-cultural one. On the latter, Wollheim is severely critical of the institutional theory of art while himself accepting that art is well understood as what **Wittgenstein** called a 'form of life'. At least that requires that a form of life is not an institution, but something more basic, even primitive. And why not? Wollheim regards the cave paintings in France and Spain as the first markings of surfaces that were intended in ways that go beyond (or fall short of?) any ritual or superstitious uses they may have had. And we don't know whether they had such, or mainly had such, non-artistic purposes anyway. It is perhaps snobbery on our part not to allow that our earliest forebears included some artists.

This element in the institutional theory (that of Arthur **Danto**, for example) involves the conundrums about utterly similar things being produced as works of art, or as utilitarian artefacts with no artistic intent whatsoever lurking behind them (such as Marcel Duchamp's 'readymades'). Wollheim's reaction to this is, I believe, exemplary. He thinks it enough to emphasize that it is a contingent fact about human life on earth that this kind of replication just doesn't go on. If there are such things as works of art as opposed to other categories of things, and if such a form of life as that of art depends on this contingency, so be it. That is the way to respond to troublesome philosophers who urge thought-experiments which seem to require us to say that there need be no perceptual difference to be found between a work of art and something that is not one.

A great deal can be said about much that is involved in perception (generally) that removes the sting of this point. But it is enough just to acknowledge that it is contingent that there is art; it is contingent that human beings, all over the earth, who do not go in for making things in certain ways, try to do it so well, unless they want more out of what they do than a practically useful item.

Biography

Richard Wollheim Born London 1923. His studies at Oxford were interrupted by service in World War Two between 1942 and 1945. From 1949 to 1982 he taught philosophy at University College, London (from 1963 as Grote Professor of Mind and Logic). Since leaving London, he has taught at Columbia University and at the Berkeley and Davis branches of the University of California. He is currently Chair of Philosophy at Berkeley.

Bibliography

Main texts

Art and its Objects, 1968; 2nd edn, with six supplementary essays, Cambridge and New York: Cambridge University Press, 1980.

Freud, London: Fontana, 1971.

On Art and the Mind: Essays and Lectures, London: Allen Lane, 1973.

Panting As an Art: The A.W. Mellon Lectures in Fine Arts, London: Thames and Hudson, 1987 (delivered at the National Gallery of Art, Washington DC, 1984).

The Thread of Life, Cambridge, Mass.: Harvard University Press, 1984 (The William James Lectures at Harvard, 1982).

The Mind and its Depths: A collection of essays, Cambridge, Mass.: Harvard University Press, 1993.

On the Emotions, New Haven: Yale University Press, 1999 (The Ernst Cassirer Lectures, 1991).

Richard Wollheim on the art of painting: art as representation and expression, Rob van Gerwen (ed.), Cambridge: Cambridge University Press, 2001.

Secondary literature

Hopkins, J., and Savile, A. (eds), *Psychoanalysis, mind, and art: perspectives on Richard Wollheim*, Oxford: Blackwell, 1992.

LLOYD REINHARDT

WILHELM WORRINGER (1881–1965)

GERMAN ART HISTORIAN AND THEORIST

The immediate and lasting success of Wilhelm Worringer's first book, *Abstraktion und Einfühlung: Ein Beitrag zur Stilpsychologie* (1908), reflects its author's fine sense of a new form of controversy that had been overtaking the arts. By the year of its publication, the implacable division between a generalized sense of avant-gardism on one side and an apparently naturalized canon of taste on the other, had emerged in full power. The first translation into English appeared in 1953, under the title *Abstraction and Empathy: A Contribution to the Psychology of Style*. The translator faithfully rendered both the exuberant polemical spirit and the broad applicability of Worringer's language to supply readers in the English-speaking world with a text that has likewise retained its incisiveness. That penetrating quality has little to do with the solidity of an argument within the scholarly discipline of art history, though the text was written as a doctoral dissertation in that field, but rather lies in the strategy of its critique. Using the position of

an art historian to attack what he describes as the established preconceptions in the separate discipline of aesthetics, Worringer develops a rhetoric of opposing tendencies derived from a sphere of artistic production enlarged far beyond the classical aesthetic canon. From this broad sphere of material, he derives a general psychology of artistic response from two fundamental motivations of the human spirit.

He invokes Kant as a model in asserting that all artistic necessity should be founded on *a prioris* located in the contemplating consciousness, though of course the tradition of aesthetics, and the classical standard associated with it that he rejects, still looked to Kant for its own philosophical basis. It is important to emphasize that what he introduced in *Abstraction and Empathy* did not depend on any positive declaration about the direction that should be taken by contemporary artists. It contained no programmatic statement about future developments in the manner of, say, Marinetti's *Futurist Manifesto* from the following year. His innovation lay in the expansive quality of the polemic as such. He directs his critique at the narrow sovereignty of the Western imagination. Though he attacks the idea of a unified aesthetics, he has no interest in substituting an alternative singular ideal such as one might find in some expressions of romantic theory, or indeed, Futurism.

Drawing on the knowledge and critical analysis developed by art historians during the last decades of the nineteenth century, he finds himself well placed to make the multiplicity of artistic styles across the regions of the world into a more appropriate basis of 'objectivity'. The classical ideal of Antiquity, the Renaissance, or of modernity as constituted in the aftermath of the Renaissance, present a valid direction in art, he readily concedes, but only one. Its form of expression now offers an inadequate, narrow and subjective basis for our artistic experience of twentieth-century humanity with its suddenly expanded horizons of knowledge. Accordingly, he presents an alternative framework elaborated between the two active poles of 'abstraction' and 'empathy', towards which all artistic sensibilities tend, and between which all artistic developments move. He also asserts a typology of three distinct metaphysical situations within which he defines all national traditions of artistic style: 'primitive man', 'classical man', and 'the Oriental'. Each of these arises with a particular condition of knowledge, and hence the confidence or insecurity that characterizes the relationship between the human sphere and the natural world that encompasses it.

The primordial condition of mankind entails a clear instinct for the

inadequacy of human knowledge, and the primitive man is therefore prey to 'an immense spiritual dread of space' (*eine ungeheure geistige Raumscheu*). Artistic ability does not fall short in any stage of development, including this primitive phase, but human desires will differ. Here, Worringer adopts the idea of an 'artistic volition' (*Kunstwollen*) from the enormously influential art historian Alois Riegl. Primitive man creates his art in order to find release from that dread of his world. Because he can bring only the most rudimentary forms of knowledge to them, the phenomena of nature appear to him to lack all stability or regularity. He desires art objects that compensate for that lack. Accordingly, he develops a language of geometric or crystalline motifs whose rigid, expressionless form 'abstracts' the contemplating sensibility from the turmoil and torment of uncontrollable changes apparent in nature.

The classical mode of art comes about under circumstances where perceptual knowledge of nature overcomes the dualism between man and his world, and replaces 'primitive dread' with a joyful sense of harmony between the human and the non-human, or, as Worringer puts it, with a total anthropomorphization of the cosmos. The reconciliation between man and nature brought about by this metaphysics produces the organic suppleness and harmonious form of Greek antiquity. The abstraction of artistic contemplation gives way to what he calls 'empathy' (*Einfühlung*), a term he adopts from the German psychologist Theodor Lipps. In empathy, the contemplator of an art object seeks the forms of living matter, and finds a beauty there that Lipps calls 'objectified self-enjoyment'. This experience corresponds to beauty as defined by the terms of aesthetics. Worringer insists that other traditions do not present this beauty because it does not correspond to their artistic volition, and it does not correspond to that volition because they do not inhabit a cosmos where everything reflects the same anthropomorphized order of knowledge.

The Oriental cultural situation does not take its place 'before' the advent of classical orders of knowledge, but stands 'beyond' that knowledge in an immeasurably deeper sense of the impenetrable universe. This more complex version of transcendent metaphysics also gives rise to an art of abstraction. Its motifs also represent rigid, pure, clear shapes, uninflected by the living expression of organic form. To the 'magnitude of the sensibility' that creates such work, the notion of beauty animating classical art would have to appear 'quite petty and insignificant'.

If there remained any doubt in the discussion of *Abstraction and Empathy* that Worringer regards primitive art as also capable of

achieving this magnitude, he returned to this issue in 1911 with his book *Form in Gothic*, where he observes that, with the transition from primitive to classical modes of knowledge, artistic life 'becomes more beautiful, more joyful, but it loses in depth, in grandeur, and in force'.

It is obvious at once that his reduction of the world's artistic traditions into these three types weakens all authority in the art-historical basis of his argument. While 'primitive art' may still survive as the loose term used to describe the production of non-literate societies, we have to baulk at his use of the term 'Oriental'. His main reference here is to Egypt, but he ascribes the same criteria to the various civilizations of Asia as well. His distinction between them and the heritage of Greek classicism clearly suggests that he has simply imagined that entire non-European world as a foil by which to define the European modernity he wishes to critique precisely for its ethnocentrism. It is this, and many allied rhetorical turns, that allow us to identify the principal force at work in his text as the critical imagination rather than systematic analysis, historical discrimination or philosophical construction. Indeed, we can now see how much the daring qualities that have kept his thesis so vital and provocative from his own time to the present have also limited his ability to establish a school of followers in the discipline of art history, or even to sustain this initial burst of innovative ideas through his own academic career. Following a strategy that has become much more familiar in polemics from later years of the twentieth century, *Abstraction and Empathy* erected a structure of critical opposition to an established orthodoxy through its primary terminology, and then boldly set about dismantling accepted appearances through the perspective imposed by this device. The kinship in method between his approach and those corresponding enterprises in more recent years can be illustrated in Gilles Deleuze and Félix Guattari's *A Thousand Plateaus: Capitalism and Schizophrenia* (1980), in which the authors take over Worringer's concept of an inorganic crystalline language of artistic form as they reject the inheritance of humanist order.

The difficulty that kept Worringer from building further on his brilliant first foray into modernist art theory stands clearly on show in 1911, with the discussion of Gothic form. His intention to vindicate the value of a quintessentially Germanic style leads him to complicate his own conception of what is meant by 'abstraction'. The abstract elements of Gothic art remain opposed to the 'expressive' or 'sensual' quality of Mediterranean classicism, but also find their own mode of expressiveness none the less in response to the restless energies of a Germanic artistic volition. This produces an uncanny hybrid – not a

synthesis – that he calls 'super-organic'. His conception grows in complexity until he arrives at the hypothesis of a Gothic relationship to nature of 'sensuous–super-sensuousness', whose objective basis then begins to unravel.

He served at the front during World War One, but when he resumed writing, his publications during the Weimar period reflected a more conservative cultural politics. The national, and sometimes even racial, turn that had freed his sensibility from subservience to the classical model in earlier thinking, now introduced a damaging narrowness into his viewpoint. The book he brought out in 1927, *Egyptian Art*, engages its topic to present something of a German, or at least a European, chauvinistic position on American modernity.

His relations with the expressionist movement in art underwent a parallel shift between the years before and after World War One. Although no document supports a direct impact of Worringer's book on Kandinsky's first experiments with completely non-figurative painting, it is clear that the two men quickly became aware of one another, and grew warmly disposed to one another's work during the crucial period around 1911 when Kandinsky was forming the Blauer Reiter group. Worringer is credited with introducing the term 'Expressionismus' in his review for the journal *Der Sturm* of an exhibition by the Blauer Reiter. In 1920, in a lecture subsequently published under the title *Künstlerische Zeitfragen* ('Questions Concerning Contemporary Art'), he explicitly stated that expressionist art did not successfully represent the spirit of modern times. He also declared that painted images (*Malbilder*) no longer stood in the forefront of modern development, but that this role had now fallen to images in scholarly and philosophical thinking (*Denkbilder*).

The impact of Worringer's work depends much more on his moving the term 'abstraction' to the centre of his speculations about art rather than anything specific in those speculations. The appearance of such a broad hypothesis about abstraction certainly helped the sudden innovation of abstract art justify itself, even if it may not really have done as much to help it explain itself. The term 'abstraction' in the title of *Abstraction and Empathy* does not refer to any opposition between figurative and non-figurative painting. In Worringer's opinion, the urge to create images that imitate objects in the world should never be confused with the authentic artistic impulse. He never passes up an opportunity to repeat this, nor to distinguish what he means by naturalism from any 'menial' copying of nature. Looking to ornament for the essence of artistic volition, he is able to insist that both 'naturalism' and the geometrical style 'represent at bottom an

abstraction, and their diversity is really only one of degree.' Though the formal language or rhythms of Greek art are 'organic', and it therefore 'appeals first and foremost, with the whole of its being, to our empathic impulse', it 'still conforms to the abstract need' that determines every work of genuine art.

The polar opposition between abstraction and empathy remains entirely within this permanent and universal feature of formal purity in art. Drawing on Theodor Lipps, he even suggests that all art, and perhaps 'every aspect of the human sensation of happiness', might be attributed to the impulse of self-alienation active in our appreciation of such objective form. Nevertheless, the fundamental distinction between those poles leads back to a basis in psychology, or in metaphysics as a reflection of a general psychological *température d'âme* in a national tradition. The impulse to abstraction arises from an alienated relationship to nature, the impulse empathy from a joyful unity with nature. Both the effectiveness of his analysis of the contemporary situation in art, and the contradictions in his argument, come into focus through the vexed question of a modern relationship to nature.

Biography

Wilhelm Robert Worringer Born Aachen, Germany, 13 January 1881. He studied art history at Freiburg, Berlin and Munich before moving to Bern, where he completed his doctoral dissertation in 1907. This dissertation, *Abstraktion und Einfühlung: Ein Beitrag zur Stilpsychologie*, attracted immediate attention, and was published 1908. He taught as a *Privatdozent* at Bern University between 1909 and 1914. Worringer became acquainted with Wassily Kandinsky and the other members of the Blauer Reiter group in Munich. He published *Form in Gothic* in 1911. After military service in World War One, he taught at Bonn University from 1918 to 1928, becoming Professor in 1920. In that year he distanced himself from Expressionist painters and became more interested in contacts with philosophers, including Martin Buber. He taught at the universities of Königsberg, 1928–44; and Halle, 1946–50. Worringer died in Munich on 25 March 1965.

Bibliography

Main texts

Abstraction and Empathy: A Contribution to the Psychology of Style (Abstraktion und

Einfühlung: Ein Beitrag zur Stilpsychologie, 1908), trans. Michael Bullock, New York: International Universities Press, 1953.

Lukas Cranach, Munich: Piper, 1908.

Form in Gothic (*Formprobleme der Gothik*, 1911), Introduction by Herbert Read, London: Putnam's, 1927.

Die altdeutsche Buchillustration, Munich: Piper, 1912.

Künstlerischer Zeitfragen, Munich: Piper, 1921.

Urs Graf: Die Holzschnitte zur Passion, Munich: Piper, 1923.

Deutscher Jugend und östlicher Geist, Bonn: Friedrich Cohen, 1924.

Die Anfänge der Tafelmalerei, Leipzig: Insel, 1924.

Buch und Leben des hochberühmten Fabeldichters Aesopi, Ulm 1475, Munich: Piper, 1925.

Egyptian Art (*Ägyptische Kunst: Probleme ihrer Wertung*, 1927), trans. Bernard Rackham, London: Putnam's, 1928.

Griechentum und Gotik: Vom Weltreich des Hellenismus, Munich: Piper, 1928.

Über den Einfluß der angelsächsischen Buchmalerei auf die frühmittelalterliche Monumentalplastik des Kontinents, Halle: Niemeyer, 1931.

Fragen und Gegenfragen: Schriften zum Kunstproblem, Munich: Piper, 1956.

Secondary literature

Arnheim, R., 'Wilhelm Worringer on Abstraction and Empathy', *New Essays on the Psychology of Art*, Berkeley and Los Angeles: University of California Press, 1980.

Buttegieg, J.A., 'Worringer among the Modernists', *Boundary* 2, 6 (1979), 359–66.

Deleuze, G. and Guattari, F., *A Thousand Plateaus: Capitalism and Schizophrenia* (1980), trans. Brian Massumi, Minneapolis: Minnesota University Press, 1987.

Donahue, N.H. (ed.), *Invisible Cathedrals: The Expressionist Art History of Wilhelm Worringer*, University Park, Penn.: Pennsylvania State University Press, 1995.

Holdheim, W.W., 'Wilhelm Worringer and the Polarity of Understanding', *Boundary* 2, 7 (1978), 339–58.

Jones, A.R., 'T.E. Hulme, Wilhelm Worringer and the Urge to Abstraction', *British Journal of Aesthetics* 1 (1960), 1–7.

Saint-Martin, F., 'La vie et la mort en peinture', *Etudes Littéraires* 31 (1998), 59–74.

Schulze, I., 'Wilhelm Worringer und die bürgerliche Opposition gegen den großdeutschen Nationalismus auf dem Gebiet der Kunstgeschichtsschreibung', *Wissenschaftliche Zeitschrift der Martin-Luther-Universität Halle-Wittenberg*, Gesellschafts und sprachwissenschaftliche Reihe 18, 1969, 65–85.

Sheppard, R., 'Georg Lukács, Wilhelm Worringer and German Expressionism', *Journal of European Studies* 25, 3 (1995), 241–82.

Zijlmans, K. and Hoosgeveen, J., *Kommunikation über Kunst. Eine Fallstudie zur Entstehungs- und Rezeptionsgeschichte des 'Blauen Reiters' und von Wilhelm Worringers 'Abstraktion und Einfühlung'*, Leiden: Alpha, 1988.

MARCUS BULLOCK

INDEX

Abstract Expressionism 5, 71, 149,
151, 242–3
abstraction 71, 149, 154, 242; African
decorative forms 194, 196–7; in art
of primitive man 288; Worringer's
ideas 287, 288, 289–90, 290–1
Academy: undermining of by avant-
garde 58–9
Adami, Valerio 202
Adorno, Theodor **3–8**, 180, 240, 244
advertising 28, 29, 43, 54
aesthetic emotion: addressed by Lévi-
Strauss 186, 187, 187–8
Aestheticism 159
aesthetics: Adorno's critique 4; A.L.
Locke's theory 193, 195; in Bau-
drillard's writings 28–9, 29–30;
Bell's theory 38, 39–41; Benjamin's
theory 44–5; Berger's concern with
the social 50; Bourdieu's ideas 57–8;
Burke's influence on contempor-
aries 201; classical 44, 47, 283;
Croce 81–2; Damisch's psycho-
analysis of 88; deconstructionist 98,
100–1; Dewey's views 104, 106–7;
Foucault's work 113, 114–15; Fry's
theory 32, 125–7; Gadamer 130–1;
Goodman 143, 147–8; Greenberg
on judgements 153–4; importance
of Stokes 256; integration with
commodity 28–9; Kristeva's views
170–1, 171–2; Lyotard's contribu-
tion to theory 199; Modernism 106;
positivist writers on art 34; Simmel's
theory 245–6, 247, 248; and under-
standing beauty 186; Wittgenstein's

philosophy 269, 270, 273; Wölfflin's
ideas 276; Wollheim's writings 281;
Worringer's views 286–7, 288
African art: and African-American
cultural expression 193–4, 196–7;
A.L. Locke's support of 193, 196–7;
Fry's work 125
African masks 38
African-Americans: A.L. Locke's view
of cultural progress 192–7
Agostino di Duccio 259
Agrippa, Heinrich Cornelius 224
Albers, Josef 106
Albert Memorial 257
Alberti, Leon Battista 259
Albi: Mâle's study 206–7
Algeria: Bourdieu's study of Kabylean
villages 56
allegory: Benjamin's study of Baroque
47–8; Croce's view 82
allographic art 146
Alpers, Svetlana 85
Althusser, Louis 231, 244
American art: integration of Negro
subject into 195
Amerindians: Lévi-Strauss's study of
mythology 186, 188–9; *see also*
Pueblo Indians
anarchism: artists in Clark's studies 72;
Read's perspective 235
ancient world: in Foucault's historical
framework 113, 114; *see also* Antiq-
uity; classical Greece; Egyptian art
Angelico, Fra 128
Antal, Frederick 50
anthropology 27, 176, 186, 187–8, 263